HUBBLE

IMAGING SPACE AND TIME

HUBBLE

IMAGING SPACE AND TIME

NATIONAL GEOGRAPHIC

WASHINGTON, D.C.

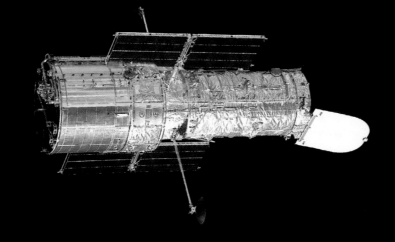

Right now, about a dozen spaceborne telescopes of assorted sizes and shapes are out there, providing astrophysicists a view of the cosmos—unobstructed, unblemished, and undiminished by Earth's atmosphere.

Nearly all of them are designed to detect bands of light invisible to the human eye. You can easily recognize these parts of the spectrum from their earthly applications; they include microwaves, infrared, x-rays, and gamma rays. Entire classes of objects and phenomena in the cosmos reveal themselves only through one or more of these invisible cosmic windows.

As important as these telescopes are to advancing the research frontier, most perform their duties anonymously, without the public's awareness or recognition. Not so the Hubble Space Telescope. The beloved Hubble telescope—with its stunningly crisp, colorful, and detailed images of the cosmos. Hubble is the first and only space telescope to image the universe in visible light, becoming for us a supreme version of our eyes in space.

Yet Hubble's appeal to us all derives from far more than vicarious cosmic vistas. Hubble came of age in the early 1990s, during an exponential growth of the public's access to the Internet. That's when Hubble's digital images, obtained via tax-based dollars to NASA, were first cast into the public domain. As we all know, anything fun, free, and forwardable spreads rapidly across the Internet. Hubble images, each one more splendorous than the next, became screen savers and desktop "wallpaper" for computers owned by people who would never before have had the occasion to celebrate, however quietly, our place in the universe.

Not only that, most space telescopes are launched with no means of servicing them. Parts wear out. Gyroscopes fail. Batteries die. These hardware realities typically limit a telescope's life expectancy to anywhere from three to seven years. Not so the Hubble. It was designed, built, and launched to be serviced by shuttle astronauts, granting Hubble unprecedented longevity for a space-based telescope. And with smart engineering and clever retrofitting, Hubble's talents were not simply sustained over the years; mission by mission, they were vastly improved.

With the Hubble Space Telescope well into its second decade of performance, students in high school have never known a time without Hubble as their conduit to the cosmos. Hubble brought the universe into our backyard, with images so intellectually and spiritually fulfilling that they don't even need captions. It practically didn't matter what the image contained: planets, star fields, interstellar nebulae, black holes, colliding galaxies, or fields of galaxies. You were content just to gaze at them.

In 2004, when NASA announced that Hubble would not receive its fifth servicing mission—which would prolong its life yet another five years, maybe ten—there was an outcry. And the loudest voices were not the scientists, but the general public. Akin to a modern version of a torch-wielding mob, there were angry editorials, op-eds, letters to the editor, and talk shows on radio and television, all urging NASA to restore the funding and keep Hubble alive. At last, following pressure from Congress, NASA reversed its decision—Hubble would be serviced one last time.

Something remarkable had occurred: The public took ownership of the Hubble Space Telescope. I know of no time in the history of civilization when the masses banded together to save a scientific instrument. So for perhaps another decade, Hubble will continue to do what it does best for one and all: bring the universe down to Earth.

—Neil deGrasse Tyson, Astrophysicist
AMERICAN MUSEUM OF
NATURAL HISTORY, NEW YORK CITY

The Hubble Space Telescope is perhaps the most productive scientific instrument ever created by humans. The images and data gleaned from the observations made by this unique observatory in Earth orbit have provided clues to some of the most fundamental questions in science. The reach of the Hubble has extended well beyond the realm of astronomy, with the result that Hubble has become an icon for science.

The chronicles of the Hubble are about more than a telescope in space. They are a story of imagination and dreams, of struggles, failures, and triumphs, sometimes against all odds. The major players in this story are among the best and brightest of our planet's scientists and engineers, including such luminaries as Lyman Spitzer, John Bahcall, and, of course, Edwin Hubble himself. Few are as well suited to present this continuing story as the authors of this volume. In *Hubble: Imaging Space and Time* David DeVorkin and Robert W. Smith take the reader along a journey that is more than out of this world.

Why has the Hubble Space Telescope become a scientific celebrity? A major reason is that astronomers using the Hubble are answering fundamental questions: Where do we come from? What is the origin and evolution of the universe? How are stars and planets born, and how do they die? This book, featuring the Hubble's latest images, will help to describe our origins and fate. The

Hubble's popularity has a more human side as well. It represents the best synergy of the robotic space science program and the human space flight program. Only by the visits of astronauts has the Hubble survived the rigors of the space environment. And, with each visit, astronauts have reinvented the Hubble, turning it into a new, state-of-the art facility.

Five teams of astronauts have serviced the Hubble. The first mission restored the vision of the telescope and rescued the image of NASA in the public eye. In the Hubble story it is the space-walking men and women astronauts riding to the rescue in their white suits who capture the broader imagination. I have had the privilege of working on three of those missions, and of "hugging" the Hubble in Earth orbit. On those missions we renovated systems, fixed broken instruments, and installed highly capable new sensors, including the Advanced Camera for Surveys (ACS). Many of the fantastic images in this book were taken with the ACS. In 2009 I returned

to my old friend, Mr. Hubble, leading the spacewalkers on the fifth and final servicing mission (HST-SM4) on which we installed a new suite of scientific instruments and performed critical repairs.

As noted in these pages, the final mission was cancelled after the tragic loss of the space shuttle *Columbia* in 2003. Public outcry, Congressional action, and support from the scientific community kept the Hubble storyline alive; NASA scientists, engineers, and technicians solved the problems that plagued *Columbia,* and other safety issues as well. At last NASA approved the mission to service the Hubble.

This book brings the Hubble chronicles up to date, but the final chapters are yet to be written. The Hubble's most exciting discoveries are derived from new instruments. The HST-SM4 mission has left the Hubble at the apex of its scientific capability, and all of us on the edge of our seats, awaiting the next wave of science.

—John Mace Grunsfeld, Ph.D.
ASTRONAUT, HST-SM4, 2011

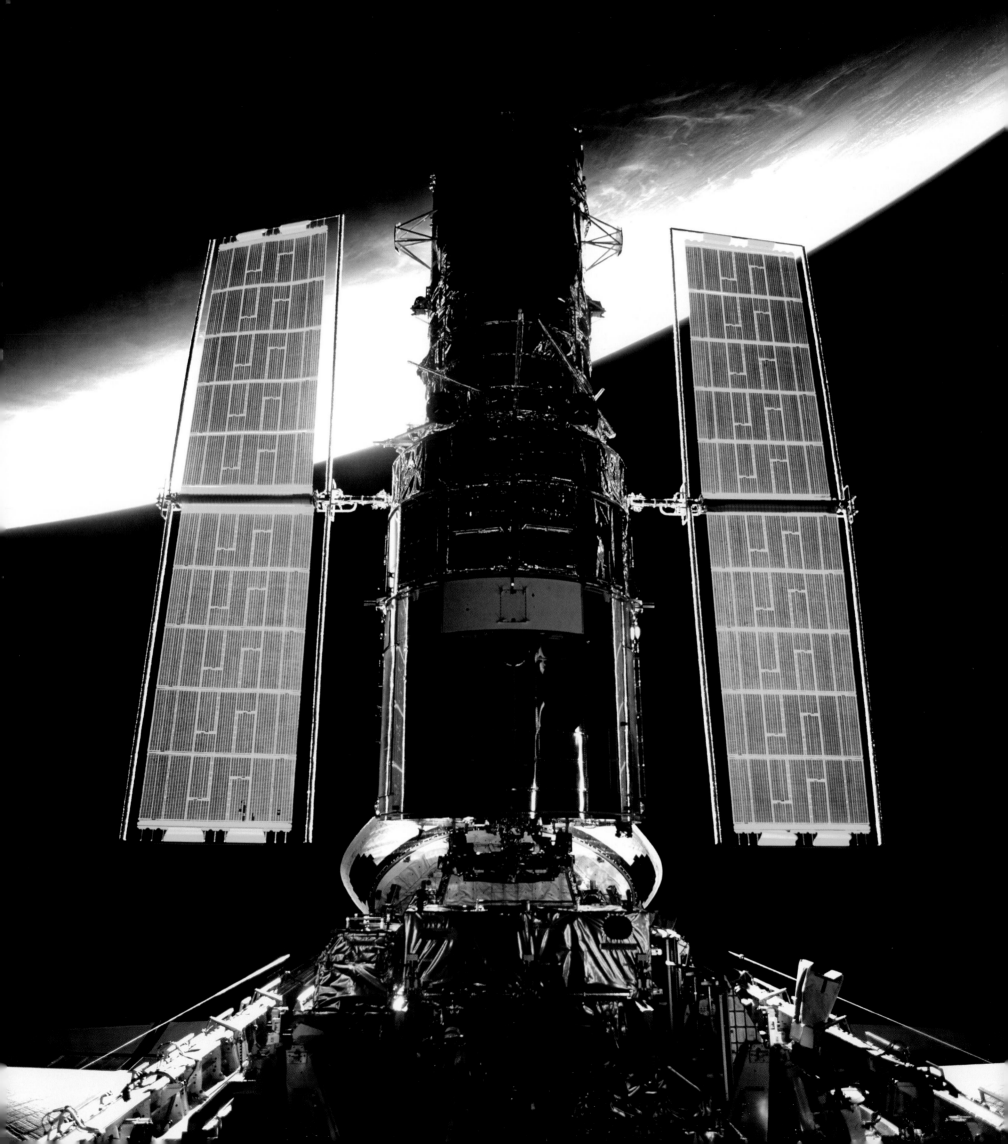

January 14, 2004.

The auditorium in NASA's downtown Washington, D.C., offices is crowded and the mood expectant. Almost two years earlier, at the end of a 16-day mission to space, the space shuttle *Columbia* had ripped apart as it reentered Earth's atmosphere. Seven astronauts died in its fiery disintegration. Since that day, the remaining shuttles had been grounded and the U.S. civilian space program heavily criticized. As President George W. Bush prepares to speak to the people in the room and beyond, he aims to provide a new direction and vision for NASA.

The President stands in front of large screens that give viewers the sense of being in mission control for a spaceflight. Another screen displays enthusiastic workers at the Jet Propulsion Laboratory in California. NASA, the President announces, is going to "extend a human presence across our solar system." First, the United States would return astronauts to the moon. But, unlike in the days of the Apollo missions, the moon would not be the endpoint of this new project, the Vision for Space Exploration. The long term goal is for astronauts to voyage to Mars.

The new goals for NASA mean a new generation of launch vehicles to loft people and payloads into orbit around Earth and beyond. Once the remaining space shuttles had played their part in completing the International Space Station, they would be retired.

The bombshell came two days later. NASA head Sean O'Keefe explained that as a result of the *Columbia* disaster, NASA would apply new safety rules to shuttle flights. Therefore, O'Keefe was canceling the long-planned shuttle servicing mission to the orbiting Hubble Space Telescope (HST), Servicing Mission 4 (SM4). The new safety guidelines meant that such a mission would involve costly inspection and repair techniques for the shuttle orbiters. If something went badly awry when a shuttle visited the Hubble, the orbiter would not be able to reach the safe harbor of the International Space Station. A second shuttle would therefore have to be on the launchpad, ready and primed to conduct a rescue.

But the shuttle was the only way to reach the Hubble. Two new scientific instruments had also been built for the telescope: the Wide Field Camera 3 and the Cosmic Origins Spectrograph. Without the shuttle they could not be installed. Even more seriously, without a shuttle service call within a few years, critical components of the orbiting observatory would likely fail. Engineers reckoned that the HST's batteries and gyroscopes, devices that keep the telescope pointed to specific astronomical targets over extended periods, were particularly critical. The HST was unlikely to last beyond 2010, if that. O'Keefe, in the eyes of many astronomers, had

Opposite: **1993 REPAIRS** The Hubble sits in the space shuttle *Endeavour*'s payload bay, awaiting repairs, in 1993. The chief purpose of this repair was to add corrective optics and to replace the imaging camera in order to fix the Hubble's vision, thus enabling the telescope to return to Earth its spectacular images of space and time. A model of the Hubble is in the National Air and Space Museum in Washington, D.C.

condemned the Hubble Space Telescope to an untimely and unwarranted death.

By the time of O'Keefe's announcement, the HST had been orbiting Earth for nearly 14 years. A joint creation of NASA, the European Space Agency, hundreds of industrial companies, government and university groups, and thousands of engineers and scientists, it was widely regarded as one of the triumphs of the space age. The Hubble had triumphed over the embarrassments of its early years, when a misshapen mirror required a shuttle service call in 1993. During five sets of lengthy space walks, shuttle astronauts had toiled patiently to install new instruments and adjust the mirror's performance. When the first images were viewed at the Space Telescope Science Institute, the mood was euphoric. The blurs astronomers had endured for over three years had been replaced by sharp images. The HST's vision was as acute as expected before its launch.

In the years to come, it began returning not only scientific data, but stunning, even mind-boggling images. From the Space Telescope Science Institute, these images reached the pages of scientific journals and textbooks, newspapers, magazines, television, and the Internet. A startling 1995 image of the Eagle Nebula, its ocher pillars of gas and dust glowing in a purple sky, became the Hubble's iconic shot. The public was hooked. The Hubble became a media superstar, winning the plaudits of politicians, journalists, astronomers, and the populace.

For astronomers, the Hubble Deep Field images in particular were a revelation. These images were the result of over 300 separate exposures of one small area of the sky late in 1995. They disclosed traces of some 1,500 galaxies, some as far away as 10.5 billion light-years, emphasizing the HST's ability to see incredibly distant regions—incredibly ancient regions—of the universe with unprecedented clarity.

Telescopes are time machines: They allow us to see back in time as well as out into space. Light travels at around 186,000 miles a second, and so when we look at the moon, the light we see has taken over a second to reach us. The light we see from our nearest star, the sun, left that body over eight minutes ago. On clear fall evenings, high in the sky in the constellation Andromeda, is a faint smudge of light known as the Andromeda Nebula. This is in fact a galaxy, very close to our Milky Way in cosmic terms; even so, light from Andromeda takes around 2.5 million years to cover the distance to us. We are seeing Andromeda as it existed 2.5 million years ago.

The various galaxies captured in the Hubble Deep Field are between 2.5 and 10.5 billion light-years away. Hence the light from the farthest Deep Field galaxies traveled for well over half the lifetime of the universe before it hit the sensors in the Hubble's scientific instruments.

These extraordinary images and the other spectacular scenes that followed would not have been possible without the series of servicing missions that reached the Hubble between 1993 and 2002. These missions not only kept the Hubble functioning smoothly, but also improved its scientific capabilities by leaps and bounds. When, for example, the Advanced Camera for Surveys (ACS) was slotted into the telescope during the 2002 servicing mission, it became the most capable camera flown aboard the HST. The Hubble, as its designers had intended, had been remade and improved in orbit.

This history forged special bonds between the Hubble and its supporters and advocates among politicians, members of the public, and astronomers. Thus O'Keefe's January 16, 2004, announcement that the space agency would leave the observatory to its fate touched a raw nerve. In the opinion of many, the Hubble was the most productive scientific instrument ever, one with which they felt a very personal involvement. Furthermore, an upgraded Hubble would produce still more exciting science following SM4. "A lot of people have put much of their scientific life into this," one well-placed astronomer lamented. "And there was no question that it would eventually come to an end, but it has not reached the peak of its capabilities yet. The best is yet to come from Hubble."

Whatever the merits of O'Keefe's decision, it was a public relations disaster for NASA. Soon the agency was buffeted by a political storm. Members of Congress, angry citizens, outraged astronomers, and some of his own NASA staff reckoned the decision misguided. A "Save the Hubble" movement sprang into life. Within weeks of O'Keefe's decision, there was such an outpouring of support for the Hubble that newspaper accounts sometimes referred to it as the "people's telescope." One congressman reported he'd not understood the level of interest in the Hubble, but "we're getting hundreds of letters and emails" over what his respondents bemoaned as a pennywise and pound-foolish decision.

One particularly well-placed and determined opponent of O'Keefe's decision was Senator Barbara Mikulski of Maryland. With the Goddard Space Flight Center and the Space Telescope Science Institute in her state, she had a special interest in space issues. Convinced that the future of the telescope "should not be made by one man in a back room," Mikulski asked the National Academy of Sciences, the nation's

most prestigious group of scientists, to examine the risks of another shuttle flight to Hubble. O'Keefe, however, was not budging. "Letting it go dark is the most unpopular decision I could have made. The easy choice would have been to flatly ignore" the safety considerations, he said. This "would have been the height of irresponsibility."

On June 1, 2004, O'Keefe faced his sternest critics when he addressed the American Astronomical Society. By now he had changed tack. "Our confidence is growing that robots can do the job," he said. Indeed, the space agency was soliciting proposals that would explore whether a robotic mission could refurbish the Hubble. But despite O'Keefe's air of optimism, many experienced people were skeptical of a robotic spacecraft's chance of success, given the date by which the mission would have to be launched. A few days before O'Keefe's speech, 27 astronauts had petitioned him, among them Mercury astronaut Scott Carpenter, the first shuttle pilot Robert L. Crippen, and Eugene A. Cernan, the last Apollo astronauts to walk on the moon. They urged a shuttle mission to the Hubble instead of pursuing what they saw as the chimera of a highly unlikely robotic mission. When the National Academy of Sciences reported a few months later, its panel of 21 experts was no more impressed than the astronauts with the chances for success of a robotic mission within the tight time limits. That panel, too, pressed for a shuttle mission to Hubble and argued that it posed no unacceptable risks to the astronauts. The astronauts, one member noted, would be able to inspect and repair the orbiter with the aid of various sensors and space walks. If necessary, the orbiter could even power down for up to 30 days and await a rescue mission from a second shuttle.

A few days after the National Acade-my of Sciences report was released, Sean O'Keefe announced that he would resign as head of NASA. Soon news leaked out that NASA had dumped plans for any kind of service mission, whether robotic or via the shuttle. The White House, in consultation with O'Keefe, had decided the one-billion-dollar price tag for robotic servicing was simply too much. The emphasis in NASA's planning was squarely on the President's vision for exploring the moon and Mars.

President Bush's nominee to replace O'Keefe was Michael D. Griffin. In contrast to O'Keefe, Griffin came from a spacecraft background and has a Ph.D. in aerospace engineering. At his confirmation hearings on Capitol Hill, Griffin made it clear that he intended to reassess the agency's plans to cancel the shuttle mission to the Hubble. He soon set in train an in-depth assessment of the risks it entailed. Griffin gave the Hubble's supporters renewed hope.

This time their hopes were not to be dashed. A two-day summit on a possible servicing mission convinced Griffin that the astronauts were very much in favor of it and that it would be no more dangerous than journeys to the space station.

And so Servicing Mission 4, long delayed, was revived. Between May 11 and 24, 2009, astronauts aboard the shuttle Discovery made five space walks to install two new major instruments, the Cosmic Origins Spectrograph and a third-generation imaging camera, the Wide Field Camera 3 (WFC3). They also replaced critical positioning and stabilizing systems. These repairs and replacements increased the power of the telescope by an order of magnitude and greatly improved its chances for an extended, highly productive life. By September 2009, NASA started releasing spectacular new images that once again demonstrated Hubble's enhanced powers of penetrating space.

ACRONYMS USED IN THIS BOOK

ACS Advanced Camera for Surveys
CCD Charge-coupled device
COSTAR Corrective Optics Space Telescope Axial Replacement
ESA European Space Agency
EGGs Evaporating gaseous globules
FOS Faint Object Spectrograph
FOC Faint Objects Camera
FITS Flexible Image Transport System
GO General Observer
GHRS Goddard High-Resolution Spectrograph
GTO Guaranteed Time Observer
HST Hubble Space Telescope
IRAF Image Reduction and Data Analysis Facility
LST Large Space Telescope
NASA National Aeronautics and Space Administration
NICMOS Near Infrared Camera and Multi-Object Spectrometer
OTA Optical Telescope Assembly
ORUs Orbital Replacement Units
PRP Proposal Review Panel
SI Scientific Instruments
STIS Space Telescope Imaging Spectrograph
STScI Space Telescope Science Institute
SSM Support Systems Module
TAC Time Allocation Committee
TDRSS Tracking and Data Relay Satellite System
UDF Ultra Deep Field
ULE Ultra Low Expansion
WFC Wide Field Camera
WF/PC Wide Field/Planetary Camera
WF/PC2 Wide Field/Planetary Camera 2

IMAGE DISTANCES, DATES, ICONS

The estimated distance to objects in the images is given along the right edge of relevant spreads; the distance indicators correspond to images from left to right. Icons appear below, identifying the objects. As new techniques and more powerful telescopes come online, distance estimates may change. Dates in the image captions reflect either when the data were collected or when the image was released.

planetary bodies

stars

nebulae and star clusters

galaxy

cluster of galaxies

1980s Optics company Perkin-Elmer begins construction of the space telescope's primary light-collecting mirror; problems postpone completion to 1985. **1983** The Space Telescope Science Institute (STScI) is founded. Located at Johns Hopkins University, it assumes from NASA the science management of the Hubble Space Telescope. **1985** Hubble Space Telescope is completed; it carries Wide Field and Planetary Camera (WF/PC); Goddard High Resolution Spectrograph (GHRS); Faint Object Camera (FOC); Faint Object Spectrograph (FOS). **April 24, 1990 12:33:51 UTC** Space shuttle *Discovery* lifts off, carrying the Hubble into orbit. **April 27, 1990, 19:38 UTC** Hubble Space Telescope is released into orbit.

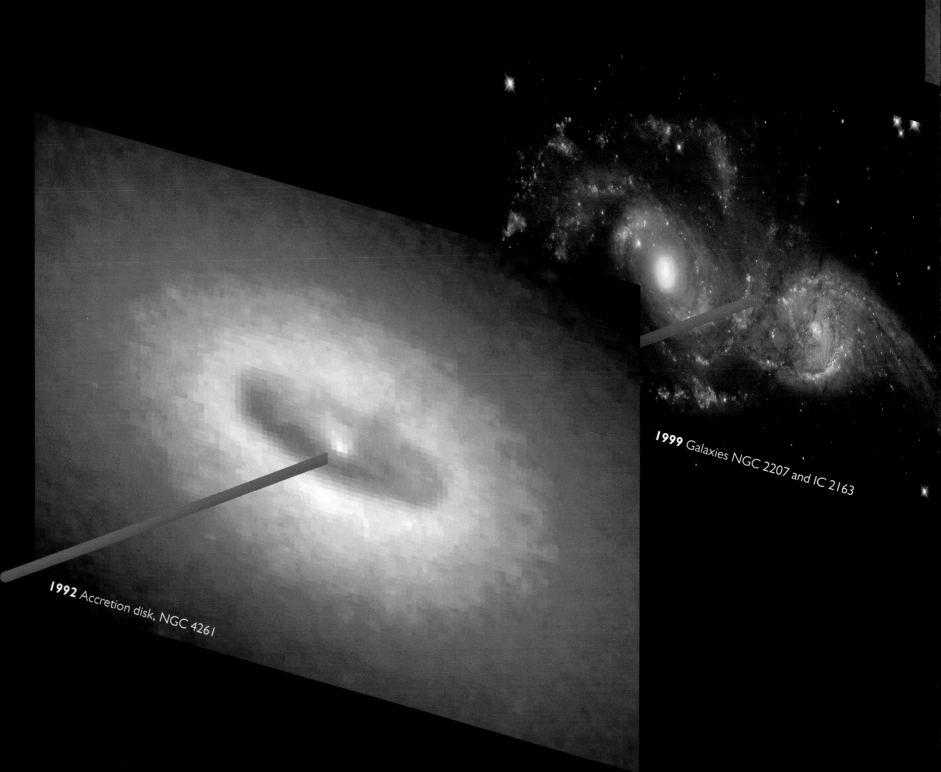

1999 Galaxies NGC 2207 and IC 2163

1992 Accretion disk, NGC 4261

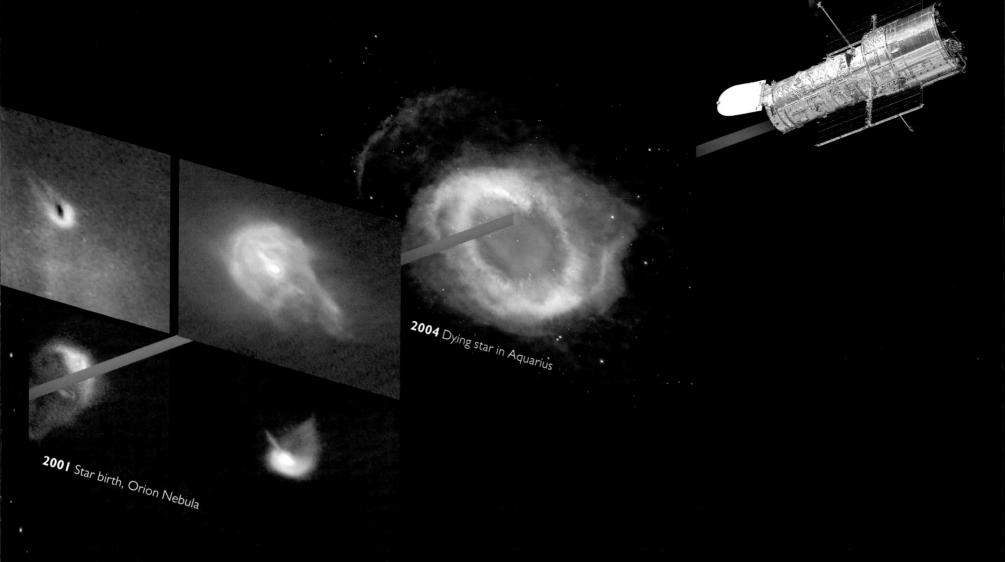

2004 Dying star in Aquarius

2001 Star birth, Orion Nebula

December 2, 1993 Space shuttle *Endeavour* launches on Hubble Servicing Mission 1. Corrective optics package COSTAR is installed to correct primary mirror's flaw. The Wide Field and Planetary Camera 2 (WF/PC2) replaces original WF/PC. **June 1994** Hubble takes images of the Orion Nebula that confirm the birth of planets around stars. **November 1995** Images taken by Hubble of the Eagle Nebula show the birth of stars. **February 21, 1997** *Discovery* launches on Hubble Servicing Mission 2. The Space Telescope Imaging Spectrograph (STIS) and the Near Infrared Camera and Multi-Object Spectrometer (NICMOS) replace GHRS and FOS. **November 13, 1999** A fourth gyroscope on Hubble fails; it can no longer aim itself and shuts down. **December 19, 1999** Space shuttle *Discovery* launches on Hubble Servicing Mission 3A. All six gyroscopes are replaced. **2003-2004** The ACS and NICMOS work together to image the Hubble Ultra Deep Field. **May 11, 2009** Fifth and final servicing mission. WFC3 and the Cosmic Origins Spectrograph installed; two instruments repaired in flight. **2018** Earliest possible launch date for the next-generation orbiting telescope, the James Webb Space Telescope.

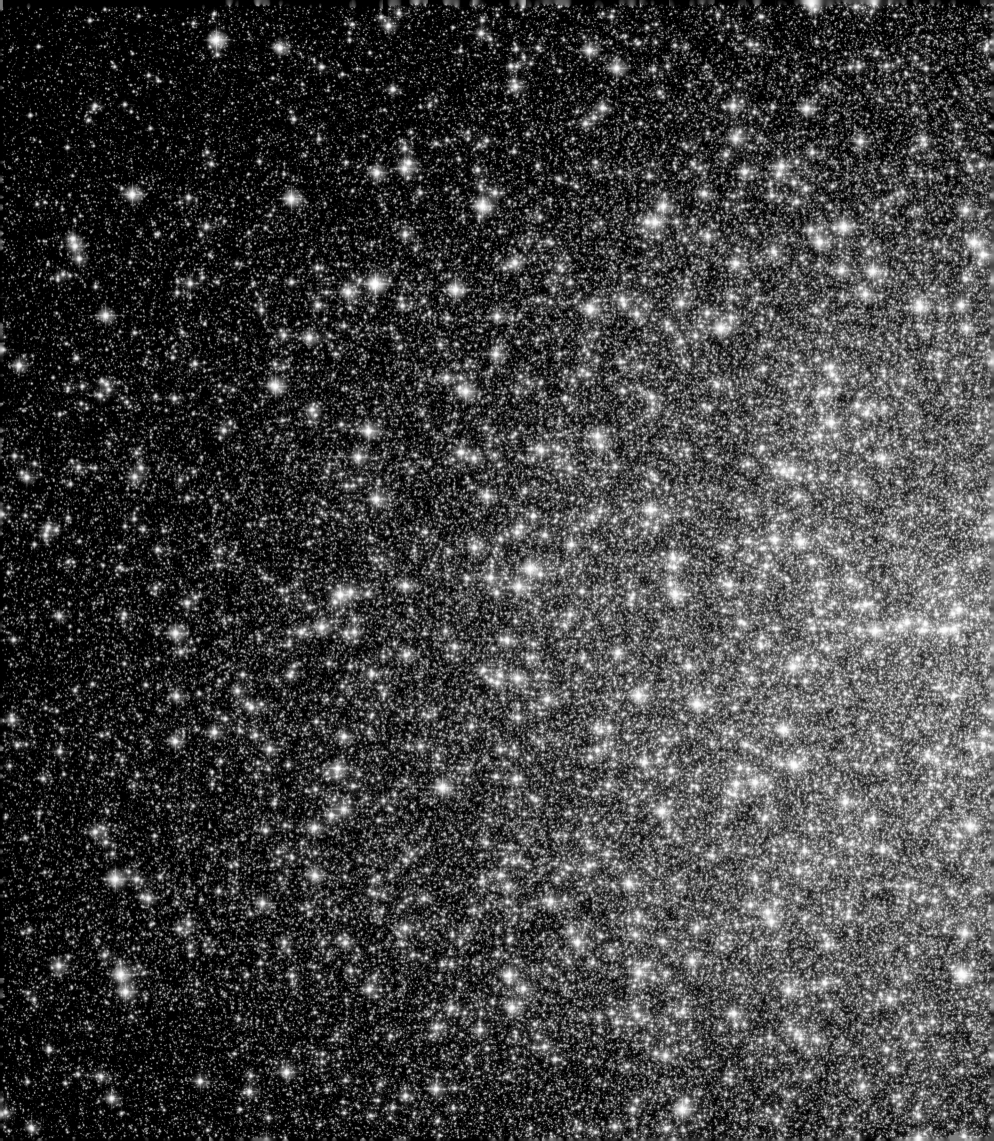

GIANT GLOBULAR CLUSTER OF STARS, OMEGA CENTAURI, NGC 5139 (2008)

17,000 LIGHT-YEARS

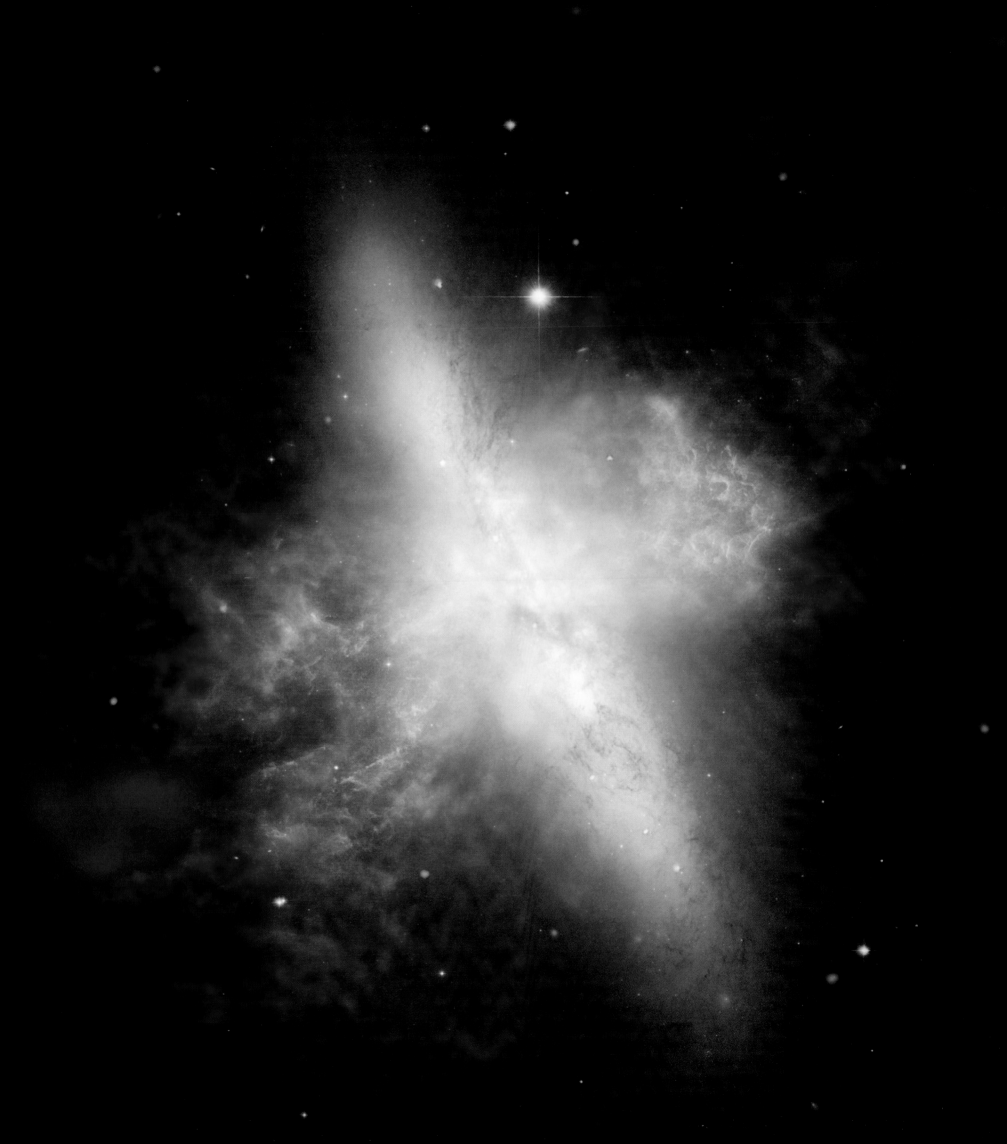

Opposite: **ACTIVE GALAXY M82 , COMPOSITE IMAGE (2006)** *This page:* **SPIRAL GALAXY NGC 3370 (2003)**

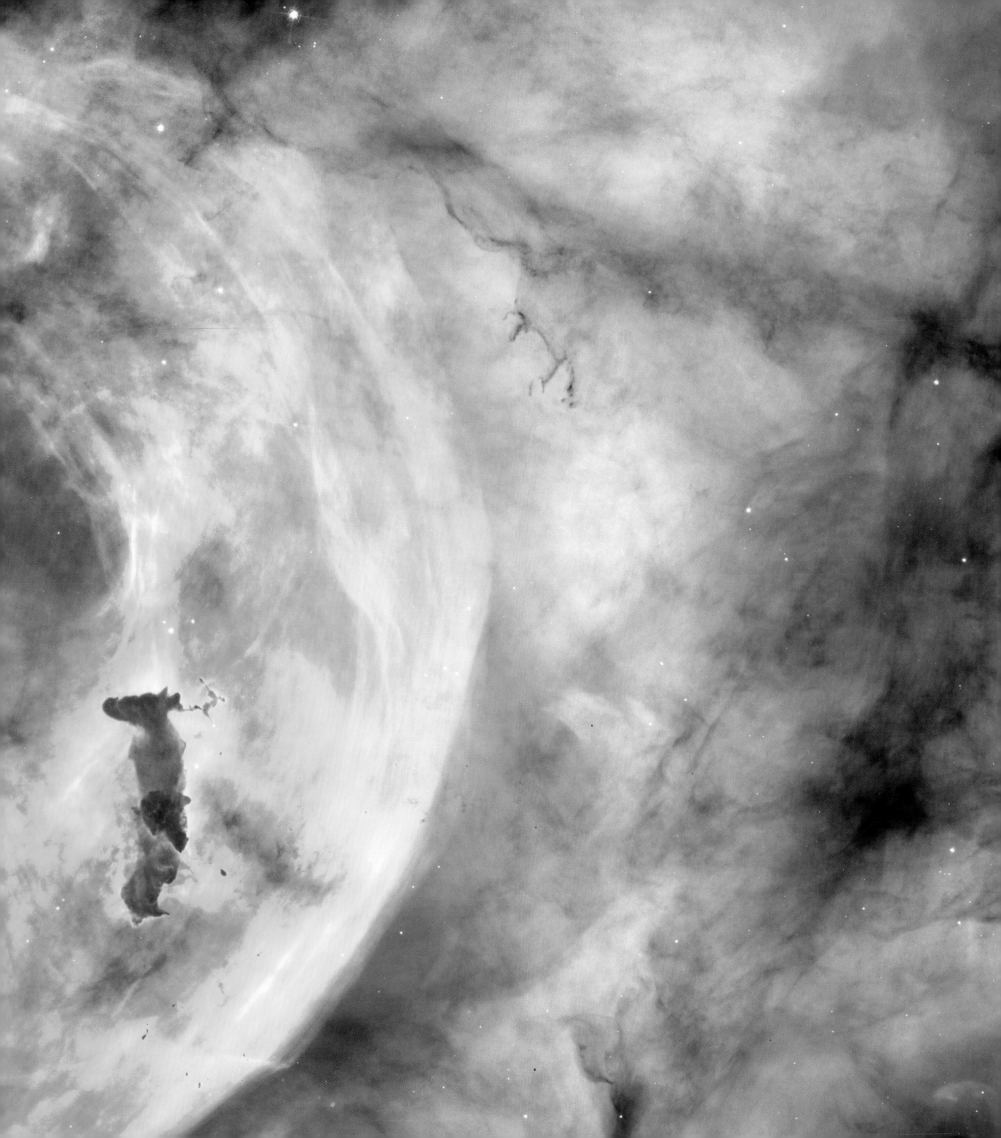

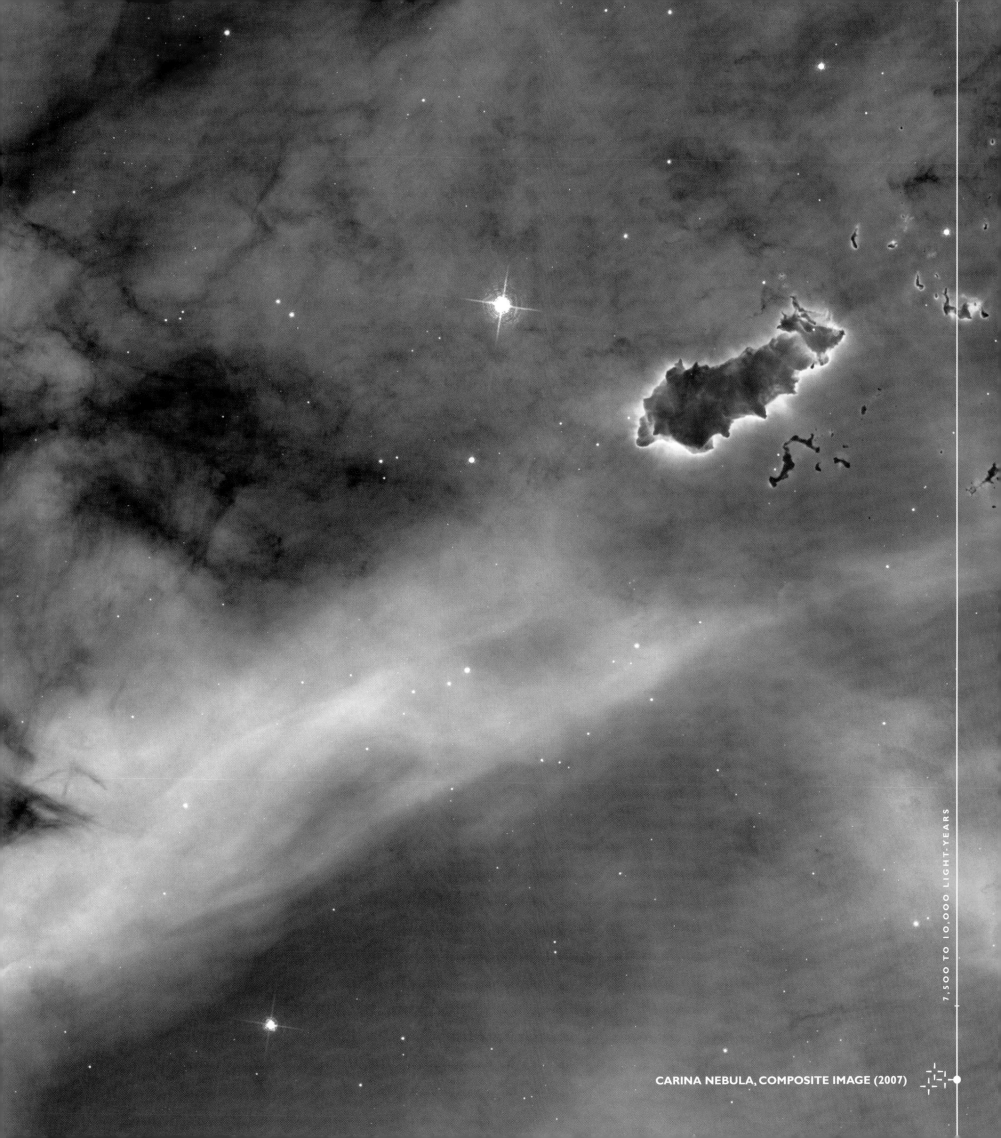

7,500 TO 10,000 LIGHT-YEARS

CARINA NEBULA, COMPOSITE IMAGE (2007)

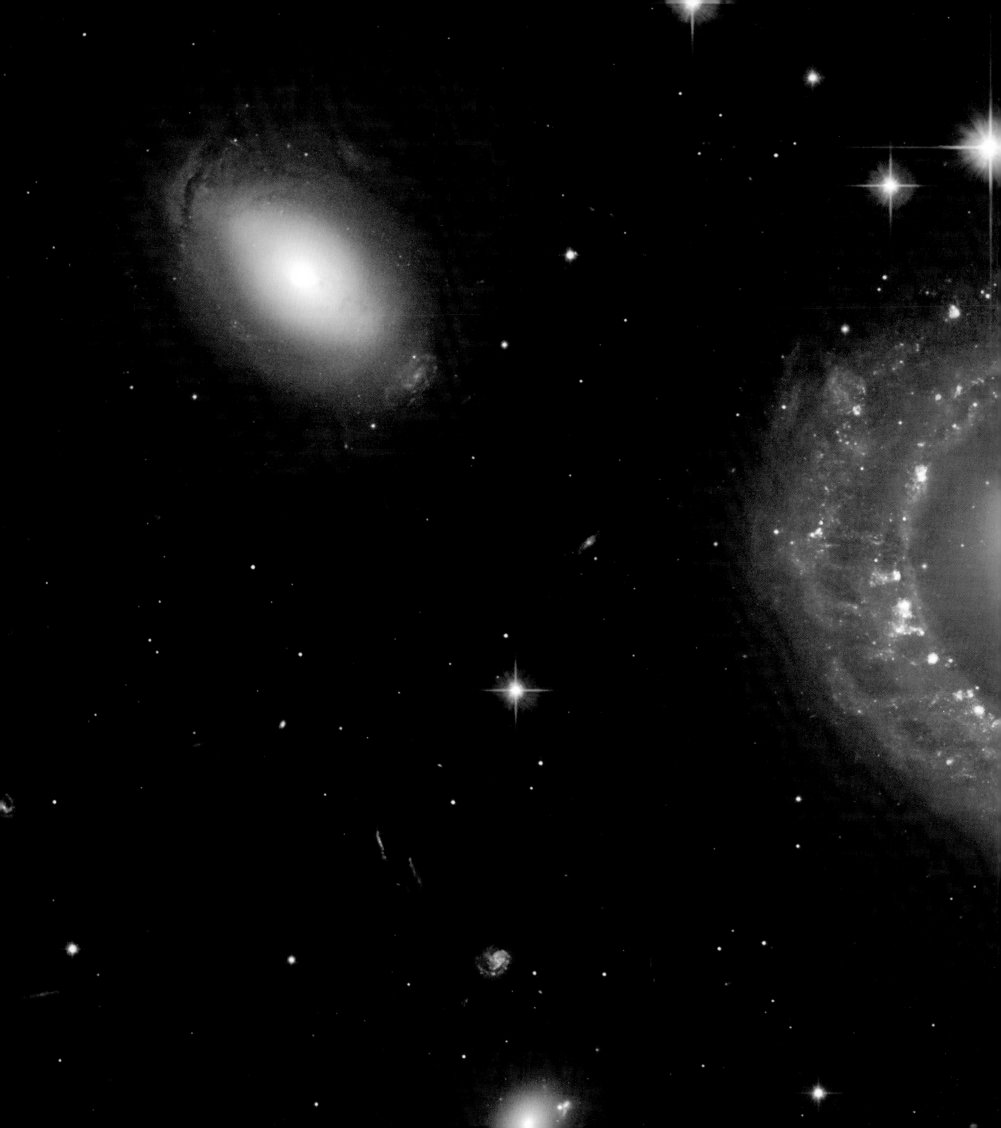

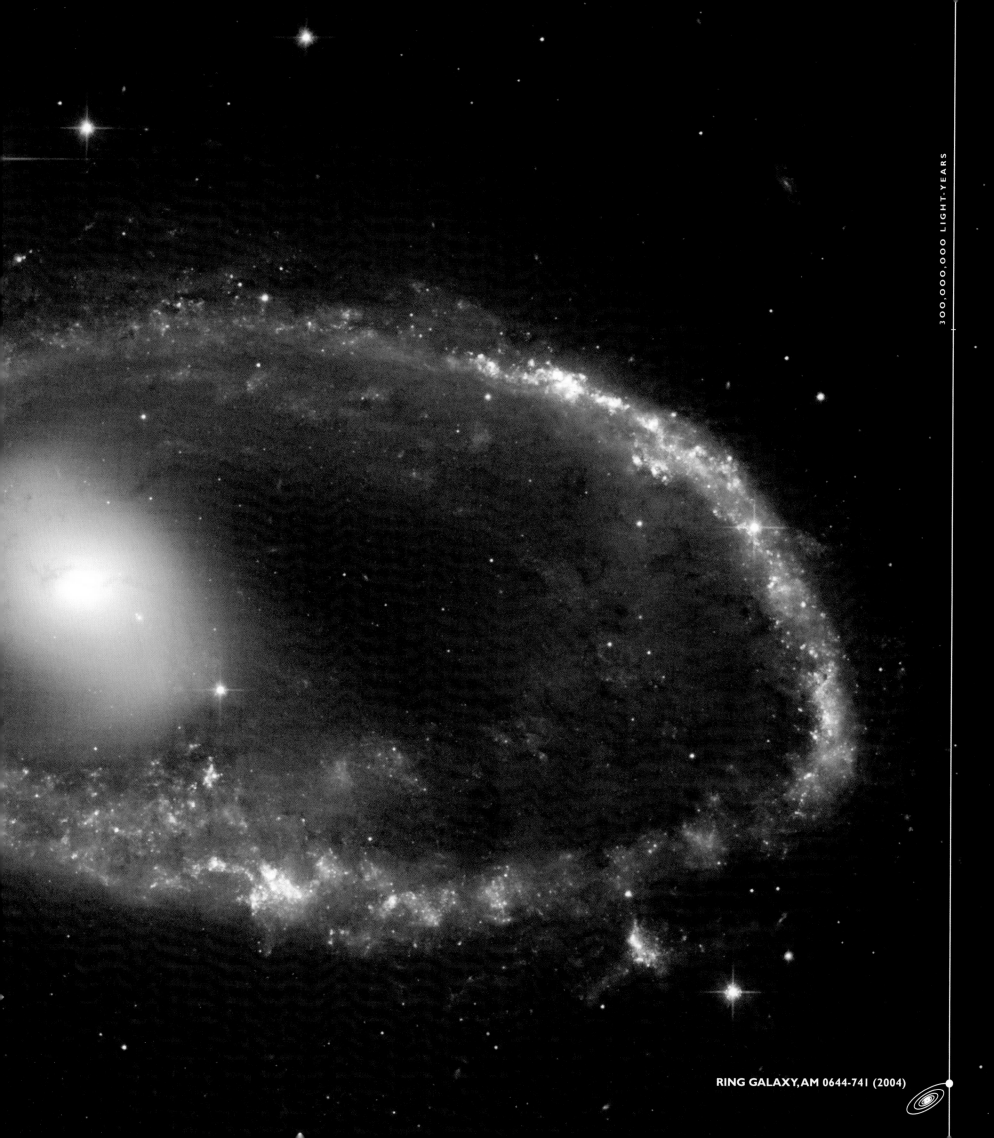

300,000,000 LIGHT-YEARS

RING GALAXY, AM 0644-741 (2004)

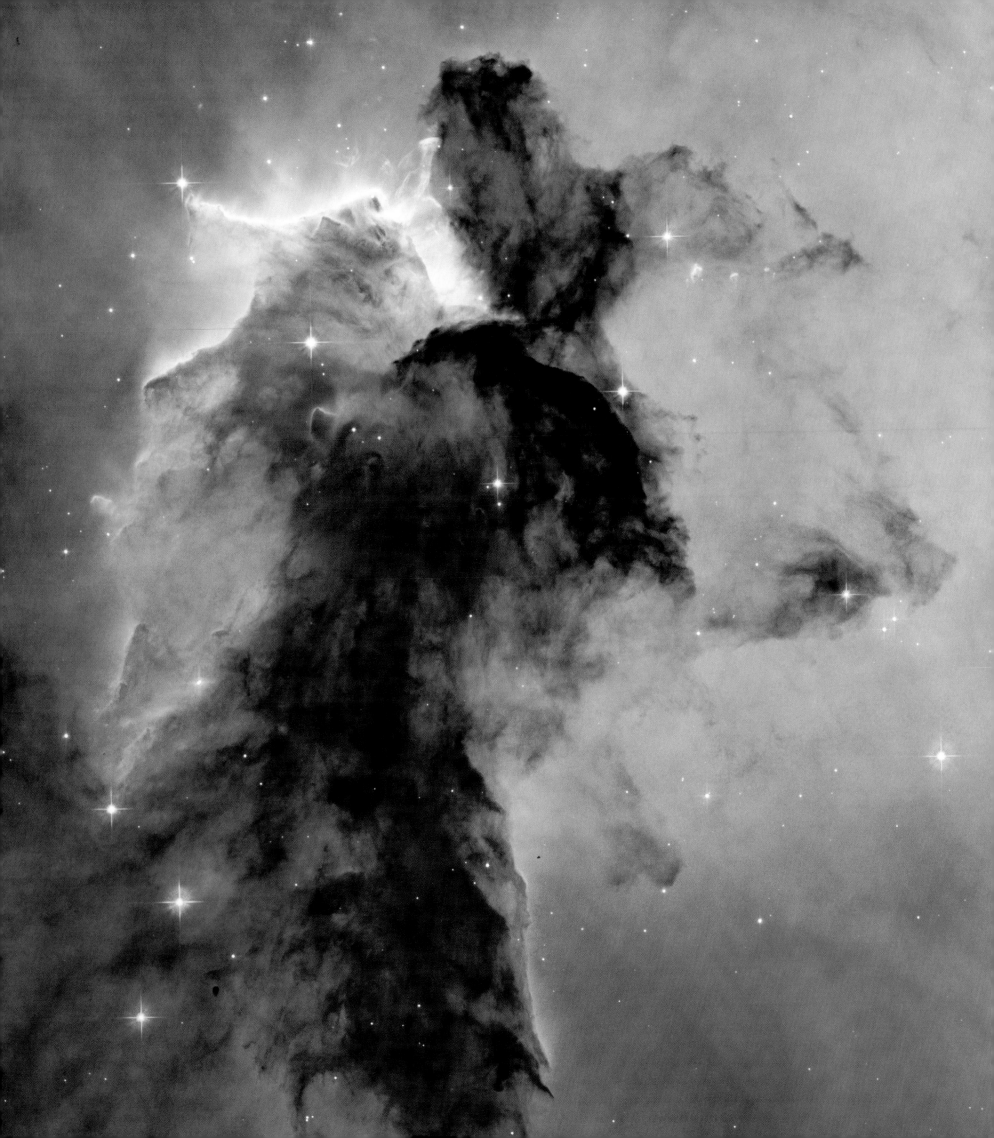

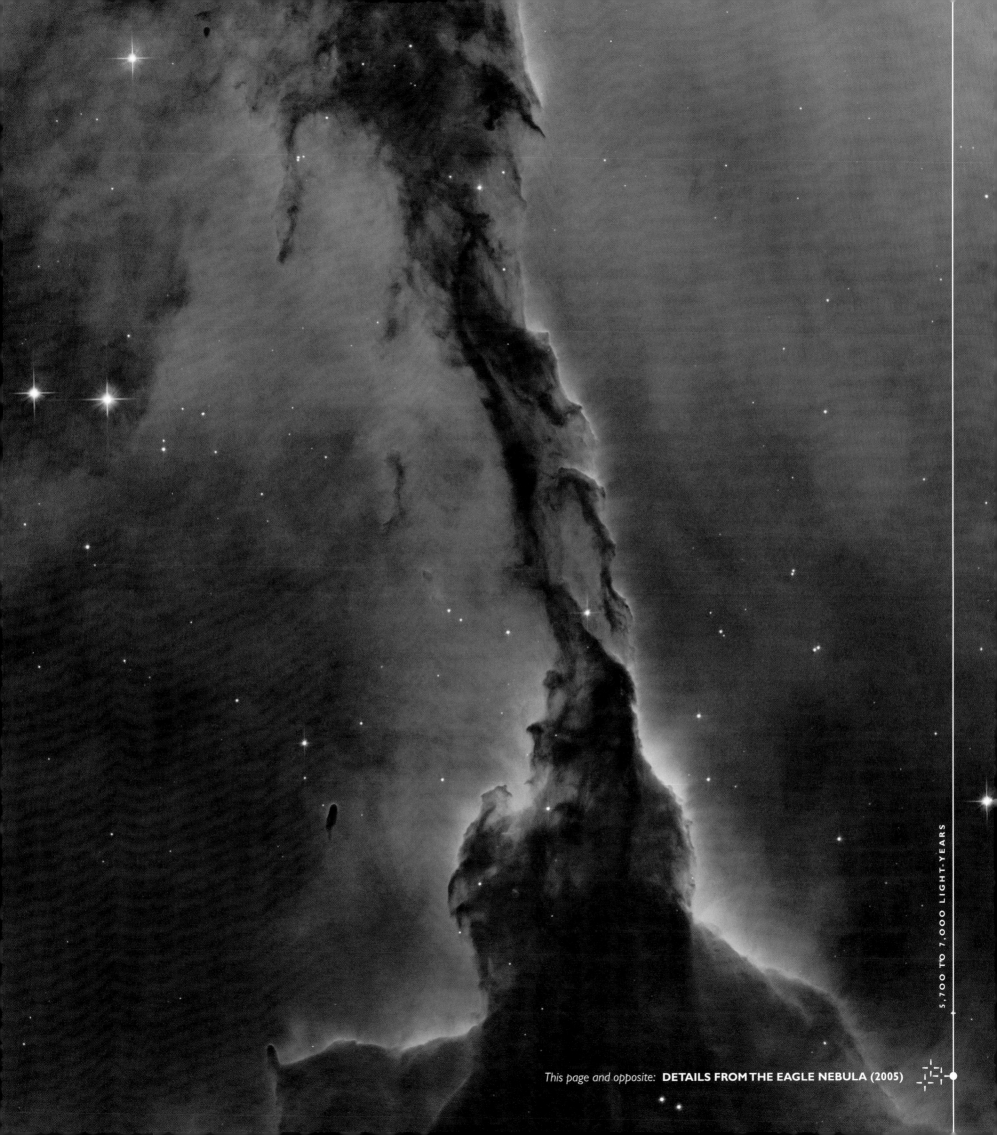

This page and opposite: **DETAILS FROM THE EAGLE NEBULA (2005)**

5,700 TO 7,000 LIGHT-YEARS

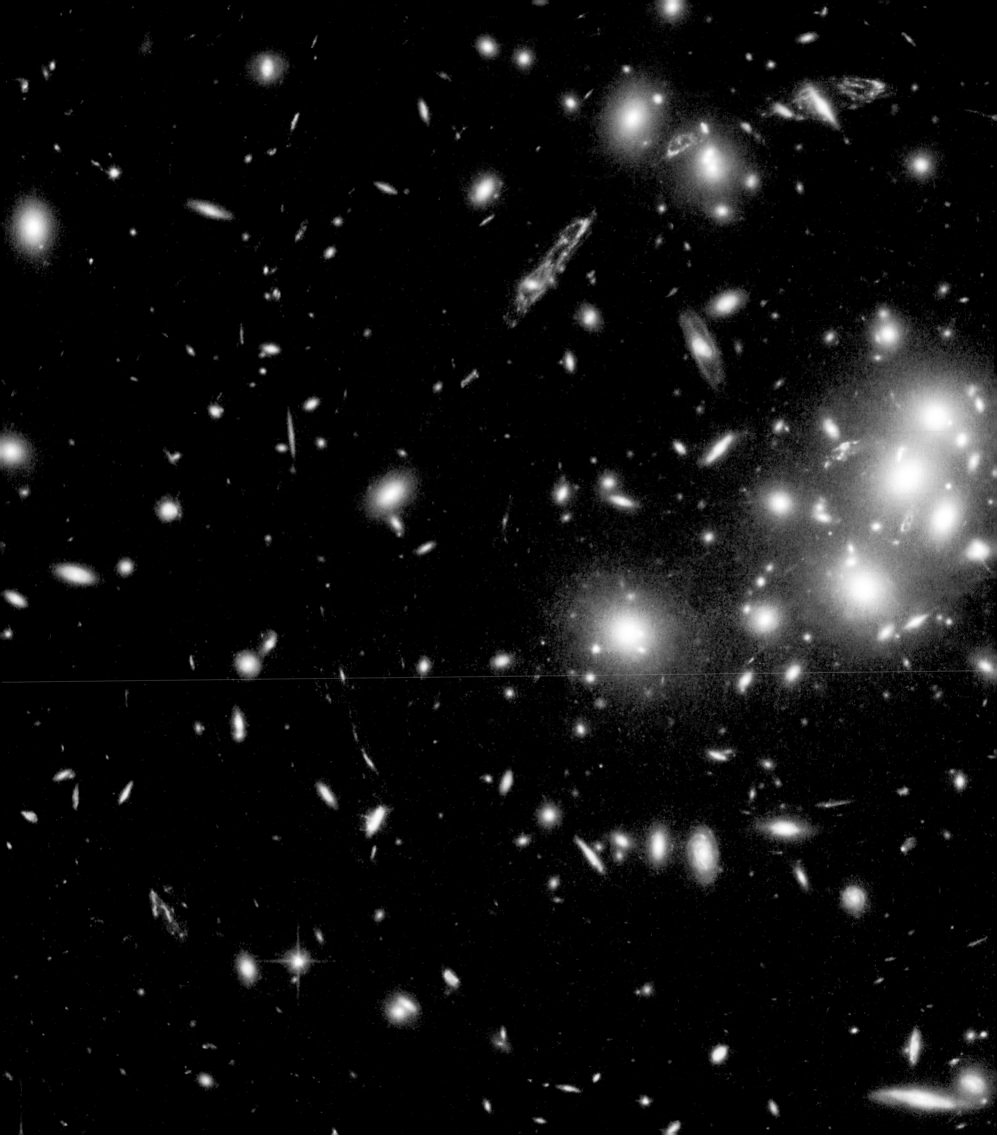

"THE VAST SUN-CLUSTERS' GATHER'D BLAZE,
WORLD-ISLES IN LONELY SKIES,
WHOLE HEAVENS WITHIN THEMSELVES, AMAZE
OUR BRIEF HUMANITIES."
—ALFRED LORD TENNYSON, 1885

5,000,000,000 LIGHT-YEARS

A RICH GALAXY CLUSTER OFFERING NEW INFORMATION ABOUT DARK MATTER (2004)

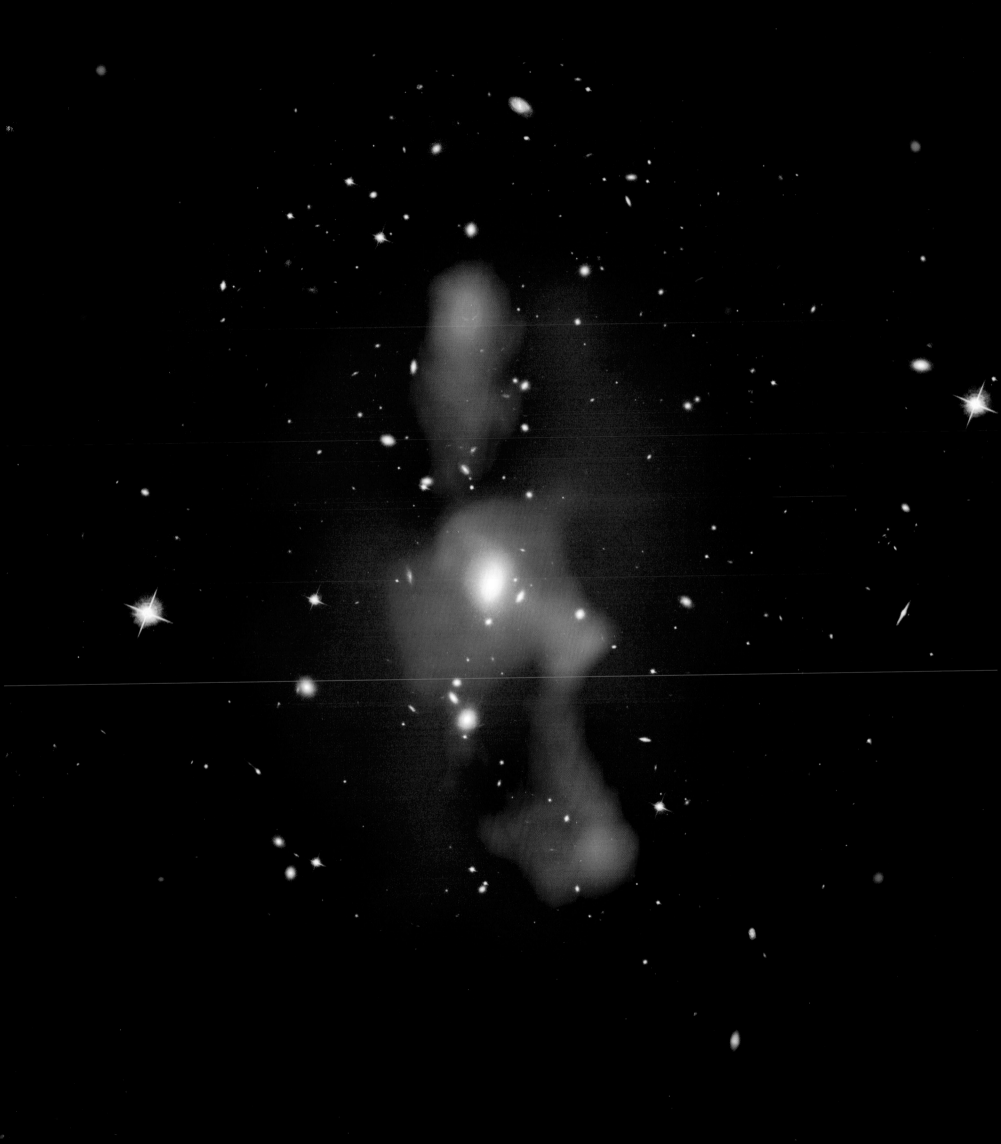

Opposite: **MONTAGE OF X-RAY, VISIBLE, AND RADIO IMAGES OF THE GALAXY CLUSTER MS 0735 (2006)**
This page: **STAR AND SUPER-STAR CLUSTERS IN THE ANTENNAE GALAXIES (2006)**

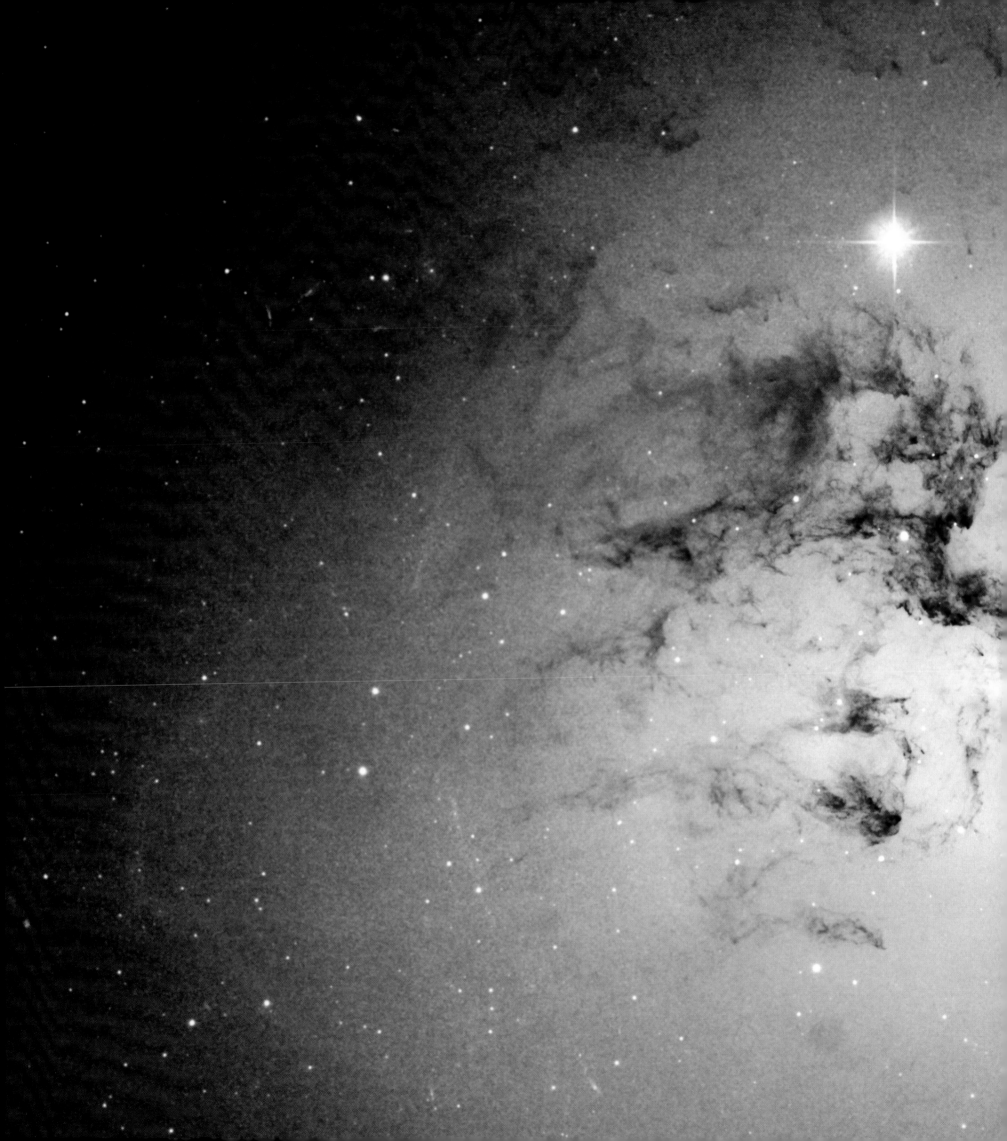

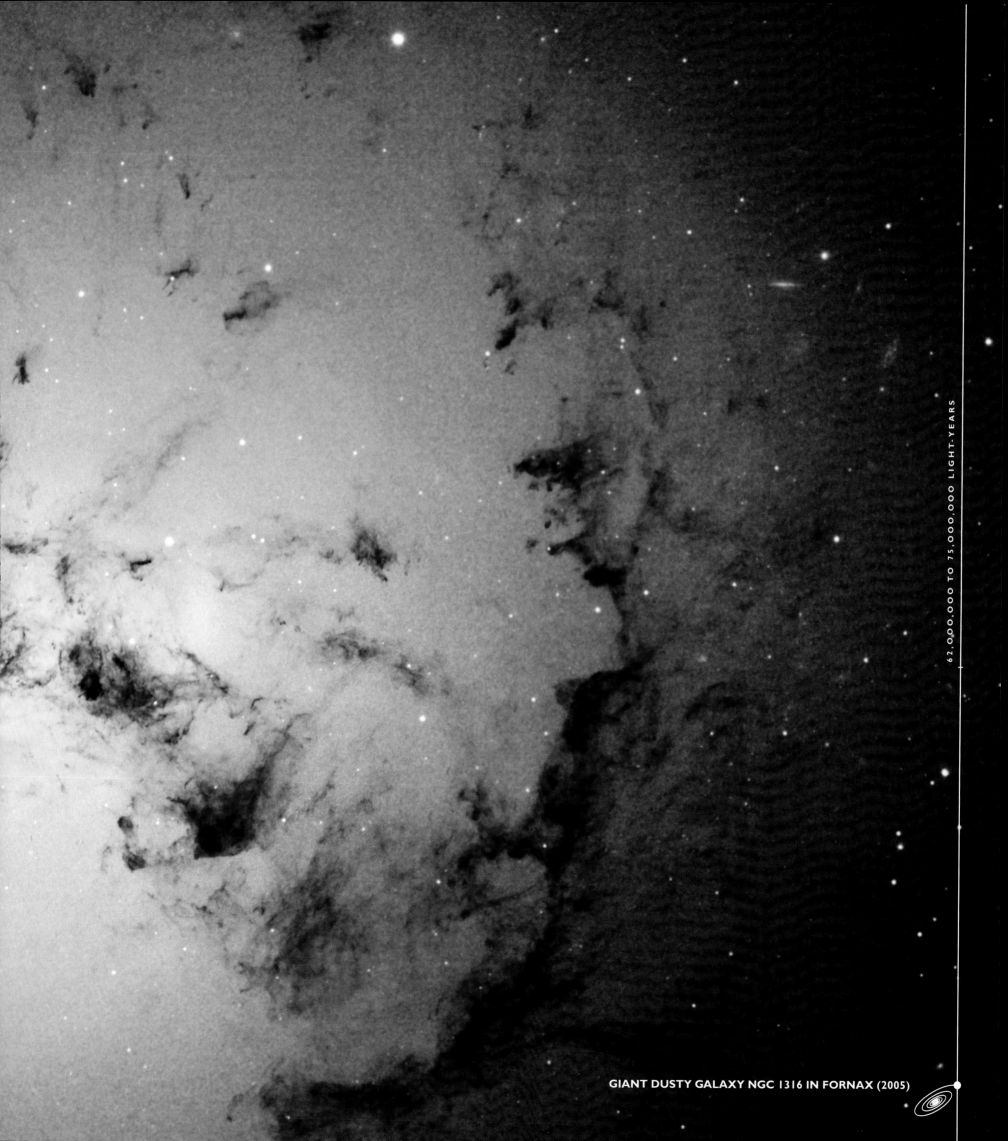

62,000,000 TO 75,000,000 LIGHT-YEARS

GIANT DUSTY GALAXY NGC 1316 IN FORNAX (2005)

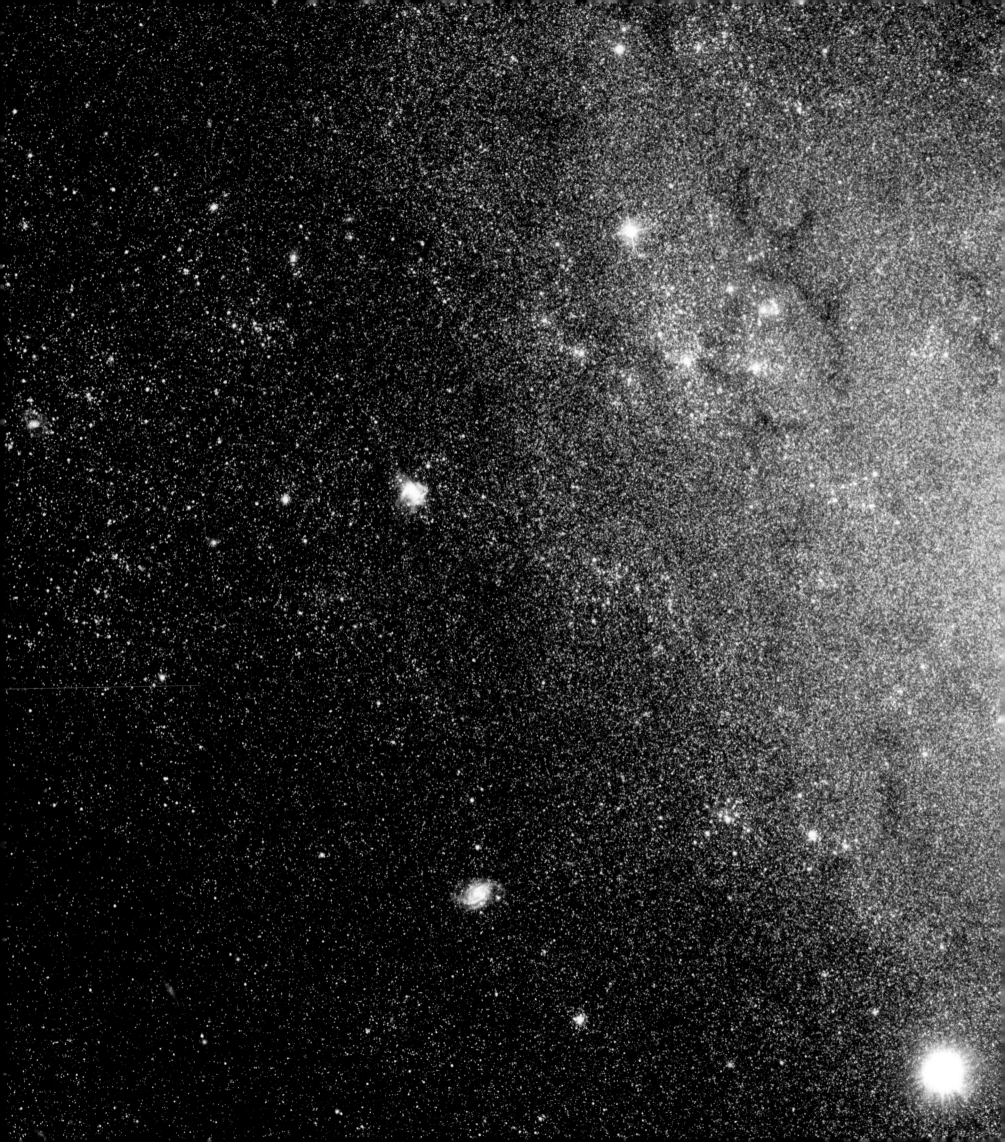

STARS RESOLVED IN THE CORE OF NEARBY GALAXY NGC 300 (2004)

6,500,000 TO 7,00,000 LIGHT-YEARS

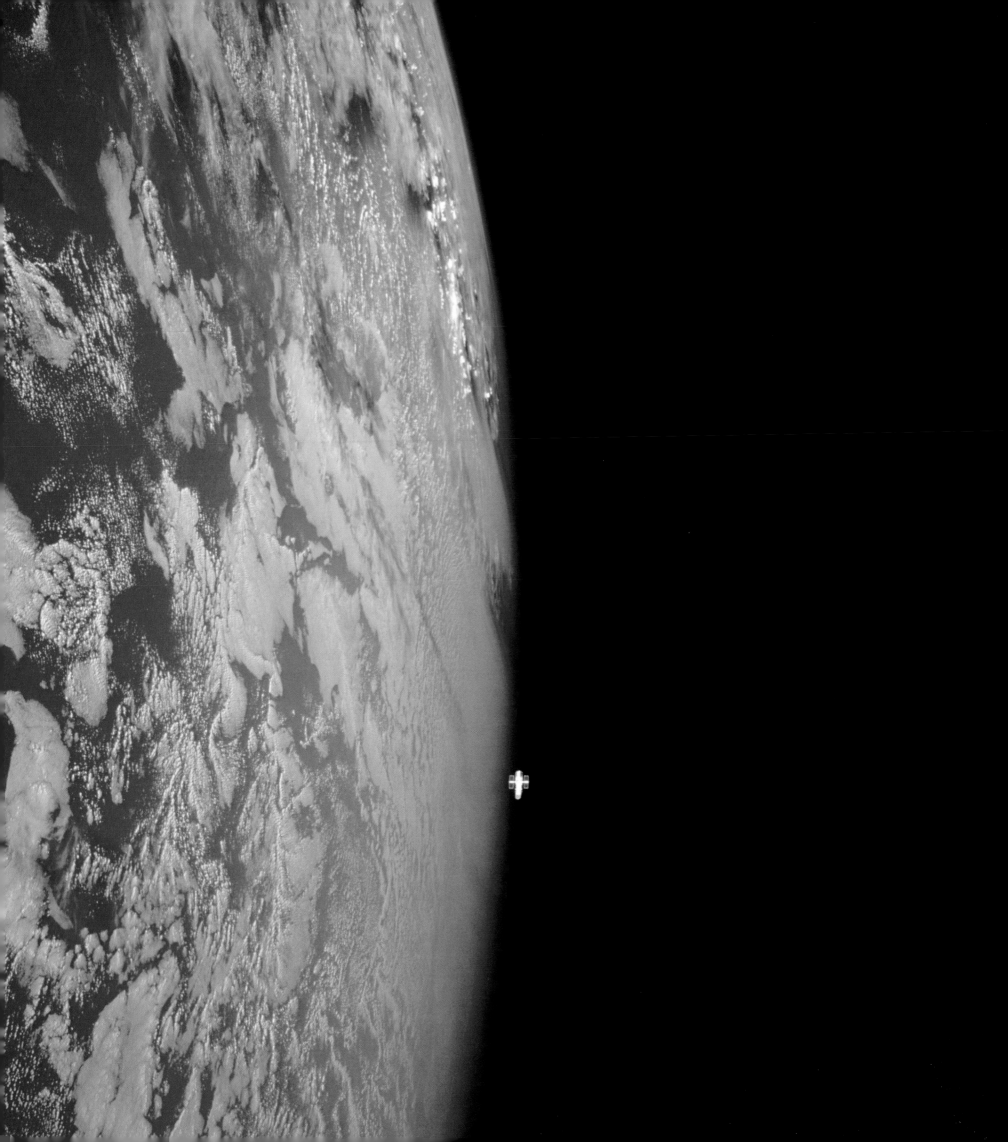

CHAPTER 1

THE MOST FAMOUS TELESCOPE

On April 24, 1990, the space shuttle *Discovery* roared into the sky above Cape Canaveral, Florida, on a column of smoke and flame. Cradled in its payload bay was the 12-ton Hubble Space Telescope (HST), the most complex multi-instrumented spacecraft ever launched. Well over 20 years of highly detailed planning, involving NASA and European Space Agency staffers, hundreds of people at the Space Telescope Science Institute, thousands of astronomers, engineers, and managers, as well as the efforts of hundreds of universities and industrial contractors across North America and Europe, had gone into its design and construction.

At times the technical and political challenges of building and flying such a sophisticated telescope had appeared almost insuperable. Yet all of these hurdles had been overcome in a device that embodied the primary aim of astronomers: To penetrate deeper into space.

One of the astronomers watching the space shuttle rise into the blue Florida sky at Cape Canaveral that April morning was Lyman Spitzer, Jr. Almost a half century earlier, in a 1946 report, "Astronomical Advantages of an Extra-Terrestrial Observatory," he had pondered what sorts of astronomical observations could be made from a large telescope in space. Like every astronomer,

Spitzer keenly appreciated how the Earth's atmosphere weakens, distorts, and blocks radiation from space.

We live under a turbulent ocean of air, constantly in motion. Astronomers think of this ocean as made up of packets of air, called cells, that range in size from a few centimeters on up. A beam of light passing through the atmosphere meets constantly moving cells of differing temperature and density. These cells distort and bend the beam; consequently, the eye will see the beam of light flicker, or "twinkle." A large telescope gathers many of these twinkles together, so the image it forms is composed of many small flickering images that produce a larger blurred image during a time exposure. The upper atmosphere also glows faintly and blocks virtually all ultraviolet rays, x-rays, and gamma rays, and most infrared rays as well. This is good for our health, but keeps critical information away from an Earth-based telescope's sensors. As one astronomer quipped in 1933, when astronomers died, they should be "permitted to go, instruments and all, and set up an observatory on the moon," where of course there is no air.

A large space observatory, Spitzer conceded in 1946, was years away. In that year, no man-made object

Preceding pages: **THE HUBBLE SPACE TELESCOPE (HST) IN ORBIT (2002)** Brilliantly illuminated by sunlight, Hubble orbits above the Atlantic Ocean southwest of the Cape Verde Islands during the 2002 servicing mission. *Opposite:* **INSPECTING HUBBLE AT THE LOCKHEED MISSILES AND SPACE COMPANY (1986)** Hubble's parts were assembled and tested at Lockheed before the observatory was shipped to the Kennedy Space Center. They included the two solar arrays that would convert sunlight into electrical power for the spacecraft, one of which is seen here.

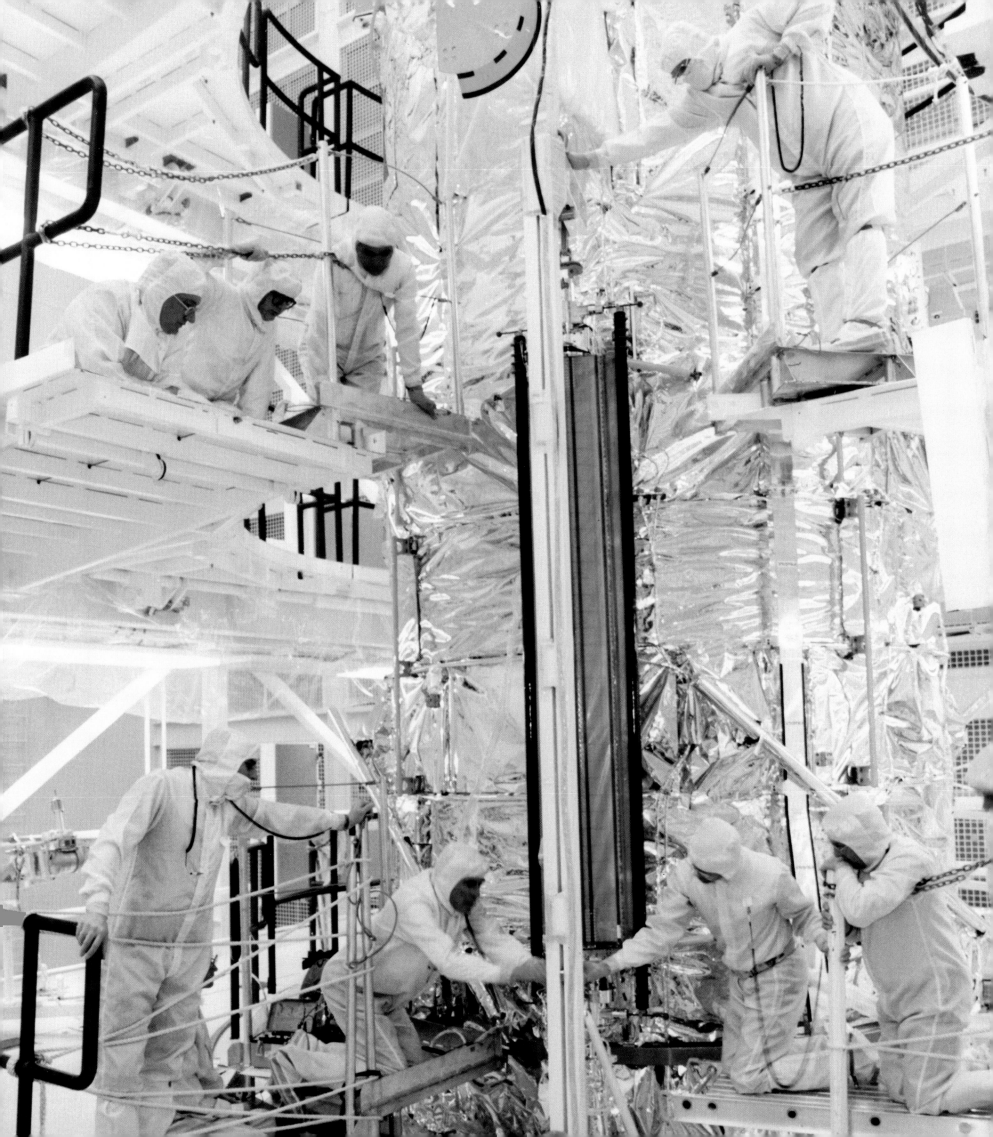

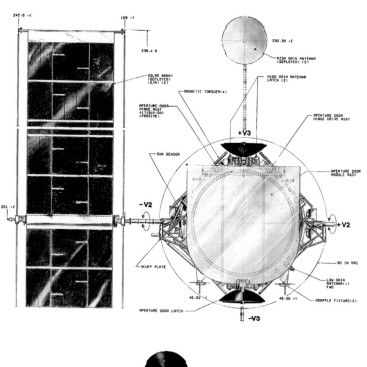

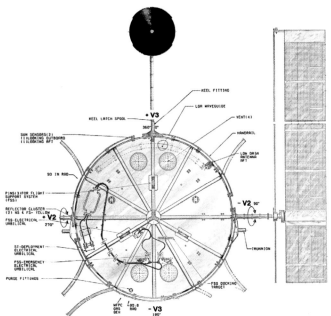

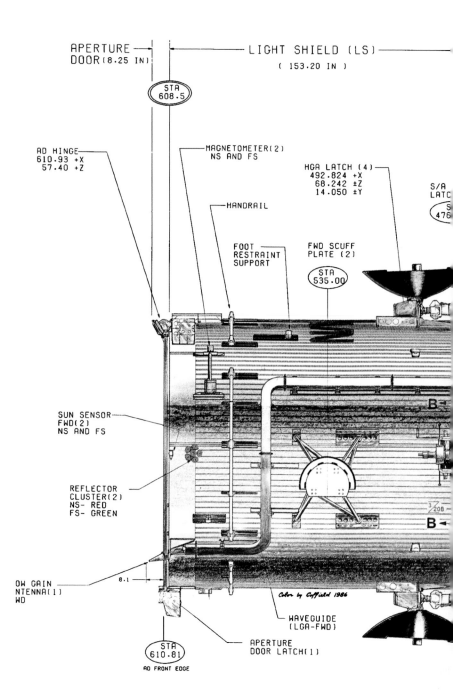

DESIGN FOR THE HUBBLE A technical drawing shows the final design for the HST, as envisaged in the mid-1980s. At its heart is a 2.4-meter primary mirror that concentrates light onto the observa- tory's scientific instruments. Hubble has both low-gain and high-gain radio antennas so that ground controllers and science planners can communicate instructions and download data from it. In the side view

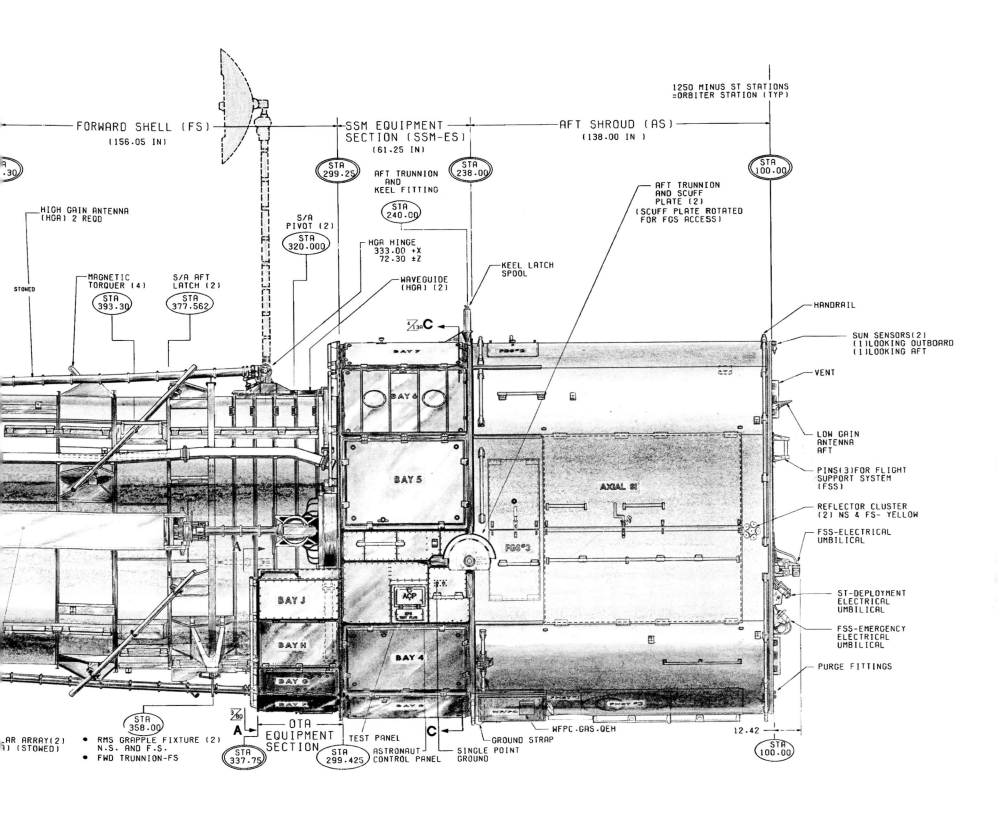

FORWARD SHELL (FS)
(156.05 IN)

SSM EQUIPMENT
SECTION (SSM-ES)
(61.25 IN)

AFT SHROUD (AS)
(138.00 IN)

1250 MINUS ST STATIONS
=ORBITER STATION (TYP)

STA 299.25

AFT TRUNNION
AND
KEEL FITTING

STA 238.00

STA 100.00

HIGH GAIN ANTENNA
(HGA) 2 REQD

STOWED

S/A
PIVOT (2)

STA 320.000

AFT TRUNNION
AND SCUFF
PLATE (2)
(SCUFF PLATE ROTATED
FOR FGS ACCESS)

STA 240.00

HGA HINGE
333.00 +X
72.30 ±Z

KEEL LATCH
SPOOL

HANDRAIL

MAGNETIC
TORQUER (4)
STA 393.30

S/A AFT
LATCH (2)
STA 377.562

WAVEGUIDE
(HGA) (2)

C

SUN SENSORS(2)
(1)LOOKING OUTBOARD
(1)LOOKING AFT

BAY 7

VENT

BAY 6

LOW GAIN
ANTENNA
AFT

BAY 5

AXIAL 21

PINS(3)FOR FLIGHT
SUPPORT SYSTEM
(FSS)

REFLECTOR CLUSTER
(2) NS & FS- YELLOW

A

FGS*3

FSS-ELECTRICAL
UMBILICAL

BAY J

ACP

ST-DEPLOYMENT
ELECTRICAL
UMBILICAL

BAY H

FSS-EMERGENCY
ELECTRICAL
UMBILICAL

BAY G

BAY 4

PURGE FITTINGS

BAY

STA 358.00

A

WFPC.GAS.QEH

12.42

STA 100.00

AR ARRAY(2)
) (STOWED)

• RMS GRAPPLE FIXTURE (2)
 N.S. AND F.S.
• FWD TRUNNION-FS

STA 337.75

OTA
EQUIPMENT
SECTION

STA 299.425

TEST PANEL

ASTRONAUT
CONTROL PANEL

C

GROUND STRAP

SINGLE POINT
GROUND

of Hubble in the shuttle's payload bay *(bottom right)*, the two high-gain antennas are positioned flat against the spacecraft. They would be rotated into position once the HST was deployed. Two images on

the left show a front view *(top)* and end view *(bottom)* of Hubble. In the front view, the telescope's aperture door covers the telescope tube. During usual scientific operations, the aperture door is raised.

had ever been lofted into Earth orbit. Astronomers had placed telescopes on mountains, and a few researchers were experimenting with observations from balloons and rockets sent high into the atmosphere, or with sensitive radio equipment on the ground, but these techniques were not yet major research areas in astronomy.

By the 1960s, however, the pace of research above the atmosphere began to accelerate. The launch of Sputnik 1 in 1957 set in motion a space race between the United States and the Soviet Union. Money for space endeavors became available as never before, and Spitzer's 1946 dreams moved rapidly from the world of science fiction into the realm of the possible. During the 1960s, the newly formed space agency, the National Aeronautics and Space Administration (NASA), promoted plans for what was called by the end of the decade the Large Space Telescope, or LST.

Astronomers, engineers, and industrial contractors teamed up with NASA staff, particularly at the Marshall Space Flight Center in Alabama and the Goddard Space Flight Center in Maryland, to study what the LST might look like and do. They intended the telescope to be so well engineered—capable of being pointed precisely and holding its gaze accurately for long periods of time—that by escaping the atmosphere its images would be practically perfect. The mirror would be the largest that could be built for transport into space by one of the agency's powerful rockets. After initially proposing a three-meter mirror, astronomers eventually settled on a more economical 2.4 meters. A 2.4-meter mirror could still examine fine details of astronomical objects far better than any optical mirror from the ground in that day. Its resolving power would be

equivalent to being able to distinguish the left and right headlights of a car in California seen from New York, or features less than 1/30,000th the size of the full moon. This was at least a tenfold increase over the atmospheric limit. Reflecting the reduction in the mirror's size, the Large Space Telescope became the more modestly named Space Telescope. In 1983 it was renamed the Hubble Space Telescope after famed American astronomer Edwin Hubble.

A SPACECRAFT TAKES SHAPE

From the early 1970s on, the design of the telescope was divided into three parts: the Optical Telescope Assembly (OTA), the Support Systems Module (SSM), and the Scientific Instruments (SI). The OTA was the telescope, with the primary, or main, mirror at its heart. The Hubble's battery of scientific instruments would be positioned behind the primary mirror. The SSM enveloped the optical system and was designed to manage the spacecraft's housekeeping functions. The SSM's tasks would include routing energy from the solar panels to the instruments and systems for heating, pointing, and moving the telescope to new targets. It also would house systems for, among other things, data handling and radio communication.

Originally, NASA intended to launch the telescope aboard a Titan III rocket, but after President Nixon approved the space shuttle in 1972, the agency mated the shuttle to the telescope both as a launch vehicle and as the means to carry astronauts to service it. The upper limits to the telescope's size and orbit were therefore set by what could be carried in the shuttle's payload

bay and then serviced by the shuttle.

Most astronomers agreed that the best design for the Hubble's telescope was the Ritchey-Chrétien, named after its designers, George Willis Ritchey and Henri Chrétien, who first suggested it at Mount Wilson around 1910. In this compact and efficient reflecting telescope, light from an astronomical object travels down the telescope tube and reflects off the primary mirror back up the tube to the secondary mirror. The light is then bounced back toward the primary mirror and through a hole in its center, where it can be analyzed. The design provides wide-field views of exceptional fidelity and has been used on some of the world's finest ground-based telescopes. The optical system is folded and the scientific instruments are located behind the primary mirror, a big advantage in balancing a bulky space observatory.

The telescope's mirror had to survive the extreme rigors of launch and then exposure to the harsh conditions of space. It was critical that it not become distorted, otherwise it would not produce high-quality images. The Corning glassworks built a special lightweight mirror of ultra low expansion (ULE) glass. The egg-crate design, consisting of interleaved vertical slats between two circular plates, was far lighter than a solid mirror, an attractive feature to spacecraft engineers.

The Hubble contained far more than a telescope, however. It was designed to be a long-lived space observatory using many powerful instruments, their data transmitted to Earth electronically. Two devices were chosen as core instruments, critical to the telescope's goals: the Wide Field Camera and Planetary Camera (WF/PC2) and the Faint Object Spectrograph (FOS).

For many astronomers, the WFC

was key. Because the telescope would study the faintest and most distant objects in the universe, astronomers wanted a camera with a relatively large field of view. The desired size was three-by-three arc minutes, which would capture distant clusters of galaxies in one frame. Although this field was barely 1/100th the size of the full moon in the sky, it was generous by most large telescope standards.

Astronomers also decided that the WFC would use what was then a new form of solid-state detector, called a Charge-coupled Device, or CCD. An image from the telescope would be guided by the camera's optics onto the CCD chip and produce an electronic image built up from a large number of discrete picture elements, or pixels. The information from each of these pixels would be handed, bucket-brigade fashion, to another area of the chip, stored with an identification tag, and then passed on to Earth. To gain the widest field of view, a team led by Caltech astronomer James Westphal devised a way to combine four CCDs, turning them, in effect, into one big chip. In fact, light could be directed onto two sets of four CCDs, and thereby cleverly combine a Planetary Camera and a Wide Field Camera in the same instrument.

Adding to the instrument complement was the Faint Object Camera provided by the European Space Agency (ESA), which was now a partner on the project. In addition, the Hubble would contain a High Speed Photometer (to measure extremely rapid variations in brightness of astronomical objects) and two spectrographs—a Faint Object Spectrograph (FOS) and a High Resolution Spectrograph. These would separate the light from various objects into its constituent wavelengths and investigate the result.

One absolutely crucial element of the telescope's performance would be its ability to find its astronomical targets and then to stay locked on them, so that the incredibly faint light from far-off objects could slowly accumulate on the instruments' light detectors. When astronomers and engineers worked out the pointing requirements, they found the telescope had to be stabilized to an unprecedented 0.012 arc second (by comparison, the full moon has an angular size of about 1,800 arc seconds). This is like keeping a laser in New York trained on a dime in Washington, D.C. Since the spacecraft would be orbiting Earth at 28,160 kilometers an hour (17,500 mph), this was a hugely demanding task. Compounding the difficulty was the telescope's jitter, or tiny shaking motions from its mechanisms.

Engineers worked out a way to make minor adjustments by shifting the body of the spacecraft itself. To keep the craft pointed in the right direction, light from a guide star would fall on a Fine Guidance Sensor. The sensor would measure the star's position, converting the measurement into an electrical signal. This signal would then command the Support Systems Module to adjust the telescope's direction, keeping it locked on its astronomical targets.

By 1977, the main design features of the Space Telescope had been set. Its telescope, instruments—each roughly the size of a phone booth and weighing several hundred pounds—and other mechanisms would be tucked into a craft approximately 14 by 5 meters

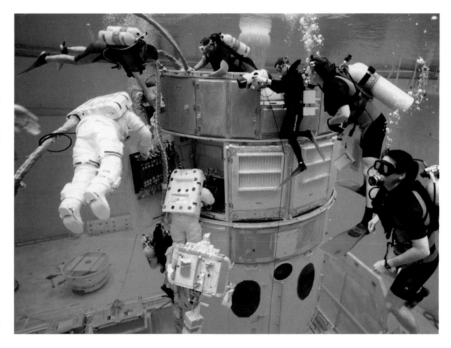

ASTRONAUTS TRAIN UNDERWATER (1999) Astronauts practice servicing the Hubble Space Telescope in a tank at the Johnson Space Center. Pressure-suited astronauts and their equipment become neutrally buoyant when immersed in these tanks, simulating the weightlessness of space. Shuttle servicing missions have worked so well that the Hubble has effectively been remade on five occasions and each time has become a more powerful scientific tool.

AN EYE IN SPACE

THE INITIAL COMPLEMENT OF INSTRUMENTS

When the Hubble Space Telescope was launched in April 1990, it carried a complement of five dedicated scientific instruments. Four were axial instruments; that is, they were inserted into the telescope parallel to its main optical axis. These instruments were all roughly three by three by seven feet in size and weighed several hundred pounds. The wedge-shaped Wide Field/Planetary Camera (WF/PC) was inserted radially into the telescope.

All of the instruments were designed to be modular, so astronauts could repair or replace each separately in space. To hold the instruments securely in place to very precise tolerances yet still easily allow an astronaut in a bulky spacesuit access to them, 27 special latches had to be fabricated. The latches were extensively tested in the gargantuan water tank at the Marshall Space Flight Center that contained a full-scale mock-up of the HST.

FAINT OBJECT CAMERA

Built by the European Space Agency, the Faint Object Camera (FOC) was designed to make full use of the HST's ability to resolve fine detail in astronomical images, but had a small field of view. It contained two complete and independent cameras, each with its own optical path and detector system, one working at a camera speed of f/96, the other at f/48.

Intended to observe very faint objects in both visible and near ultraviolet regions of the spectrum, the Faint Object Spectrograph (FOS) employed a type of one-dimensional light detector known as a digicon. Digicons convert light falling on them into a stream of electrons, which are then focused on a string of silicon diodes. The diodes transform the different levels of light intensity into electrical signals.

GODDARD HIGH RESOLUTION SPECTROGRAPH

Designed to observe in the ultraviolet region of the spectrum, the Goddard High Resolution Spectrograph was built to analyze the light of relatively bright objects in high resolution. It also employed digicons as light detectors.

The two spectrographs were designed to be complementary. Each was sensitive to somewhat different ranges of wavelengths of light, but they overlapped in the middle of their ranges and so backed up each other.

HIGH SPEED PHOTOMETER

Mechanically the simplest of all the instruments, the High Speed Photometer had no moving parts and was designed to measure rapid changes in the brightness of an astronomical object over times as small as ten microseconds. The HST's pointing system was used to direct light precisely into a combination of tiny filters and apertures in this instrument.

WIDE FIELD/PLANETARY CAMERA

This instrument held eight postage-stamp-size CCD detectors, arrays of 800 x 800 pixels that acted like very sensitive rewritable electronic film. It could be operated in two ways, each using four of the CCDs. To image extended faint objects such as galaxies and diffuse nebulae, the Wide Field Camera was used. The Planetary Camera was designed to image small bright objects, such as planets, using a narrower and higher-powered field of view.

There was also in effect a sixth instrument: The telescope's three Fine Guidance Sensors could also act as accurate position-measuring devices.

When two of the Fine Guidance Sensors locked onto guide stars so that the telescope could be precisely pointed toward an astronomical target, the third could serve as a scientific instrument by measuring the positions of stars relative to one another.

Opposite: **INSPECTING THE PRIMARY MIRROR (1982)** The 1,800-pound, eight-foot wide concave primary mirror concentrates and redirects light from astronomical objects to the much smaller secondary mirror, which reflects it back through a two-foot hole in the the primary mirror's center to the telescope's Fine Guidance Sensors and scientific instruments. In this image, the hole has been temporarily covered by a plate. *Right:* **THE CHARGE-COUPLED DEVICE (CCD)** Each of the eight roughly thumbnail-size CCDs used in the first Wide Field/Planetary Camera had 640,000 light-sensitive picture elements, or pixels.

in size, or about the dimensions of a school bus. After a three-year battle to secure funding, the White House and Congress at last gave their approval. Compromises had been made, but on the drawing board was what promised to be a superb observatory.

TIME TO BUILD

The construction phase of the Hubble Space Telescope began in 1978. This vast, complex effort involved thousands of people and hundreds of institutions, companies, and universities across North America and Europe. Predictably, it took more time and cost more money than originally planned. NASA's first "low-cost" approach to building the HST gave project managers, scientists, and engineers simply too few resources to do what they needed. After much discussion, in the early 1980s NASA opted, as one senior manager put it, to "swallow hard" and preserve the integrity of the program by adding time to the schedule and more money to the budget. The HST's launch was pushed back well beyond the original date of 1983, and the projected cost jumped by hundreds of millions of dollars.

Against this troubled backdrop, in 1981 Perkin-Elmer, the company manufacturing the Optical Telescope Assembly, had completed Hubble's most important component: the 2.4-meter primary mirror. The primary's surface needed to be ground, then polished to great precision. To reach this goal, Perkin-Elmer repeatedly ran through a three-step cycle in which it polished, cleaned, and then measured the shape of the mirror. Critical to this process was a device known as a reflective null corrector, used to measure the mirror's surface. With its aid, laser light created a grid, or optical template, that could be compared with the actual HST primary mirror. Perkin-Elmer engineers knew they had reached their goal when the differences in the patterns produced by the actual mirror and the optical template were zero, or null. After the polishing ended, NASA and Perkin-Elmer pronounced the mirror practically perfect. What they didn't know in 1981 was that the reflective null corrector itself contained a flaw.

One dividend of the new, higher budget was the decision to build a second Wide Field/Planetary Camera, which would image the cosmological depths as well as the surfaces of planets. Worried that the possible loss of WF/PC and its stream of images early in the HST's life in orbit would be devastating to the program, as insurance NASA managers authorized the construction of a second WF/PC. What became known as Wide Field/Planetary Camera 2 would possess significant enhancements over WF/PC 1, most notably in its superior CCDs.

By 1984, telescope components began to arrive at the Lockheed Missiles and Space Company in Sunnyvale, California, for assembly into the HST. A late 1986 launch was in sight. But on January 28, 1986, shortly after the shuttle *Challenger* left the launchpad, a joint in its right solid-fuel booster failed, sending the booster crashing into the shuttle's external tank. The *Challenger* was destroyed and all seven crew members killed. The entire shuttle program—including the launch of the Hubble—was put on hold.

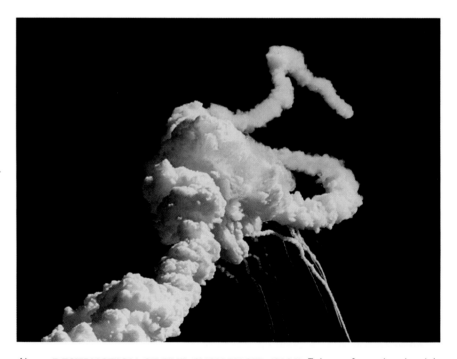

Above: **DESTRUCTION OF THE *CHALLENGER* (1986)** Exhaust from the shuttle's main engines, solid-rocket booster plumes, and an expanding ball of gas signal a disastrous failure in the spacecraft's right solid booster. *Opposite:* **HUBBLE'S ORBITAL PATH** Launched by the space shuttle, the Hubble's position in space is limited to low-Earth orbit, approximately 320 nautical miles (about 368 mi) high. It completes one orbit every 97 minutes, its path inclined at a 28.5° angle to the Equator.

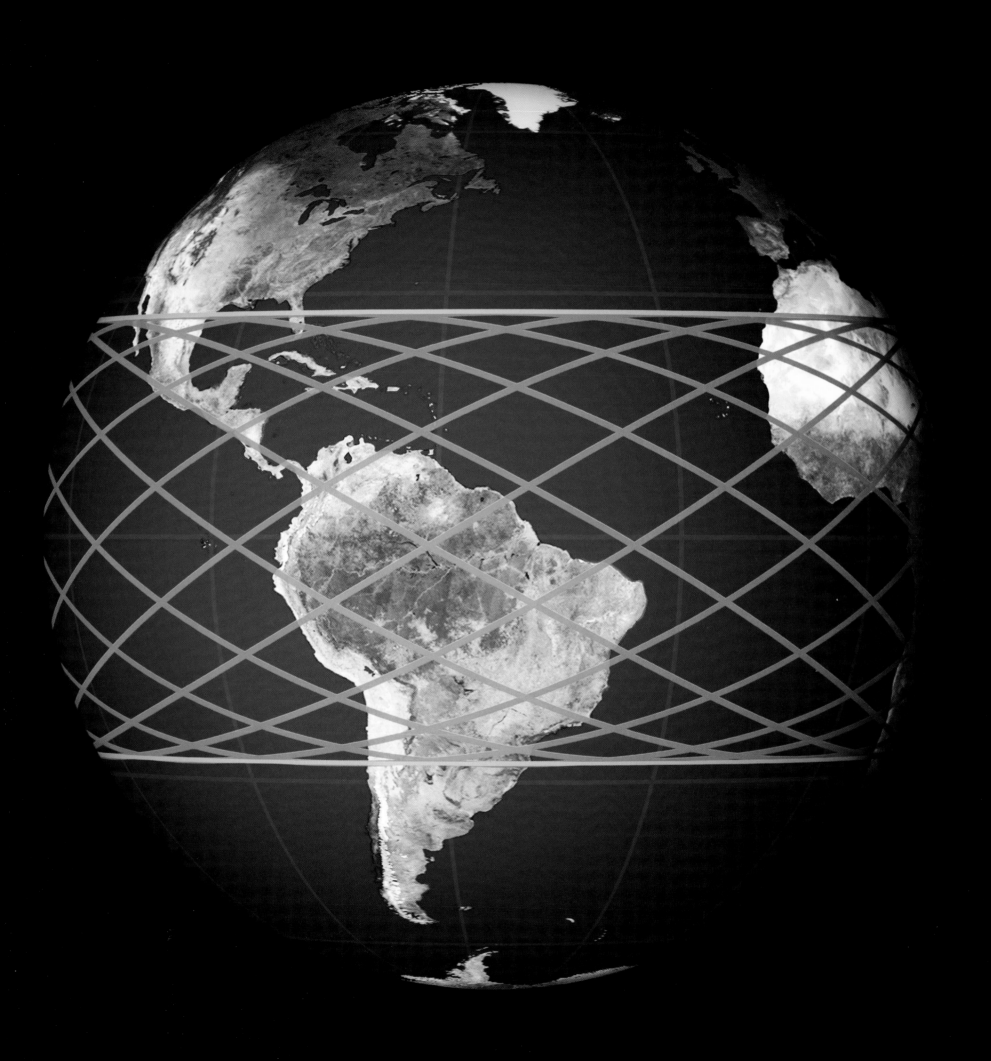

CHAPTER 2
THE REALM OF THE NEBULAE

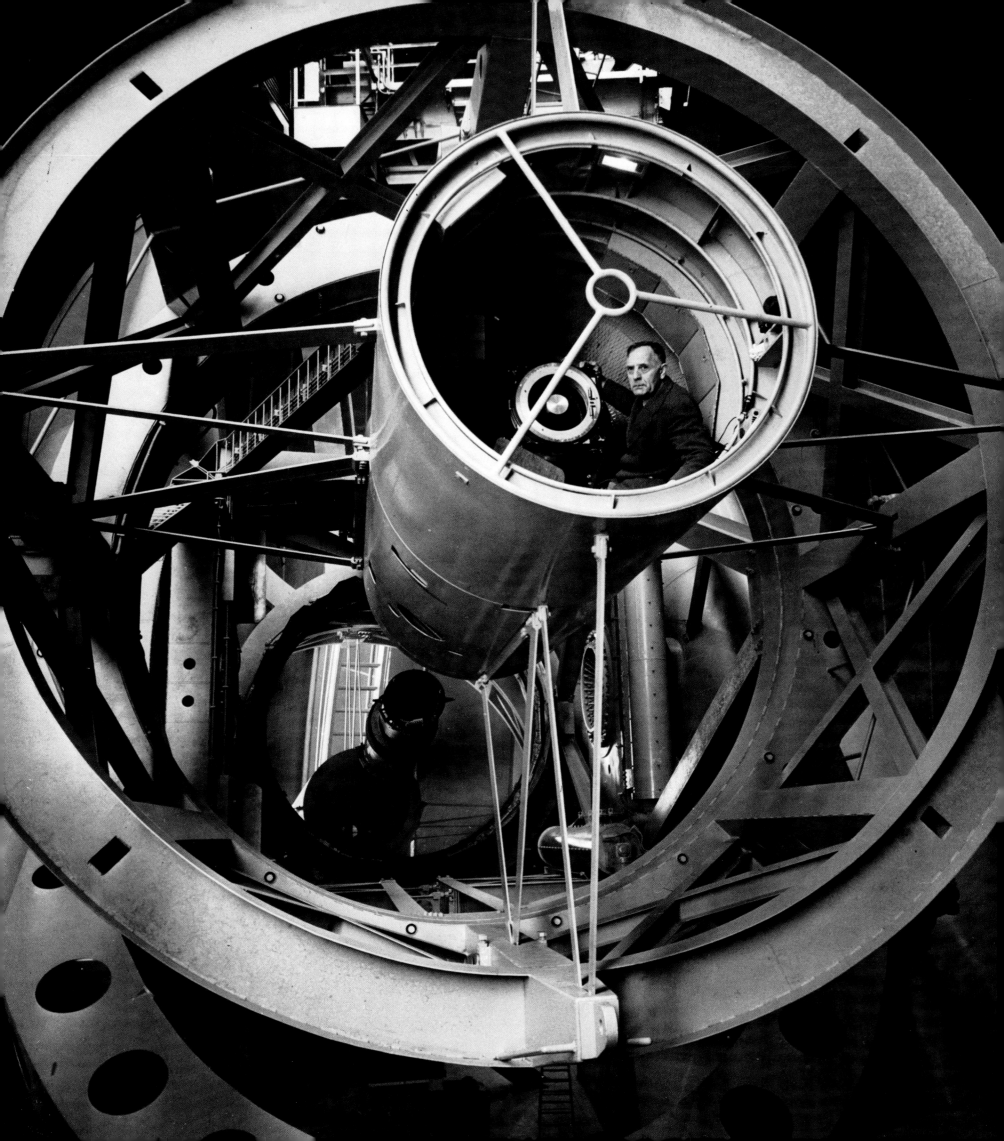

Astronomers have sought to understand the intricate workings of the cosmos for thousands of years. For most of that time their attempts have been limited to what the human eye could discern. All that changed early in the 17th century with the invention of a remarkable new instrument: the telescope. In the hands of Galileo Galilei, it would drive a revolution in human thought and understanding. Galileo would also set in motion innumerable efforts to build ever better and more powerful telescopes, efforts that would lead in time to the Hubble Space Telescope (HST).

The power of the telescope became evident just after sunset on a Sunday in early January 1610, when the middle-aged Paduan astronomer turned a thin tube-shaped device toward Jupiter, rising in the southeastern sky in the constellation of Taurus, the Bull. He had been building and using these devices for almost six months, but had turned them to the sky only recently. The astronomer was excited by the sights they had disclosed. Through them he had seen that the moon was not a perfect orb, as Aristotle taught, but was riddled with pocks, mountains, and seas: It was Earthlike. He had been examining the moon since late November, and now he turned to Jupiter to see what his

perspiculum, or spyglass, would reveal. Jupiter was a tiny disk, much smaller than the moon, but definitely not starlike.

He could, however, make out three tiny stars in a perfect line drawn through Jupiter, one to the west and two to the east. The next night, "guided by what fate I know not," he again trained his

glass toward Jupiter. The three stars were now all on one side of the planet! He continued to observe Jupiter and these stars every clear night, musing how they seemed to mimic the motions of tiny planets around a central sun. After a week he began to notice actual movement from hour to hour. Each night he carefully drew what he saw and recorded these images in a manuscript he was preparing for publication. This record of his little stars—now known to be three of Jupiter's moons—and their motion around Jupiter became "possibly the most exciting single manuscript page in the history of science."

Galileo Galilei, professor of mathematics at the University in Padua, did not invent this astonishing device, but he did improve its ability to magnify. A convex lens at the front of his spyglass, or optic tube, or—as it was

Preceding pages: **EDWIN HUBBLE AT THE 100- AND 200-INCH TELESCOPES** Over most of his professional life, Edwin Powell Hubble used the largest telescopes in the world. Here he observes at the side of the 100-inch telescope at Mount Wilson, in California, which he used in the 1920s and 1930s *(left)* and sits inside the 200-inch telescope's prime focus at California's Palomar Observatory, where he worked in the late 1940s and early 1950s *(right)*. *Opposite:* **GALILEO'S LENS** Cracked but intact, a telescope lens made and used by Galileo Galilei circa 1609 is mounted in an elaborate ivory relief showing crossed telescopes. It is on display in Florence. Galileo donated this 38 millimeter-diameter lens to a patron, which enhanced its chance for survival.

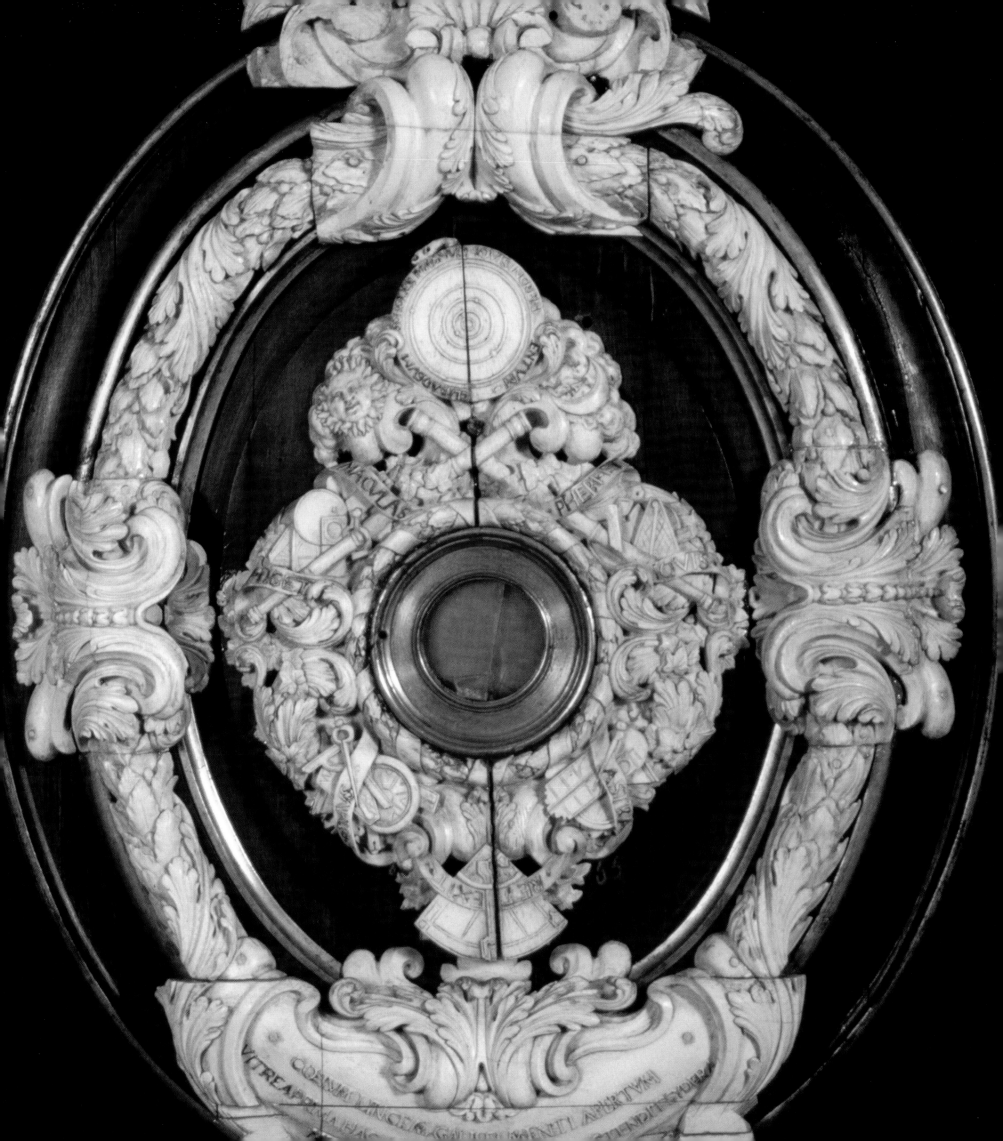

soon coined—his telescope, collected and concentrated light from a distant locale in a thin converging cone to intersect a smaller concave lens at the back of the tube, where the light then entered his eye. Galileo's first telescope magnified objects three times, making them appear three times closer and so nine times larger. Soon he was making telescopes that could render objects 30 times closer.

Galileo and others realized that telescopes possessed additional capabilities. Dim objects appeared brighter (we call this "light-gathering power") and could clarify indistinct or blurry scenes (what is called "resolving power"). The advantages offered by such a device for the identification of friend or foe at sea or on land was obvious. But Galileo was the first to use the telescope for sustained and systematic study of the heavens. In doing so, he applied considerable talent as an observer, well versed in "the art of picturing and drawing." He saw the universe through new eyes and sought to share these stunning and novel views with others.

Galileo knew the persuasive power of visual evidence. The first public announcement of Galileo's remarkable findings in the heavens came in a small book titled *The Starry Messenger,* published hastily in early 1610. In it he included drawings of the moon and the motions of Jupiter's moons. Galileo also explained how, viewed through a telescope, the Milky Way revealed its true nature as a vast realm of faint stars. He drew the star fields of the belt and scabbard of Orion and the Pleiades and Praesepe, and described how, with the aid of his telescopes, he could detect far more stars in these fields than were visible to his eyes alone.

Galileo's success at resolving the Milky Way into stars, and showing that fuzzy patches in Orion and the Pleiades were in fact fields of stars too faint and densely packed to be seen individually with the eye, marks the beginning of a 300-year quest to picture the universe as an assemblage of stars. Even as the performance of telescopes was constantly improved, however, this quest was often challenged by astronomers' detection of blurry, nebulous objects in distant space. The attempts to determine the nature of the nebulae stimulated the practice of telescopic astronomy, an enterprise that over the years involved increasingly powerful instruments, the best that patronage and technology could provide.

Along with this growth in telescopic power came an evolution in the means astronomers employed to record what they observed, from pen and ink to the photographic plate and now to digital and electronic means. The Hubble Space Telescope is only one of the latest expressions of this legacy. The data stream it returns to Earth has been shaped into images that are striking testimony to the telescope makers' quest to expand our knowledge of the universe.

TELESCOPIC ASTRONOMY

Throughout the 17th and early 18th centuries, astronomers used telescopes to steadily improve maps and tables depicting the positions and motions of stars and planets. But some astronomers wanted to pursue a very different goal. They wanted to penetrate deeper into the heavens. These astronomers looked for ways to increase the light-gathering and magnifying powers of their telescopes. The bigger the lens, the more light was gathered; the longer the focal length, the more images were magnified. Some telescope builders followed in the footsteps of Isaac Newton in the 17th century and explored ways to use reflecting optics, or mirrors, to collect and focus light. Unlike lens-based, or refracting, telescopes, these reflecting telescopes did not depend upon the clarity of the glass, and their mirrors could be made of a bronzelike alloy called speculum that, when polished, presented a highly reflective surface. But speculum mirrors tended to be brittle and quick to tarnish, requiring a complete repolishing. Both lenses and mirrors were prone to fuzzy images (spherical aberration) and lenses were also prone to spurious color (chromatic aberration). Reflecting telescopes slowly became larger and more refined as artisans succeeded in forging better speculum mirrors, but they generally remained less than six to seven inches in diameter. This situation would change dramatically with the reflectors of William Herschel.

During the night of March 13, 1781, Herschel, a Hanoverian organist and amateur astronomer living in Bath in southern England, was standing outside his home carefully surveying the heavens with a seven-inch speculum reflector when he encountered an unusual object: a tiny disk. He recorded it, thinking it might be a comet. Yet when astronomers calculated its orbit, they found that its path was that of a planet, not a comet. William Herschel thus became the first person in recorded history to discover a major planet, now known as Uranus. This momentous event catapulted Herschel into the limelight.

For his spectacular find, Herschel gained a pension from George III as the King's Astronomer. Now he enjoyed

a freedom few astronomers shared. As long as Herschel periodically provided amusement at court by showing what could be seen through his telescopes, he could do anything he wished with his pension and his free time. What he chose to do was build the biggest and most powerful telescopes in the world, increasing his power of penetrating into space. With such state-of-the-art instruments, he could better map the arrangement of the stars in the visible stellar system as well as probe its limits.

Herschel had his greatest success using a telescope with a mirror 47 centimeters in diameter and a focal length of 6 meters. Herschel also designed an elaborate wooden framework for holding the telescope securely yet leaving it free to move horizontally in short arcs across the southern sky. In this manner Herschel swept the heavens systematically to determine the structure and extent of the stellar system and to hunt for new nebulae and map their distribution and enigmatic forms. These gargantuan tasks would not have been possible without his dedicated associate, his younger sister Caroline, who rapidly became a notable astronomer in her own right. She also drew William's attention to newly found nebulae, helping him map their distribution. Over the course of his career, William's views on these diffuse objects changed more than once, but it seems that at the end of his life he viewed some nebulae as indeed truly nebulous, whereas other nebulae he judged to be enormous collections of stars that appeared misty because of their vast distance.

The question of the true nature of the nebulae—whether they were distant collections of stars, maybe even far-off galaxies, or closer clouds of "ethereal fluids"—became bound up with building bigger telescopes. In 1845, using a monster telescope with a 1.8-meter speculum mirror (dubbed the Leviathan of Parsonstown), William Parsons, the third Earl of Rosse, and his observing staff confirmed Herschel's observations that many nebulae were star clusters. But Rosse also found a wholly new class of nebula when he turned to the 51st object from Messier's famous 18th-century catalog: M51, in the constellation of Canes Venatici, the Hunting Dogs. During several weeks of careful scrutiny, Rosse and his observers and draftsmen recorded and then rendered spiral filaments protruding from the core of the object, suggesting to them that it was shedding material or fleeing through space.

Rosse and his colleagues also observed other spiral-shaped nebulae. What were these spirals, and would even larger telescopes eventually resolve them into stars as well? Or were they evidence of truly nebulous material in space? The next twist in this debate would come from an unexpected direction— the application of spectroscopy to astronomical observation.

A NEW WAY OF LOOKING

On the night of August 29, 1864, William Huggins, observing from his home in London, turned his 20-centimeter refractor to a small bright nebula in the northern constellation of Draco, the Dragon. Huggins was not measuring the position of the nebula or trying to draw its structure. Instead, he had attached a small apparatus containing a prism to his telescope, a device that took concentrated telescopic light and broke it into a rainbow spectrum. Huggins was thus armed with the latest analytical tool, based upon the practice of spectrum analysis established by two German scientists, Gustave Kirchhoff, a physicist, and Robert Bunsen, a chemist. They had shown that their "spectroscope" could reveal the physical state and chemical composition of an object emitting its own light. Incredibly, one could determine what stars were made of merely by analyzing the rainbow spectrum of their starlight.

As Huggins peered into the eyepiece of his spectroscope at the nebula in Draco, known today as the Cat's Eye, at first he saw only darkness instead of the usual rainbow of color, save for a single bright green line. Once he decided that his equipment was not at fault, the laws of spectrum analysis and common laboratory practice told him that this kind of spectrum was produced by a gas, and not by a liquid or solid. Soon Huggins located two other bright, or emission, lines. Even though the bright lines remained unidentified for more than 60 years, Huggins had established that the nebula was definitely not a collection of stars; a star cluster would instead have exhibited a continuous spectrum like the sun.

Other centrally condensed nebulae in Cygnus and Taurus, as well as the famous Ring Nebula, showed the same type of bright-line spectrum. Huggins also turned his telescope to spiral nebulae. The spectrum of the Great Nebula in Andromeda was featureless, but the Orion Nebula displayed bright lines, the signatures of a hot gas. However, when Huggins trained his spectroscope on the bright blue stars in the Trapezium, at the heart of the Orion Nebula, he found characteristics of a star only. When he penned his first

report to the Royal Society, Huggins was sure the bright-lined objects were not collections of stars, and concluded with a flourish: "We … find ourselves in the presence of objects possessing a distinct and peculiar plan of structure."

THE PHOTOGRAPHIC UNIVERSE

Another important tool to explore the stars was developed at the same time as spectroscopy. By the late 19th century, many astronomers looked to photography as a way to escape the subjectivity of the observer. As one astronomer put it, through photography "stars should henceforth register themselves" without the intervention or bias of an observer. Thus in concert with spectroscopy, photography became a central tool in astronomy.

The powerful combination of photographic recording and large reflecting telescopes forever changed astronomy. Even early photographic emulsions were more sensitive than the human eye, because photography accumulates light over time, whereas the human eye does not. Glass-backed photographic plates made large-format, wide-field surveys of the deepest realms of the sky possible and provided a permanent record of an object's position or overall character.

In the late 1880s California's Lick Observatory installed a 36-inch reflector purchased from Edward Crossley in England; with it James Keeler began examining the enigmatic spiral nebulae with long-exposure photography. Keeler's surveys convinced him that at least 700,000 spirals existed within the range of his telescope. Their distribution in space was uneven: They avoided the plane of the Milky Way, which suggested they were beyond our galaxy.

A decade after Keeler's death in 1900, Vesto Melvin Slipher, working at Arizona's Lowell Observatory, improved the capabilities of his spectrograph, and with its aid he made some curious discoveries. Most baffling were the shifts he found in the spectral lines of many spiral nebulae. Slipher interpreted these displacements, using the Doppler effect, to mean that many of these objects were traveling away from us at great speeds. Indeed, some of Slipher's nebulae were traveling over a thousand kilometers a second, unbelievably fast for any terrestrial mind to comprehend. Also, why did the great majority of the spirals seem to flee Earth?

Slipher's puzzling observations, as well as Keeler's astounding conclusions, posed mysteries to scientists that could not be solved until the advent of bigger telescopes—and a new type of astronomical practice.

THE GROWTH OF ASTRONOMICAL DISCOVERY

George Ellery Hale was the quintessential American booster for astronomy. A child of industrial and corporate America, raised in Chicago in the 1870s and '80s, he was a genius at persuading newly rich American patrons to fund the construction of big telescopes. From the 1890s to the 1930s, he built the largest telescope in the world four times: the 40-inch Yerkes refractor, the 60-inch and 100-inch reflectors at California's Mount Wilson, and the 200-inch Hale telescope at California's Palomar. A land that could make great battleships and bridges, Hale once mused, could always build a bigger telescope.

The 60-inch telescope was completed in 1908 with the support of the recently established Carnegie Institution of Washington. With this instrument, Hale's staff was soon taking high-resolution photographs of star clusters and spiral nebulae. Between 1914 and 1919, Harlow Shapley used the telescope to photograph globular clusters. These great balls of stars were scattered through the sky but seemed to be concentrated around the brightest region in the Milky Way, in the direction of the constellation of Sagittarius. Shapley hunted in them for a class of variable star called a Cepheid (after the prototype found in the constellation of Cepheus). The variation in a Cepheid's light output was an indicator of how bright the star was. With its true brightness known, astronomers could then calculate its distance. With the assistance of the Cepheids, Shapley measured rough distances to dozens of globular clusters.

In the 1910s, nearly everyone believed that the sun was very close to the center of the Milky Way. Shapley, however, reached a very different conclusion. He reckoned that the globular clusters formed a spherical system, centered on a point in the Milky Way somewhere between 60,000 and 100,000 light-years away from the sun. If this was true, the Milky Way was a disk of stars 300,000 light-years in extent, far larger than anyone had previously thought. And the sun was tens of thousands of light-years from its center, which lay in the direction of the constellation Sagittarius.

Even as Shapley studied the globular clusters, Hale was intent on building a much bigger telescope than the 60-inch. Supported by private and corporate philanthropy, Hale enlisted teams of experts ranging from glassmakers and optical specialists to battleship manufacturers to build a 100-inch telescope and its mirror, mounting, and surrounding dome. By 1920, the telescope had even been equipped with a device that actually measured the angular diameters of red giant stars, far beyond the normal resolution limits of the Earth's atmosphere. The completed telescope was by far the most powerful ever built, and Hale hired a young astronomer named Edwin Hubble to be one of those to use it.

THE PUZZLE OF THE SPIRAL NEBULAE IS RESOLVED

In the fall of 1923, Hubble began photographing the Andromeda Nebula (M31) repeatedly from the shortest and fastest focus of the 100-inch telescope. This required him to sit on a platform high off the floor and carefully guide the photographic plate holder with precision screws for hours. By the end of the year and many long nights of observing, Hubble had collected and examined many sets of photographs. On one particular plate, taken in early October, he found what he at first thought was a nova in that nebula, a star that would brighten rapidly and violently to a luminescence far outshining all other stars. But when he examined another photograph taken a bit later in the sequence, he found that, unlike a nova, the star quickly dimmed. Plates taken later showed it brightening again. From the pattern of its light variations, Hubble decided, it must be a Cepheid variable. He quickly found a second example.

Those two Cepheid variables enabled Hubble to estimate the distance to M31: astonishingly, around one million light-years. With other finds rapidly following in the wake of the first two, Hubble swiftly settled the question of the nature of the spirals: They were indeed "island universes" well beyond the borders of the Milky Way and comparable to it in size. The Andromeda Nebula was in fact what we would now term a galaxy and the universe was not made of stars, but of galaxies.

With the most powerful telescope in the world, sitting in the mile-high dark mountain air above Los Angeles, Hubble was master of the extragalactic realm. He turned his attention to the strange shifts Slipher had found in the spectral lines of many spiral nebulae. He gradually built up a means of determining distances to ever fainter—so presumably more distant—spirals that allowed him to calculate how the spectral shifts (which according to the Doppler effect measured the speed) of galaxies changed with distance. By 1929, he knew that there was a definite, though yet rough, correlation between the distance of the galaxy and the size of the shift of its spectral lines. Double the distance, double the shift toward the red end of the spectrum.

In the 1930s Hubble and fellow astronomer Milton Humason continually refined this so-called redshift-distance relation. Others were quick to interpret the redshifts as Doppler shifts. If this was right, the universe was expanding, and the redshifts revealed that it had no center to its expansion. The rate of expansion, later to be known as the Hubble Constant, became the holy grail of cosmology. Hubble (who in fact had doubts that the redshifts were really Doppler shifts) first calculated the rate of expansion at 500 kilometers a second for every megaparsec (one million parsecs—a parsec is approximately 3.26 light-years) one traveled into space. He also concluded that Keeler's estimate of 700,000 visible spirals (or galaxies, as almost all astronomers now judged them to be) had to be revised upward into the millions and soon hundreds of millions. The more distant the galaxy, the faster it moved. By 1936, Mount Wilson observers had detected velocities as high as 40,000 kilometers a second for a faint cluster of galaxies in Ursa Major. There seemed to be no end to the universe, but Hubble wondered what the recessional velocities really meant. Was the universe truly expanding, or was the apparent expansion an artifact of some effect of space and time that was not yet understood?

Understanding this phenomenon became a mission for astronomers for most of the rest of the century: Refine the observed rate of expansion, determine how it varied with time, and, most of all, explore the nature and extent of the vast and apparently boundless system of galaxies that constitutes our universe. And it was largely the dream of exploring these most distant regions of the universe with an unprecedentedly powerful telescope that drove some astronomers to press for, and then help build, the Hubble Space Telescope. By the time the Hubble Space Telescope sat on the launchpad in Florida in April 1990, it carried a heavy weight of astronomers' hopes and ambitions. Whether or not it could fulfill them was yet to be seen.

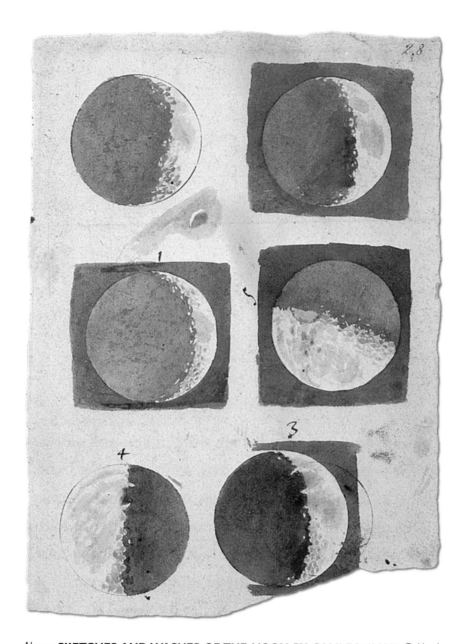

Above: **SKETCHES AND WASHES OF THE MOON BY GALILEO (1610)** Galileo's renderings of the moon as seen through his telescope highlight shifting shadows on the lunar surface, and hence the moon's imperfect, corporeal nature. *Opposite:* **COMPOSITE IMAGE OF THE NEAR SIDE OF THE FULL MOON (1969)** Created by the National Optical Astronomy Observatory, the portrait uses digital mosaic imaging techniques reminiscent of the Hubble's Wide Field/Planetary Camera.

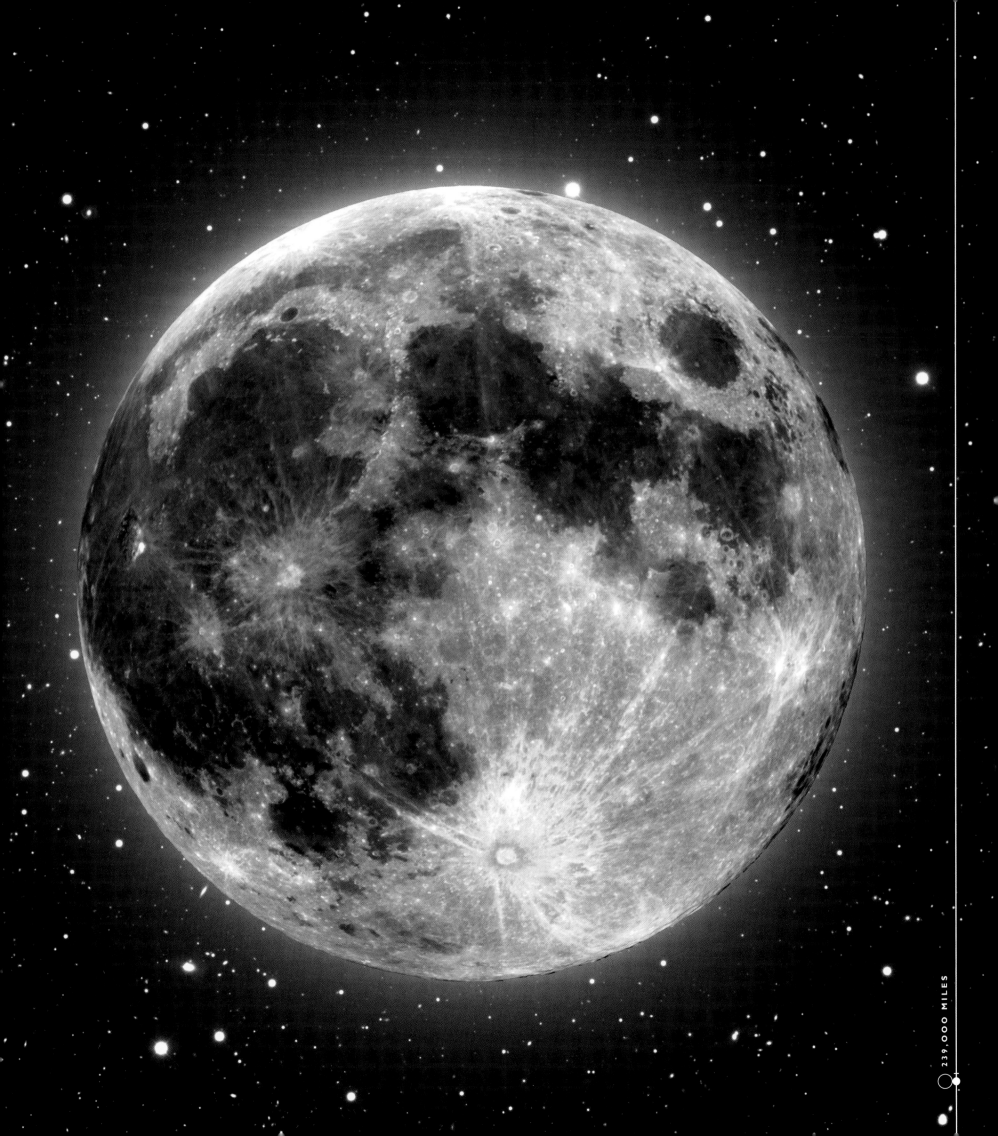

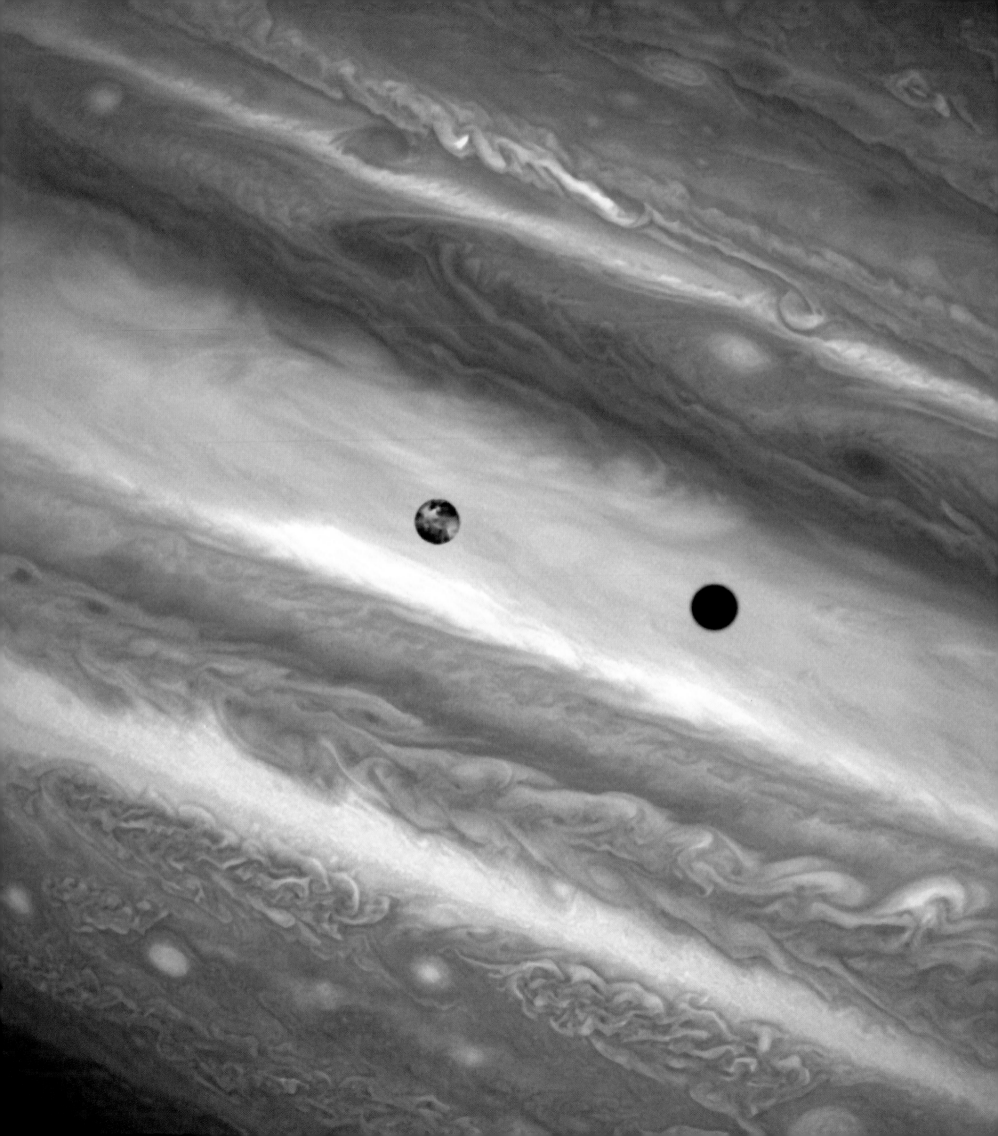

Above: **GALILEO'S NOTES ON THE MOONS OF JUPITER (1610)** Galileo's observations of moons circling Jupiter revolutionized cosmology, showing the Earth was not the only center of motion in the universe. *Opposite:* **JUPITER'S MOON IO (1993)** While scrutinizing the surface of Io, one of the Galilean moons, the Hubble Space Telescope also captured its shadow superimposed on Jupiter's atmosphere.

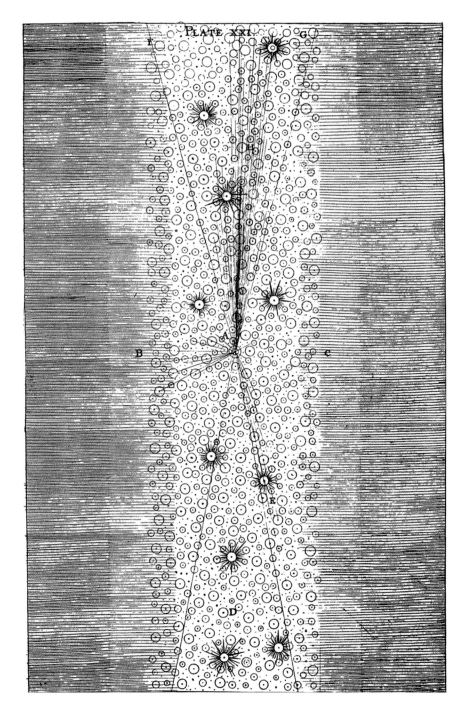

Above: **A PAGE FROM THOMAS WRIGHT'S** *AN ORIGINAL THEORY OR NEW HY-POTHESIS OF THE UNIVERSE* **(1750)** The confinement of the Milky Way to a narrow plane in the sky gave rise to speculation in the 18th century about the structure of the universe. Thomas Wright of Durham, England, hypothesized that the Earth was at the center of a vast spherical shell of stars. His representation of a slender portion of such a spherical shell presages telescopic views of the sky. *Opposite:* **SOUTHERN MILKY WAY (2007)** An image of the Milky Way as seen in the Southern Hemisphere was captured by a wide-field lens at the Cerro Tololo Inter-American Observatory in Chile.

Above: **THE GREAT NEBULA IN ORION AS DRAWN BY THE EARL OF ROSSE (1868)** From 1848 to 1867, William Parsons, the third Earl of Rosse, and his observing staff repeatedly scrutinized the Orion Nebula with their gigantic telescope, the Leviathan of Parsonstown, looking for evidence of change. In 1868, the fourth Earl of Rosse, Lord Oxmantown, published a composite view from his father's detailed sketches, noting that it was made "with the advantage of instrumental power far exceeding that at the disposal of previous observers...."

Opposite: **ORION NEBULA (1995)** Just as the Rosse image is a composite, so too is this modern image of the core of the great nebula, taken with the Hubble Space Telescope. The image is derived from a mosaic of 45 separate images of 15 fields using blue, green, and red filters between January 1994 and March 1995, covering a field only 1/20th the size of the full moon. Searching for evidence of star and planetary system formation, astronomers were rewarded by the discovery of over 150 proplyds (protoplanetary disks) surrounding infant stars.

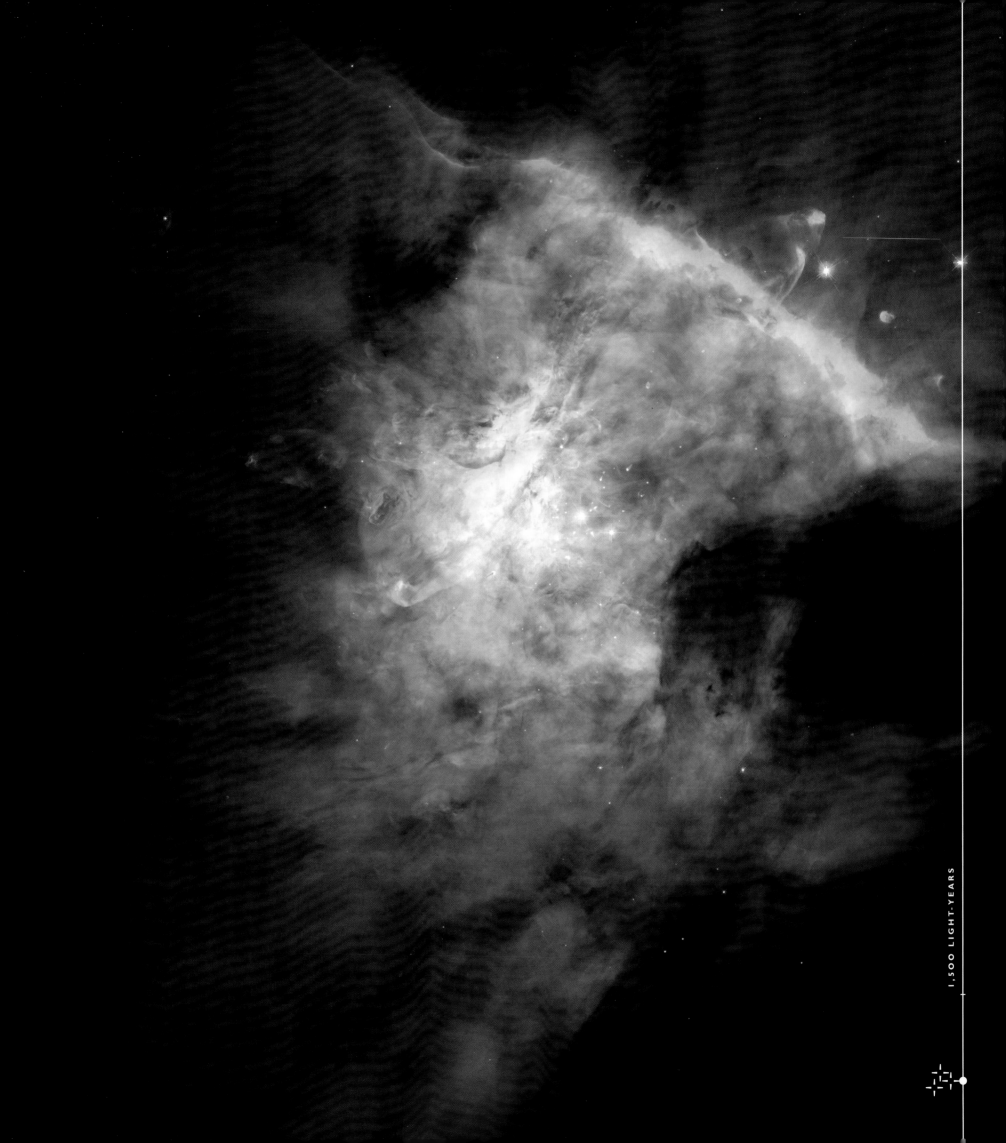

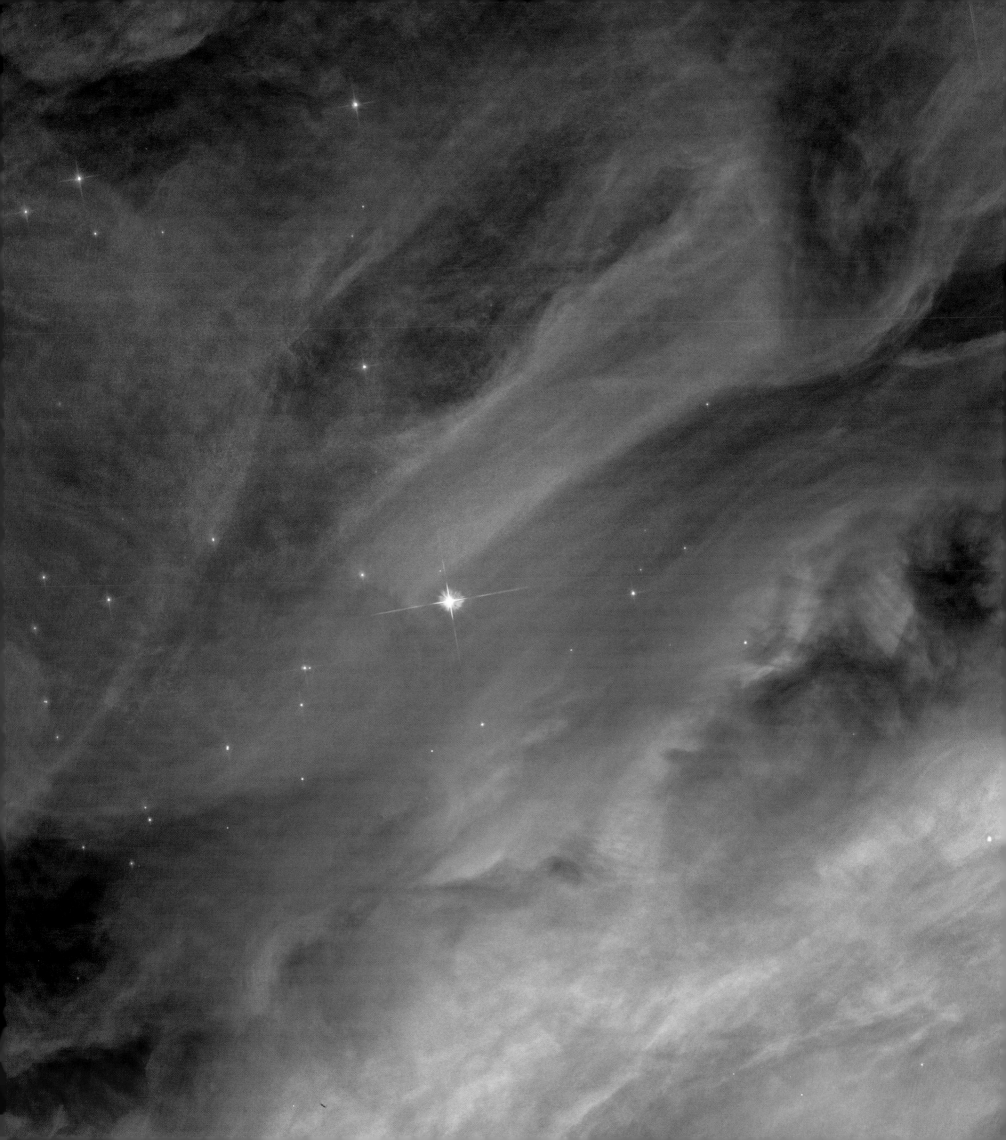

"BUT WHAT A FIELD OF NOVELTY IS HERE
OPENED TO OUR CONCEPTIONS!
A SHINING FLUID..."

—SIR WILLIAM HERSCHEL, 1791

PANORAMIC VIEW OF THE ORION NEBULA (2006)
A group of astronomers devoted over 105 orbits of observing time with the Hubble to make this the closest study of the vast Orion Nebula ever attempted. Employing all the imaging instruments aboard Hubble simultaneously, including the Advanced Camera for Surveys (ACS), the Wide Field/Planetary Camera 2 (WF/PC2), and the Near Infrared Camera and Multi-Object Spectrometer (NIC-MOS), the group created an album of images. This one reveals a wall of gas defining one of the many cavities in the nebula created by the light pressure from super-hot stars.

1,500 LIGHT-YEARS

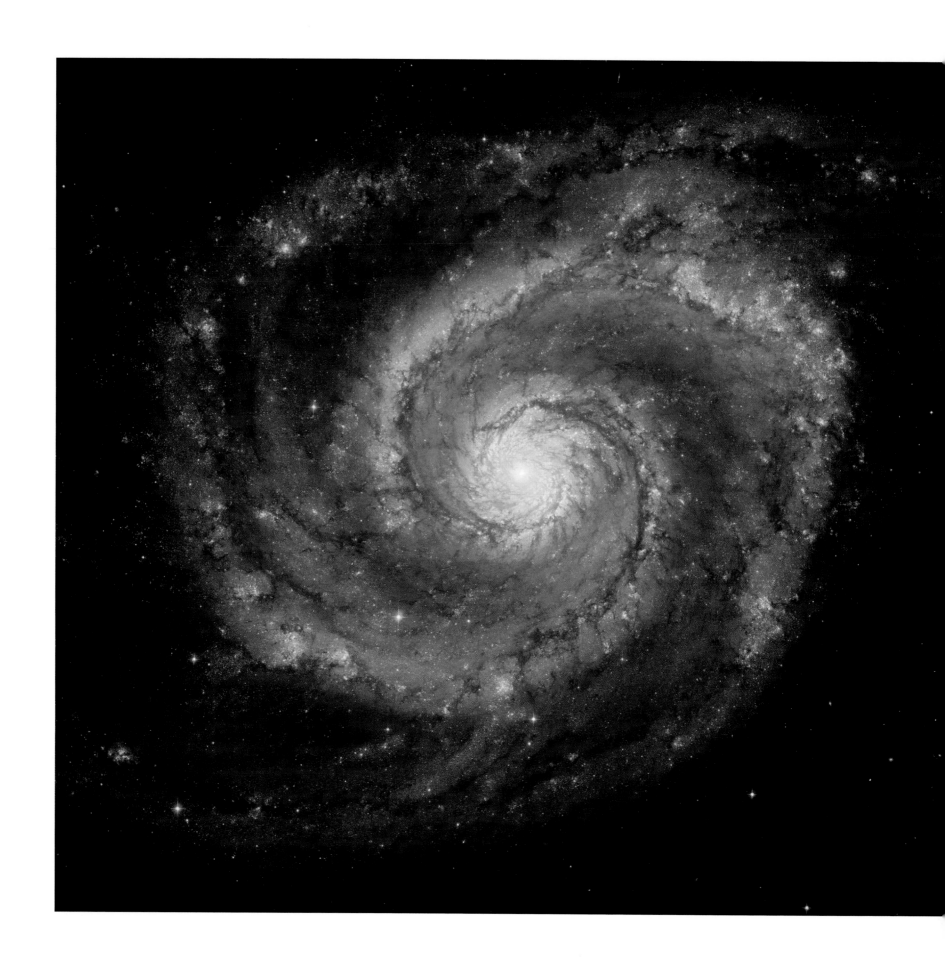

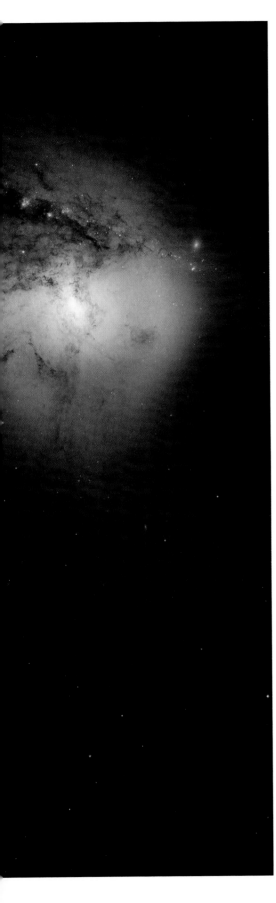

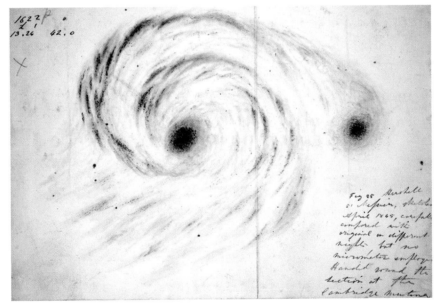

Above: **DEPICTION OF WHIRLPOOL BY THE EARL OF ROSSE (1845)** In April 1845, William Parsons, the third Earl of Rosse, turned his new six-foot speculum reflector toward a nebula in the far northern constellation Canes Venatici. After observing and sketching the object for weeks, Rosse combined his impressions into this distinctly spiral shape, which led him to search for more such forms. *Left:* **WHIRLPOOL GALAXY (2005)** This ACS image of the Whirlpool galaxy (M51) was compiled from observations taken in January 2005. The Whirlpool has been an object of constant scrutiny to those interested in the structure of "grand-design" spiral galaxies, as some call them. Why the spiral forms exist at all has been a subject of lively debate for more than a century and has led to many new insights into the formation and evolution of stars and galaxies. The prominent arms in M51 are believed to be due to a combination of a "density wave" mechanism and to the perturbations caused by its companion galaxy, NGC 5195.

EDWIN POWELL HUBBLE

NAMESAKE OF THE SPACE TELESCOPE

Edwin Powell Hubble was born in 1889 in Missouri. He studied at the University of Chicago and received his Ph.D. at Yerkes Observatory in 1917 for a meticulous reconnaissance of the forms of faint spiral nebulae, which even at this time Hubble suspected to be, in reality, distant galaxies.

After wartime service, Hubble was hired by George Ellery Hale and immediately put to work at Mount Wilson, the world's leading observatory and where he had access to the most powerful telescopes anywhere, most significantly the newly constructed 100-inch reflector. Hubble was relatively junior for an astronomer when he made the momentous discovery of Cepheid variable stars in the Andromeda Nebula, which immediately led him in 1924 to determine the distances to spirals.

His employment at Mount Wilson was important, but his name was hardly known. As a result, Hubble had two major hurdles to overcome to establish beyond doubt the correctness of his findings. The first was proving the remoteness of the spiral nebulae using the Cepheid relation. And the second, more subtle but nonetheless equally critical, was the fact that a senior Mount Wilson astronomer, Adriaan van Maanen, had been collecting evidence that showed the spirals to be in rapid rotation. Matching photographs of these spirals taken over several years, he believed he had detected actual shifts in the position of the arms. Taken along with the spectroscopic determinations of their velocities of rotation, Van Maanen and others were able to estimate the distances to these nebulae and found them relatively close by, just tens of thousands of light-years away, meaning they could not be remote galaxies.

Van Maanen was only five years older than Hubble, but was almost ten years advanced over him professionally. Upon his subsequent arrival at Mount Wilson, he had quickly established himself as an expert in positional photographic

astronomy. Hubble knew that his findings would make Van Maanen a formidable adversary. He spent much of 1924 redoubling his efforts to present a solid case for the remoteness of the spirals. Hubble's confidence in publishing his results on the Cepheids in the Andromeda Nebula was strengthened when influential astronomer Henry Norris Russell urged him to send a report to the national meeting of the American Association for the Advancement of Science.

Hubble was unable to attend the meeting, so Russell offered to read it for him. The astronomers in attendance voted to send it to the AAAS Awards Committee; it shared the prize that year and helped make his reputation.

From this auspicious beginning, Hubble continued to exploit the Mount Wilson telescopes and later those on Palomar Mountain to expand knowledge

of the universe, opening up new doors in astronomy. With collaborators Richard Tolman and Milton Humason in the 1930s, Hubble addressed fundamental

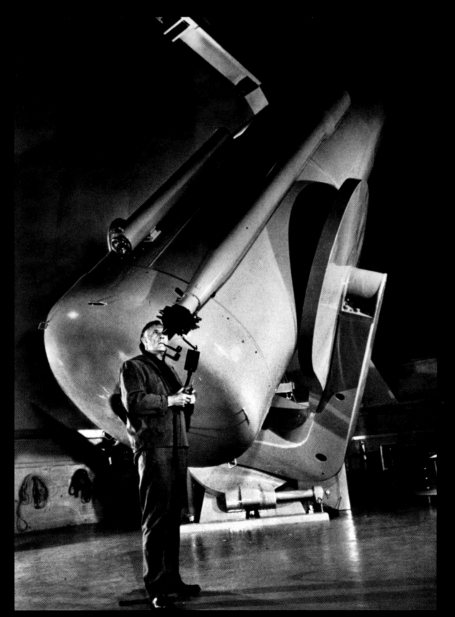

questions about the nature and structure of the universe and tirelessly continued to observe its depths, venturing out as far as his telescopes could carry him.

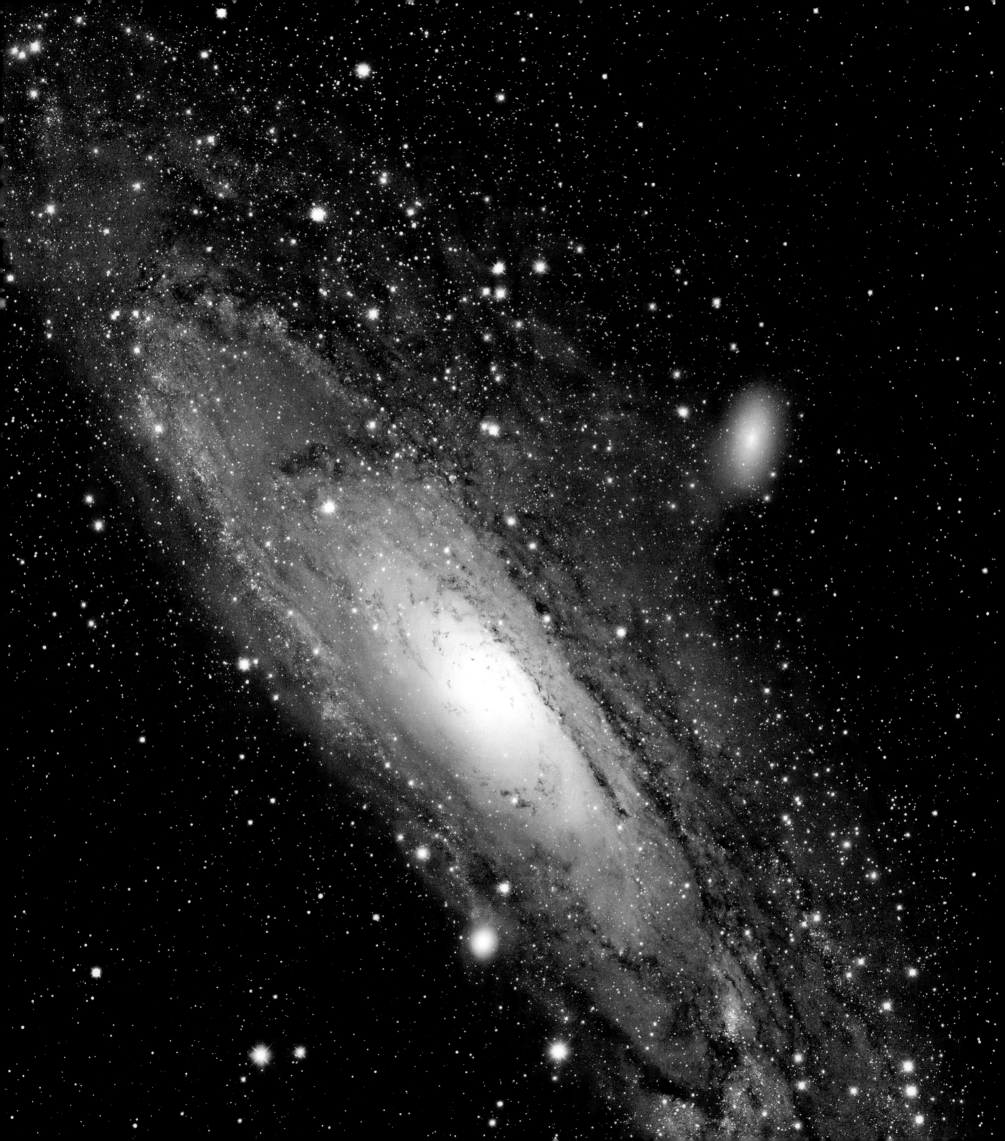

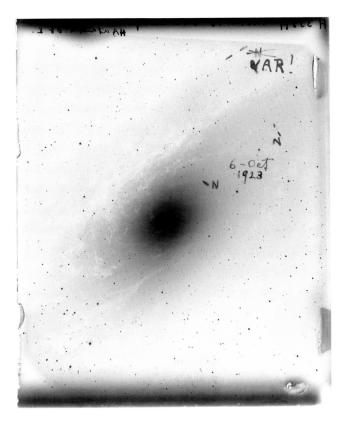

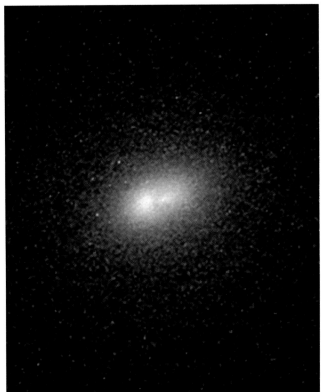

Opposite: **ANDROMEDA GALAXY (2002)** This mosaic image of the Andromeda galaxy (M31) was created by amateur astronomer Dr. Robert Gendler, a Connecticut physician. Gendler used a sophisticated 12.5-inch Ritchey-Chretién wide-field Cassegrain and a CCD camera, combining some 50 hours of exposures taken between September and November 2002 with wider fields taken with smaller instruments. *Above left:* **HUBBLE'S NEGATIVE OF ANDROMEDA (1923)** The Great Nebula in Andromeda, as it was originally known, was one of the first targets for Edwin Hubble's searches for novae in and near nebulae. In a series of photographs with the 100-inch telescope in the fall of 1923, Hubble realized that one of the stellar images that had flared up was not a nova, but a variable star. His excited exclamation point on the negative shows that Hubble knew that he had made his mark. *Above right:* **HUBBLE IMAGE OF THE CORE OF ANDROMEDA (2005)** The Hubble Space Telescope has now given astronomers the ability to peer directly into the tiny but intensely active core of the galaxy. This WF/PC2 image from 2005 reveals a ring of red stars and a disk of blue stars in the grip of a 140-million-solar-mass black hole.

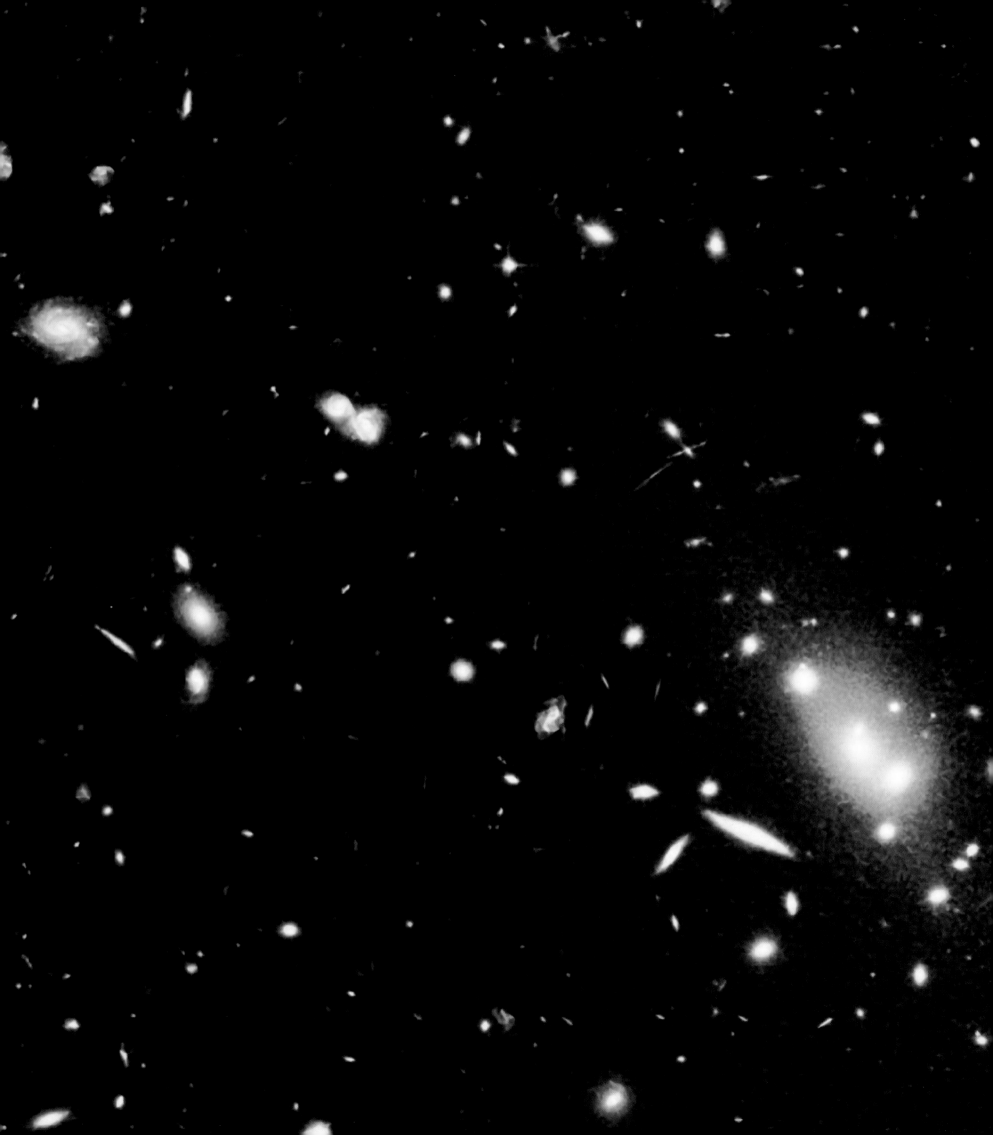

CLUSTER OF GALAXIES IN URSA MAJOR (2005) Beginning with Galileo, telescopes have penetrated ever farther into the universe. The Hubble Space Telescope continues the optical campaign, typified by this fine cluster of galaxies, some five billion light-years distant, known as Abell 1576. The rich cluster of galaxies was identified by George Abell as he collected the first generation of Palomar Sky Survey plates and studied them looking for new, higher-order classes of extragalactic organization.

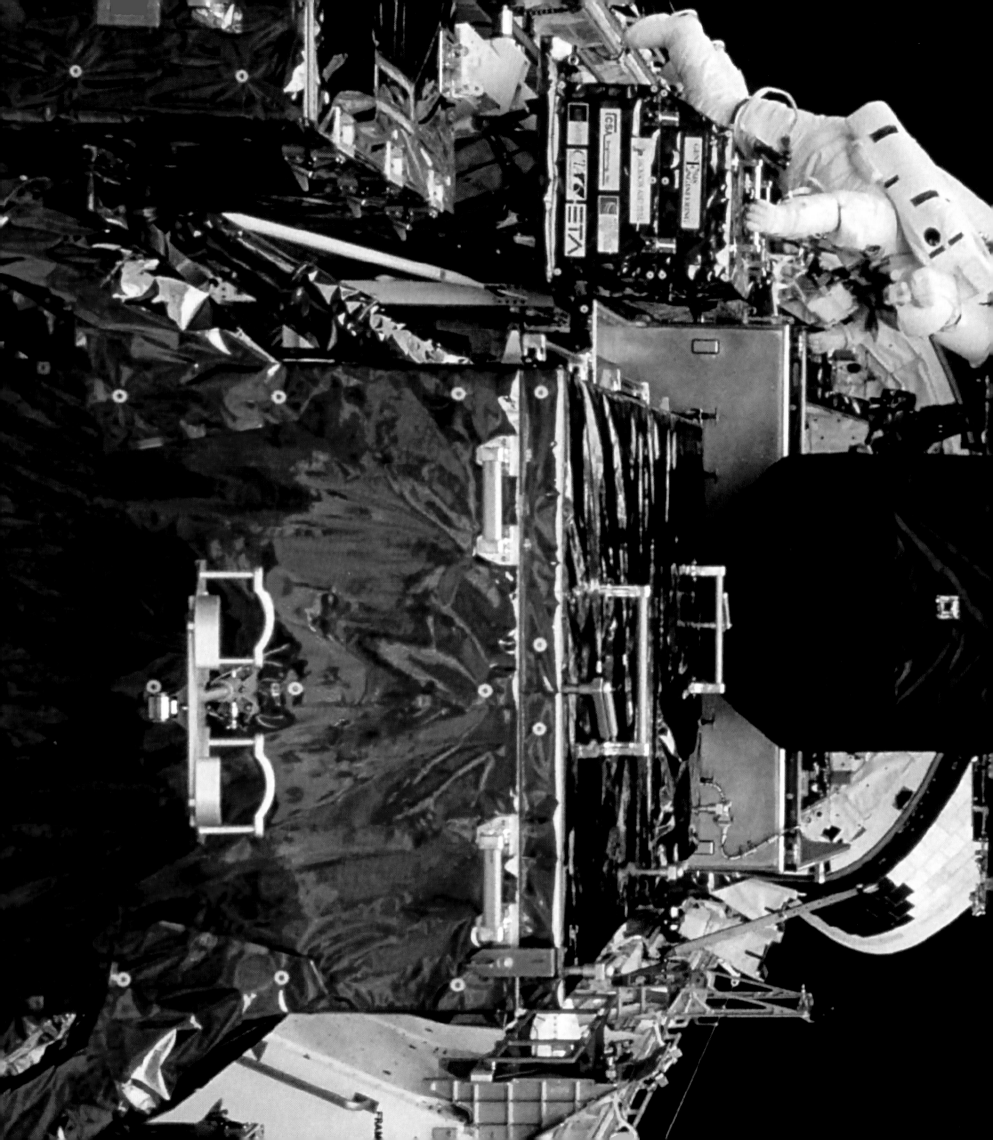

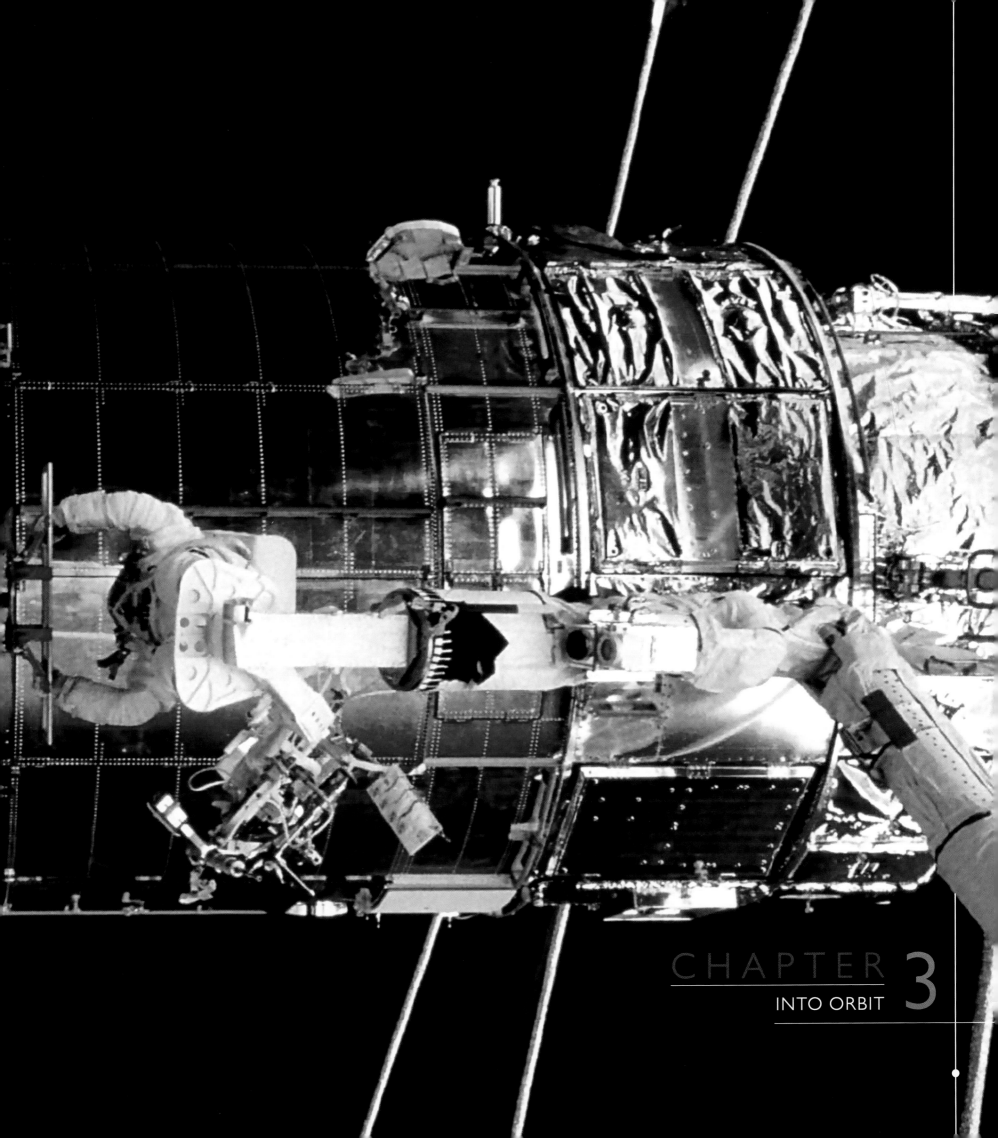

Four years passed between the destruction of the space shuttle *Challenger* and the launch of *Discovery* with the Hubble Space Telescope aboard. Some 44 years had elapsed since Lyman Spitzer first envisioned such a telescope in space. Finally, on April 24, 1990, *Discovery* lofted the HST successfully into orbit, where it was gingerly lifted out of the shuttle's payload bay and placed into space, 375 miles above Earth. By April 27, the orbiter's crew had finished their tasks, and *Discovery* slowly drifted away from the telescope. Hubble had become an automated observatory in the hands of its ground controllers.

The first astronomical image the telescope returned was of a star, sent on May 20 by the Wide Field/Planetary Camera (WF/PC). There were three main features to the image: Ten percent of the star's light resided in a small, bright core, around which was a halo as well as funny-looking features that would soon generally become known as tendrils. As an engineer put it, "This is all very encouraging for the first try.... Think what they can do with fine tuning the images. [Hubble Space Telescope] might actually work."

Yet one astronomer, Roger Lynds, had serious reservations. In his view the star's appearance was odd, and at a project meeting he voiced the opinion that it was due to one of the most common sorts of telescope aberrations, spherical aberration, which results in blurry images. Soon other astronomers, particularly Chris Burrows at the Space Telescope Science Institute, were reaching the same conclusion. At first there seemed to be a possible easy fix. Astronomers clung to the notion that if spherical aberration was present it could be readily compensated for by use of mechanisms behind the primary mirror. Perkin-Elmer had designed these electromechanical torquing levers to impart small forces to different parts of the mirror so that its shape could be altered very slightly. But at a project meeting on June 19, a representative from Hughes Danbury Optical Systems (the company that had recently purchased the mirror's maker, Perkin-Elmer) pointed out that if spherical aberration indeed existed, this system would be able to remove only a minor part of the problem. One astronomer at the meeting reckoned, "This is the moment we find out that we are doomed to failure."

When further tests confirmed that the HST suffered from serious spherical aberration, NASA decided to make the news public. Hapless NASA managers, engineers, and scientists faced baffled reporters at a briefing at the Goddard

Preceding pages: **SECOND SERVICING MISSION (1997)** Astronauts Joseph Tanner, on the robotic arm, and Gregory Harbaugh replace one of the Hubble Space Telescope's Fine Guidance Sensors. *Opposite:* **FIRST SERVICING MISSION (1993)** Story Musgrave rides on the shuttle's robotic arm en route to the top of the Hubble. The HST was transformed by the visit of the space shuttle *Endeavour*'s seven astronauts in December 1993. Most significantly, its optical flaw was corrected. Over its lifetime, the Hubble has been reborn five times following service calls by shuttle astronauts.

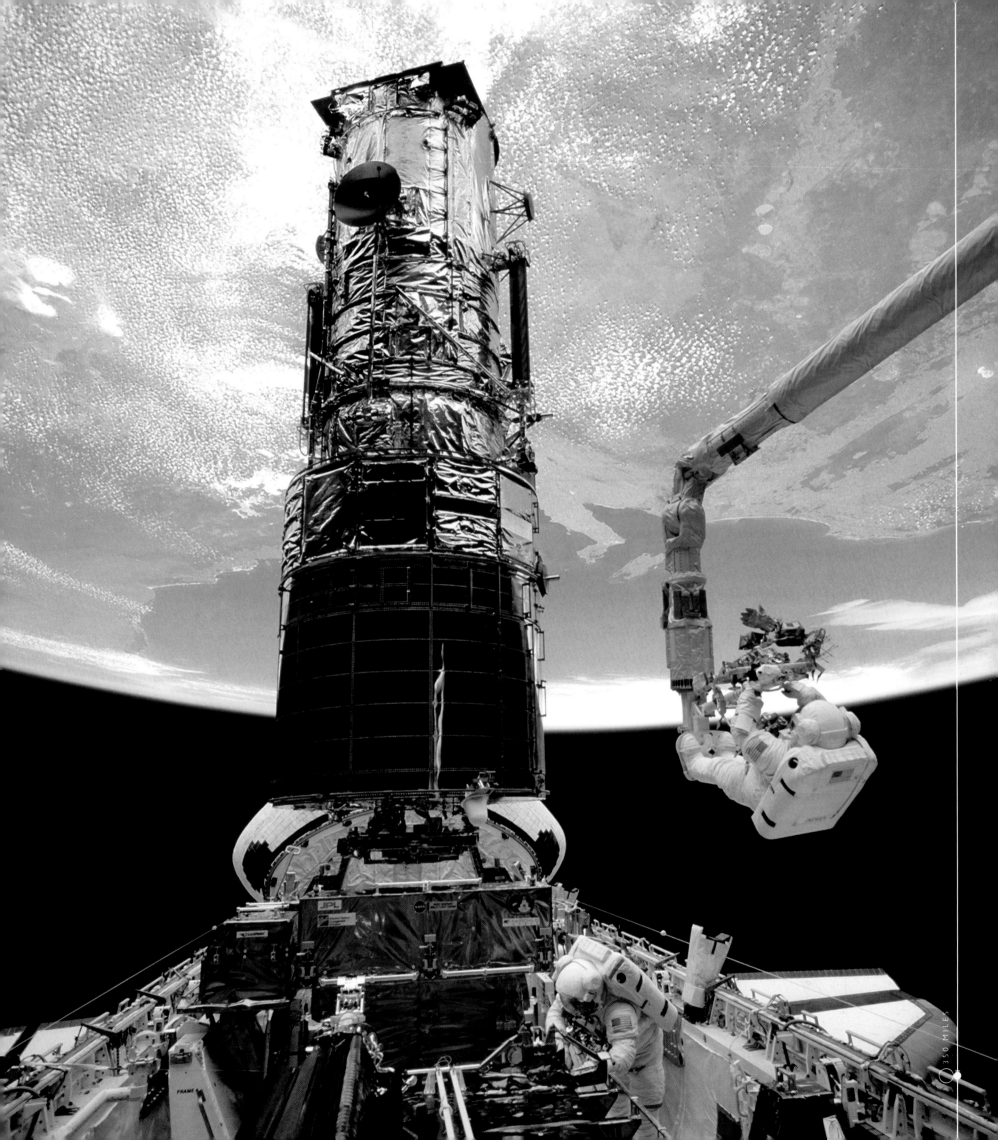

Space Flight Center on June 27, 1990. Instead of singing Hubble's praises, they had to concede that the telescope's primary mirror was built to the wrong shape. Many members of Congress were outraged. "Hubble Trouble" headlines appeared in the media. Spherical aberration so alarmed some astronomers that there now seemed the nightmarish but real possibility that either NASA or Congress might cancel the project.

Scientists were only now learning that a time bomb had been put into place during the mirror's polishing process in 1981, one that was sure to explode when the telescope was operated in space. One of the devices used to measure the shape of the primary mirror, called the reflective null corrector, had not been assembled properly.

As astronomers and engineers painfully reconstructed the process in 1990, they discovered that the lens in the reflective null corrector had been inserted approximately 1.3 millimeters out of position. To position the lens, a Perkin-Elmer engineer had used a measuring rod, over which was placed a metal cap. To be sure the rod was in the right place, a light beam had to be directed onto the end of the rod, and its reflection would check its position. A hole had been drilled in the center of the cap to reveal a portion of the end of the rod, sufficient to provide the actual reflection from the rod. The cap had been painted, but a small piece of paint had become detached. The light beam directed at the end of the rod hit the exposed bit of metal on the cap instead and was reflected back. Perkin-Elmer had been measuring the position of the top of the cap and not the end of the rod.

This was a critical misstep. Even so, if there had been cross-checks in

the program to catch such a mistake, it might have been corrected. There were not. With a strained budget and no additional money for extra tests, the small number of people who knew that there might be a problem had rung no alarm bells. The result was a misshapen primary mirror. It was too flat at its edges by only 2 microns, or about 1/50th the thickness of a sheet of paper, but in the world of precision optics that was a gross blunder.

THE COSTAR FIX

Astronomers, managers, and engineers in 1990 had to live with the consequences of spherical aberration. Project members attempted to keep their focus on maximizing the scientific results from the telescope, despite its hobbled state. Even before the public announcement of the mirror's problems, a number of astronomers were eagerly investigating what could be done through careful computer processing of the Hubble Space Telescope's images. For instance, there were ways to subtract a significant part of the halo around each star image caused by the poorly focused light. Astronomers applied sophisticated image-processing techniques and demonstrated in the summer and fall of 1990 that the Hubble Space Telescope was still capable of producing significant discoveries. A headline in the *New York Times* at the end of August announced, "First Hubble findings bring delight," and recounted "surprising and puzzling observations" of a galaxy's center. By 1992, a report in *Time* magazine on "The Best of Science in 1992" proclaimed, "The latest take: it's not

perfect, but even a nearsighted Hubble is pretty powerful." But the new space telescope had achieved at best partial success. As one astronomer put it: "We are getting great science from the Space Telescope despite its problems.... Unfortunately, we are not getting all of the science we paid for. We wouldn't have paid $2 billion for the capabilities it has." Clearly, the spherical aberration had to be fixed, but how?

A number of astronomers and engineers advocated bringing the Hubble Space Telescope back to Earth to replace the mirror. Such a scheme, however, would cost many hundreds of millions of dollars, and some astronomers worried that if the HST was returned, it might never be reflown. Astronomers at the Space Telescope Science Institute led the charge for an alternative scheme, which ultimately became NASA's chosen means of fixing the problem. They would build a device known as the Corrective Optics Space Telescope Axial Replacement (COSTAR) that would replace one instrument in the original complement of instruments already aboard the Hubble Space Telescope.

COSTAR would contain a set of mechanical arms with mirrors on them that, once in place inside the Hubble Space Telesceops, would swing into exactly calculated positions. Light collected by the main mirror would first bounce off these mirrors, which were precisely curved to compensate for the primary mirror's spherical aberration, before entering three of the remaining scientific instruments. Like a pair of spectacles, COSTAR's mirrors would thereby correct the mirror's vision for these three instruments.

The Wide Field Camera's planned replacement, the Wide Field/Planetary

Camera 2 (WF/PC2), had too wide a field to employ the tiny COSTAR mirrors. Knowing it too would display the effects of spherical aberration unless action was taken, astronomers and engineers redesigned WF/PC2's optical components to counteract the primary's spherical aberration directly and produce well-focused images on the camera's light detectors, despite the flawed primary mirror.

MECHANICS IN SPACE

Installing both COSTAR and the new camera in Hubble, as well as making other repairs to the telescope, meant planning a very complex and highly demanding space shuttle mission. The astronauts would need to capture the HST in orbit and bring it into the payload bay, then perform space walks over the course of several days to replace the old components with new ones. If the mission did not go well, the telescope's future would be in jeopardy. Indeed, it seemed that NASA's own future was in doubt. News stories suggested that many lawmakers on Capitol Hill would take a dim view of NASA's ability to assemble a space station in orbit— NASA's flagship project—if the space agency proved unable to repair the Hubble Space Telescope.

The stakes were therefore very high when the space shuttle *Endeavour* blasted off from Cape Canaveral in December 1993. The shuttle mission, however, went remarkably smoothly, including a record five space walks by the *Endeavour*'s astronauts. The WF/PC was removed and WF/PC2 installed in its place. COSTAR replaced the scientific instrument that had been the

least used by astronomers, the High Speed Photometer. New solar arrays were installed with the aim of correcting a jitter problem. This malfunction was noticeable whenever the telescope moved from very warm sunlight into frigid night when the Earth eclipsed the sun. The sharp changes in temperature caused the original solar panels to wobble a little and shake the spacecraft by tiny but significant amounts.

The *Endeavour* crew had performed their roles flawlessly, but as the orbiter returned to Earth the crucial question for astronomers after the December repair was: "Had the fix worked?" An excited and concerned crowd of astronomers

anxiously awaited the first astronomical images from the upgraded telescope, gathering at the Space Telescope Science Institute to witness the first star image from the repaired Hubble to emerge on a computer screen. A cheer erupted when it became clear that most of the light was in fact concentrated into the star image's core. The spherical aberration had been eliminated.

As before-and-after images dramatically marked the major improvement in the Hubble Space Telescope's performance, appearing in newspapers and magazines and on television, public perception of the telescope rapidly began to shift.

GROUND-BASED AND HST VIEWS OF DOUBLE STARS An image of stars in a double star system *(above left)*, taken with a ground-based telescope, blurs the two stars into one. Part of the first image that Hubble's Wide Field/Planetary Camera returned after the telescope was launched in 1990 shows the same two stars distinctly *(above right)*. Further tests of Hubble's optical system, however, soon revealed that the telescope was not performing nearly as well as expected before launch.

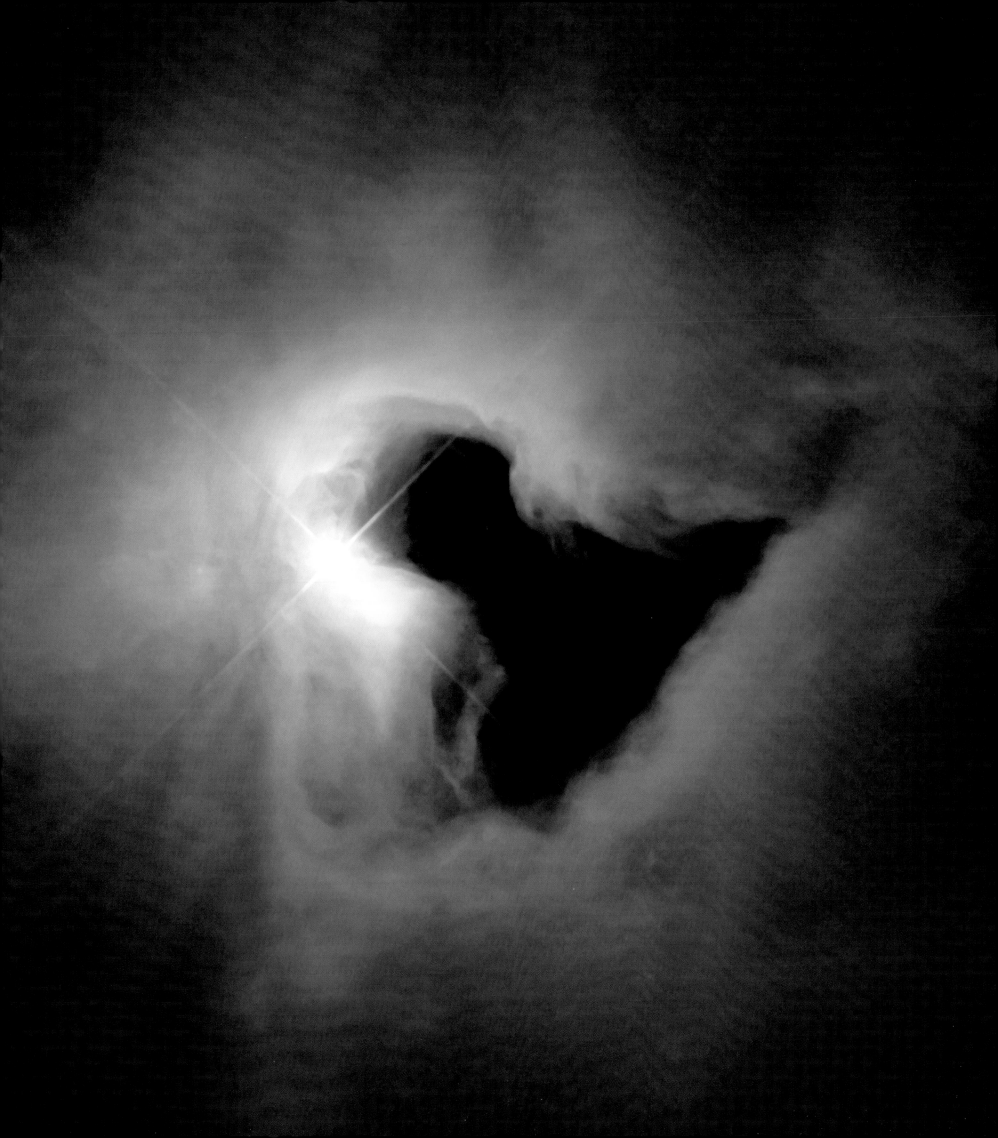

No longer was Hubble synonymous with trouble. Another key step in the public rehabilitation of the Hubble Space Telescope came in 1994, when the telescope was used to observe a fragmented comet approaching and smashing into Jupiter. The collisions drew tremendous interest, and the HST's extremely public role in observing them underlined its capabilities. A spectacular WF/PC2 image, taken in early 1994, of a recent supernova remnant that appeared to show a system of rings and halos also won wide publicity for the Hubble.

These and other images positively engaged the general public and garnered applause from the telescope's patrons in NASA and ESA, on Capitol Hill, and in the White House. The Hubble Space Telescope was at last performing up to the standards originally envisaged for it. Provided no insuperable technical difficulties arose, the space telescope's life was now guaranteed, at least for the near future.

By the time of the first servicing mission to the Hubble Space Telescope in late 1993, two new scientific instruments were well on the way to completion, and both were transported to the Hubble during the second space shuttle servicing mission, in February 1997. The Space Telescope Imaging Spectrograph (STIS) was designed to replace many of the capabilities of the two original spectrographs and was a more powerful instrument in many respects than both combined. The Near Infrared Camera and Multi-Object Spectrometer, or NICMOS, was designed to observe objects in the near-infrared part of the electromagnetic spectrum—that is, light of a wavelength invisible to the human eye—and provided a powerful complement to the WF/PC2. In order to detect infrared light from astronomical targets, not from the heat radiation created by its own electronic systems, the NICMOS's detectors needed to operate at extremely cold temperatures. For this reason they were fitted inside a thermally insulated cooler somewhat like a thermos bottle, which contained a 230-pound block of nitrogen ice to serve as the coolant.

Unfortunately, a problem soon developed after the NICMOS was installed in the telescope. Instead of lasting four and a half years as planned, NICMOS ran out of coolant after only two, in January 1999. The instrument was effectively out of commission. When the fourth shuttle servicing mission was launched to the telescope in March 2002, the astronauts of the space shuttle *Columbia* carried to orbit a specially designed NICMOS Cooling System. The astronauts successfully inserted the device, which operates much like a household refrigerator, and it chilled the NICMOS to below a very frigid minus 321° F.

Brought back from the dead, the NICMOS happily performed even better than it did in its first incarnation. During the same 2002 shuttle mission, astronauts installed a new and highly efficient camera, called the Advanced Camera for Surveys (ACS), in one of the scientific instrument bays behind Hubble's primary mirror. Replacing a now obsolete instrument, the ACS had a field of view twice as large as the WF/PC2. It was able to observe in the ultraviolet, visible, and near-infrared regions of the spectrum with larger, more sensitive detectors giving twice the image sharpness. The ACS added much more observing capability to the Hubble Space Telescope.

By March 2002 the Hubble Space Telescope was in many ways a very different observatory from the one first launched in 1990. All of the original scientific instruments had been replaced by more powerful ones. The telescope's support systems on Earth and in orbit had received major upgrades over the years, too. In the end, the Hubble's scientific performance had even exceeded the hopes that had sustained its advocates over so many years. By early in the 21st century, after more than a decade in space, it had come to be widely regarded as the most productive observatory ever built.

Two new scientific instruments were planned: Wide Field Camera 3 (WFC3) and the Cosmic Origins Spectrograph (COS). When these instruments were finally added in the contested and delayed fifth servicing mission, users of the Hubble Space Telescope had an even more capable instrument, adding to its reputation as a scientific and engineering triumph.

REFLECTION NEBULA, NGC 1999 (2000) Imaged here by the Wide Field/Planetary Camera 2 (WF/PC2), this reflection nebula was first observed by William Herschel. It lies close to the famous Orion Nebula, roughly 1,500 light-years from Earth. Reflection nebulae do not emit any visible light of their own. Rather they, like fog around a streetlight, shine as a consequence of reflected or scattered starlight. Reflection nebulae often look bluish, the result of blue light being reflected more efficiently by dust particles than red light. The bright star illuminating this reflection nebula is just left of center in the image. It formed very recently, has a surface temperature almost twice that of our sun, and it still is surrounded by a cloud of leftover material from its formation. It is this leftover material that produces the reflection nebula.

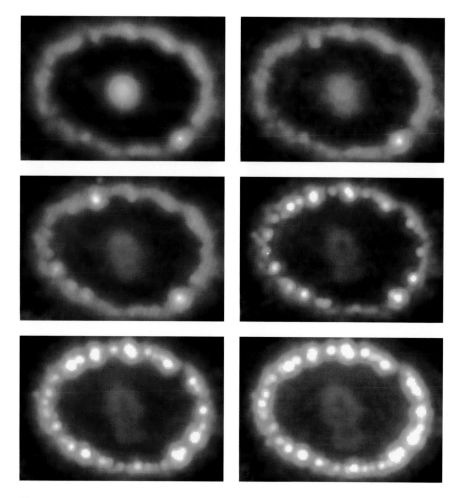

Above: **HOT SPOTS AROUND SUPERNOVA 1987A (1991–2006)** In February 1987, astronomers witnessed one of nature's rarest and most spectacular events: a Type II supernova explosion, in the Large Magellanic Cloud, a galaxy only 180,000 light-years away. The supernova itself lies on the near part of the galaxy, at 168,000 light-years away. Type II supernovae are huge stars that violently eject most of their mass in just a few seconds, releasing so much energy that it exceeds the amount the sun will produce over its ten-billion-year lifetime. Since it was launched in 1990, the Hubble Space Telescope has regularly observed the remnants of this supernova. The images above, obtained with the WF/PC2 and the Advanced Camera for Surveys (ACS), show so-called hot spots along a ring of gas. The spots are formed when the supersonic shock wave released by the explosion smashes into a ring of material around the blast at a speed greater than one million miles an hour, compressing and heating the material.

Opposite: **A STRING OF COSMIC PEARLS (2006)** Supernova 1987A continues to provide a brilliant light show to the Hubble and other space observatories. This image displays dozens of bright spots that form a ring, estimated to be about a light-year across, that was probably shed by the star some 20,000 years before it exploded. The shock wave of the explosion itself is now overtaking the ring and causing it to glow.

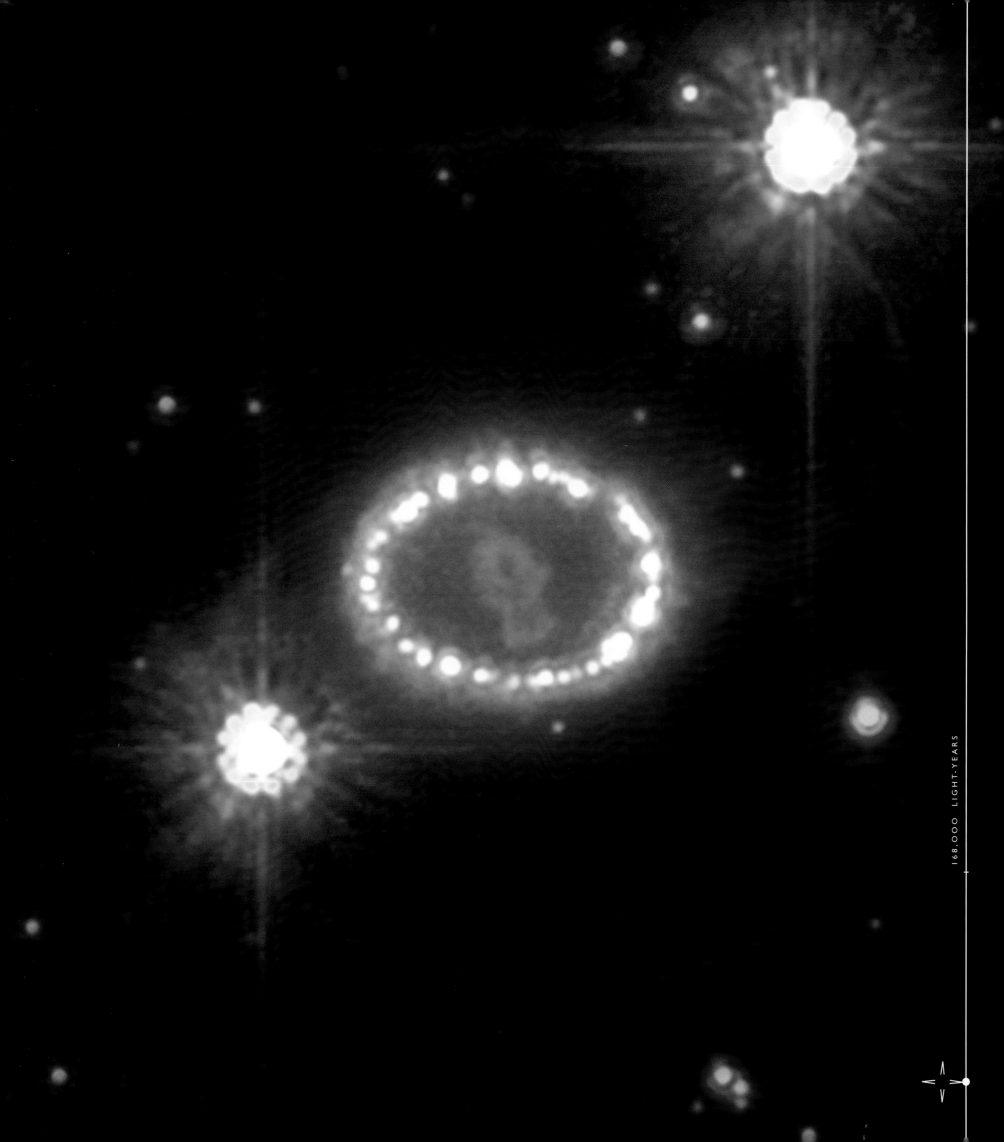

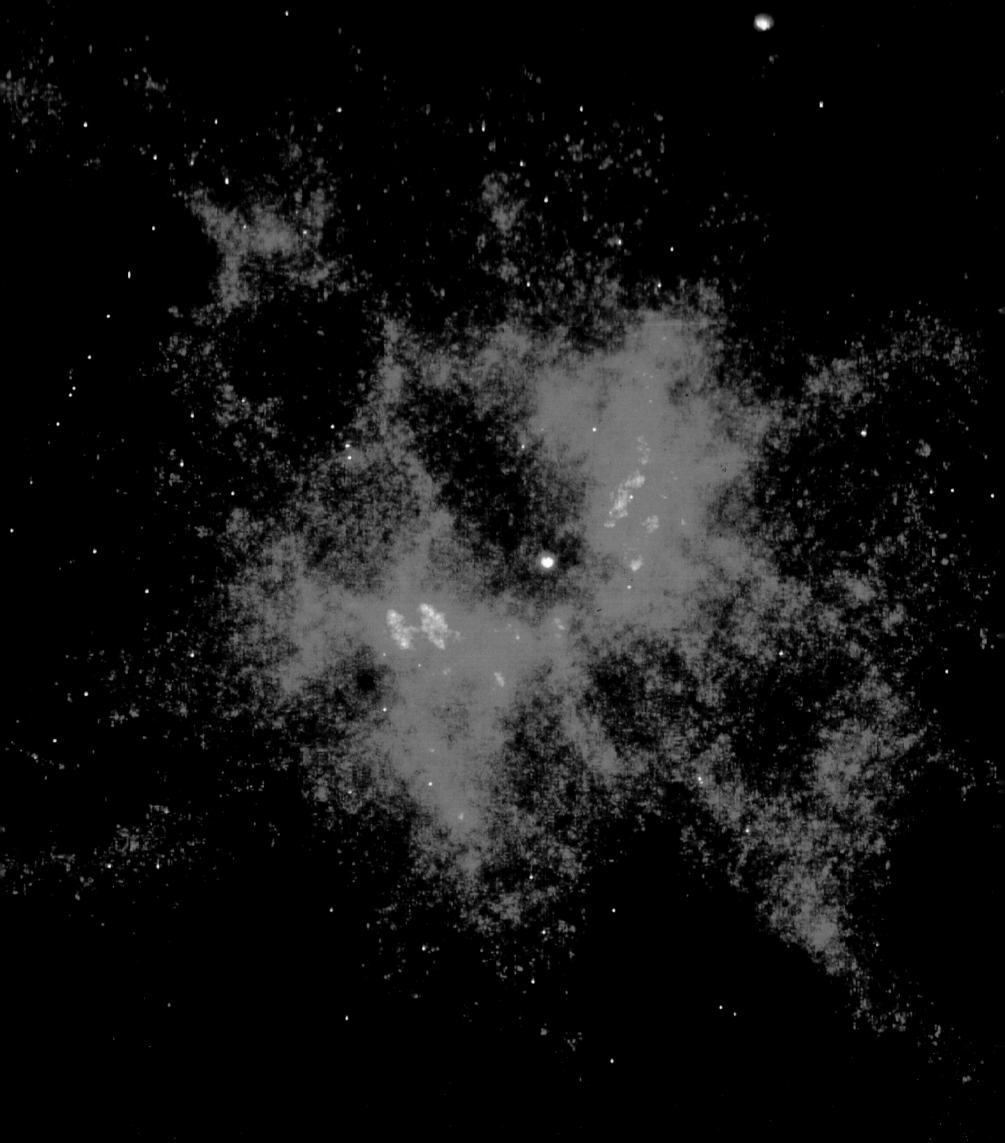

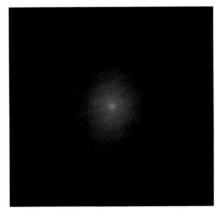

Opposite: **VERY HOT STAR IN THE CENTER OF NEBULA NGC 2440 (1992)** The discovery in June 1990 that the Hubble suffered from spherical aberration came as a huge disappointment to astronomers and as a shock to policymakers and the general public. These early WF/PC images nevertheless underline the fact that the aberrated Hubble could still produce worthwhile science. The white dot near the center of the image opposite is a star with a surface temperature of around 200,000K, making it one of the hottest on record. It is surrounded by a glowing nebula with many intricate structures. *Above:* **TWO VIEWS OF GALAXY NGC 7457 (1990)** The images of galaxy NGC 7457, which is about 40 million light-years distant, were both secured soon after the Hubble went into space. The high-contrast image on the right reveals the galaxy's central region. That on the left shows a high concentration of stars at the very heart of the galaxy.

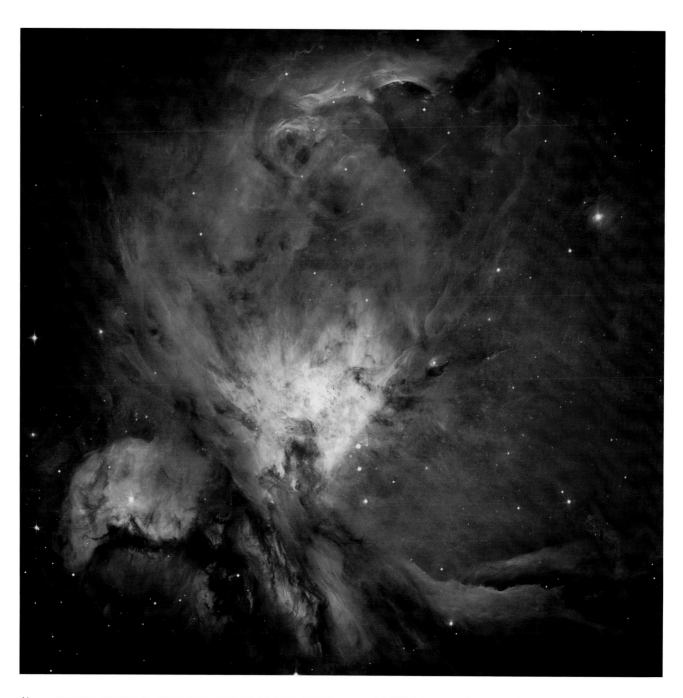

Above: **ORION NEBULA, GROUND-BASED IMAGE (1979)**
The Orion Nebula, in the famed constellation of Orion, the Hunter, is one of the most studied objects in astronomy. It is visible even to the naked eye in the winter months, located in the scabbard of Orion below the three stars in his belt. The nebula is a stellar nursery composed of young stars, gas, and dust. It is an esti- mated 1,500 light-years distant, and so, given that our own galaxy has a diameter of around 100,000 light-years, is practically on our cosmic doorstep. *Opposite:* **THE ORION NEBULA'S BIGGEST STARS (2005)** The four Trapezium stars (seen in the center of the image) pour out intense ultraviolet light that sculpts a cavity in the nebula and influences the evolution of many smaller stars.

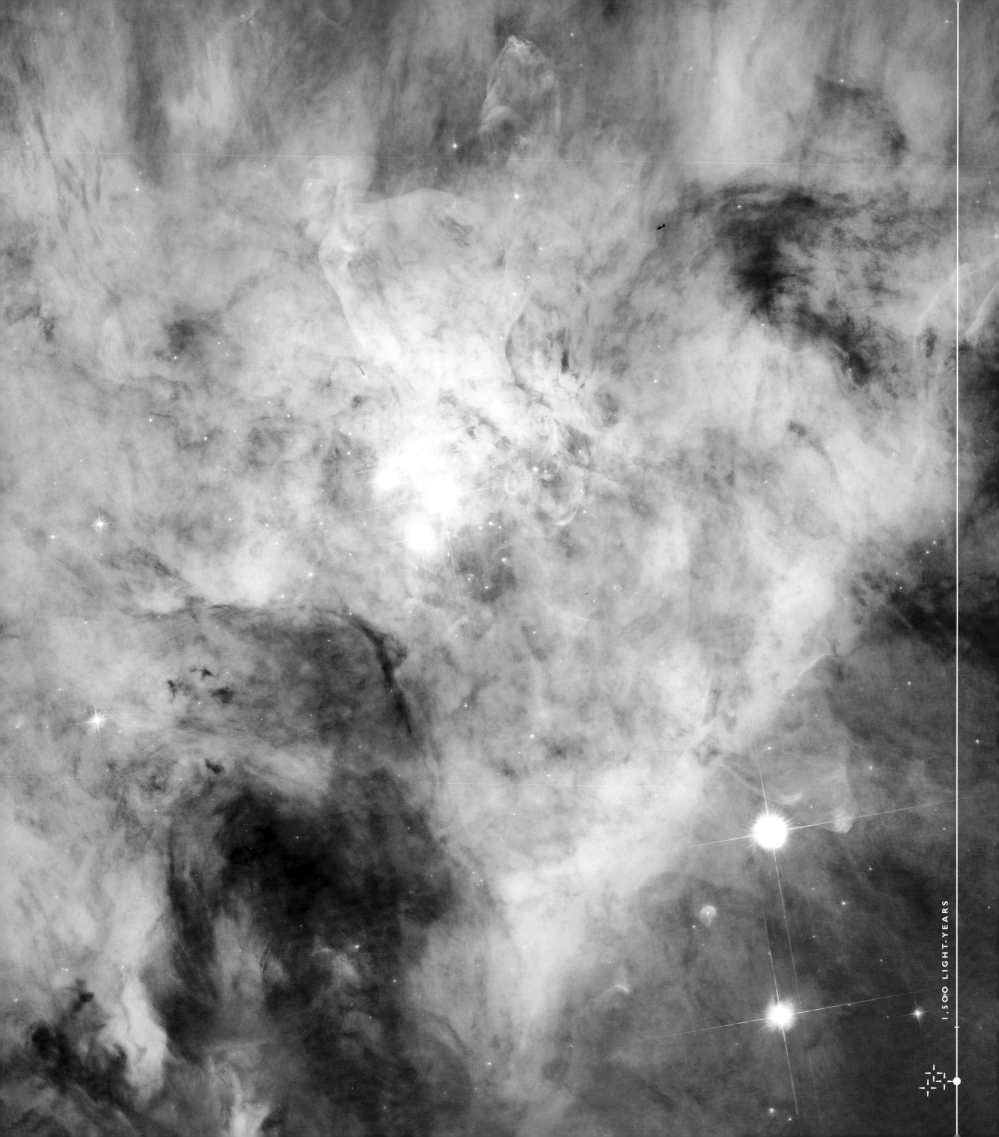

SAVING HUBBLE

THE FIRST SERVICING MISSION

The Hubble Space Telescope was the first space observatory designed to be maintained and refurbished in orbit. Besides the modular design of its scientific instruments and Fine Guidance Sensors, many other components of the telescope were Orbital Replacement Units (ORUs), built to be accessible to astronauts on space walks. Following the discovery in June 1990 that the Hubble was hobbled by spherical aberration, astronomers and engineers examined various schemes to fix the problem. Senior NASA managers finally settled on a shuttle mission that would push the limits of maintenance and servicing.

The mission called for astronauts to fly to the HST aboard a space shuttle, don their spacesuits, and install a special optical device called the Corrective Optics Space Telescope Axial Replacement (COSTAR). They would also install the Wide Field/Planetary Camera 2 (WF/PC2) in place of Wide Field/Planetary Camera (WF/PC). To optimize Hubble, astronomers and engineers also pressed for other changes. They wanted to remove the two existing solar arrays and replace them with a new set to fix a problem known as jitter, which on occasion caused the telescope to shake by a tiny but perceptible amount. In the final plan for the mission the astronauts were assigned 11 servicing tasks.

Managers decided that a recordbreaking five spacewalks would be needed, with the capability for an additional two if necessary. The various on-orbit tasks were meticulously rehearsed. The astronauts trained extensively in the Neutral Buoyancy Simulator at the Marshall Space Flight Center in Huntsville, Alabama, a 1.6-million-gallon water tank that contained a full-scale mock-up of the telescope; they also trained in a similar tank at the Johnson Space Center near Houston.

During training at the Goddard Space Flight Center in Greenbelt, Maryland, the astronauts handled the hardware they would carry with them into space. They also practiced virtual-reality computer simulations in order to develop a better sense of what the tasks would entail in space, marking the first time such simulations were used in training for a shuttle mission.

The astronauts rehearsed operations on frictionless floors at the Johnson Space Center in order to simulate working in reduced gravity with the various components they would use in space. Crew members even visited the Smithsonian's National Air and Space Museum in Washington, D.C., to work with the museum's full-size model of the space telescope. Parts of two of the 1993 flights of the shuttles *Endeavour* and *Discovery* were also devoted to evaluating the designs of the tools astronauts would need to service the HST.

When the journey began with the launch of the shuttle *Endeavour* from Cape Canaveral at 4:27 p.m. EST on December 2, 1993, it was one of the most eagerly anticipated missions in the history of human spaceflight. Once in space, *Endeavour* pursued the ailing telescope for several orbits before rendezvousing with the HST.

The astronauts captured the observatory and placed it in the cargo bay. Because the Hubble was designed to be serviced in orbit, features such as handrails and foot restraints were built in to the telescope. These features would aid astronauts performing repairs in the cargo bay as the shuttle orbited Earth at 17,500 miles an hour. Three of *Endeavour*'s astronauts assisted from inside the orbiter; the other four performed a series of space walks over the course of several days.

The complex mission went almost flawlessly. The spacewalks took place in public view, made possible by broadband television feeds from orbit. When images from the repaired HST began to be returned to Earth, all concerned could see that the repairs had worked. The Hubble's vision problem had been corrected.

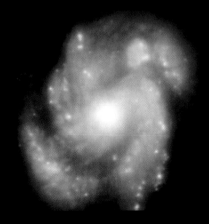
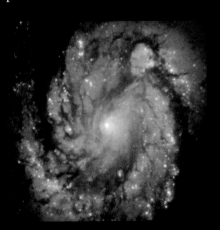

SPIRAL GALAXY M100 BEFORE AND AFTER FIRST HUBBLE SERVICING MISSION (1993) The image on the left shows the central regions of galaxy M100 as taken by the Wide Field/Planetary Camera on November 27, 1993, a few days before the space shuttle *Discovery* was due to visit the Hubble. The image on the right, made after servicing on December 31, 1993, was taken by the Wide Field/Planetary Camera 2. The improvement in image quality and in Hubble's resolving power is dramatic. M100 is one of many galaxies in the Virgo cluster of galaxies and is located some 56 million light-years away.

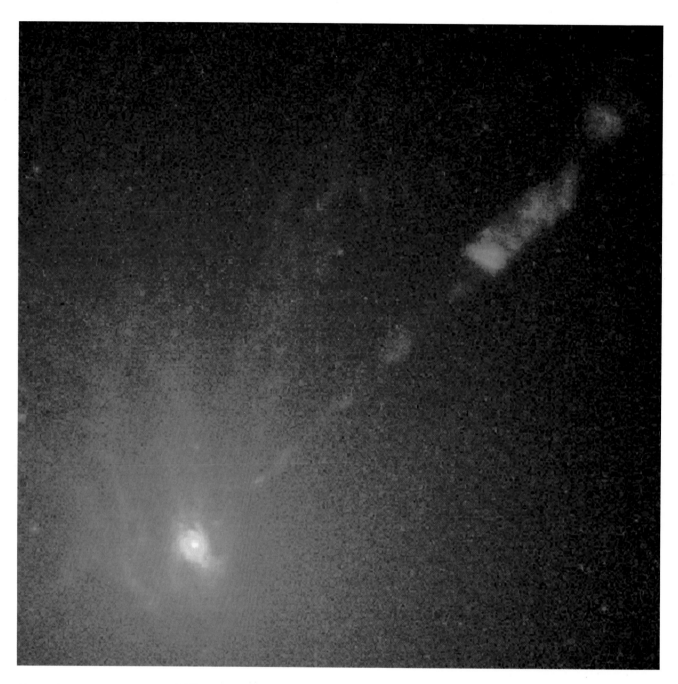

Above: **GALAXY M87 (1994)** M87 is a giant elliptical galaxy some 60 million light-years distant. Astronomers have known for decades that it has a bright, peculiar, and very long (around 5,000 light-years) jet emerging from its center. The image above, secured with the WF/PC2, surprised astronomers by revealing a spiral-like structure at the very heart of the galaxy. *Opposite:* **CORE OF M87 (1991)** This WF/PC image shows the galaxy's central core as well as the jet. The faint and starlike points of light that surround the core are not single stars but great balls of stars, known as globular clusters, that each contain 100,000 to one million stars. Hubble also measured the speeds of the gas rotating around the center of the galaxy. Combined with the images, these data led astronomers to conclude there was a massive black hole at the galaxy's center. It contains a mass equal to as much as three billion times that of the sun, concentrated into a space no bigger than the solar system.

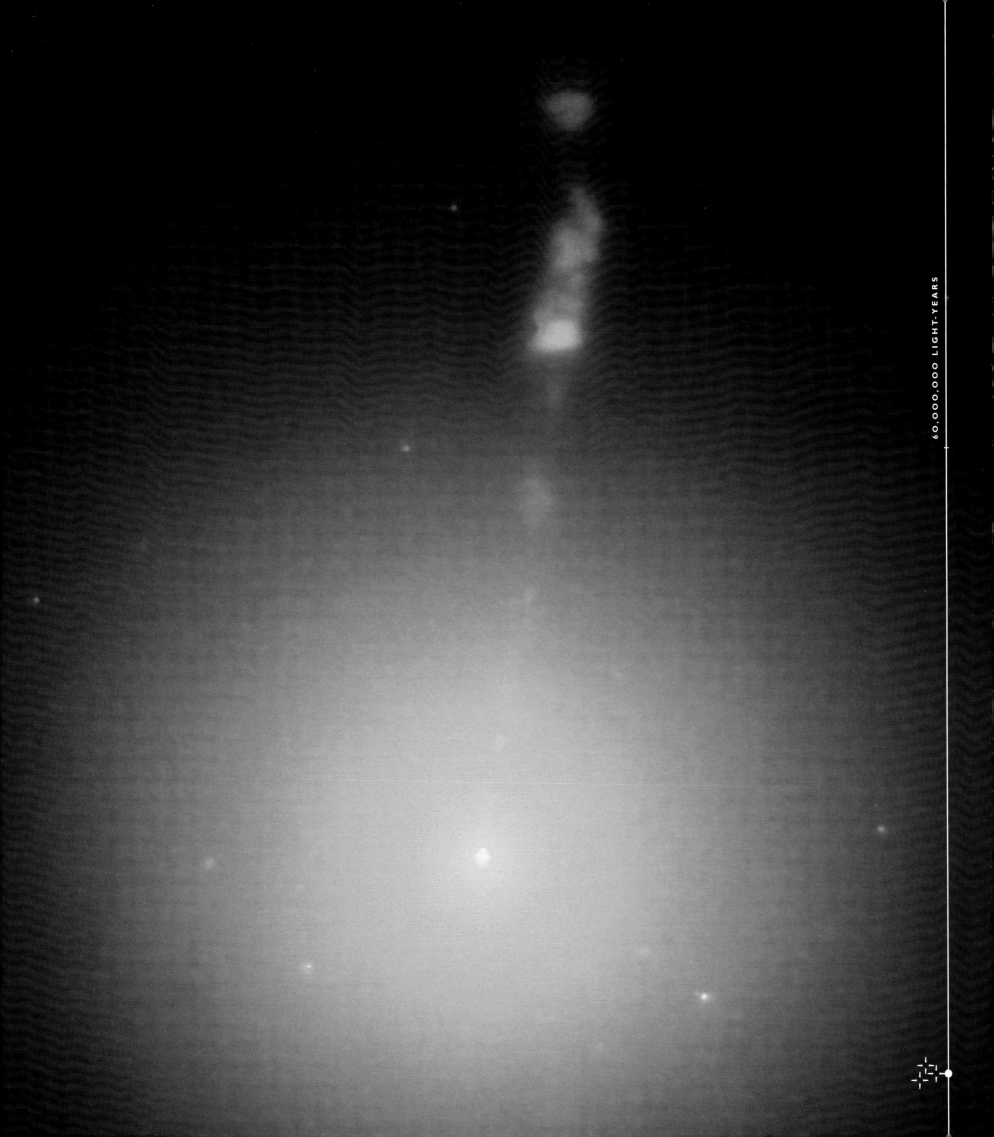

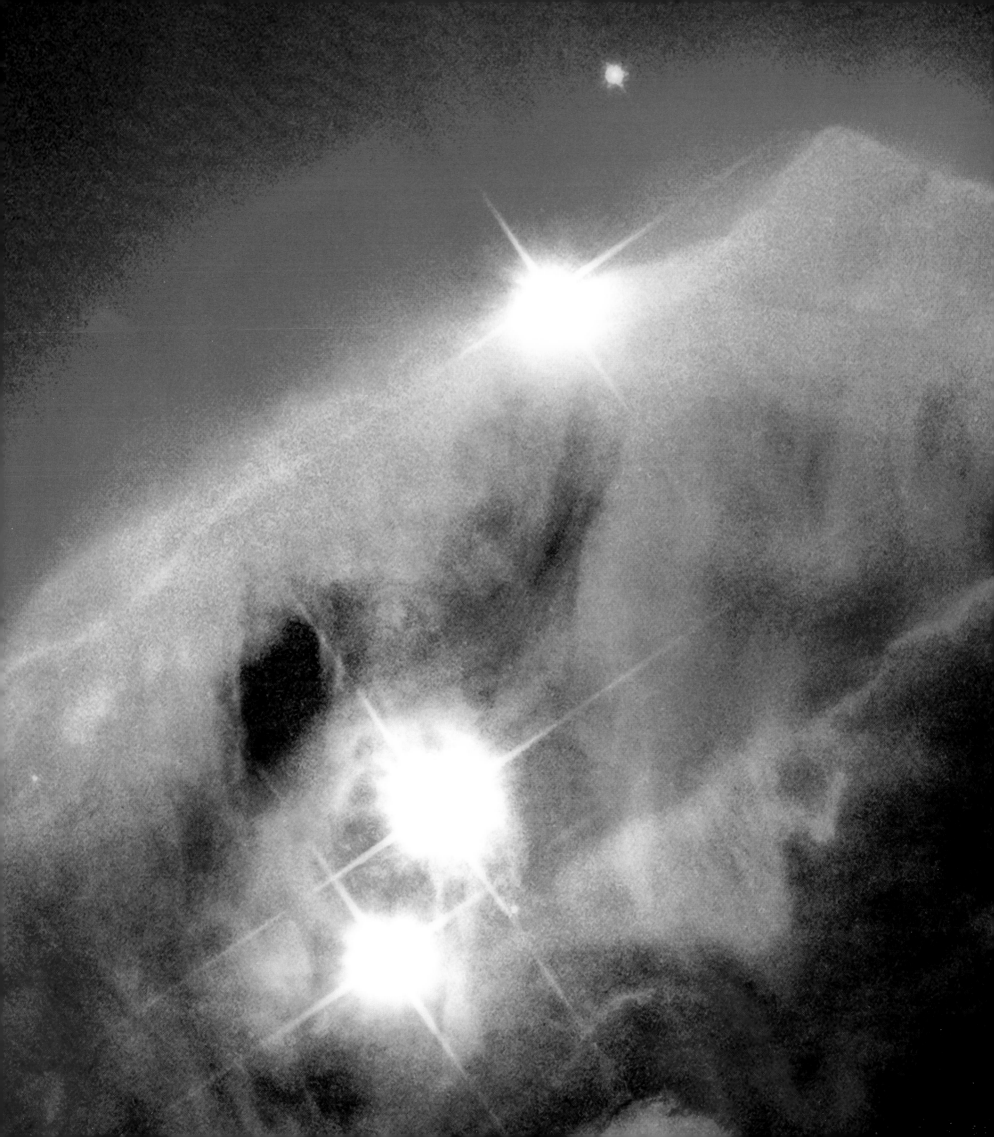

Opposite: **ACS IMAGE OF UPPER PART OF CONE NEBULA (2002)** The Cone Nebula, some 2,700 light-years away in the constellation Monoceros, is so-called because of the distinctive shape of its roughly seven-light-year-long dusty pillar. The image comes from the Advanced Camera for Surveys that was inserted into the Hubble during the 2002 servicing mission. *Above:* **NICMOS IMAGE OF UPPER PART OF CONE NEBULA (2002)** The Hubble Space Telescope's Near Infrared Camera and Multi-Object Spectrometer (NICMOS) was restored to operations by the 2002 shuttle servicing mission. The NICMOS detects near-infrared light, which means that, unlike other Hubble instruments, its gaze can penetrate deeply into layers of dust in star-forming clouds. The NICMOS was able to see through the layers of dust that obscure the nebula's inner region, giving it a more three-dimensional feel than the ACS image.

2,700 LIGHT-YEARS

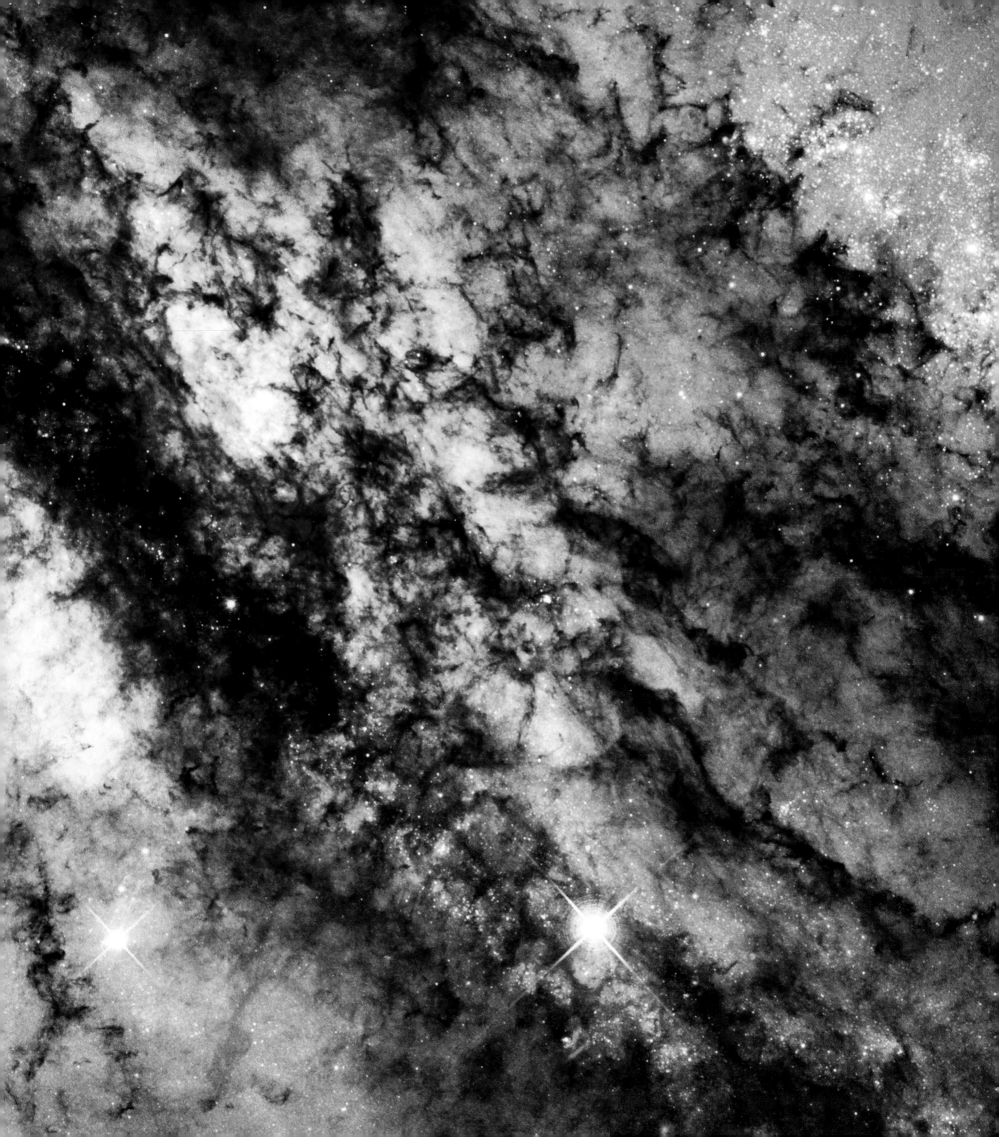

GALAXY CENTAURUS A (2010) Some 11 million light-years from Earth, Centaurus A is the galaxy closest to Earth with an active nucleus. An extremely massive black hole lurks at its center and spews gas out into space at high speeds in the form of jets.

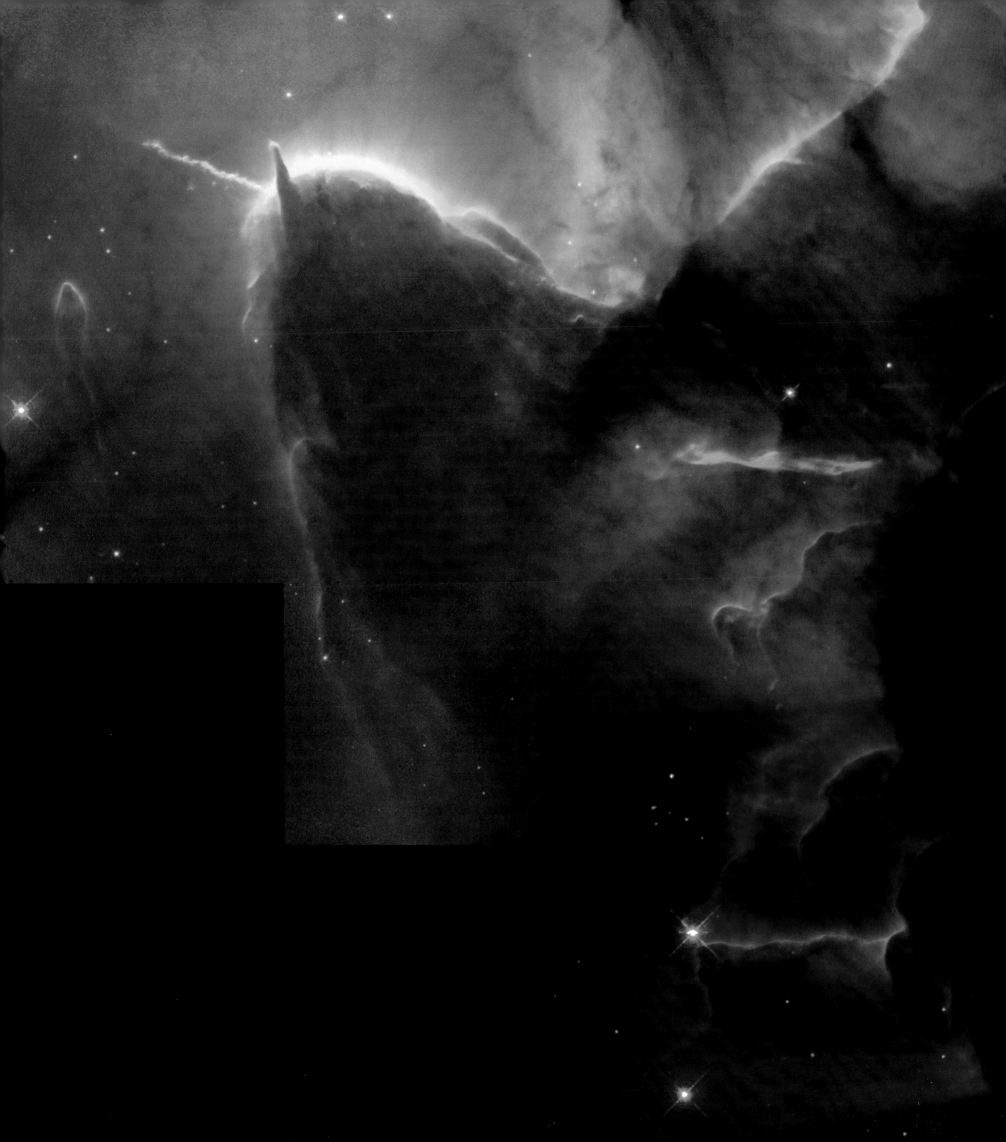

Above: **TRIFID NEBULA, GROUND-BASED VIEW (1999)** Located possibly as far away as 9,000 light-years from Earth in the constellation Sagittarius, the nebula is famous for its odd three-lobed appearance. *Opposite:* **TRIFID NEBULA, HUBBLE VIEW (1999)** Hubble's WF/PC2 captured this view of the portion of the nebula marked in the image above. Dominating the image is what looks like a dark mountain—in reality, a dense cloud of dust and gas. Deep within the cloud, new stars are forming. Evidence for the presence of one such very young star comes from the corkscrew-shaped stellar jet emerging from the tip of the mountain, caused by the star within. Next to the corkscrew is a fingerlike column of gas, one of the evaporating gaseous globules (EGGs) made famous by Hubble. The Trifid Nebula, however, is under threat from a nearby massive star (not visible, positioned above this image). Eventually, the intense radiation from that star will destroy this stellar incubator.

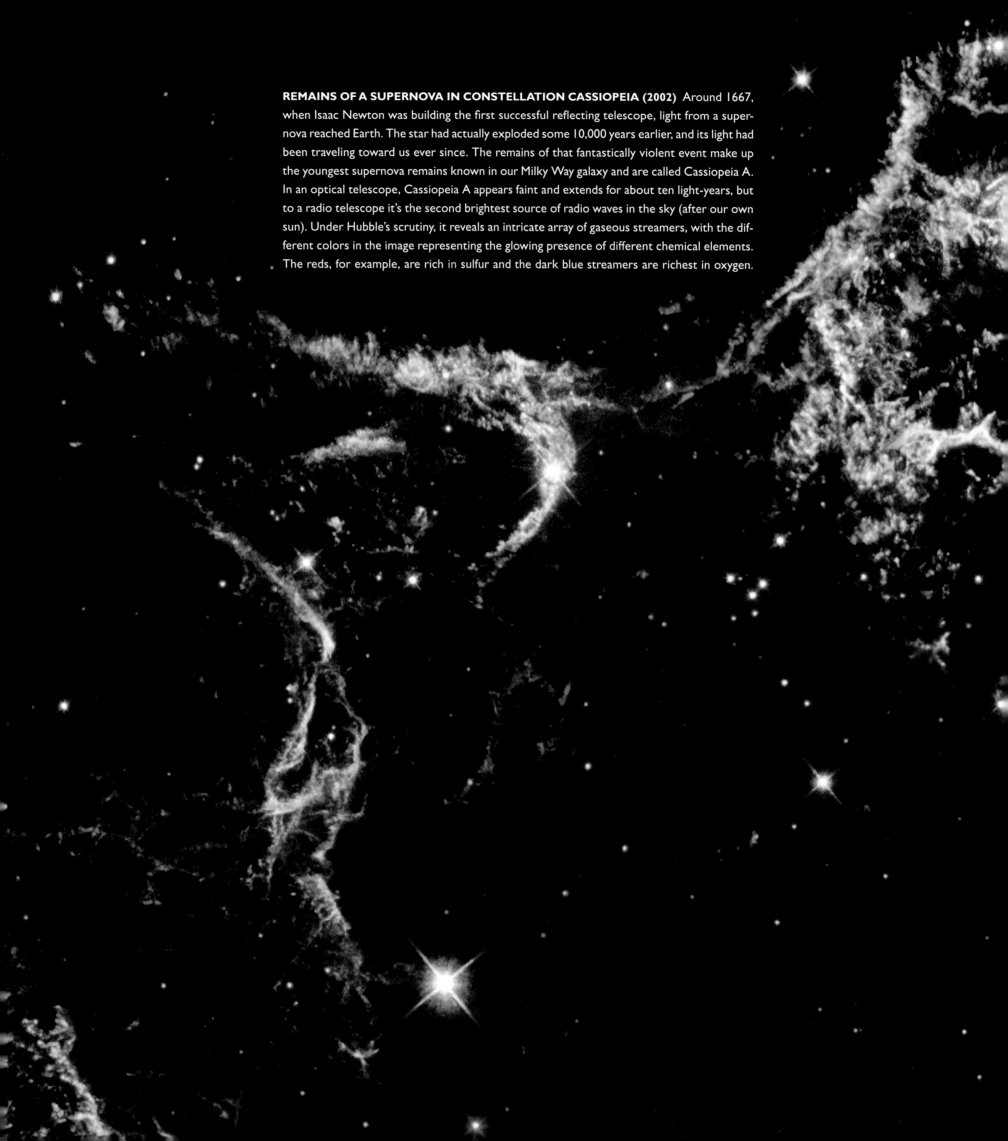

REMAINS OF A SUPERNOVA IN CONSTELLATION CASSIOPEIA (2002) Around 1667, when Isaac Newton was building the first successful reflecting telescope, light from a supernova reached Earth. The star had actually exploded some 10,000 years earlier, and its light had been traveling toward us ever since. The remains of that fantastically violent event make up the youngest supernova remains known in our Milky Way galaxy and are called Cassiopeia A. In an optical telescope, Cassiopeia A appears faint and extends for about ten light-years, but to a radio telescope it's the second brightest source of radio waves in the sky (after our own sun). Under Hubble's scrutiny, it reveals an intricate array of gaseous streamers, with the different colors in the image representing the glowing presence of different chemical elements. The reds, for example, are rich in sulfur and the dark blue streamers are richest in oxygen.

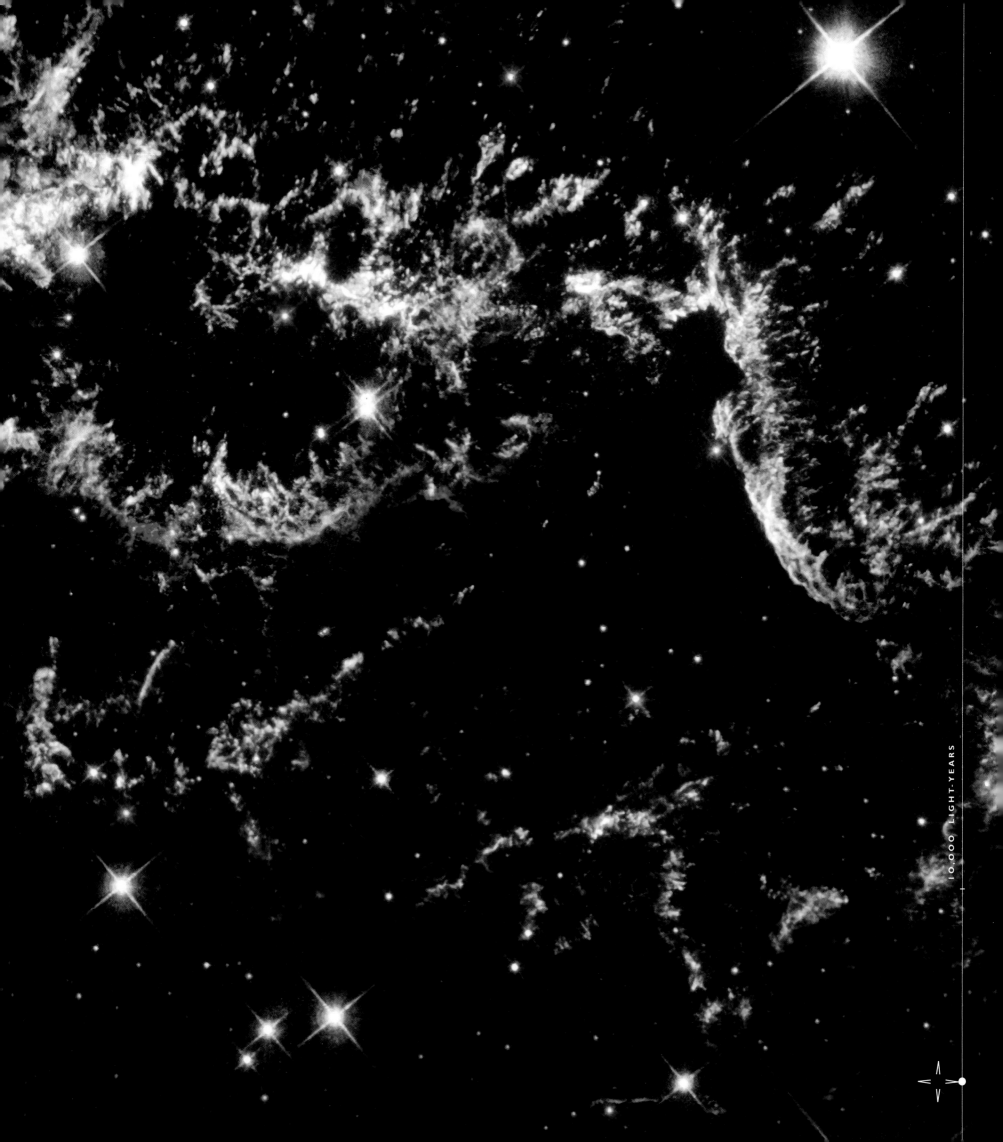

10,000 LIGHT-YEARS

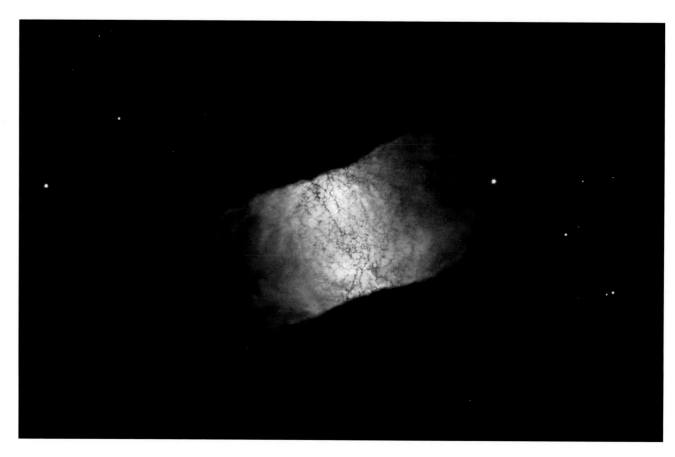

RETINA NEBULA IN BLACK AND WHITE (2002) Secured with Hubble's WF/PC2, this image is a black-and-white version of the color image opposite. The Retina Nebula, some 1,900 light-years away, is one of approximately 1,600 planetary nebulae known in our own galaxy. Planetary nebulae were misleadingly named in the 18th century: They have nothing to do with planets, but are instead made of luminous shells of gas expelled by old, pulsating red giant stars. The ejected material leaves behind a very hot core with a surface temperature of around 100,000 K. The stellar core—which is now in effect a dying star—radiates ultraviolet light, some of which is absorbed by the ejected material, causing it to glow.

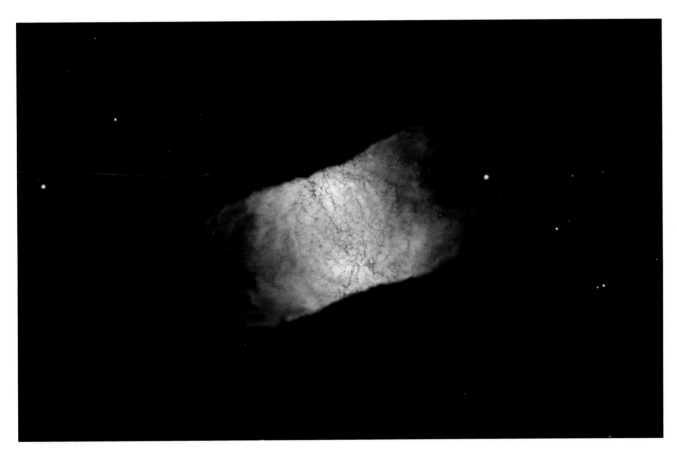

RETINA NEBULA IN COLOR (2002) The color image has been designed to make it easier to see the apparently delicate tendrils and streamers of dark dust lanes that crisscross the center of the nebula. These dark lanes are roughly 160 astronomical units (AU) wide (one AU is the mean Earth-sun distance, about 93 million miles). In this image, light from oxygen is shown as blue, hydrogen is green, and nitrogen red. As is common for planetary nebulae, the left and right halves of the nebula are nearly symmetrical. If Hubble could be miraculously transported above the nebula instead of viewing it from the side, we'd see that the nebula is in fact composed of a huge donut-shaped cloud of gas and dust.

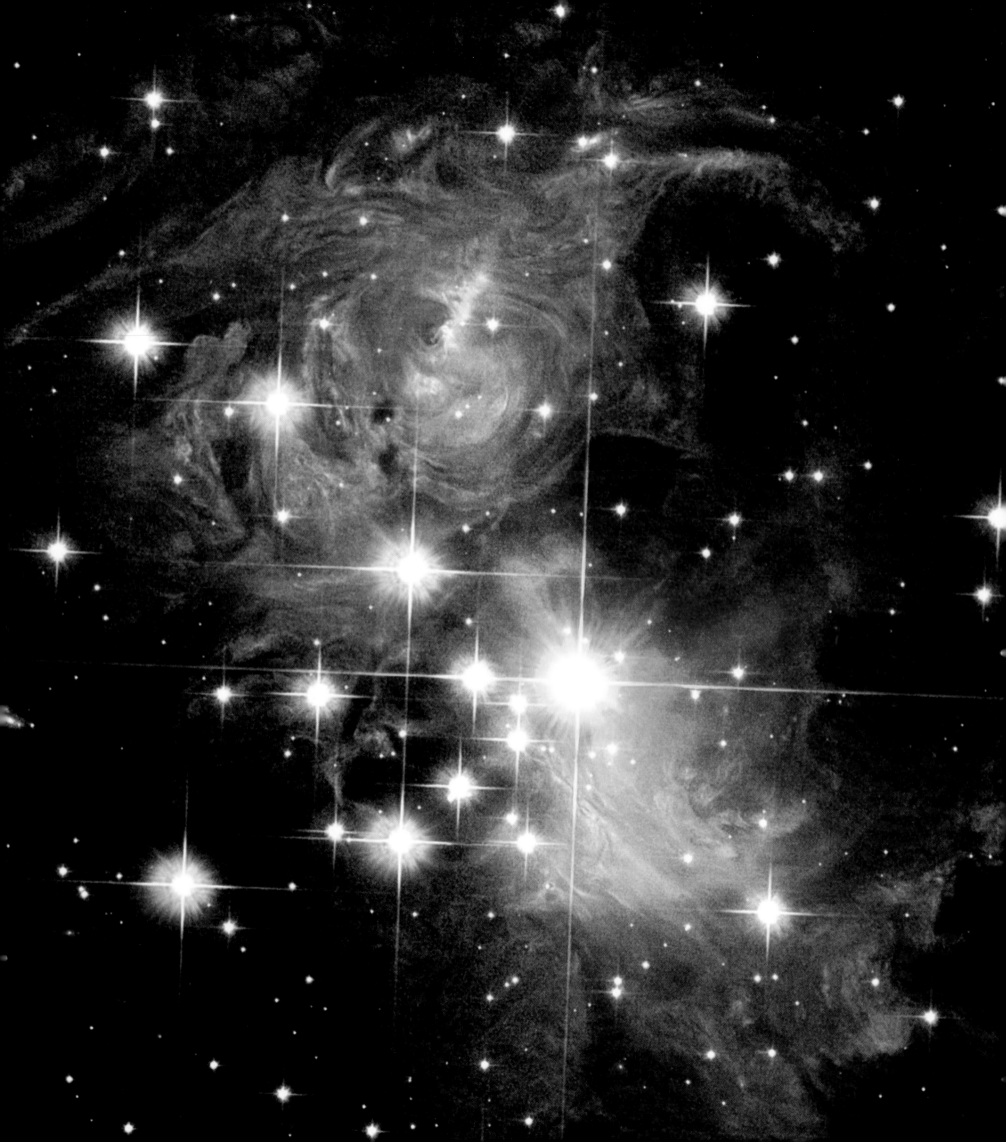

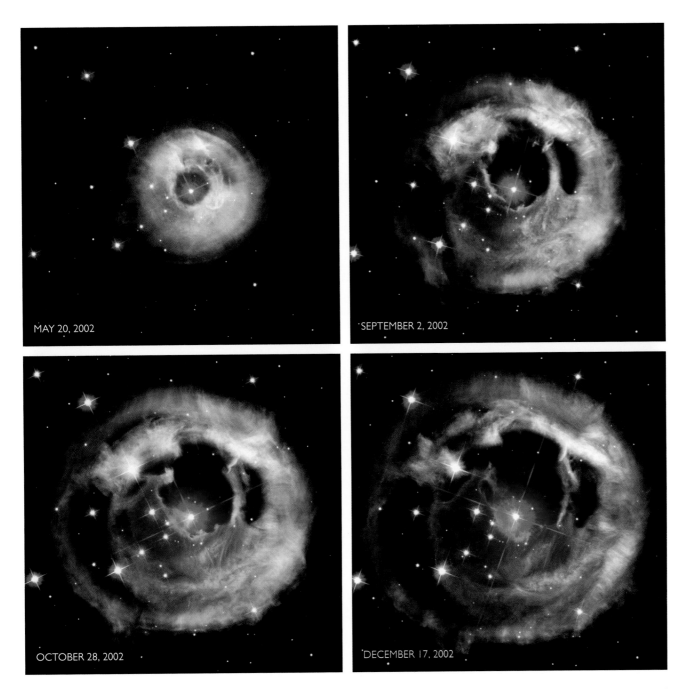

MAY 20, 2002

SEPTEMBER 2, 2002

OCTOBER 28, 2002

DECEMBER 17, 2002

Above: **LIGHT ECHO AROUND V838 MONOCEROTIS (2002)** About 20,000 light-years from Earth is the variable star known as V838 Monocerotis, with the V838 indicating it is the 838th variable star in the faint constellation Monoceros. In January 2002, the star suddenly increased in brightness to become briefly about 600,000 times more luminous than our sun. At first, astronomers believed the star was a typical nova, a violent event in which a star explosively expels its outer layers. However, this interpretation was soon dropped when V838 Monocerotis's outburst was accompanied by an enormous increase in the star's size. Like light from a huge exploding flashbulb, the star's spherical light blast illuminated a large intervening cloud of dust. As the light blast front reached the dust, it "echoed" (or was reflected) off the dust and the intersection grew through the cloud, apparently faster than the speed of light. The images above, taken between May and December 2002, show the emerging circular intersection between the blast wave and the intervening cloud. Because the light scattered from the dust had slightly farther to travel, it reached Earth after the light from the original outburst. *Opposite:* **LIGHT ECHO AROUND V838 MONOCEROTIS (2006)** A more recent image shows light continuing to move outward through the dust cloud.

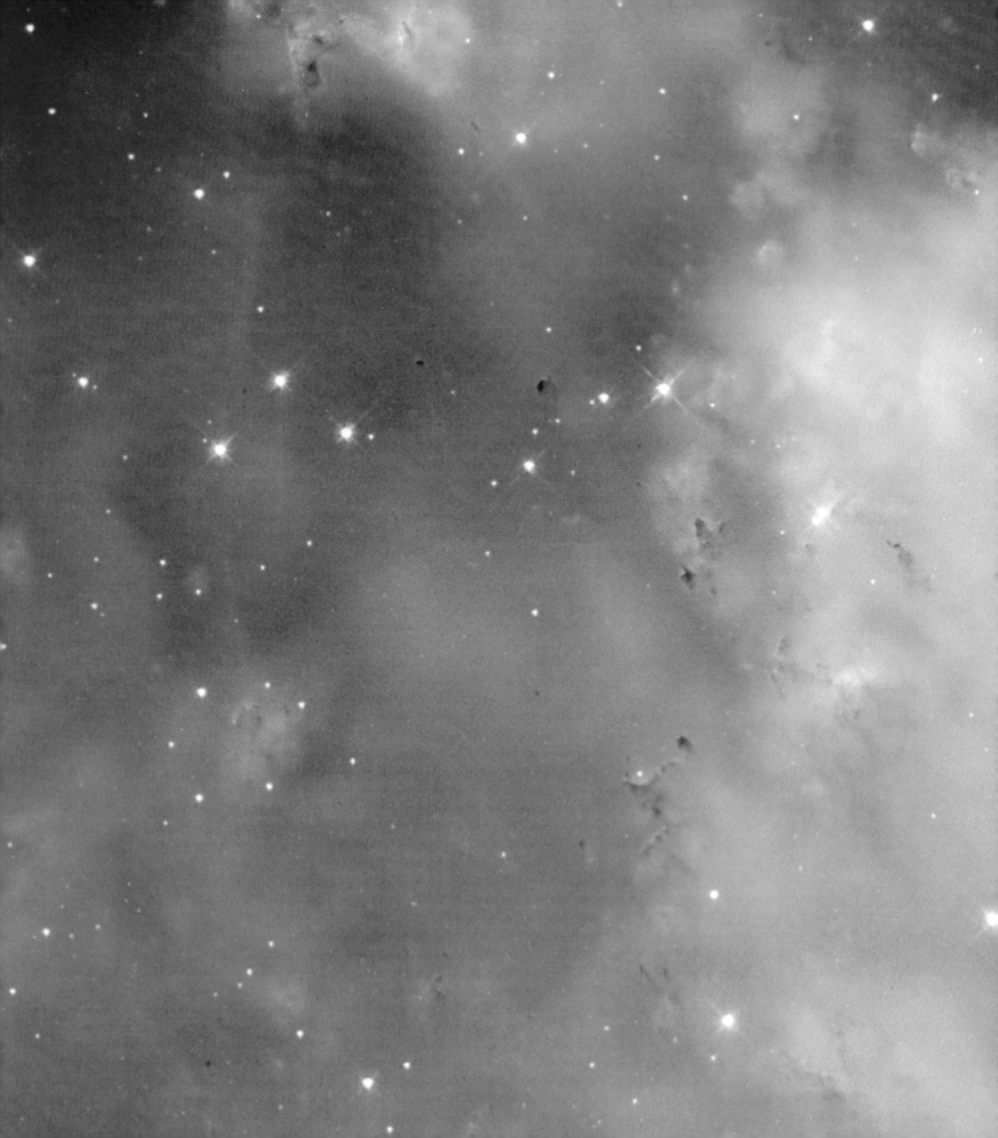

DETAIL FROM THE DUMBBELL NEBULA (2001) The Dumbbell Nebula, a bright planetary nebula in the constellation Vulpecula, is about 1,200 light-years from Earth. Seen as a whole, the nebula resembles a dumbbell, though from Earth it is too faint to be seen by the naked eye. This is nevertheless the easiest planetary nebula for backyard astronomers to observe. Perhaps the Dumbbell is also giving us a glimpse of the sun's distant future, as this is the type of nebula our own sun is expected to produce when nuclear fusion reactions halt in its core. In this WF/PC2 image, many knots of gas and dust are visible, their sizes ranging from 11 to 35 billion miles. across. Hubble has observed such knots in all the relatively nearby planetary nebulae; they might be a feature common to all planetaries.

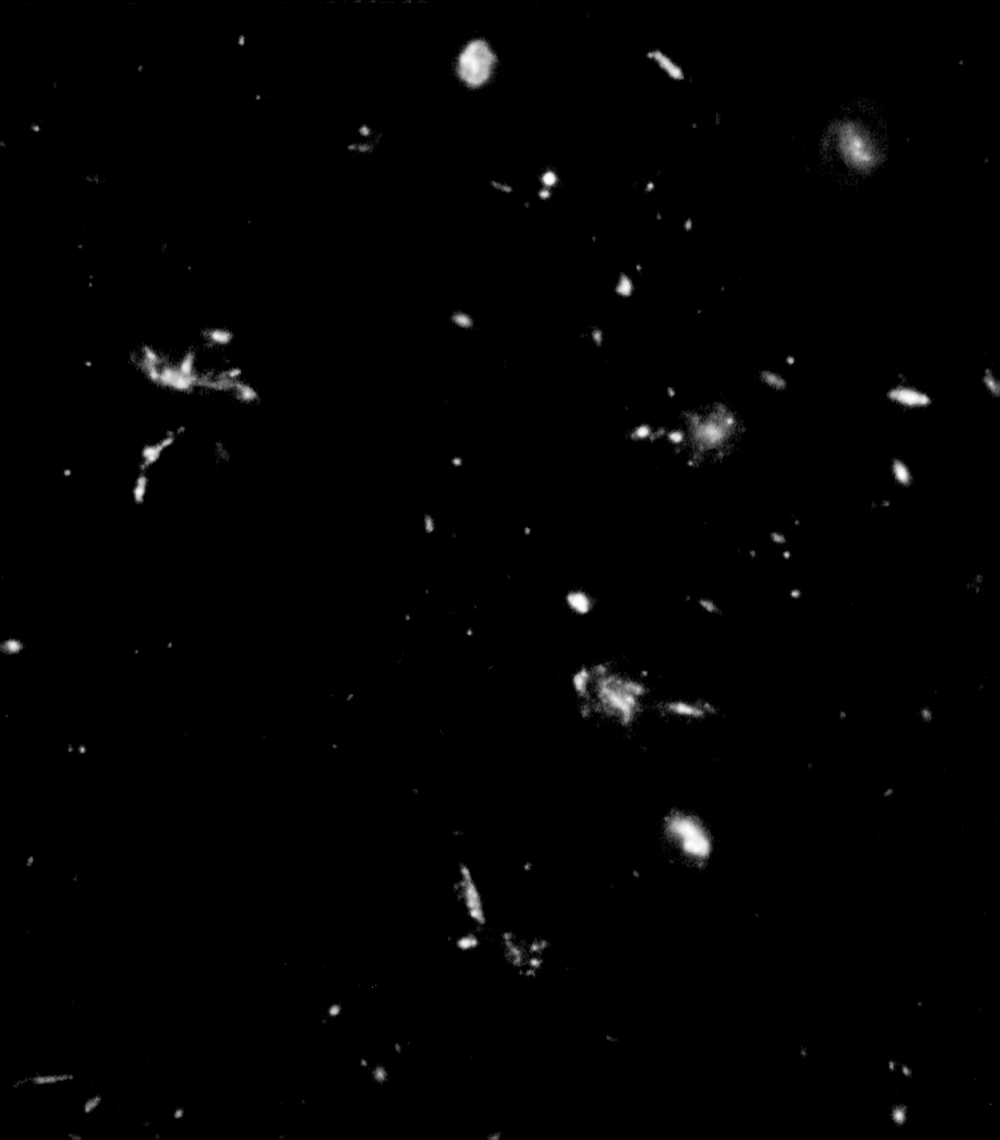

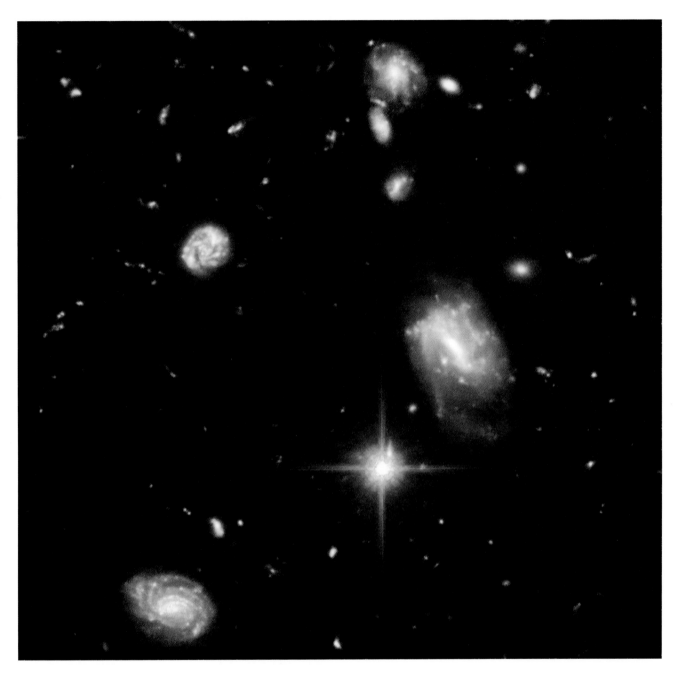

GALAXIES AT THE EDGE OF THE VISIBLE UNIVERSE (2004)
Between September 24, 2003, and January 16, 2004, the Hubble Space Telescope embarked on a journey to the very deepest reaches of the universe. During this period, the Hubble took a long series of exposures of one very small area of the sky in the constellation Fornax. The Hubble was directed at this target over the course of 400 orbits for a total exposure of around 36,000 seconds. The result was the Hubble Ultra Deep Field, celebrated as "the deepest portrait of the visible universe ever achieved by humankind." The images above and opposite both show small sections of the Ultra Deep Field. The image opposite illustrates the results of many close encounters between galaxies that distorted their original forms. In total, the Ultra Deep Field contains around 10,000 galaxies. It includes some so distant that they emitted the light we are seeing here about 800 million years after the Big Bang, meaning that it has been travelling toward us for around 13 billion years.

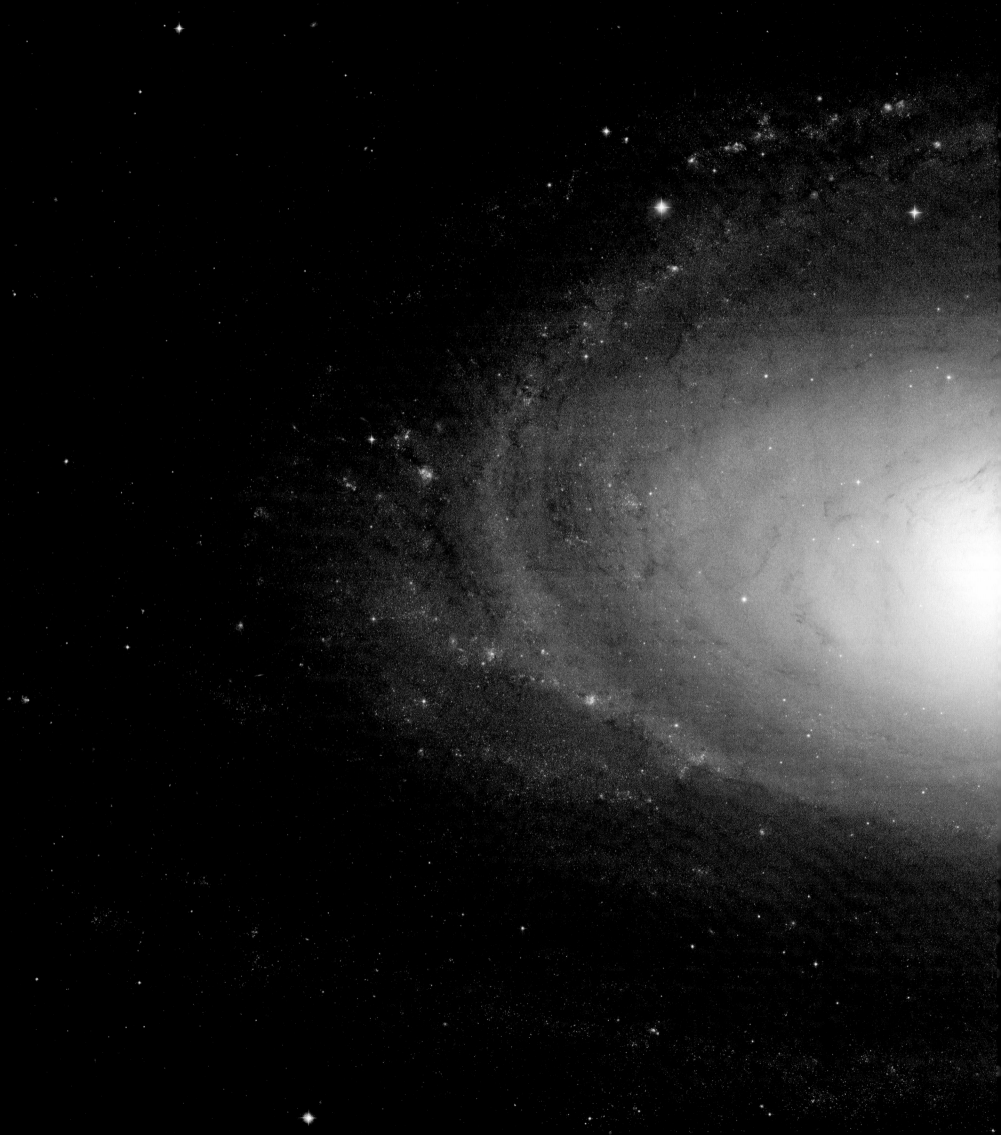

CHAPTER 4

OBSERVING WITH HUBBLE

Since the 1980s, Nicholas Zabriskie Scoville had been interested in how stars form in the spiral arms of galaxies. Now a Caltech astronomer, he had used radio telescopes in Massachusetts and the Owens Valley in California to study the behavior of giant molecular clouds in both the radio and infrared regions of the spectrum. By the mid-1990s, he decided to study the distribution of hot hydrogen gas surrounding very hot stars in the central portions of spiral galaxies. The Whirlpool galaxy (known as M51) became his primary target.

He assembled a team of like-minded colleagues, including Maria Poletta from the University of Geneva; Sean Ewald and Susan R. Stolovy, staff members at Caltech; and Rodger Thompson and Marcia Rieke, two astronomers from the Steward Observatory in Tucson, Arizona. Thompson was principal investigator for the Near Infrared Camera and Multi-Object Spectrometer (NICMOS), which would be placed on the Hubble in the second servicing mission in February 1997, and Rieke was also very active in the building of the NICMOS. In the spring of 1996 the team applied to the Space Telescope Science Institute (STScI) for telescope time as a General Observer, or GO, to explore the spiral structure and formation of the

hottest stars in M51. They wanted to produce high-resolution images in both broad and narrow ranges of the visual and infrared spectrum, which would reveal the structure of dust lanes within the spiral arms. Members of Scoville's team also proposed to observe the Whirlpool with the NICMOS. Since they were members of the instrument team, the scientists were allotted two

observing runs as Guaranteed Time Observers, or GTOs.

The astronomers were fascinated by the larger problem of what triggers the formation of stars in active galaxies such as the Whirlpool. Scoville regarded the Whirlpool—a comparatively close galaxy—as a "Rosetta Stone" for such work: Its face-on orientation reveals its spectacular spiral pattern, and the amount of gas and dust lurking within its magnificent arms provides ample material to make new stars. The gas and dust itself is a mix of the original stuff that formed the galaxy, plus younger materials formed in the hearts of massive stars that have already lived and died in the galaxy's history. "From these ashes," Scoville later stated, "the future generations of stars will arise."

Nick Scoville's proposal was certainly intriguing, and he and his team had the combined experience and

Preceding pages: **SPIRAL GALAXY, M81 (2007)** The "grand design" spiral galaxy M81 is a beautiful example of a spiral where a few arms dominate. This image is a composite of exposures made with blue, visible, and infrared filters in the Advanced Camera for Surveys (ACS) between 2004 and 2006. Opposite: **WHIRLPOOL GALAXY, M51 (2000)** M51 is the prototype spiral photographed by all new major optical telescopes in the Northern Hemisphere. Its face-on orientation makes it an excellent choice for studying star formation. This five-color composite image was taken with a 0.9-meter telescope from Kitt Peak National Observatory near Tucson, Arizona.

31,000,000 LIGHT-YEARS

know-how to make an effective run. But this is the case with the vast majority of observation proposals, and only a fraction are accepted. How was it, then, that the Hubble Space Telescope (HST) was pointed toward M51 to catch those red photons on July 21, 1999, at 4:30 in the morning? The key in getting Hubble observing time is persuading the granters that the goals of the proposal are worth the sacrifice of other potential goals. For every individual or team that succeeds in getting a run, many others are left without the use of Hubble's eyes. Scoville's team would win this battle, but would have to wait two years for the privilege of a run.

One factor aiding the decision over who gets an observing run is the general value of the data, beyond the specific uses the proposers may have. Ultimately, from this observing run, a contribution will be made to the Hubble Data Archive, which serves as the repository for collected data. In this manner, the data gathered will be of use to astronomy long after Scoville's team has completed its analysis.

THE PROPOSALS

The Space Telescope Science Institute regularly asks astronomers to submit proposals for using the telescope. Each time such a call is issued it starts a new annual observing cycle. There are two phases to the proposal process. In Scoville's case, he knew that his team's Phase I proposal was due at the Institute by September of 1996. In order to convince peer reviewers that the request justified the use of the HST, the scientists needed to fashion as strong a case as they could for the scientific importance of their planned observations. Scoville's team also had to predict reasonably well

how much observing time, measured by the required number of telescope orbits around Earth, would be needed by one of the Hubble's instruments to meet their goals.

The team's first hurdle was to gain the approval and support of a Proposal Review Panel (PRP), eight astronomers who convene at regular intervals at the STScI to examine proposals in a particular specialty, such as galaxies and clusters of galaxies, hot stars, cool stars, the interstellar medium, or solar system objects. The chairs of each PRP then carry their reports to a second-tier review group called the Time Allocation Committee (TAC). The TAC for Cycle 7 met on three days in late November 1996. At the end of December, Scoville and his team found out that they had secured 280 minutes—almost three orbits' worth—of precious HST observing time with the WF/PC2.

The reward for those who survived the Phase I competition was to provide a far more detailed proposal to the STScI two months later. Now the team, with the assistance of Institute staff, had to identify specific requirements for virtually every second of the observing run. The Institute staff would then translate Scoville's proposal into a libretto that would identify every step in the process: locating the guide stars that would direct the Hubble to the different portions of the Whirlpool galaxy that he hoped to record, calculating the required exposure times, determining the order of the filters they would observe with, and planning the most efficient ways to process the data.

Each exposure with the Hubble Space Telescope has to be meticulously planned, as there are limits to where the telescope can be pointed at any particular time. This is usually done by taking the coordinates of the objects the

observer wants to study and entering them into a computer program that includes the orbital whereabouts of the HST, the Tracking and Data Relay Satellite System (TDRSS) that forms a link between Hubble and the ground, the Earth, the sun, and the moon. The program then develops a detailed schedule that helps the telescope staff plan out every step of the observing run. This preparation lies at the heart of a Phase II proposal.

The observatory must work within certain physical limits. The Hubble Space Telescope is in low Earth orbit, only about 375 miles above its surface, not even in true space. At this altitude, the HST completes an orbit every 97 minutes at a speed of 17,500 miles an hour. No matter what, it must never be pointed toward, or even near, the extremely brilliant sun. The sun is so bright that in normal operations the HST rarely looks closer than 50 degrees in its direction. If direct sunlight fell on its incredibly sensitive light detectors the results would be disastrous for its future operations. Hence, if the Hubble drifts to within 20 degrees of the sun, it shuts its aperture door so that no light can enter the telescope tube. Plus, there are parts of the orbit where intense magnetic fields require that the telescope partially shut down to avoid damaging the sensitive detectors and other electronic components.

While the optics of the telescope must always avoid the sun, its housekeeping elements, such as the solar panels that generate the power the telescope requires, actually need the sun. Also, two radio antennae on the Hubble Space Telescope must always be able to connect with the TDRSS in higher Earth orbit, or with one or more ground stations.

Astronomers today spend very little time actually looking through telescopes. No longer do they work in darkness with a huge, slow-moving apparatus. Computers, video technology, and remote-control systems automate observing routines using electronic recording, spectroscopy, and photometry, turning telescopes into robots. Instead of braving the frigid night air, astronomers now typically sit in secure, lighted and heated offices at the observatory, or even at home. And it makes little difference where the telescope is located: in the next building, around the world, in low Earth orbit (like the HST) or even 23,000 miles overhead in Earth-synchronous orbit. Observing today is also a far more efficient process. Short visits to the telescope, called observing runs, have replaced unending observing seasons.

An observing run on the HST is usually a fully automatic, programmed process. For this reason, once the observing schedule is established, almost endless little details have to be thrashed out ahead of embarking on the actual observations. Anywhere up to a dozen observing projects may be contained in one set of commands, so the program combines them into a seamless continuum with the aim of wasting as little time as possible in shifting the telescope to new parts of the sky after one set of observations is finished. The fewer seconds wasted, the more time that can be spent observing astronomical targets.

One crucial task is choosing the best stars to guide the telescope. These must be identified well ahead of time and their positions carefully programmed into the observing schedule. They should be bright enough for the Fine Guidance Sensors to lock onto, but not so bright that they do not allow for sensitive adjustments to be made in the telescope's position. These guide stars have to fit within well-defined arc-shaped regions called pickles in the Hubble's field of view. Guide stars are found using a giant digital sky survey maintained at the Institute, based upon the classic Palomar Sky Survey. The HST pointing system requires star positions to be accurate to 0.3 arc second, or more than 6,000 times smaller than the disk of the full moon.

The observing schedule is complete when the guide-star fields are selected and exposure times calculated. This information is then entered into the Institute's Science Planning and Scheduling System, and eventually the actual sequence of commands is stored in the HST's onboard computer.

THE WONDERS OF M51

As Hubble completed a series of calibration tasks for the charge-coupled device (CCD) chips in the Space Telescope Imaging Spectrograph (STIS), it was also preparing for its next program, slowly moving toward the location of the Whirlpool galaxy, an area within the arc defined by the handle of the Big Dipper known as Canes Venatici (the Hunting Dogs). Sensitive onboard gyroscopes told the telescope when it was pointed in the right direction, causing counter-rotating reaction wheels to stop the telescope's motion. When the gyros reported that the telescope had reached the correct position, small telescopes called star trackers refined the telescope's position to less than a minute of arc

(1/30th the full moon disk). At this stage, the Hubble was ready to acquire the object field and the guide stars. Once the Fine Guidance Sensors locked on to the right guide stars, tiny adjustments were made and every part of the system reported that all was well. The telescope went into its fine-lock mode and began to explore the Whirlpool in the first hours of July 21, 1999.

During an exposure, astronomers and technicians at the Institute monitor a large bank of computer screens that display real-time data on the performance of the scientific instruments and the environment inside the spacecraft. If streams of raw data downloaded from the HST show anything at all amiss, adjustments can be made in real time if the conditions are right and the operator acts quickly and decisively. One of the most serious concerns is that the telescope may loosen its lock on its guide stars and so on the object being observed—something that can happen any time because the gravitational field of Earth is uneven, its magnetic field creates differential forces, and the tiny amount of residual atmosphere at the height of the telescope can disturb it. Problems arise if the telescope drifts by more than seven ten-thousandths of a second of arc. The flight computer will usually instruct the reaction wheels to compensate, but the process is one that has to be watched closely.

The Hubble had been instructed to take 11 exposures of M51 between 12:58 a.m. and 5:39 a.m. EST, on July 21, observing in six wavelength ranges between the ultraviolet and the near infrared with exposures lasting from 300 seconds up to 1,300 seconds. Whirlpool data were first relayed through one of the satellites of the Tracking and Data Relay Satellite System in geostationary

orbit to a ground station at White Sands in New Mexico, then to the Goddard Space Flight Center, and finally to the Institute for processing.

After traveling to Earth for 30 million years, photons from the Whirlpool galaxy ended their lives on the four CCDs in the WF/PC2. Each CCD reported a data stream including intensities and coordinates that were stored separately, but which astronomers would later combine into a wide-field image of a large portion of the galaxy.

INTERPRETING THE DATA

There are two major steps in bringing the data to the end user: downloading it from the satellite, and calibrating and correcting it for both systematic errors due to the instrument and random errors due to momentary peculiarities of the space environment. Data archived at the Space Telescope Science Institute are electronically rendered into a standard data format called the Flexible Image Transport System, or FITS, which every astronomer is supposedly able to read and manipulate no matter which scientific instrument produces the data.

An astronomer using FITS can calibrate and edit data, adjust for systematic errors such as the flatness of an image or wavelength calibration, and even subtract background noise. But more sophisticated and comprehensive management of the data requires another level of processing. To meet the challenge, astronomers created a software system called the Image Reduction and Data Analysis Facility, or IRAF. The United States, the U.K. and Europe, Australia, and Japan all adhere to the system, managed by the IRAF programming group housed at the

National Optical Astronomy Observatory home base in Tucson, Arizona. IRAF provides astronomers with a tool to process images and produce graphics as well as a standardized way to analyze all forms of electronic data in the FITS system. Major astronomical instruments, both ground-based and space-based like the Hubble, also have specialized software packages to facilitate the data-processing procedures for the end user.

Armed with high-powered image-processing workstations, Nick Scoville and his team had the know-how to manipulate FITS data using IRAF, which embodies many of the features found in commercial software such as Photoshop. They could cut and paste, crop, flatten, shift, dither, drizzle, or add color to individual images to better reveal how the particular gaseous elements emitting light in that wavelength range are distributed. These techniques can enhance contrast, not only to make various structures visible, but also to retain full control of the information contained in the image.

Each manipulation of an image, however, carries with it some level of interpretation, and requires that the astronomer, through training, talent, and intuition, retain intellectual control of the entire process. Every form of image manipulation has to be justified and rationalized among peers who ultimately arrive at some consensus about what is proper practice and what is out of bounds. Deciding where to draw the line when trying to find the continuum in a noisy spectrum or trying to establish the nature of a light curve of a rapidly varying star takes judgment. These skills with digital images are as central today to astronomical practice as knowing how to properly calibrate and develop a photographic plate was

to astronomers just a generation ago.

Scoville's team first made the separate exposures covering the M51 field fit as neatly as possible into a mosaic, taking care to reduce distortion where they connected. They then subtracted noise and the spurious cosmic-ray tracks that appear on every image but have nothing to do with the objects being scrutinized. Then, they fitted the clean mosaic based upon WF/PC2 data to infrared observations they later secured from the NICMOS. They also added to these archived WF/PC2 data from an earlier observing run by another group of astronomers, led by Holland Ford of the Johns Hopkins University. In fact, Scoville's WF/PC2 images were a supplement to complete what Ford had started in 1995. (By agreement, the data obtained for Principal Investigators remain proprietary for only a year. After that anyone who registers for an account to access astronomical data at the Institute can use them, assuming these researchers have the right computer equipment. All the data from a national astronomical facility become freely available after a set time.) Scoville's goal was to combine all the images from both instruments to better determine the overall spiral structure of the Whirlpool's arms. This structure was defined by the different components of the arms: cold dust clouds and hot, excited hydrogen shells surrounding very hot, young blue stars. These stars more often than not exist in small clusters known as associations, much like the group of brilliant stars lighting up the Orion Nebula in our galaxy. Scoville's group had set out to perform a general reconnaissance of many Orion-type associations in the Whirlpool, doing whatever they could to link individual clusters of hot stars

to their original parent dust clouds. NICMOS infrared images cut through the dust and gas to see the stars still buried within their dense embryonic clouds, providing exact positions for the stars being formed. The WF/PC2 images isolated the excited hydrogen regions and the structure of the gaseous components of the clouds around stars to create an overall structure for the stars, cold dust, and hot gas.

Exploiting the WF/PC2's ability to distinguish very fine details, the team found a new structural element to spiral galaxies. Through being able to resolve structures only 12 to 30 light-years in size in the Whirlpool's arms, rather than the resolution limit of 320 light-years that had limited ground-based telescopes in the past, they found that the famous spiral structure of the Whirlpool was far more complex than

previously imagined. Hundreds of little spurs of dust could be seen branching out from the main arms like twisted Christmas trees. The structure of this dust component helped the astronomers rethink how cold dust was distributed in galaxies like the Whirlpool. Most important, from all the combined data of the WF/PC2 and the NICMOS they were able to fashion a detailed model that describes how regions of star birth migrate not only through the many compact associations they studied, but also through the galaxy itself. In so doing, Scoville and his team contributed to a fuller understanding of the evolution of a galaxy's structure over cosmic time, one of the key problems of contemporary astronomy.

The team submitted its report, "High-Mass, OB Star Formation in M51: Hubble Space Telescope H[alpha] and Pa[schen alpha] Imaging," to *The Astronomical Journal*. They also prepared other scientific papers emphasizing different aspects of their ongoing research. Well before publication of their detailed papers, however, on April 5, 2001, the world saw the results of their effort in a press release from the Institute. The central feature of the release was the best full-color image yet of the Whirlpool, in all its magnificence, using all the data available from the Hubble and adding to it images from a medium-size, ground-based telescope at Kitt Peak National Observatory near Tucson, Arizona. "Hubble and Kitt Peak Take Combined Look into the Heart of a Galaxy" was posted and ran on *Space.com* by 9 a.m. that day. Like other inspiring images from the Hubble, it was picked up by newspapers and weekly magazines and soon became part of the public's new view of the universe.

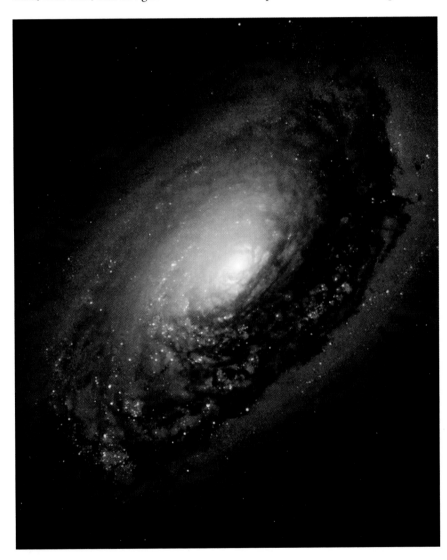

GALAXY M64 (2004) Star formation and spiral forms are often disrupted by collisions between galaxies in different stages of merging. M64 is an example of a well-merged system with a remarkable dust shell. Careful study reveals that there are two distinct systems within the galaxy: In one, stars and gases are moving clockwise, and in the other, gases are moving counterclockwise, creating shear forces that stimulate new star formation.

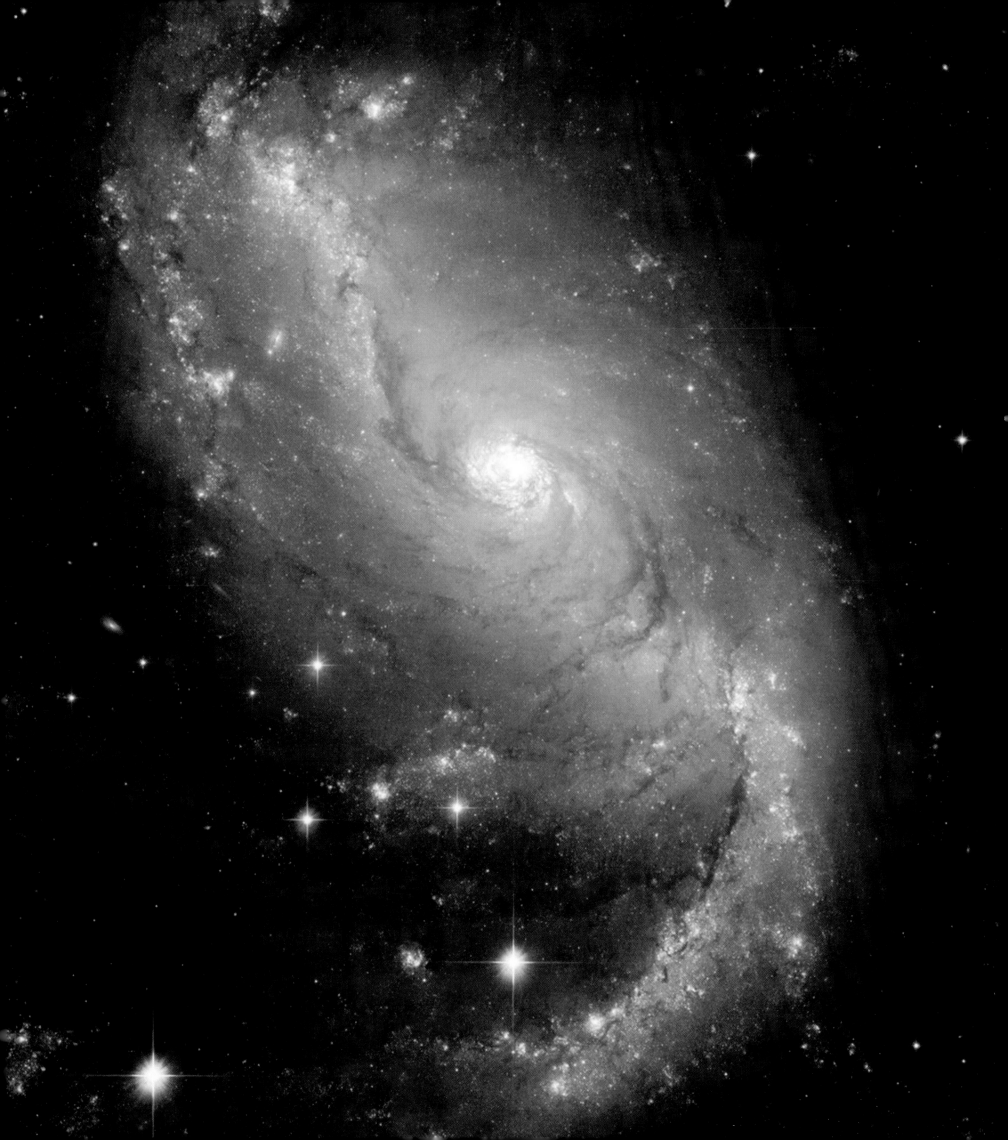

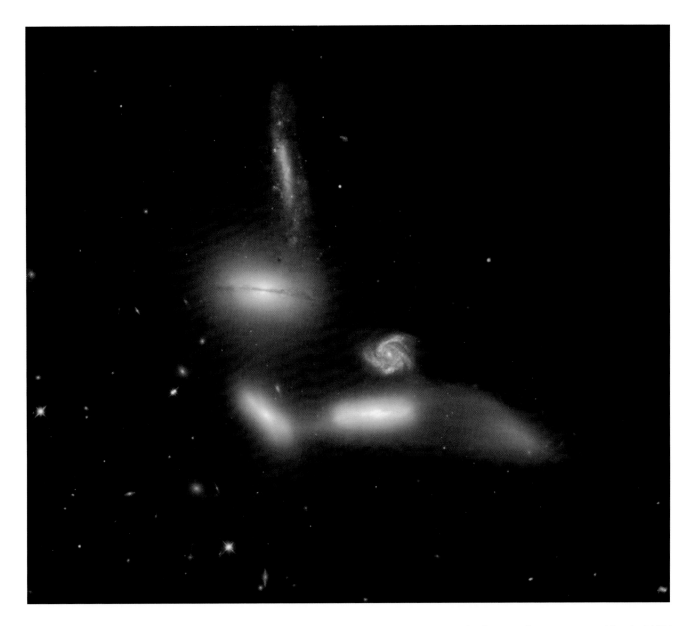

Opposite: **SPIRAL GALAXY NGC 1672 (2005)** The galaxies on these two pages represent variations on the spiral form. The elongated nucleus of NGC 1672, in the constellation Dorado, suggests that it is a barred spiral. It has asymmetrical arms and features strong dust lanes reaching into the nucleus. These define the inner edges of the spiral arms where clusters of young blue stars reside. *Above:* **SEYFERT'S SEXTET**

(2000) This cluster of galaxies in Serpens, imaged by the WF/PC2, was first described by Carl Seyfert in the 1940s. Tidal interactions are clearly taking place among the galaxies, but no merges have yet occurred, explaining the lack of intense star formation. The face-on spiral is a more distant galaxy coincidentally superimposed. It is not engaged in the slow, multibillion-year dance of the others.

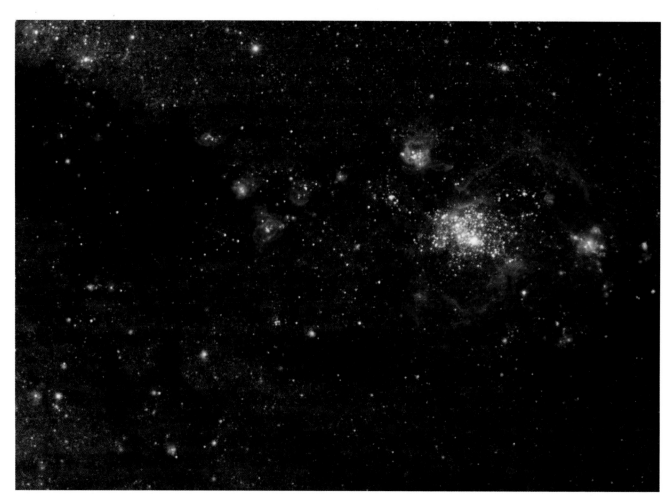

Above: **SPIRAL ARM IN M51 (2005)** Different instruments on the Hubble can examine objects in many different ways. The imaging cameras can provide data that produce close-up views of tiny fractions of the spiral arms of a galaxy, such as this image of a portion of a single spiral arm in M51. Here, intense, blue clusters of hot young stars are illuminating the hydrogen gas clouds in which they are embedded and making them glow red, engaging in the very processes of formation and development studied in 1999 by astronomer Nick Scoville's team on a ga-lactic scale. *Opposite:* **WIDER-FIELD IMAGE OF M51 (2005)** Many images of M51 with the ACS, WF/PC2, and NICMOS have been combined to produce wider-field mosaics. These can reveal the larger processes Scoville and his team study in the Whirlpool's most defining features: its arms. As Scoville and others know, the dust and gas in the arms are being confined and condensed into clusters of new stars. These detailed views are Scoville's "Rosetta Stone" for solving the puzzle of what triggers the formation of stars in active galaxies.

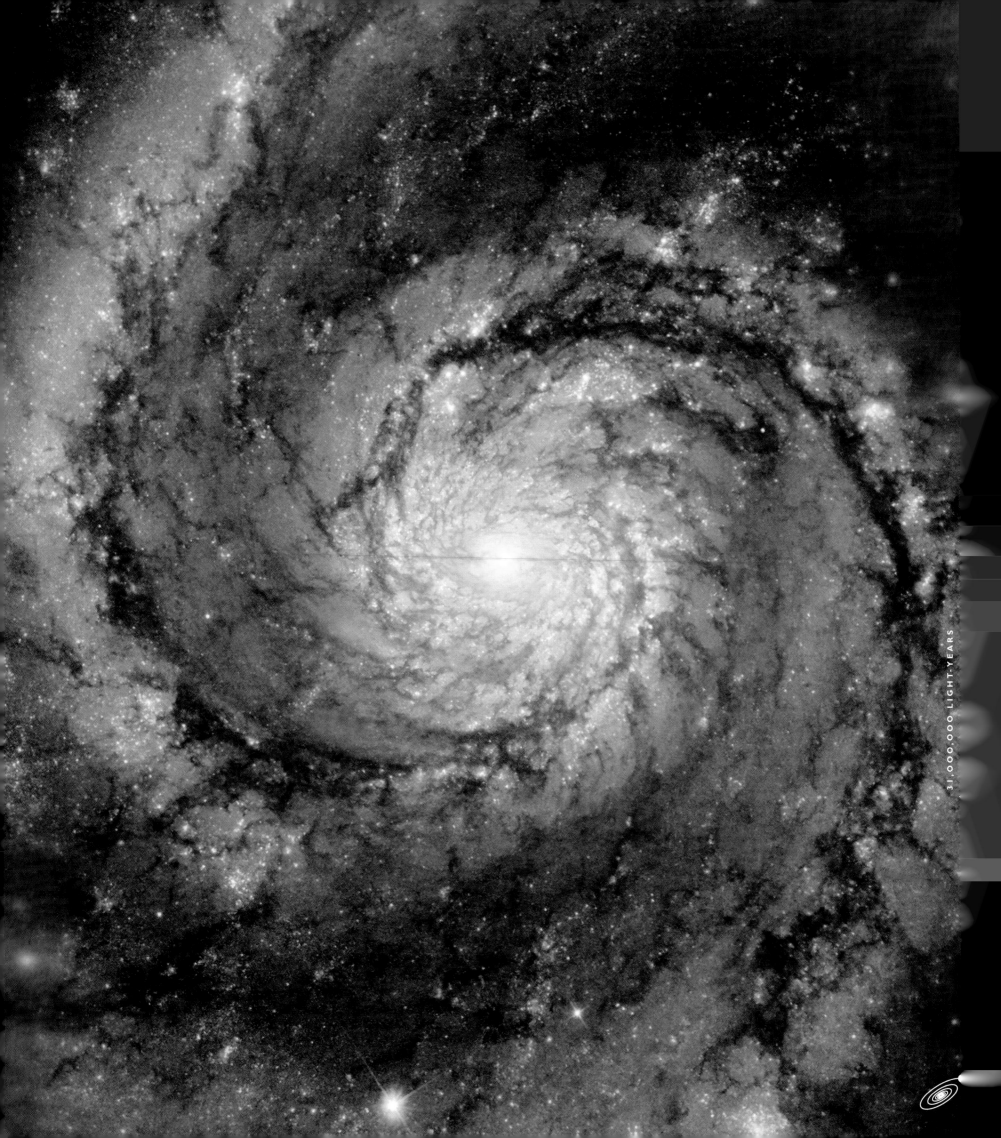

31,000,000 LIGHT-YEARS

Above: **HUBBLE FOCAL PLANE** Superimposed upon an image of the star field is a diagram of the focal plane of the Hubble Space Telescope. The outlined shapes indicate the portion of the usable field of light that is collected by the Hubble's main mirrors and how it is shared by various scientific instruments, including the WF/PC2, ACS, NICMOS, and the STIS. The three pickle-shaped regions are used by the guidance system to keep the telescope aligned and to make precision measurements of star positions. The WF/PC2 occupies the central portion of the field, that with the greatest fidelity. A small, diamond-shaped mirror protruding from the WF/PC2, the "pick-off mirror," intercepts the light in the focal plane and sends the beam to the WF/PC's CCDs. The ingenious COSTAR device, installed in December 1993 to correct Hubble's vision, also picks off light in this focal plane, sending beams selectively to all the other instruments. *Opposite:* **MOSAIC IMAGE OF WHIRLPOOL GALAXY (1996)** Data from Scoville's observations, combined with a ground-based view, produced this image of Whirlpool's heart.

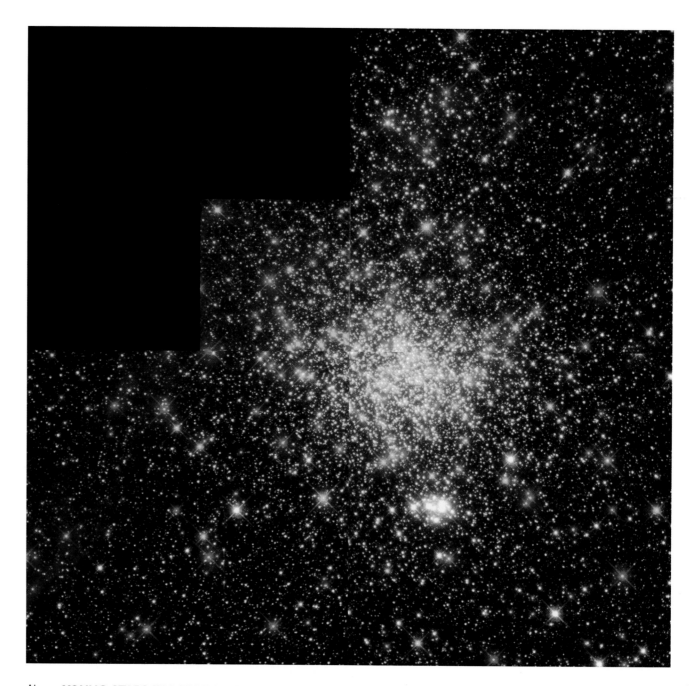

Above: **YOUNG STARS IN LARGE MAGELLANIC CLOUD (1994)** The star-forming processes active in M51 can also be studied in detail in nearer galaxies and within our own Milky Way. The Large Magellanic Cloud, in the southern constellation Dorado, is a dwarf irregular galaxy close to the Milky Way. It contains some of the most active star-forming regions known. The image above contains three distinct stellar populations of old, medium, and young stars. The main feature is a cluster of young yellow stars, NGC 1850, estimated to be only 50 million years old. The brilliant white stars in the general field are even younger, only a few millions years old and generally very massive. *Opposite:* **MIXTURE OF STARS IN LARGE MAGELLANIC CLOUD (2006)** Low-mass, very young stars and older high-mass stars of great luminosity appear in this image of a larger region in the cloud called LH 95, recorded by the ACS. The average distance to the cloud is some 160,000 light-years.

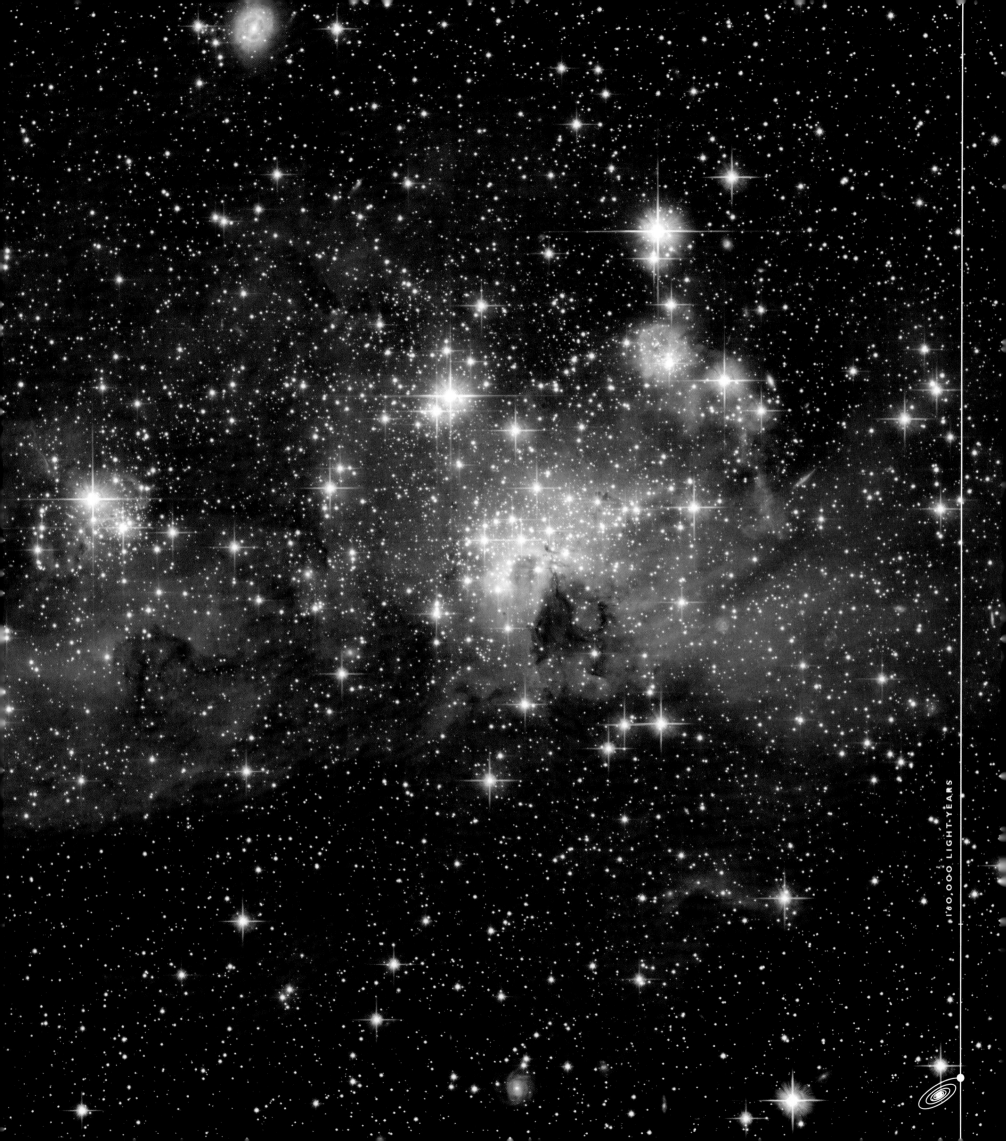

160,000 LIGHT-YEARS

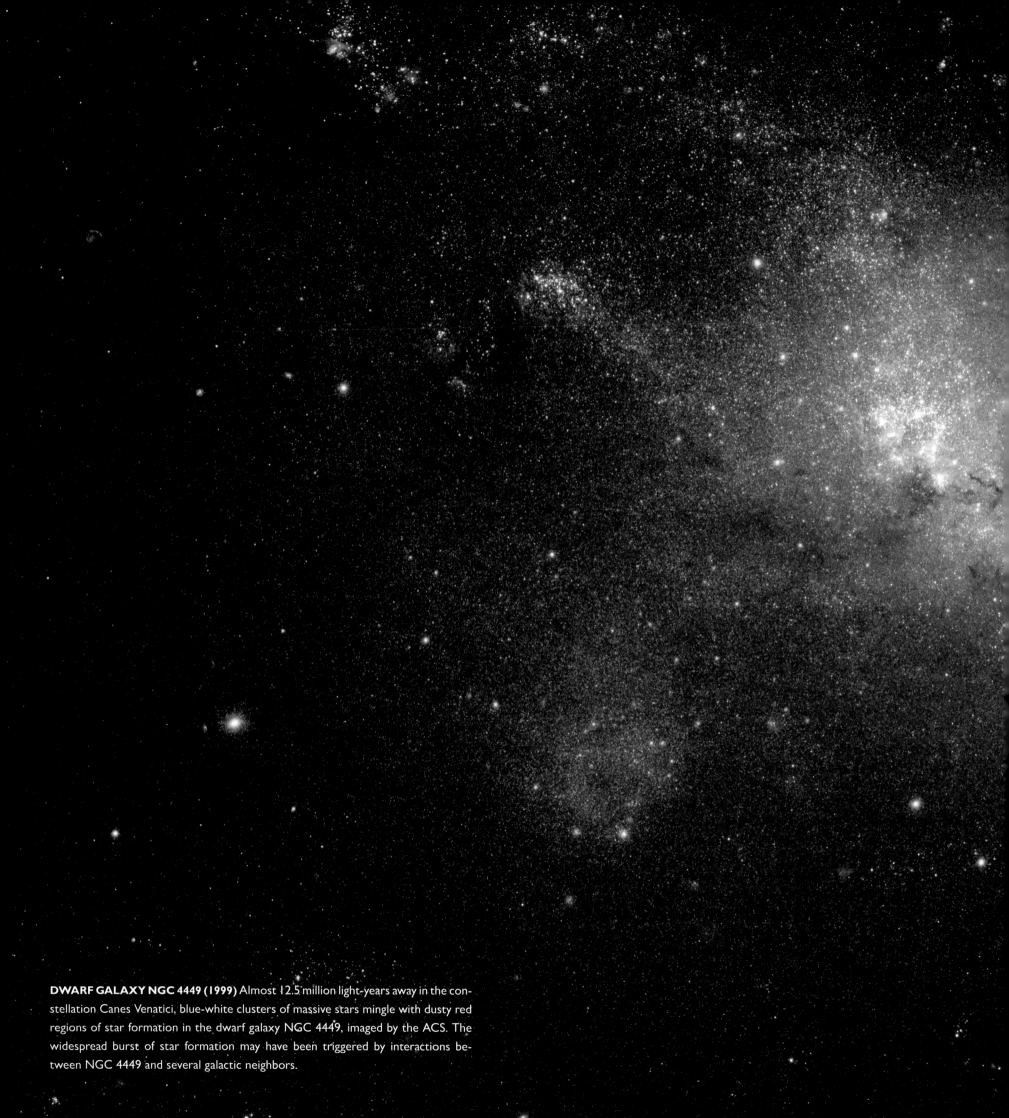

DWARF GALAXY NGC 4449 (1999) Almost 12.5 million light-years away in the constellation Canes Venatici, blue-white clusters of massive stars mingle with dusty red regions of star formation in the dwarf galaxy NGC 4449, imaged by the ACS. The widespread burst of star formation may have been triggered by interactions between NGC 4449 and several galactic neighbors.

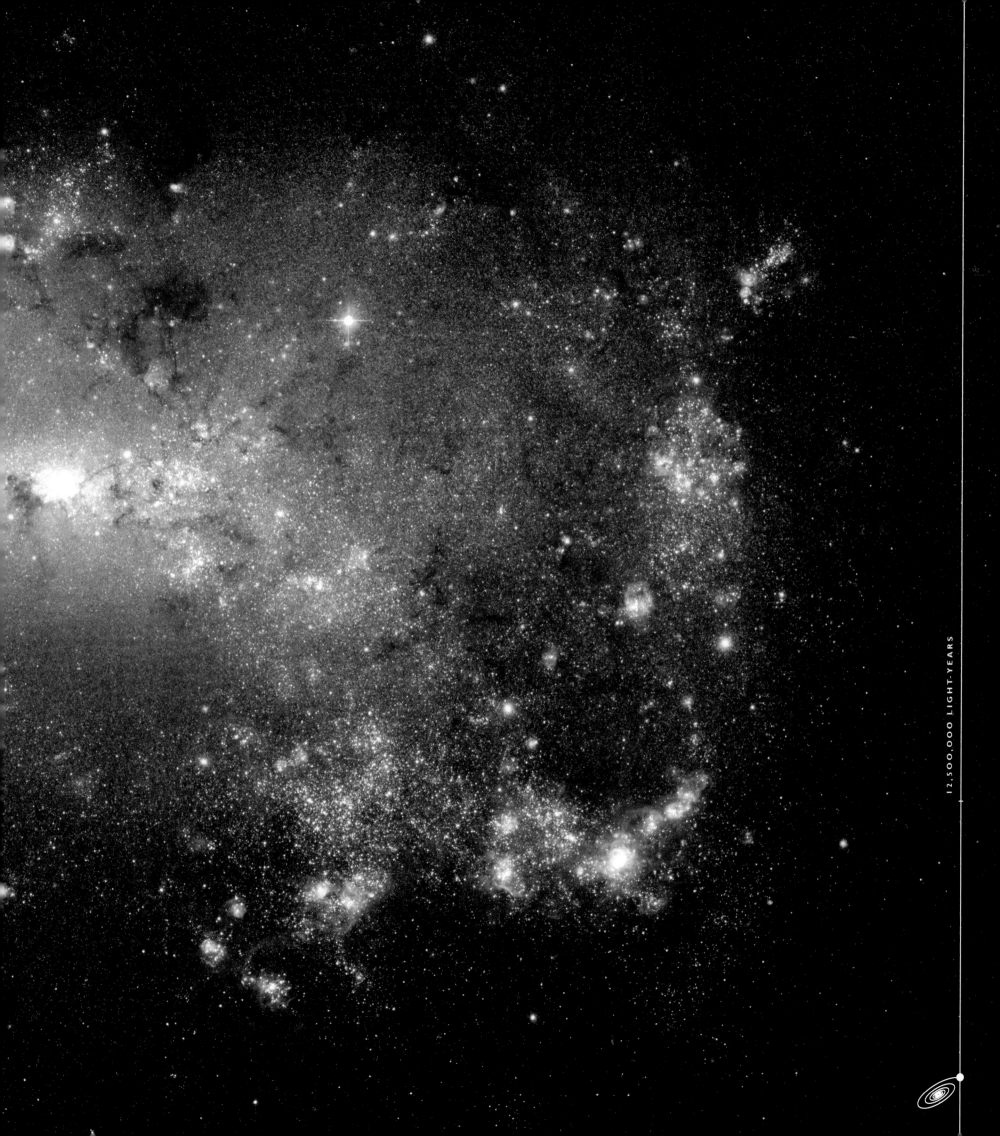

12,500,000 LIGHT-YEARS

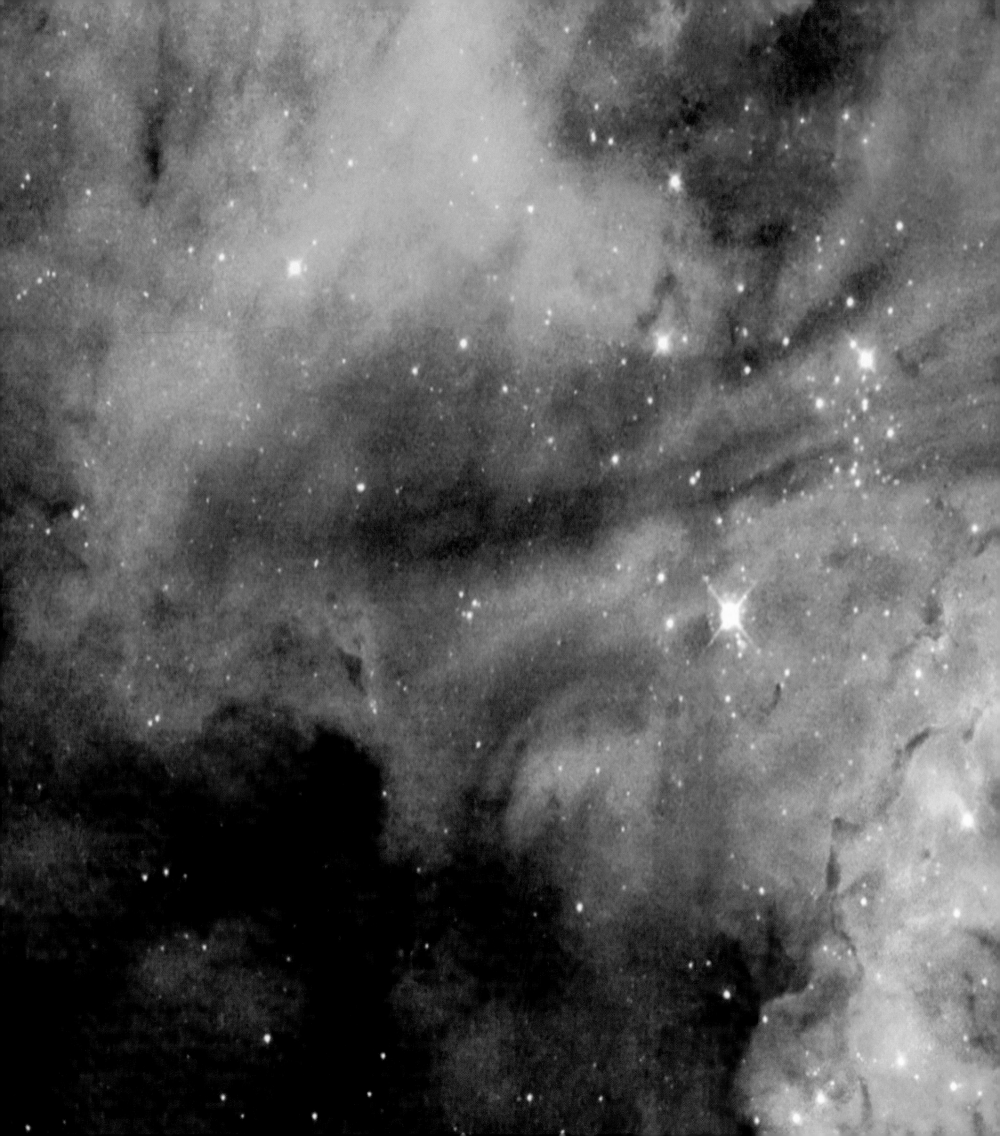

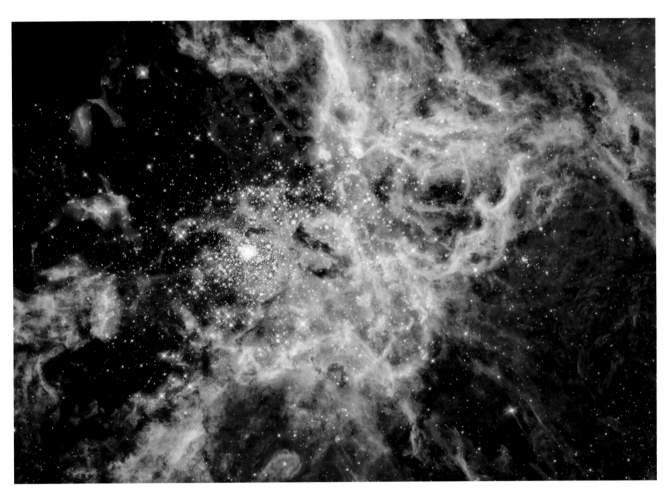

Opposite: **STAR FORMATION IN LARGE MAGELLAN-IC CLOUD (2006)** Named N 180B, this dynamic star-forming region contains rich fields of gas and dust and extremely bright star clusters. The hottest among them are more than a million times brighter than our sun. Ultraviolet radiation from these hot stars sculpts the nebula and creates violent stellar winds of charged particles that sweep away the dust, creating vast cavities and rendering the stars visible. This radiation also causes the gases to glow the characteristic red of hydrogen. Wispy one-hundred-light-year-long streamers of dust also betray regions of intense star formation at very early stages of growth, before the embedded stars shine enough to blow the dust and gas asunder. *Above:* **30 DORADUS (2001)** Possibly the best-known and most often imaged star-forming region in the Large Magellanic Cloud, the feature known as 30 Doradus contains thousands of stars in the process of forming and other massive stars at the early stages of life. Once again, ultraviolet radiation and violent stellar winds clear and shape the landscape, some 200 light-years wide by 150 light-years high.

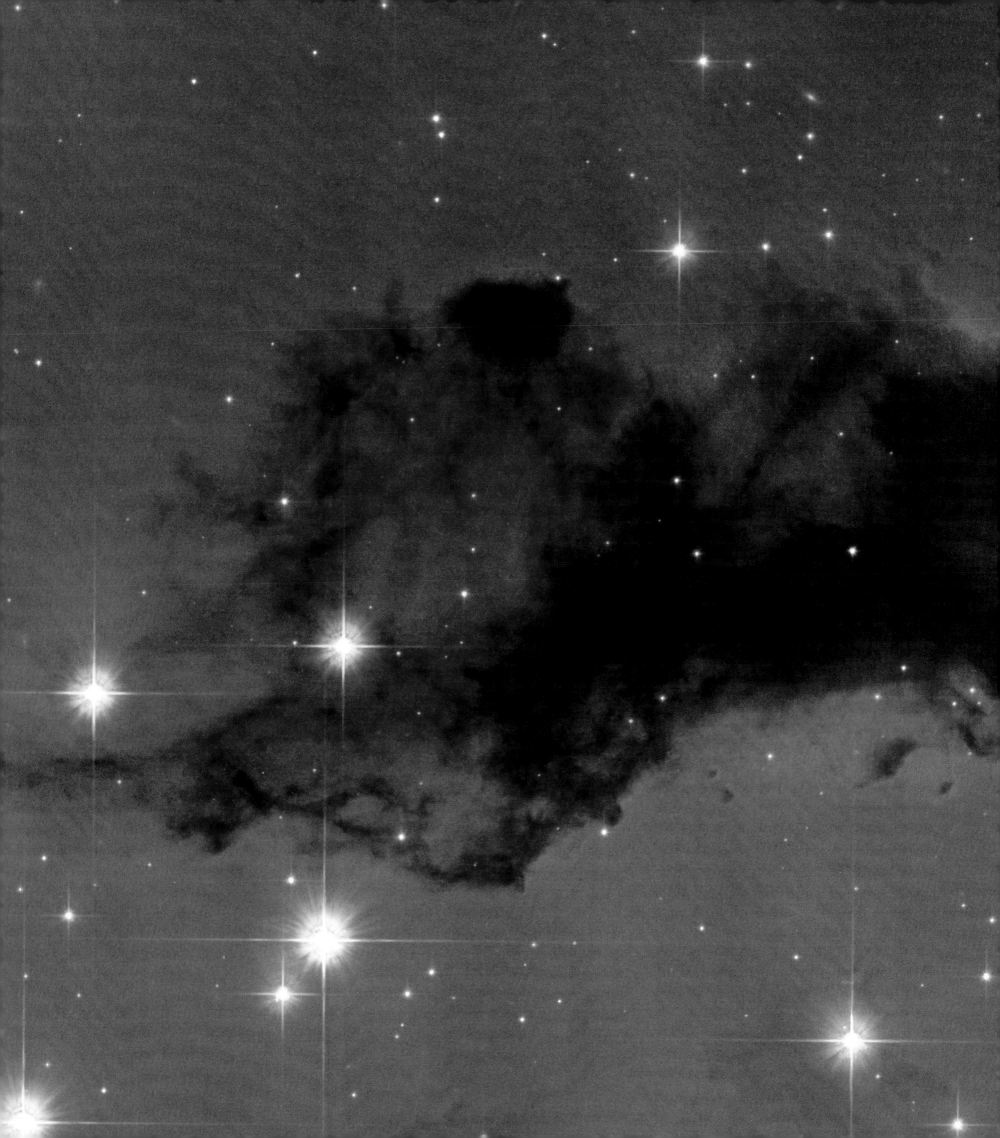

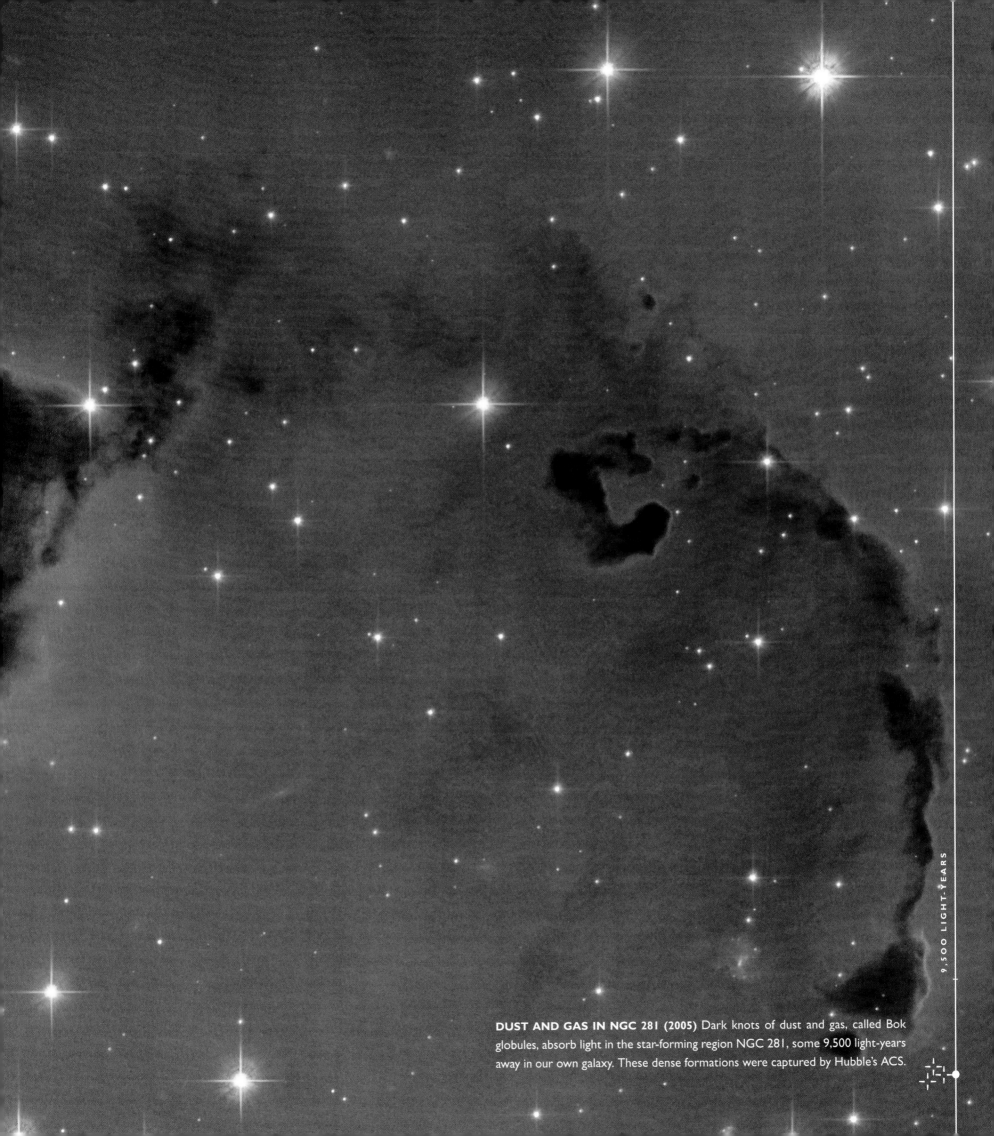

DUST AND GAS IN NGC 281 (2005) Dark knots of dust and gas, called Bok globules, absorb light in the star-forming region NGC 281, some 9,500 light-years away in our own galaxy. These dense formations were captured by Hubble's ACS.

9,500 LIGHT-YEARS

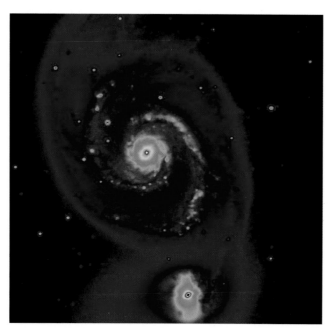

Above: **PROCESSING THE IMAGE** Image processing techniques developed at the Space Telescope Science Institute in the early 1990s *(above right)* helped to reveal many new features of the structures of galaxies. An early processed false color image of M51 *(above left)* reveals extensive intergalactic material between the two components and in a halo around both. Scoville and his colleagues employed a range of techniques to create precisely designed images of M51, uncovering new visual information on regions of star formation. Their careful superposition techniques pinpointed more than 1,300 regions of intense star formation in clouds typically 30 to 300 light-years in diameter. *Opposite:* **HYDROGEN IN M51 (2005)** The Scoville team's published mosaic from the WF/PC2 highlighted many star-forming regions in the red light of hydrogen alpha emission. Analyses of these regions helped them better understand the nature and rate of star formation in galaxies. As they noted, "Were it not for the small number of youthful, luminous stars and their ongoing genesis, much of the beauty, vigor, and evolution that is our fascination in the universe would be lost to the distant past."

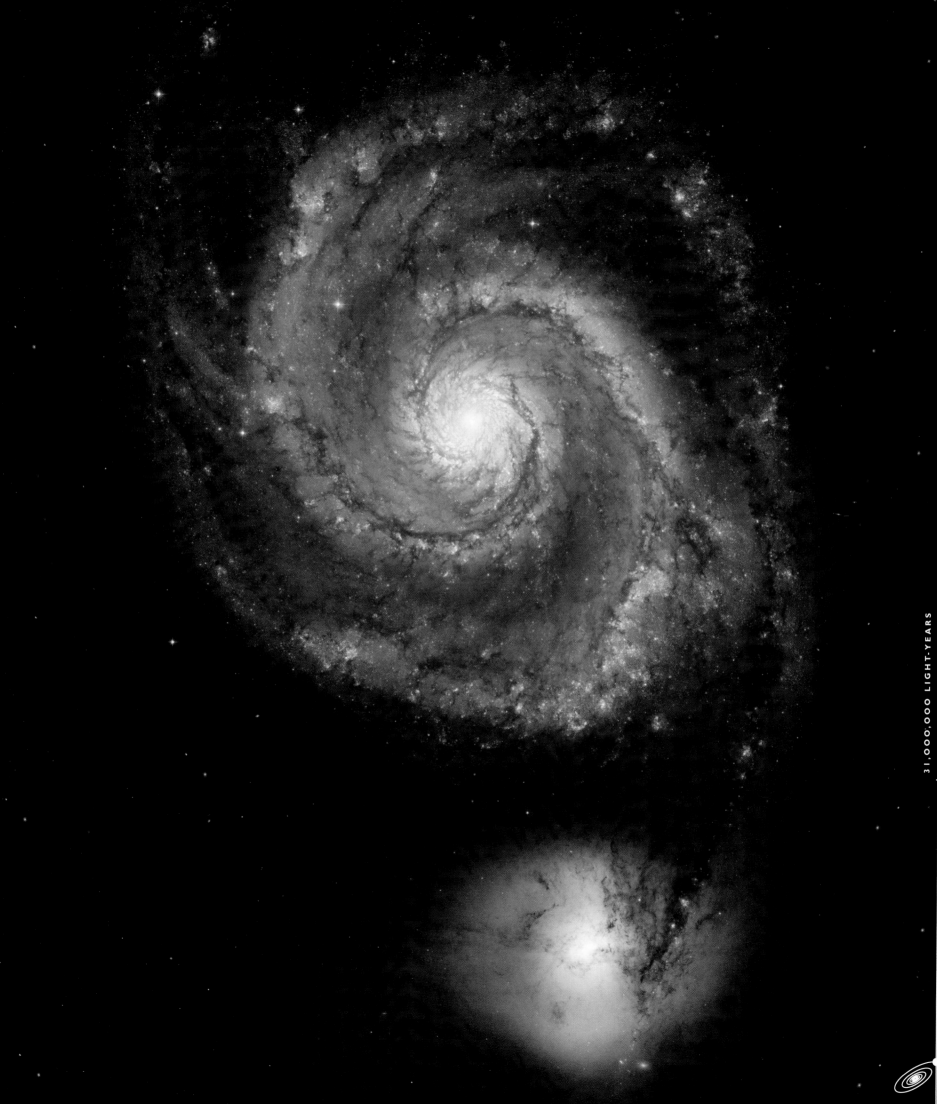

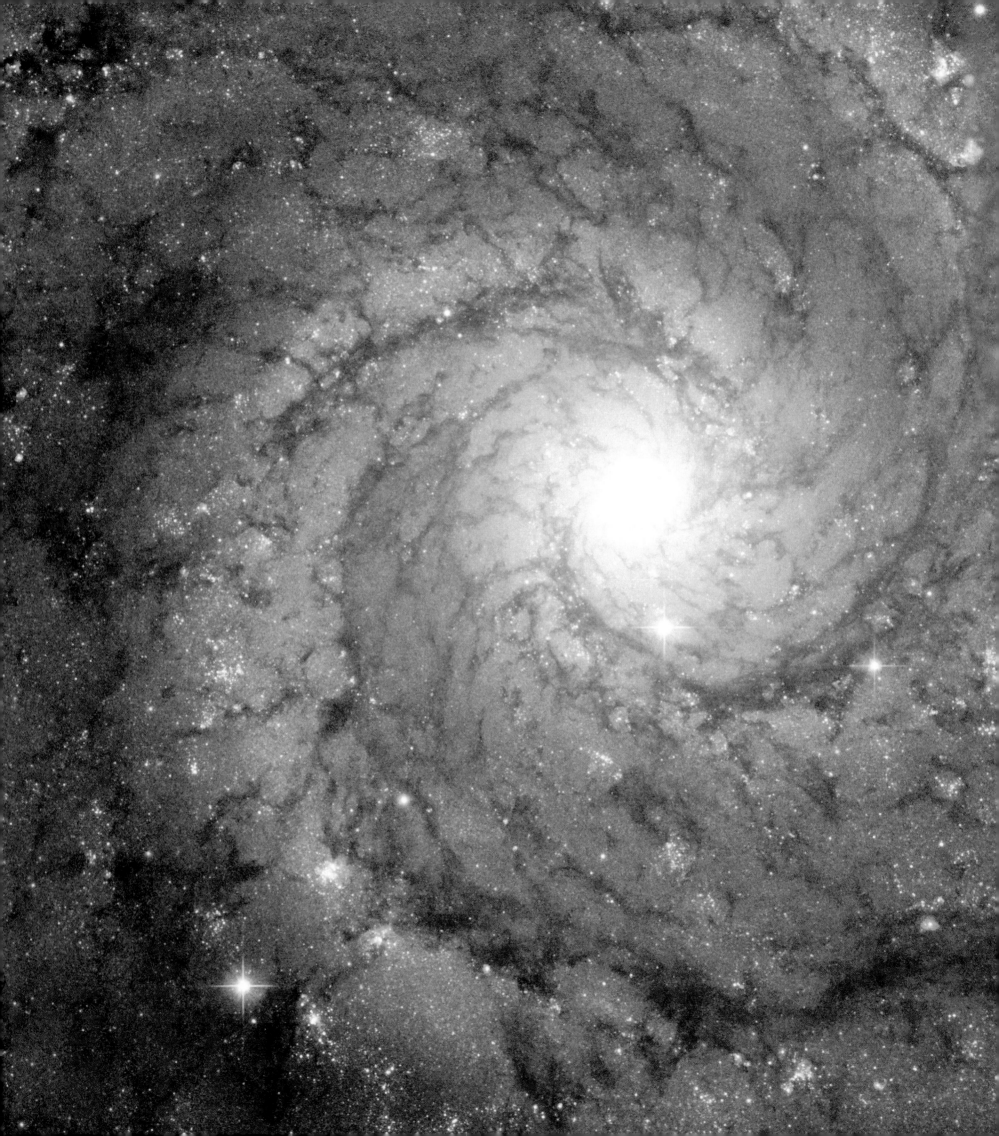

32,000,000 LIGHT-YEARS

"BUT IF A MAN WOULD BE ALONE,

LET HIM LOOK AT THE STARS...

ONE MIGHT THINK THE ATMOSPHERE WAS MADE TRANSPARENT
WITH THIS DESIGN, TO GIVE MAN, IN THE HEAVENLY BODIES,
THE PERPETUAL PRESENCE OF THE SUBLIME…"

—RALPH WALDO EMERSON, 1836

SPIRAL GALAXY M74 (2007) Messier 74, some 32 million light-years distant in the constellation Pisces, is a "grand-design" spiral galaxy similar to M51. The similarity illustrates that the work of Scoville's team applies to star-formation processes generally. Its arms contain clusters of young blue stars and glowing pink regions of ionized hydrogen, areas of star formation

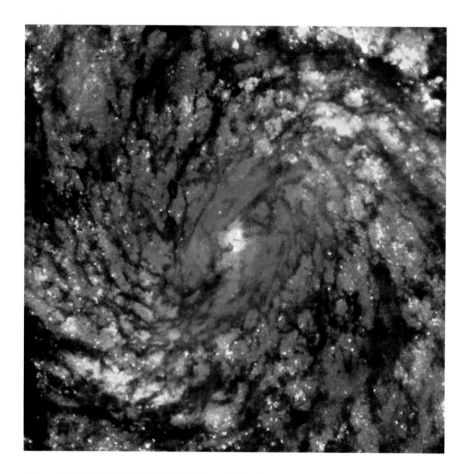

Above: **CENTER OF M51 (2001)** One of the dreams astronomers held out for the Hubble was the ability to image the cores of galaxies. Throughout the latter half of the 20th century, the largest telescopes were trained on the centers of galaxies in the hope of finding out what powered them. Yet no matter how astronomers adjusted their telescopes, the cores remained unresolved. After the Hubble was launched, the core of M51 became a target once again, and astronomers applied for telescope time to determine its innermost structure. In the close-up image above, the spiral structure continues right to the center, where there are hints of a spiral within a spiral. *Opposite:* **POSSIBLE BLACK HOLE AT CORE OF M51 (1992)** Looking closer still, a team of astronomers led by Holland Ford, using the STIS on the Hubble, detected an odd dark "X" silhouetted on the exact center of the core, marking the spot where a supermassive black hole may be lurking with a mass equivalent to one million suns.

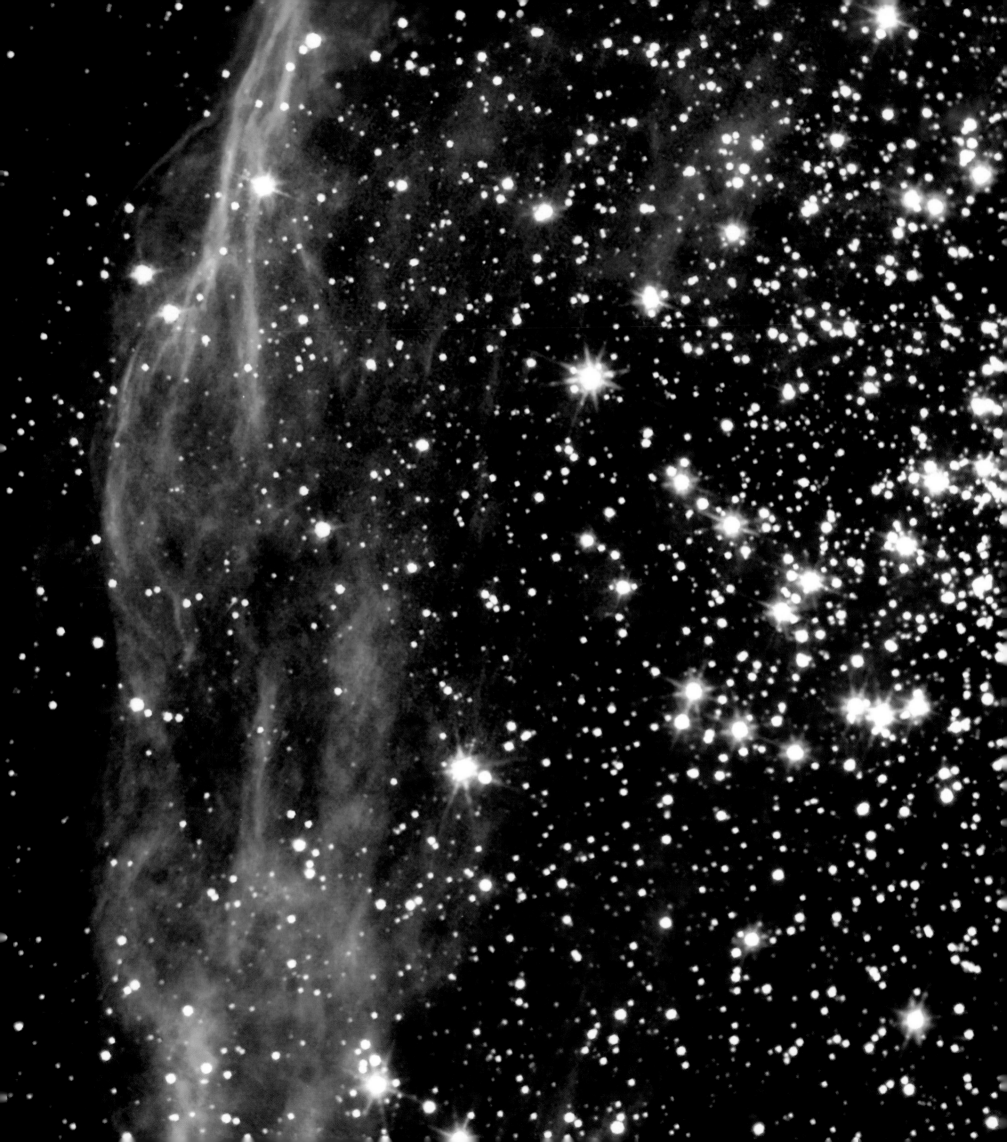

STAR CLUSTER NGC 1850 (2001) The brilliant star cluster NGC 1850 in the Large Magellanic Cloud is of globular form, but is unlike any globular cluster in the Milky Way. Its stars are massive, white hot, and very young. This is one piece of evidence suggesting that the cloud is much younger overall than the Milky Way, as the many intense star-forming regions in the Cloud attest. Being young, and in the presence of gas and dust, there were evidently some very massive stars in the vicinity that blew themselves up in the past, and left the debris field of diffuse gas, glowing blue in this image. There is a second, smaller cluster below and to the right, even younger than its globular sister, possibly a mere four million years old.

160,000 LIGHT-YEARS

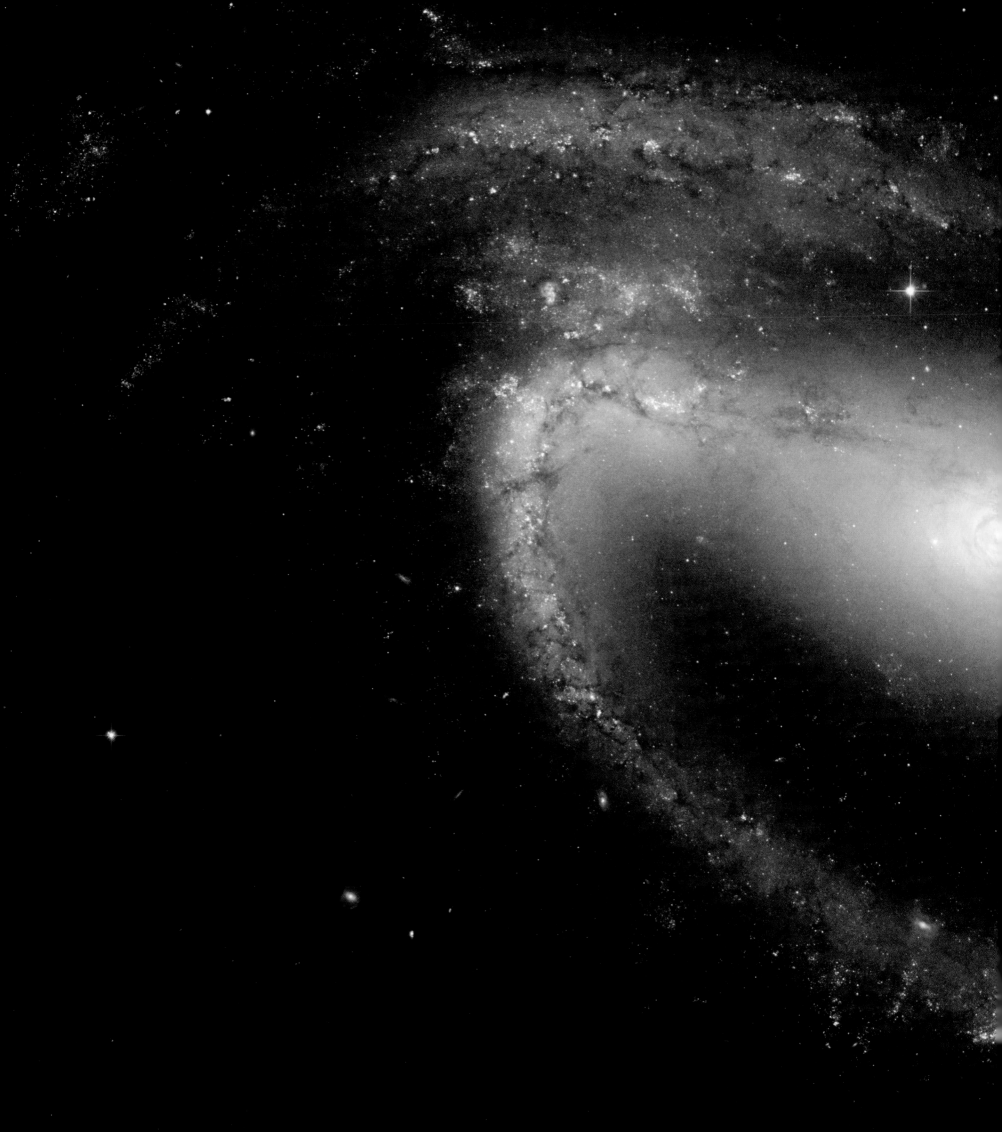

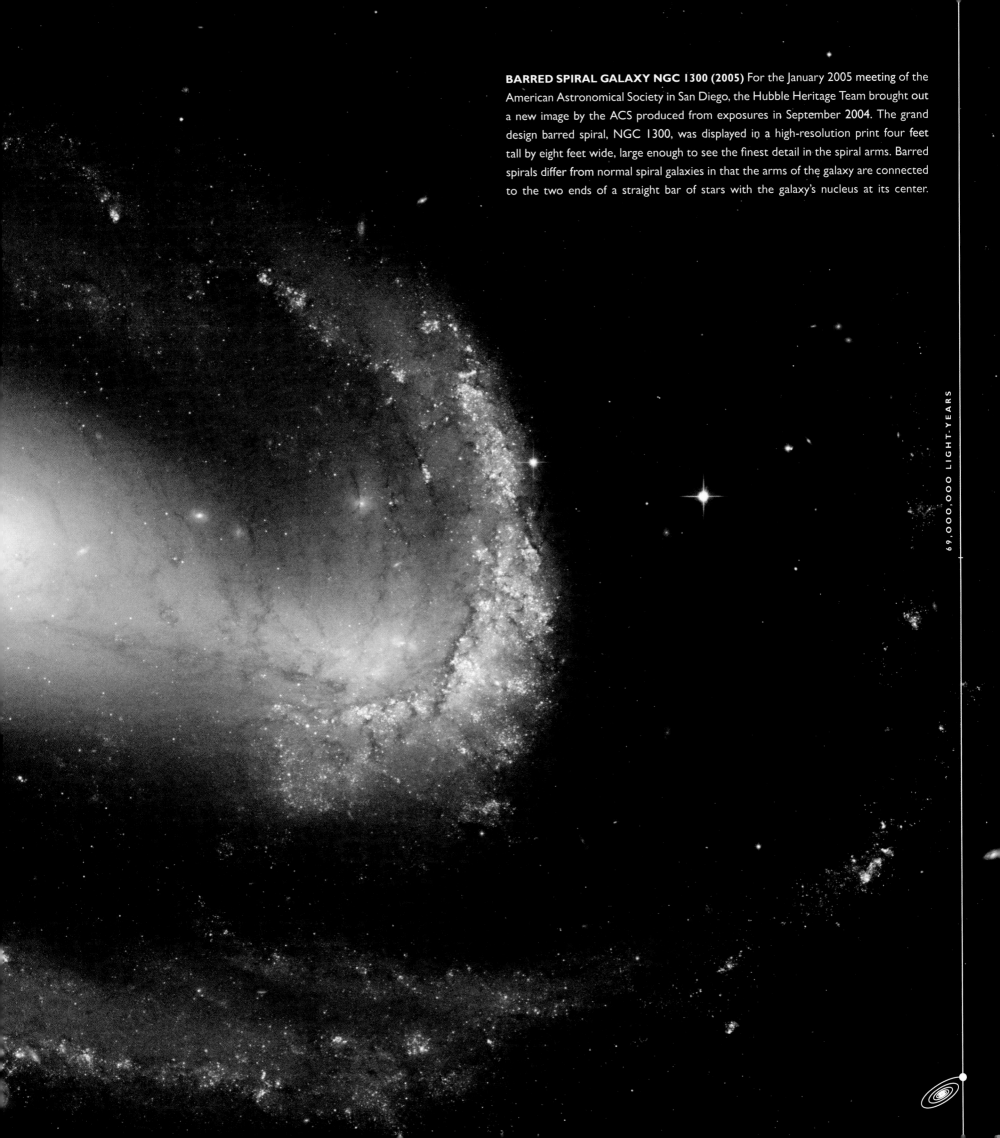

BARRED SPIRAL GALAXY NGC 1300 (2005) For the January 2005 meeting of the American Astronomical Society in San Diego, the Hubble Heritage Team brought out a new image by the ACS produced from exposures in September 2004. The grand design barred spiral, NGC 1300, was displayed in a high-resolution print four feet tall by eight feet wide, large enough to see the finest detail in the spiral arms. Barred spirals differ from normal spiral galaxies in that the arms of the galaxy are connected to the two ends of a straight bar of stars with the galaxy's nucleus at its center.

69,000,000 LIGHT-YEARS

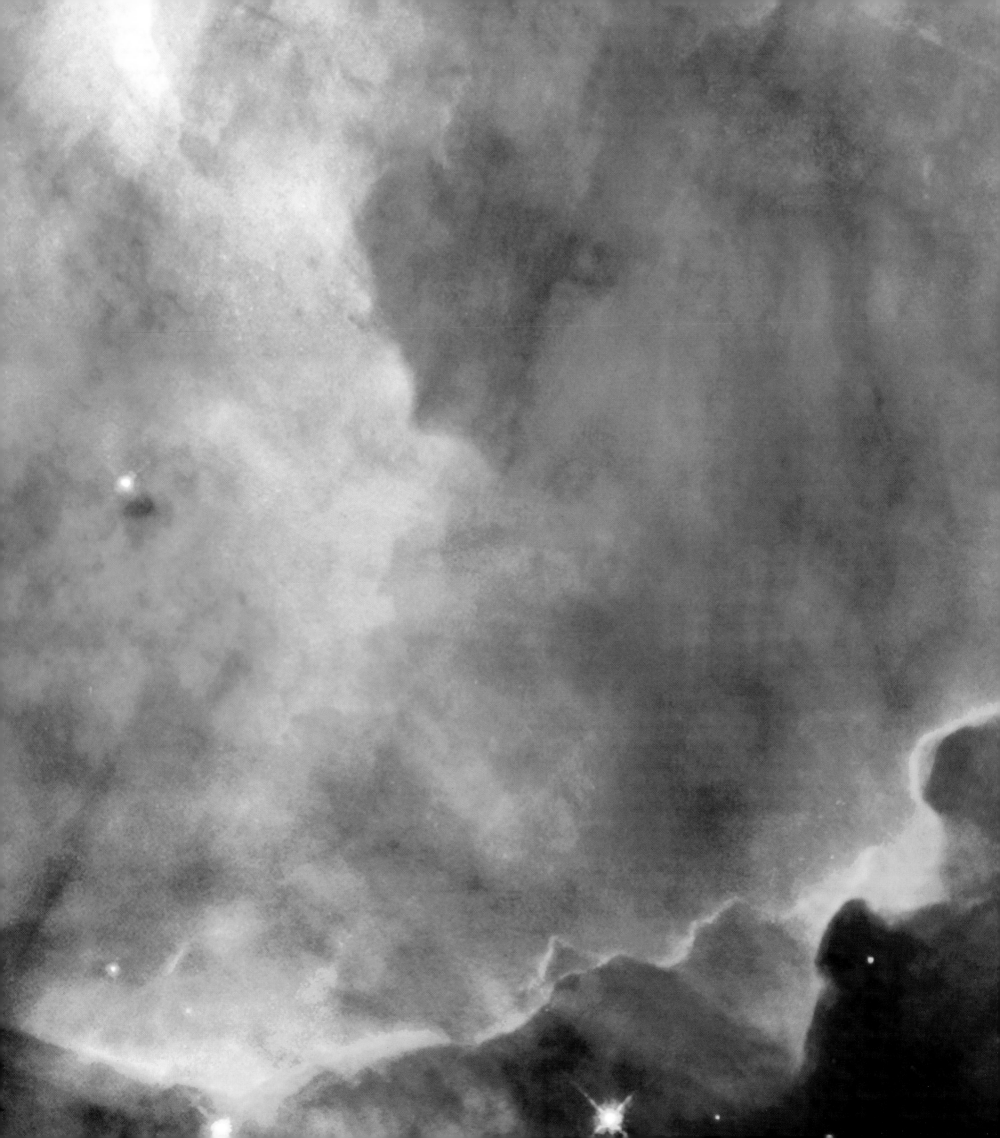

CHAPTER 5
THE WONDER OF OUTER SPACE

The Hubble Space Telescope was designed principally as an imaging instrument. But only after astronomers, administrators, and public outreach officials saw the images secured by the repaired Hubble did they develop an appreciation for the telescope's potential to produce views of great aesthetic power. Surprising as it may seem today, no early images were released when the telescope was launched in 1990. NASA managers, who were concerned about the response if the HST should malfunction, as well as some astronomers, who wanted to ensure they would be first to use this remarkable new instrument for science on particular targets, argued against immediately showing pictures to the public. Over the telescope's lifetime their attitudes would change, and most would come to recognize the popular value of the Hubble's glorious images.

public, major newspapers featured it the next day, and news magazines ran stories in the following weeks. On Novermber 3, for example, the New York Times , reported that "The dramatic new scenes captured by the Hubble Space Telescope might be called Dawn of Creation." Furthermore, "These remarkable views of a kind of fantasyland of powerful cosmic forces are giving astrophysicists a rare peek inside a star-forming incubator and may provide answers to the mystery of what processes control the sizes of stars." The other articles described the scene as dramatic, eerie, monstrous, stunning, and breathtakingly beautiful. Astronomers believed it was a star-forming region, so the image soon gained a nickname: The Pillars of Creation.

In June 1996, *The Astronomical Journal* published the scientific findings about the nebula, offering a more detailed analysis of the data gathered by the Hubble Space Telescope. Using the high-resolution pictures, astronomers Jeff Hester and Paul Scowen identified in

The startling image of the Eagle Nebula, a gaseous region more than 7,000 light-years away in the constellation Serpens, was pivotal in bringing about this change. Released on November 2, 1995, the image has become an icon of the Hubble Space Telescope's work. Silhouetted against a velvety blue background, pillars reach up like massive megaliths and glow with an unearthly light, pierced by pink

stars. The giant forms fit perfectly in the stair-step frame of the WF/PC2. After NASA and the Space Telescope Science Institute released the image to the

Preceding pages: **SWAN NEBULA (2003)** This image of a star-formation region in M17, the Swan Nebula in Sagittarius, was released to mark the HST's 13th birthday.
Opposite: **FINGERS OF GAS AND DUST IN EAGLE NEBULA (1995)** A detailed view of the Eagle Nebula (M16) in Serpens shows columns of cold material sheltering dense evaporating gaseous globules (EGGs) from the ionizing radiation of hot stars.

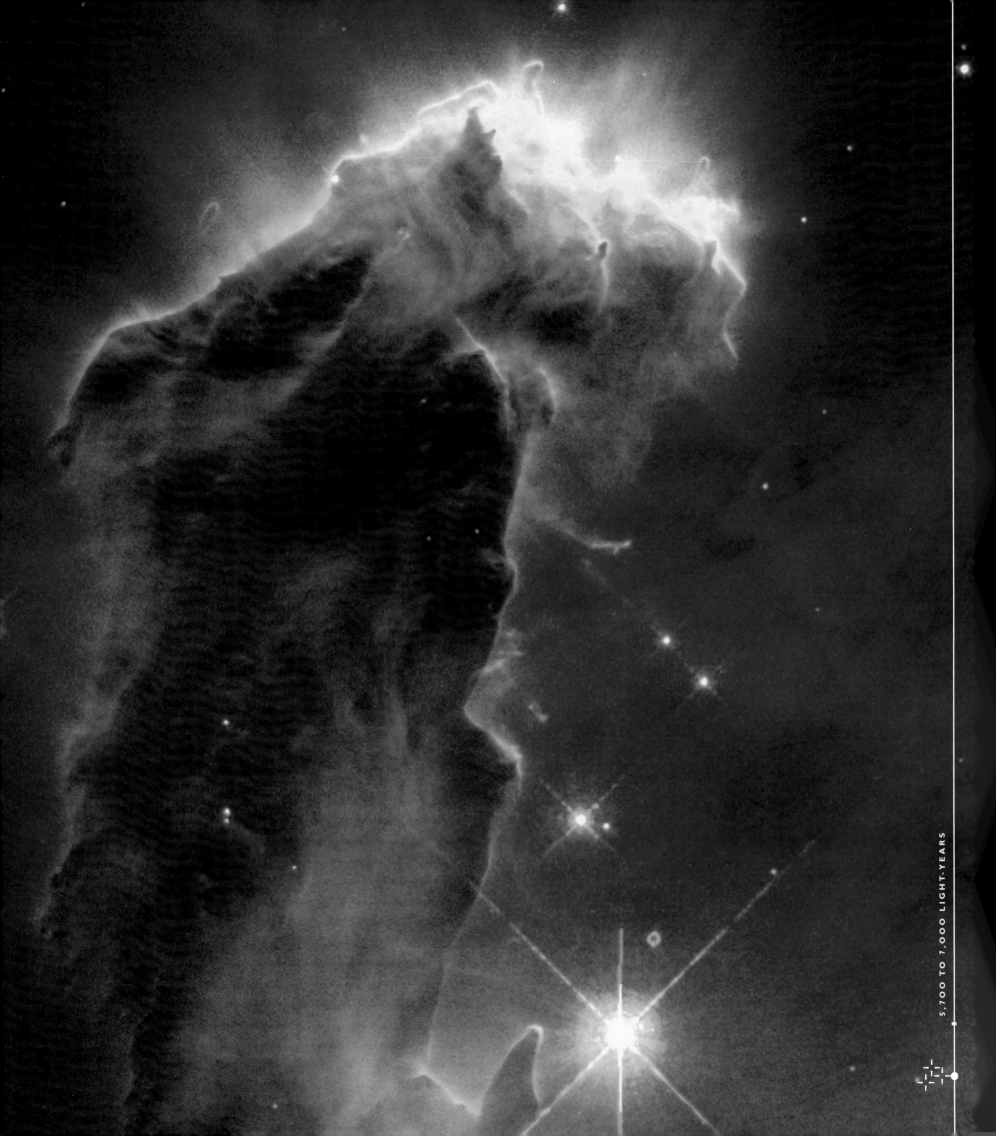

the gaseous columns smaller structures they called evaporating gaseous globules, or EGGs, which they theorized were the sites of new stars in the process of forming. The EGGs contained stellar material enveloped in molecular clouds. Over time, radiation from nearby massive stars evaporated the molecular clouds, eventually separating the stellar object from the larger column. If the proto-star was large enough, it might then develop into a true star.

The image's high resolution allowed astronomers to record the dynamics of star formation in more detail than possible from even the very best ground-based optical instruments, but, arguably, the image's appearance—and the enthusiastic response to it—had as great an impact as its scientific content. Hester and Scowen concluded that "[t]he WF/PC2 images of M16 are visually striking, and noteworthy from that perspective alone. They also provide a fascinating and enlightening glimpse of the physical processes at work in the interplay of massive stars and their surroundings."

The earliest images sent back by the Hubble were of course affected by the primary mirror's spherical aberration. Even with the aid of sophisticated image processing techniques, the resulting images fell well short of the quality that astronomers had initially anticipated. However, with the publication of more scientific articles based on the repaired telescope's observations, recognition of the images' aesthetic qualities increased. Astronomers began to use words like "dramatic" and "spectacular" to describe the Hubble images, rather than limiting themselves to the dry vocabulary typical of scientific articles. The appearance of the images released to the public also began to change. Until 1995, Space Telescope Science Institute (STScI) press releases

often featured black-and-white images. In 1992, for example, the Institute released a black and white image secured by the Faint Object Camera of a planetary nebula in the Large Magellanic Cloud. The Hubble would later produce many striking color images of planetary nebulae. But in the HST's early period in orbit, when color was used, it was often a single hue rather than a full-color array. Over the next few years, full-color images became much more common. By the time of the fourth Shuttle servicing mission to the HST in 2002, which featured the installation of a more sensitive wide-field camera called the Advanced Camera for Surveys (ACS), the Institute had fully grasped the public value of the images. Four dramatic full-color views were released to the public: the Cone Nebula, the Tadpole galaxy, the Mice Nebula, and the Swan Nebula. These images again garnered headlines. An editorial in the New York Times proclaimed: "[The Hubble] has taught us to see properties of the universe humans have been able, for most of their history, to probe only with their thoughts."

THE CRAFT OF IMAGING

The visual characteristics of the images influence how we see, understand, and respond to these scenes of distant and alien places. For astronomers, focused on scientific analysis, visual appeal is a secondary concern. If an astronomer plans to publish an image in a professional journal, the tools of the IRAF are adequate. Images for press releases, posters, and popular magazines, however, typically undergo another level of processing, often with well-known graphics programs such as Photoshop, to produce a striking shot. Hubble images are mediated views of the universe, and astronomers

and image processing specialists employ a degree of artistry to make the universe more understandable and attractive. Although derived from scientific data, those images directed at public audiences reflect a desire to balance science, aesthetics, and communication.

The incredibly sensitive instruments aboard the Hubble Space Telescope numerically record subtle distinctions in light intensity. Although these differences are evident to astronomers when analyzing the data, they cannot be directly translated into an image. Human eyes are unable to detect small shifts in brightness, and these distinctions cannot be displayed on a computer screen or the printed page. To create a visual representation of these variations, image processing specialists amplify them by adjusting the light intensity scale of the data. Using software, they stretch light values in the middle of the range and allow those at the darkest and brightest ends to be lost in white or black. The resulting image reveals fine details. But these adjustments are not determined by a set of universal standards; they depend on the object being observed, the areas of greatest interest, and on the judgment of the image specialist.

Once the image processing specialist has maximized the visibility of the structure in the image, he or she then enhances the scene by adding color. The Hubble Space Telescope returns sets of monochromatic images of each field isolated through filters that are designed to discriminate among different natural phenomena with certain known color characteristics. The full-color images most commonly associated with the Hubble Space Telescope are actually composites of three different images of the same object taken through three different filters. Each image is assigned a different color, usually red, blue, or green, to create a full-color composite image. The physical

conditions in the celestial object often influence which colors are associated with these filtered views. If a filter detects the presence of a gas that glows within a certain spectral range, this may determine the color used. For example, hydrogen glows red, and when a specific filter in the camera is selected to study it, the resulting image is often displayed as red in the composite view.

But these decisions can be complex. If two distinct physical processes taking place in the object happen to glow in the same color or spectral range, then the astronomer has to choose another color for one of them to keep them distinct, even if that color has no physical relationship to the filter. It is also common to associate color with the temperature of the gas. The hottest gases will typically be assigned to blue, while the coolest gases will be associated with red. Yet color decisions are not necessarily governed by strict rules, and the final choice often reflects a subtle mixture of scientific conventions and aesthetic judgments.

In addition to contrast adjustments and color assignments, highly refined images require cosmetic cleaning. The IRAF will automatically eliminate some of the noise, instrument artifacts, and cosmic rays. Other blemishes, such as seams between the exposures in the mosaic, are handled in Photoshop, as are bright and dark spots caused by flaws in the camera. Yet, if you look carefully, in many images you will find diffraction spikes—thin pointed beams of light caused by obstructions within the telescope—around bright stars. These spikes are familiar in celestial scenery, and also they function as strong visual cues. Image processors therefore keep them in the picture because of their symbolic and aesthetic value.

Other choices may help to transform a dull, disorganized, or uninteresting scene into a compelling or even arresting one. While astronomical images have traditionally been oriented with north at the top and east to the left, the Hubble Space Telescope's images are often oriented to create the greatest visual interest. An image may be cropped to remove distracting or less engaging features. It may be combined with data from other sources to add interest or compensate for missing sections of data. The field of view can be modified with the addition or subtraction of data to create a more conventional rectangle or square rather than a strangely shaped image caused by the design of WF/PC2. Any of these adjustments to the image's composition may also be used to achieve a better sense of balance in the picture.

The flexibility of the digital medium and the creative dynamic existing between the roles of science and aesthetics do raise questions about the truthfulness of the images, and some commentators have viewed the Hubble images with suspicion. But the adjustments occur at the level of the image, not in the data. If an astronomer sees something scientifically interesting in the image, he or she can return to the data to make measurements and calculations independent of aesthetic considerations.

Even so, Hubble images should not be compared to our visual experience of the world. The instruments of the Hubble Space Telescope do not imitate the human eye. Instead, they vastly expand upon it, registering light at wavelengths beyond our visual range and collecting it over long periods of time. Given Hubble's exceptional optical capabilities, it would be wrong to restrict its images to the limits of human eyesight or to judge them by the same standards of truthfulness humans use for their eyes.

Hubble's images are not representations of a person's visual experience, regardless of whether they looked through a powerful telescope or traveled to a distant region of the universe to examine an object close up. Instead, the final images are impressions, based on scientific data that display the universe in a visually compelling manner.

Even though the Hubble Space Telescope images are valid impressions, and astronomers and image processors are not in the business of fabricating, we all still have a responsibility to be savvy viewers. Astronomers take care to document the steps between data and display. But in the work to clarify and extract information from the data, the image moves farther from the actual phenomenon and closer to an abstraction. Critical aspects of the original are preserved and in fact are transformed into easily visualized information. But they do require some careful interpretation.

The work of science is often described as moving from the tangible to the abstract. Here the direction appears to be reversed, moving from abstract streams of numeric data returned by the telescope to images. It is easy to be seduced by images, believing they bring one closer to concrete, perceivable originals, but, in truth, they reflect instead an abstraction made visible.

THE HUBBLE HERITAGE PROJECT

Creating a clean image that exhibits a full range of light and color takes time and expertise. The Hubble Heritage Project, an effort staffed and sponsored by the

Space Telescope Science Institute, uses a range of techniques to explore the aesthetic potential of the data collected by the Hubble Space Telescope. The project started in the spring of 1997 after a group of astronomers—Keith Noll, Howard Bond, Anne Kinney, and Carol Christian, all of whom were working at the Space Telescope Science Institute—recognized the opportunity to create a lasting legacy for Hubble.

Although the Hester rendition of the Eagle Nebula underlined the aesthetic appeal of the images, only a small percentage of the images subsequently produced from the telescope's data rival it. A scientific question might as easily be answered by framing only a small portion of an object rather than the complete form. Multiple observations with different filters, necessary to create a full-color image, may not be required to reach a valid scientific conclusion and therefore are not gathered. When conducting research, astronomers process images primarily to bring out details of scientific interest, and they may not consider the overall appearance of an image. Limited resources in terms of telescope observing time and astronomers' time also constrain the production of impressive images.

Although aware of these constraints, the Hubble Heritage Team was convinced that the public, who knew little about the science behind the telescope's observations, should still have a chance to gain an appreciation of the celestial wonders they represented, if for no other reason than to raise high-minded questions about humanity's place in the universe. The founders of the Hubble Heritage Team proposed a program that would remain true to the scientific content of the images, while celebrating their aesthetic power. They presented the idea to the director of the Space Telescope Science Institute, Robert Williams, requesting a small budget and some observing time on the telescope. With his approval, they formed the team from staff astronomers, image processing specialists, and interns who would work collaboratively to generate one visually compelling image each month.

Beginning with a series rather than a single picture, the group released its first images in October 1998. The four images—a planet, a star field, a nebula, and a galaxy—constituted a summary of the Hubble's observations to that date. Saturn is depicted against a flawless black sky, its rings tracing a strong diagonal line across the picture plane. The Sagittarius star cloud teems with countless stars that shine in brilliant hues. The Bubble Nebula combines both a strong diagonal and vivid colors with two amorphous forms glowing in opposing corners of the image. In the galaxy image, a halo of bluish stars surrounds a brilliant white and yellow core. For Keith Noll, "These images communicate, at a visceral level, the awe and excitement that we experience when exploring the universe with Hubble. It is our chance to repay the public that supports us."

The Hubble Heritage Team searched the Institute data archive for visually interesting objects, particularly those with enough exposures through different filters that a full-color image could be created. The initial quartet of images all came from the archive's files. In addition, the project started requesting a small number of orbits from the director's discretionary time. The director of the Space Telescope Science Institute is given 10 percent of the observing time to distribute as he or she deems most appropriate. The project's observing time supplements existing data, such as adding exposures through another filter when only two are available. For example, the Hubble Space Telescope had observed the Ring Nebula through two filters and covered only half of the nebula within the WF/PC2's frame. With the aid of only a few more orbits, the Hubble Heritage Team collected enough additional data to showcase the entire object and create a stunning picture of the well-known celestial form. To mark the 15th anniversary of the telescope's launch, the Heritage Team (with the full support of STScI's director) pointed the Advanced Camera for Surveys (ACS), an instrument that was added to Hubble's armory in 2002, at two familiar celestial objects: the Whirlpool galaxy and the Eagle Nebula. Earlier observations focused on the core of the galaxy and only a small region of the nebula. The anniversary images used a much larger number of orbits, allowing the entire Whirlpool galaxy and its companion to be observed in greater detail than ever before and highlighting another large pillar of gas and dust within the Eagle Nebula.

Since beginning the project in 1998, about half the Hubble Heritage Project images have come from the archive and

EAGLE NEBULA, GROUND-BASED VIEW (2002) A wide-field view of the Eagle Nebula reveals how fingers and columns of gas and dust resist the sculpting action of hot blue stars at the core of the nebula. This image was created from observations with the National Optical Astronomy Observatory (NOAO) Mosaic CCD camera connected to a 0.9-meter telescope at Kitt Peak National Observatory. Hydrogen emission has been color-tagged green, ionized oxygen blue, and ionized sulfur red.

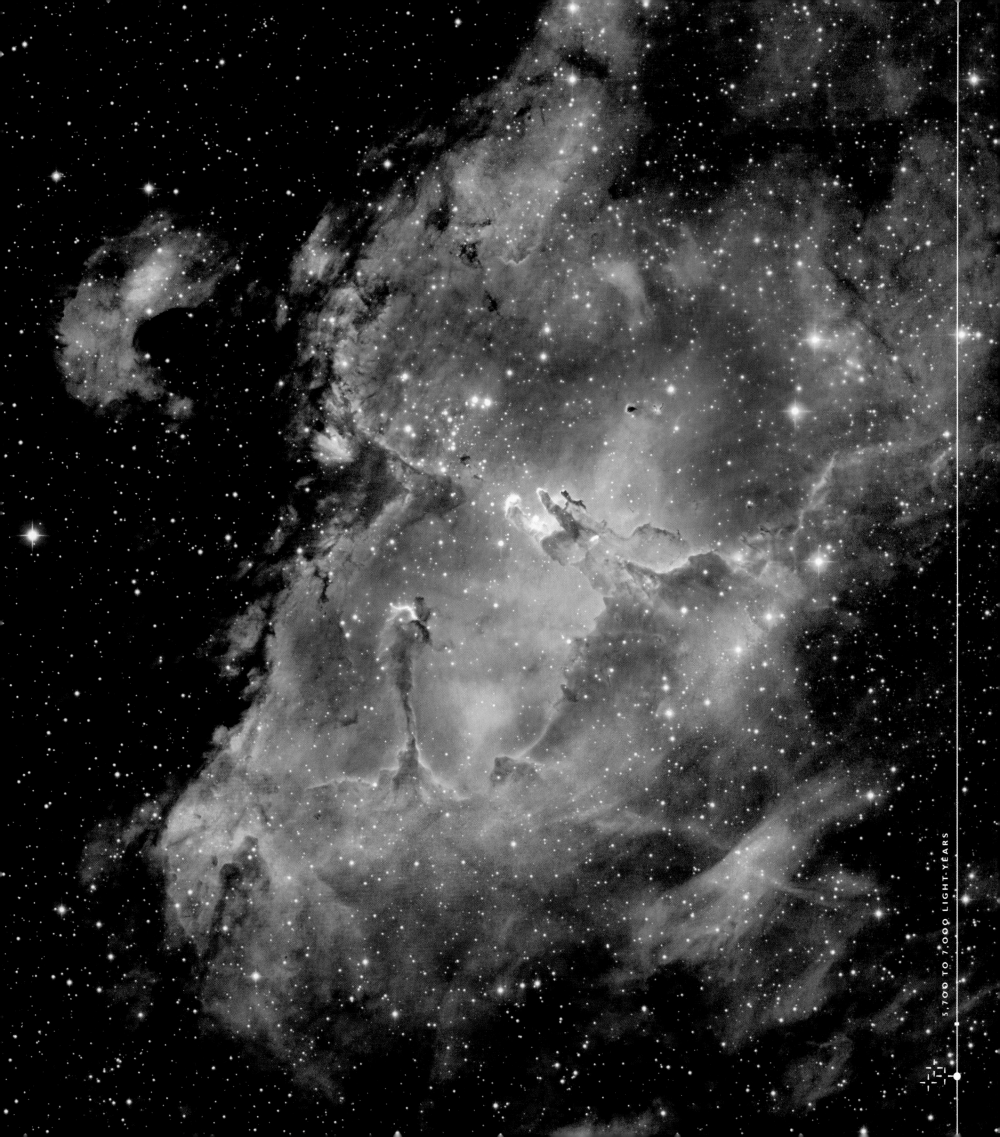

half from new observations. Using an average of 25 orbits per year, the Hubble Heritage Project takes up less than one percent of the total available observing time. Yet even that is a significant commitment and reflects the importance the Institute and NASA place on creating visually appealing images. Both argue, reflecting Keith Noll's words, that the images repay the public's continued support of the Hubble Space Telescope's scientific mission. Rather than rely on fuzzy images, graphs, or text that require a forbidding level of scientific expertise, the images use a visual language—light, color, and composition—to communicate a sense of wonder and awe about the universe. By using another mode of expression, one perfected within the world of art, the images inspire audiences at every level—from schoolchildren to adults, policymakers to astronomers.

HUBBLE'S AESTHETIC APPEAL

Why do these images lift the human spirit? They depict fascinating objects, but the way in which these objects are presented, the visual tropes used, and their relationship to a larger visual culture, also play a role. The most striking Hubble images typically exhibit a high contrast between light and dark tones. The Eagle Nebula and the Cone Nebula images include the darkest of blacks in the columns and the brightest whites in the stars and tops of the columns. In the Sombrero galaxy, the brilliant white of the core contrasts with the dark edge of the dust cloud and the black background of the sky. These examples also contain a full range

of tones between light and dark.

Vivid colors emphasize this dynamic range and give the objects a sense of solidity and mass. The pillars in the Eagle Nebula vary from mustard yellows to red, while the background begins as a deep blue at the top of the image and blends to greener tones in the regions surrounding the columns. The intensely glowing red background of the Cone Nebula enhances the three-dimensionality of the form. The image of the supernova remnant LMC N 49 weaves together blue, gold, red, and green. Against the black and white star field, the cloud of gases becomes almost a tangible form. In another example, the spiral galaxy NGC 1512 appears as a glowing yellow form streaked with red and backlit with blue and purple. While views of galaxies tend to display more subtle tones, color remains an essential element of the images. The greenish arms of the Whirlpool galaxy are ridged by reddish stars, which highlight the spiral form. These structures twist together into a glowing yellow core.

In the cases of the Eagle and Cone, choices in composition are made to evoke a sense of size. The brightest regions are positioned at the top of the images. This is an arbitrary choice with the Eagle Nebula, since north is located diagonally to the left. These glowing regions pull the eye upward, giving the forms a monumental sensibility. Composition assists in suggesting the vastness of space in other images. The brightest point is often centered, as in the Whirlpool galaxy or NGC 1512, functioning as a vanishing point would within a landscape painting, drawing the viewer into the image.

This suggestion of movement toward a center is characteristic of a spiral, but it appears in images of other

phenomena as well. In the mosaic of the Orion Nebula, the luminosity at the center contrasts with the outer edges and creates a sense of depth. As Christiaan Huygens suggested centuries ago, it looks as if the sky is opening to reveal another realm.

A scene of stars and pillars in NGC 3603 follows a similar format. The brilliant blue of the trio of stars at the center of the image draws the eye into space, while the glowing tops of the gaseous forms point toward this potentially infinite distance. Centering these phenomena obeys the logic of presenting a specimen for study and observation. It also has an undeniable aesthetic impact for the viewer, suggesting vastness and infinity.

The few images described on these pages and many others included in this book have a shared set of attributes: extremes of light and dark, vividness of color. As a collection, the Hubble Heritage images represent neither the average nor ordinary in nature, but they give us the extraordinary and spectacular. The images also reflect great interest in the dynamic, even violent, forces of the universe, often portraying colliding galaxies and exploding stars.

These same qualities define the experience of the sublime, a notion that was first applied to aesthetics in the 18th century and became associated with experiences of overwhelming grandeur and power, which can elicit feelings of awe, wonder, and even transcendence. Artists throughout the 19th century depicted the landscape as sublime, especially the unexplored frontier.

The Hubble images bring us new views of the latest unexplored frontier—outer space—and the artistry of those who created them encourages us to respond with awe.

EAGLE NEBULA (1995) Contrasting images of one of the pillars in the Eagle Nebula. The image at left was taken from data collected by the WF/PC2 in April 1995; the image at right is a colorized version from the same set of exposures. Both show fingers of gas and dust created in the shadow of dense protostar systems. These systems block radiation from intensely hot, massive stars clustered in the nebula's cavity. The tiny tips of these fingers are comparable in size to our solar system. The juxtaposition of these two images nicely captures the range of interpretive imaging that astronomers employ in the extensive processing of the digital data from the Hubble. The black-and-white image provides a high-contrast landscape, allowing the intricate structures of the nebula to be mapped. The full-color rendition was color-coded to reveal the specific behavior of different gases within the nebula. Together, this information has proven useful for deciding how stars are produced. The spectacular images of the Eagle on these pages recall the great excitement after Jeff Hester released them publicly, when they were splashed across the covers and pages of many national magazines, evoking names ranging from the "Pillars of Creation" to "space serpents."

5,700 TO 7,000 LIGHT-YEARS

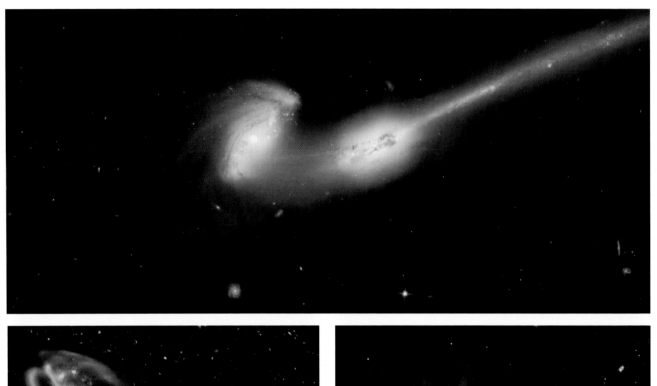

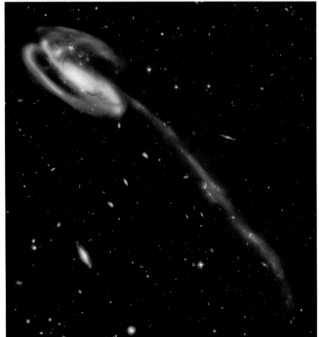

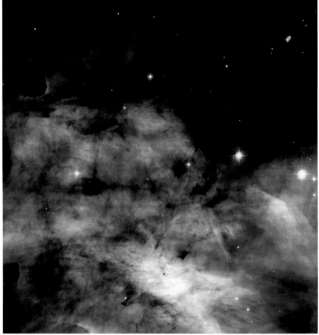

Top: **MICE NEBULA (2002)** Sheets, streamers, tails, and cones—every imaginable geometrical shape—can be found in the heavens, providing astronomers with a richly colorful arsenal of descriptive names. The "mice" —actually galaxies—chase each other some 300 million light-years away in the constellation Coma Berenices. *Above left:* **TADPOLE GALAXY (2002)** Deep in extragalactic space, 420 million light-years away, is the Tadpole galaxy, a distorted spiral suffering from the tidal effects of a colliding interloper. *Above right:* **OMEGA NEBULA (2002)** Illuminated by ultraviolet radiation from massive, newly born stars, gases in the Omega Nebula (M17) glow with the blue, green, and red light emitted by hydrogen, nitrogen, oxygen, and sulfur. *Opposite:* **CONE NEBULA (2002)** This nebula is a variation on the pillars in the Eagle Nebula and a region of recent star formation, only 2,500 light-years away.

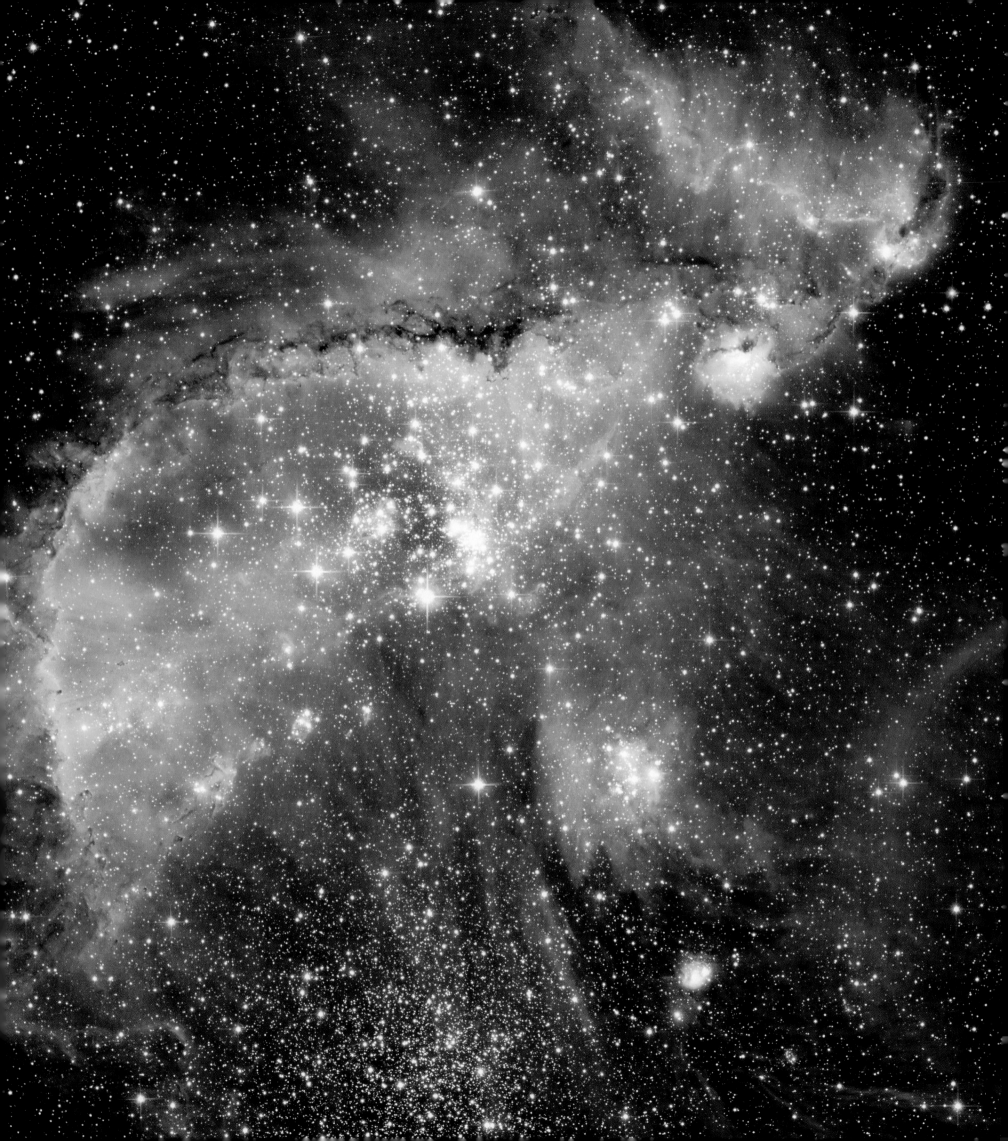

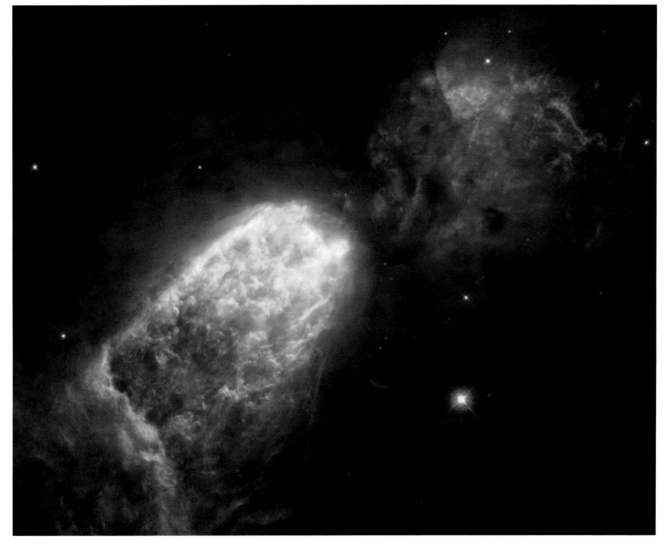

Opposite: **STAR-FORMING REGION IN SMALL MAGELLAN- IC CLOUD (2005)** A very wide-field view shows a star-forming region in the Small Magellanic Cloud, the lesser of the two galactic companions to the Milky Way. In its center, NGC 346, a very tight, bright cluster of young hot stars is blasting a hole in the nebula that gave it birth. Jagged and contorted structures, like the arch of dark-er material above the cluster, reveal areas where gas and dust are being forced into dense globules. These are the nurseries for new stars, where the Hubble has detected infants as young as a few million years old. *Above:* **BIPOLAR NEBULA IN CYGNUS (1995)** Captured by the Hubble's WF/PC2, this two-lobed cloud of ionized hydrogen may be the chrysalis of an infant star-forming region.

THE LANDSCAPE OF SPACE

THE ART OF THE HUBBLE IMAGE

The HST images depict distant skyscapes and alien objects, yet the scenes do not appear wholly unfamiliar; they resemble earthly landscapes. The press release that accompanied the Eagle Nebula image described the formation of the gaseous columns in landscape terms, as "analogous to the formation of towering buttes and spires in the deserts of the American Southwest." The comparison appears again with the Cone Nebula, which the press release portrays as a "craggy-looking mountaintop."

But more than just looking like buttes and mountains, the images continue a tradition of representing the awe and majesty of nature. In the last decades of the 19th century, artists such as Frederic Church, Albert Bierstadt, and Thomas Moran created paintings of the American West with a similar sensibility. Traveling through Colorado, Wyoming, Arizona, California, and other western states, these artists provided an eager public back home with a glimpse of the incredible scenery of the already mythical West.

In 1871, Moran accompanied a government-sponsored expedition surveying the Yellowstone region. Under the lead of F. V. Hayden, the group not only created detailed maps, but also collected scientific data; Moran documented the landscape they covered as well. Like the Hubble Heritage Project images, his work can be seen as a federally supported effort to forward the interests of science through art. Purchased by Congress, "The Grand Canōn of the Yellowstone" once hung with another of Moran's paintings, "The Chasm of the Colorado" (1873–74), in the U.S. Capitol; now

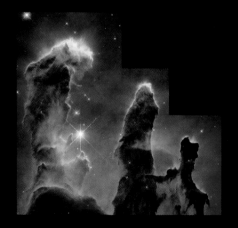

both paintings are in the Smithsonian American Art Museum. The HST images and Moran's paintings also share a set of visual characteristics. High contrast between light and dark, vivid colors, and suggestions of vastness and infinity are prominent in both. In "The Grand Cañon of the Yellowstone," areas of shadow alternate with regions flooded in brilliant light. Although a rock canyon permits only a restricted palette, Moran carefully incorporates vivid hues whenever possible. The intense blue of the river contrasts with the warm yellow tones of the canyon walls, and rich greens frame the lower portion of the vista.

Moran's paintings also suggest scale. Figures dwarfed by the landscapes that spread before them are a measure of the immensity of the scene, but they also promise the possibility of experience. Moran and his peers in the 19th century extended an invitation. New railways and hotels would soon make the sites of his paintings accessible.

Whether for science or for public display, all HST images are mediated through the telescope. Still, a human hand is at work communicating the majesty of the images. Instead of a painter at the site, astronomers and image processors interpret the data and create a compelling representation. The resulting images of nebulae, galaxies, and star fields recall a well-established aesthetic tradition and in the process make these distant spacescapes familiar.

EAGLE NEBULA AND YELLOWSTONE Astronomers using Hubble data consciously compared the new celestial vistas they were crafting with the Romantic forms of landscape art that defined American expansionism and exceptionalism in the late 19th Century. Thus after the Eagle Nebula, opposite, was imaged by the Hubble in 1995 and spread far and wide in the media, the pillars created by photoevaporation were constantly likened to the towers and stalagmite structures familiar to explorers of the American West, as depicted by Thomas Moran's "Towers of Tower Falls, Yellowstone," above.

5,700 TO 7,000 LIGHT-YEARS

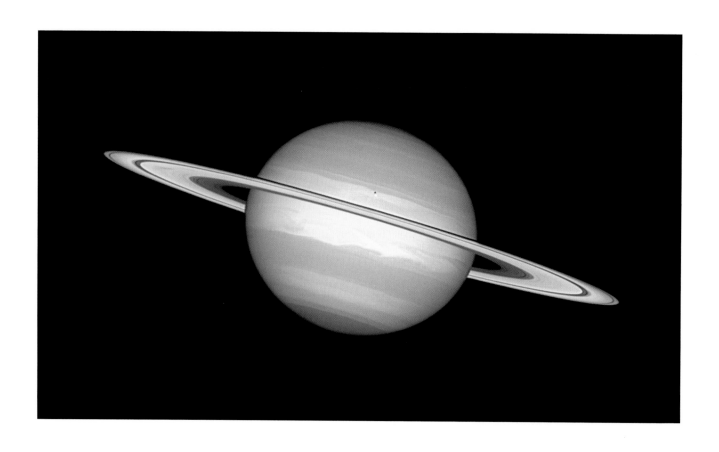

Opposite: **HUBBLE VIEW OF SATURN (1996)** The Hubble's views of the universe have been captivating us for almost two decades and range from planetary to extragalactic in scale. Sometimes, the astronomical image processors try to make an object appear just as the eye might see it from some lofty perch. This view of Saturn released in 1998 highlights the pastel colors that characterize the planet's appearance through telescopes under ideal conditions. *Below left:* **BUBBLE NEBULA, NGC 7635 (1998)** The Bubble Nebula, however, could never be seen by a human eye in this manner, so the colors have been chosen to best reveal its structure and the behavior of the major elements in the vast expanding shell of gas. *Below middle:* **STAR CLOUD IN SAGITTARIUS (1998)** This rich field of stars in the constellation Sagittarius shows the great range of actual color exhibited by normal stars. *Below right:* **SPIRAL GALAXY NGC 7742 (1998)** This dramatic face-on view of the tight spiral NGC 7742 is powered by a supermassive black hole in the center of the yellow "yolk" and ornamented by a ring of active starbirth.

 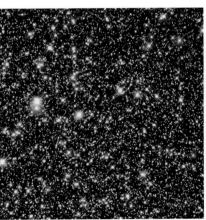 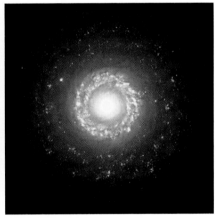

800,000,000 MILES (SATURN)

11,000 LIGHT-YEARS (BUBBLE NEBULA)

15,00 TO 20,000 LIGHT-YEARS (STAR CLOUD IN SAGITTARIUS)

72,000,000 LIGHT-YEARS (SPIRAL GALAXY)

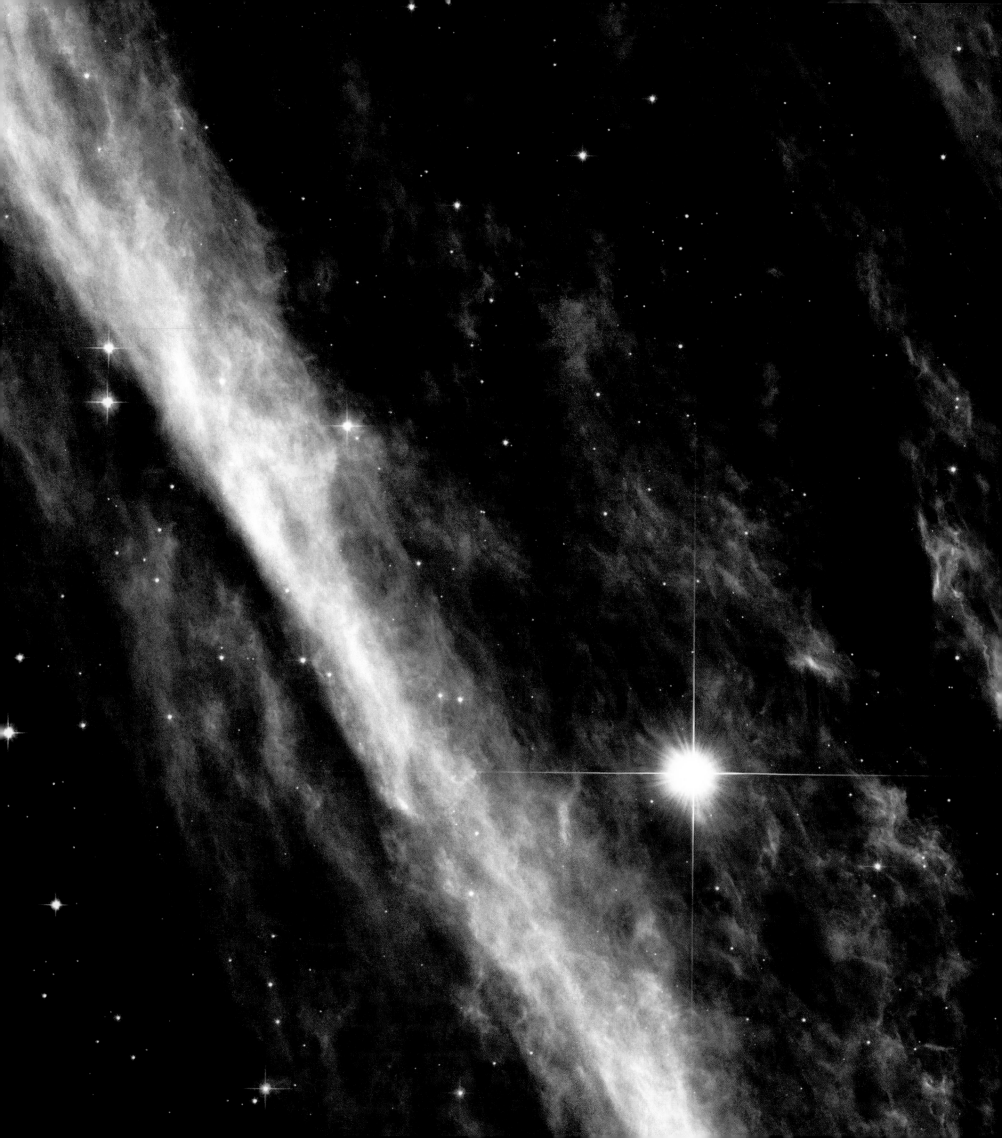

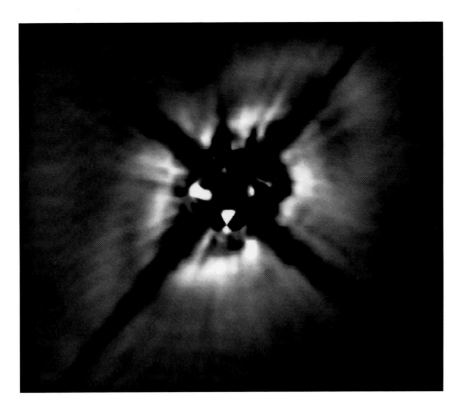

Opposite: **PENCIL NEBULA, NGC 2736 (2002)** The Hubble's Advanced Camera for Surveys (ACS) imaged this small portion of the huge Vela supernova remnant. This portion of the remnant, called the Pencil, is part of a great supernova event that was seen on Earth some 11,000 years ago. The blast wave is continuing to excite the interstellar medium in the plane of the Milky Way. *Above:* **DISK AROUND STAR HD 141569 (1999)** Some Hubble images retain obstructions that are necessary for ultra-high resolution. One example comes from the Near Infrared Camera and Multi-Object Spectrometer (NICMOS). The dark spikes are artifacts of the instrument itself, deliberately obscuring the intense light of the central star in Libra to allow its faint ring of dusty material to be studied in detail.

800 LIGHT-YEARS

320 LIGHT-YEARS

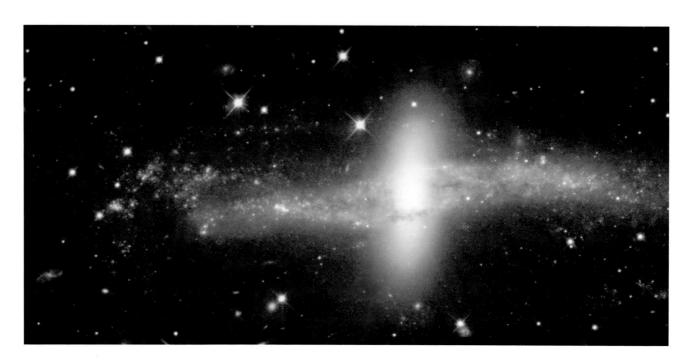

POLAR-RING GALAXY, COLOR (1999) Acknowledging the importance of popular interest in the Hubble's images, STScI astronomers asked the public to vote on the HST's next target. Some 8,000 Internet citizens picked NGC 4650A, a relatively rare "polar-ring" galaxy in Centaurus. Likely the result the collision of two galaxies, one made of old stars in the center, and the other a ring of younger stars surrounding it, the odd couple may be held together by massive amounts of dark matter.

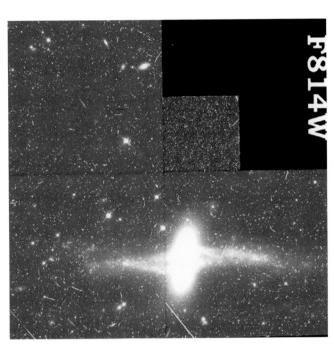

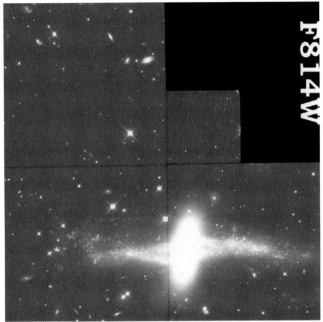

POLAR-RING GALAXY, ALTERNATE PROCESSING (1999) The color image opposite has been highly processed. To show voters what the original was like before processing, NASA also released the two additional images above. The left-hand image is raw, including speckly blemishes from cosmic rays and the intersections of WF/PC2's chips. The right-hand image has been processed in black and white.

130,000,000 LIGHT-YEARS

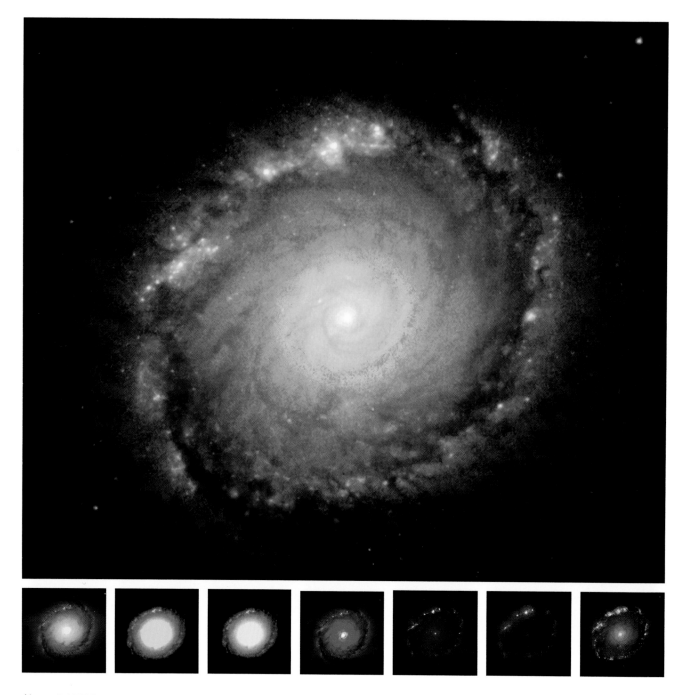

Above: **BARRED SPIRAL GALAXY NGC 1512 (2001)** Three instruments aboard Hubble—the Faint Object Camera (FOC), the Wide Field and Planetary Camera 2 (WF/PC2), and the Near Infrared Camera and Multi-Object Spectrometer (NIC-MOS)—teamed up to produce this array of images of the barred spiral galaxy NGC 1512. Each of the small images above represents the data from single filters within the instruments. Each was colorized to bring out specific physical characteristics of the objects in the ring surrounding the galaxy. All the images were combined to produce the final image (top) of the galaxy's central bulge and core. *Opposite:* **BARRED SPIRAL GALAXY NGC 1512, WIDE VIEW (2001)** The full-field view of the WF/PC2 reveals much of the NGC 1512's ring. Blue stars around the galaxy's outer edge trace its spiral arms.

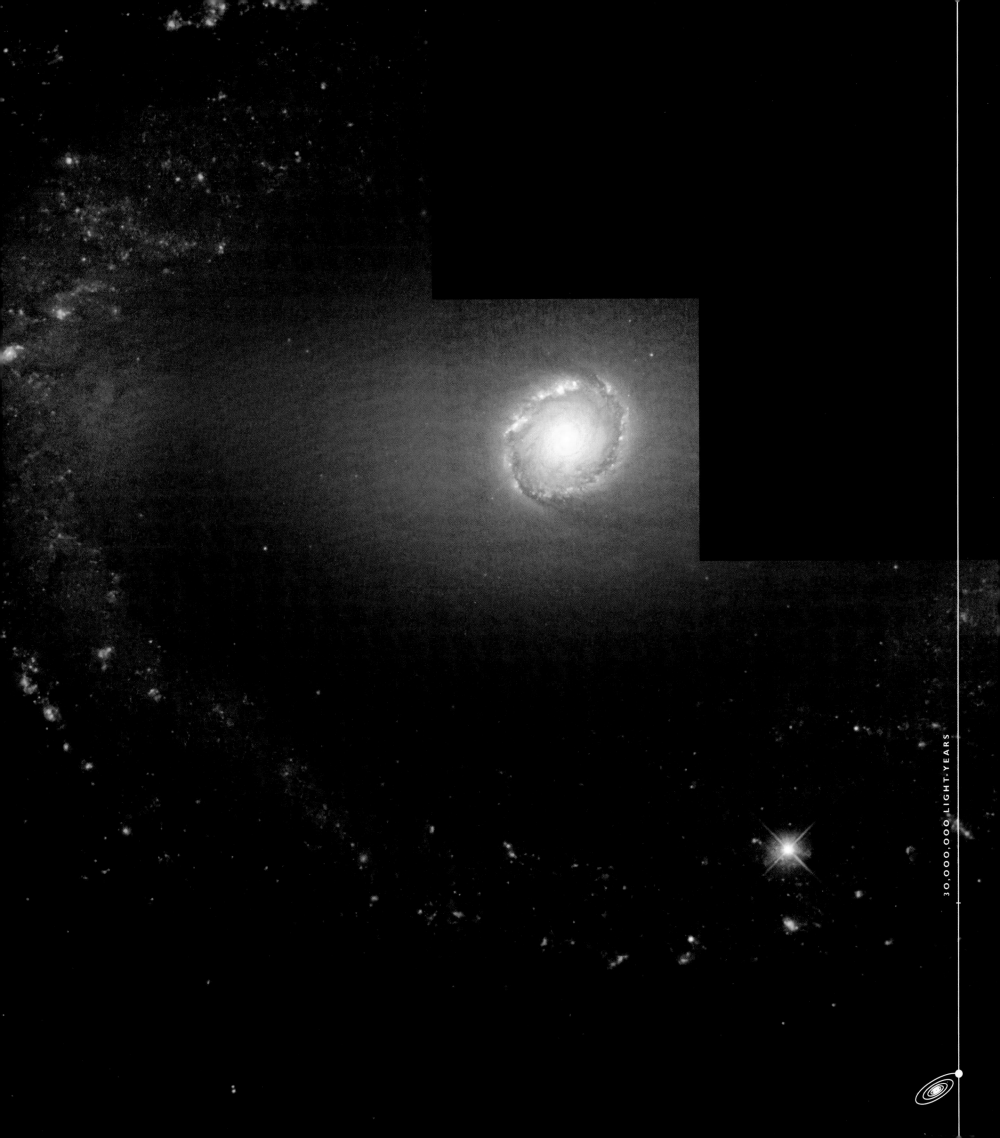

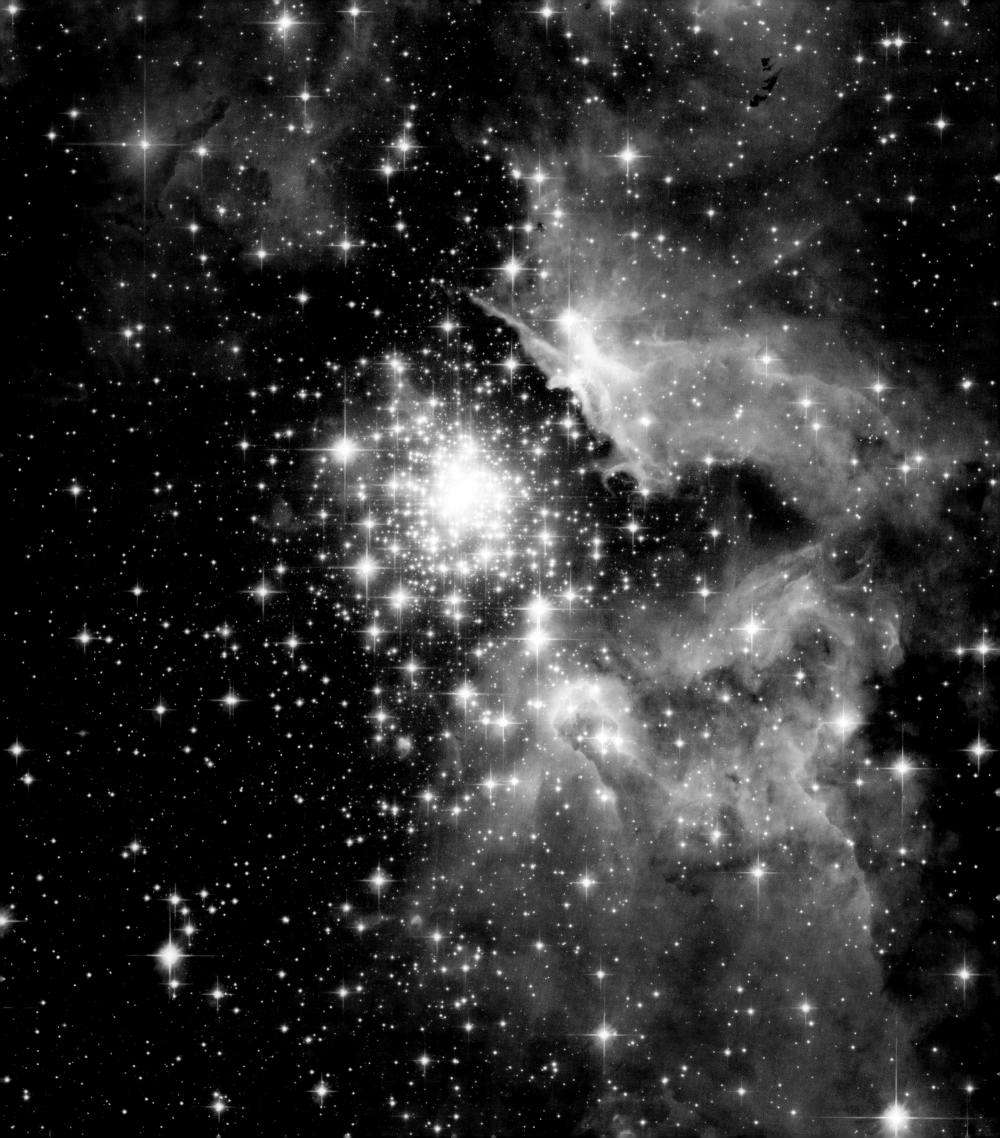

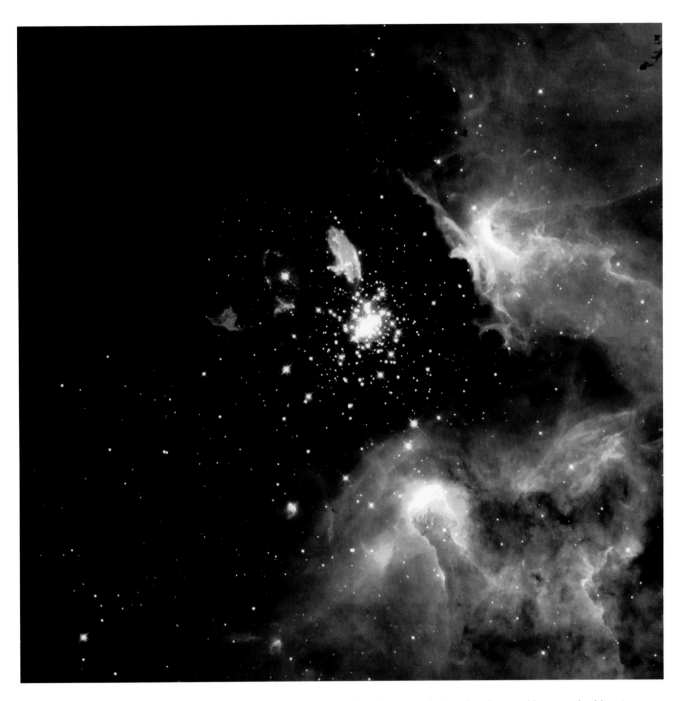

Opposite: **NGC 3603 (2007)** Two different Hubble instruments imaged a rich cluster of young hot stars in the Carina spiral arm of the Milky Way. The image opposite was made with the WF/PC2. *Above:* **NGC 3603 (1999)** This image, made with the ACS, shows a comparable field of view. In both images, the central cluster of stars is exciting clouds of dust and gas in the vicinity, a prelude to forming new stars. Several odd blue structures near the cluster are believed to be an older star shedding its outer atmosphere and a star ejecting a ring of gases in a manner similar to supernovas. The dark specks in the upper right are known as Bok globules, pre-stellar clouds of dense gas and dust named after the Dutch-American astronomer who first cataloged objects of this type. Thus within this single field one can find all stages of stellar evolution in an area of space 19 light-years wide.

20,000 LIGHT-YEARS

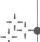

SOMBRERO GALAXY, M104 (2003) This Hubble image of the Sombrero galaxy shows its spiral structure even though the galaxy spins almost edge-on to our view. The Sombrero is on the near side of the huge Virgo cluster of galaxies on the border between the constellations Virgo and Corvus. It is among the more massive spirals in the group and is distinguished by its beautiful symmetry and by the dark band of gas and dust drawn along its equatorial girth. The Sombrero was never an official entry in Messier's published 1781 listing of objects, although he did record it. William Herschel was the first to catalog it formally and also the first to record the existence of the absorbing dust lane. It is faintly visible in small telescopes and is a favorite object of stargazers on moonless spring and summer nights.

> "THESE CURIOUS OBJECTS, NOT ONLY ON ACCOUNT OF THEIR NUMBER, BUT ALSO IN CONSIDERATION OF THEIR GREAT CONSEQUENCE, AS BEING NO LESS THAN WHOLE SIDEREAL SYSTEMS, WE MAY HOPE, WILL IN FUTURE ENGAGE THE ATTENTION OF ASTRONOMERS."
>
> —SIR WILLIAM HERSCHEL, 1789

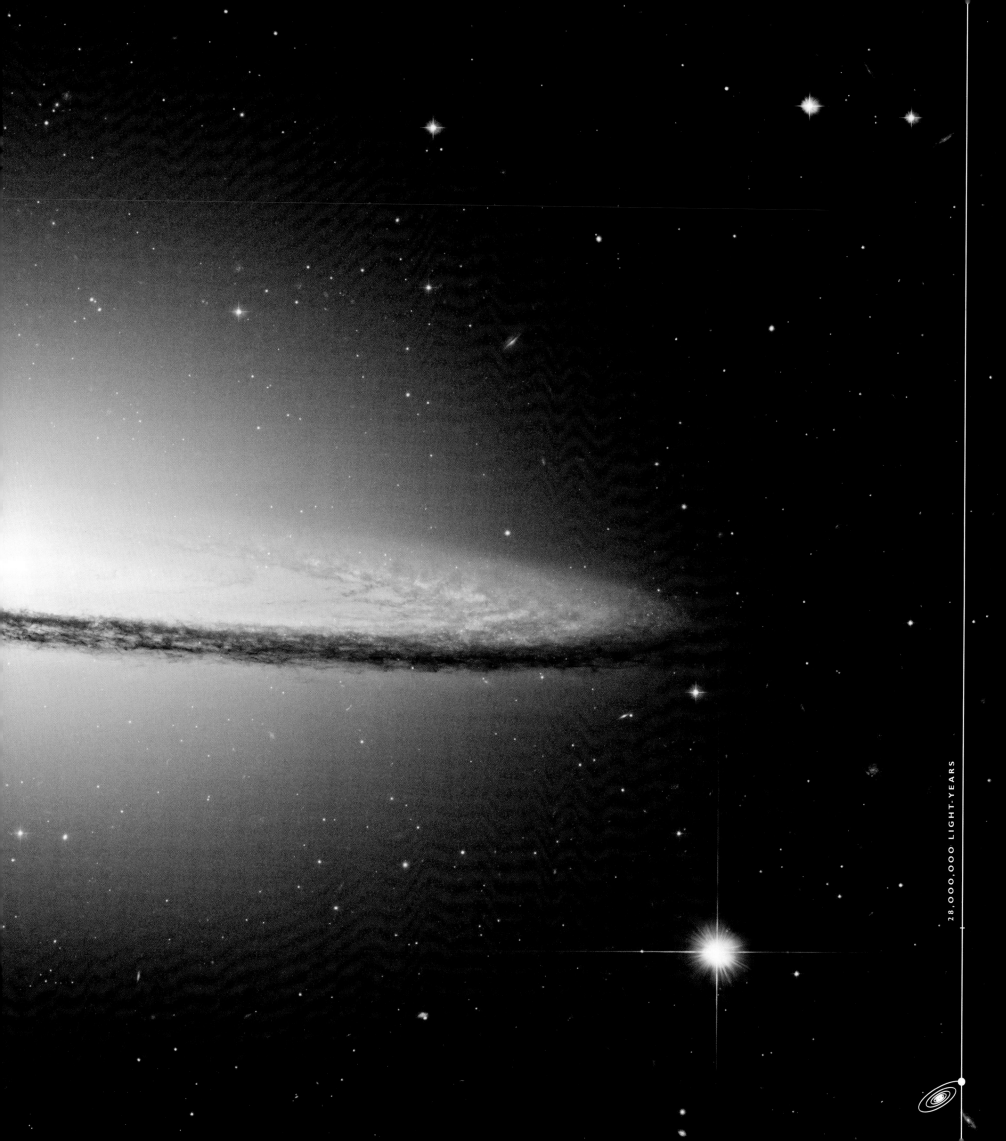

28,000,000 LIGHT-YEARS

The Hubble Space Telescope has confirmed and expanded our ideas about many kinds of astronomical objects as well as our view of the universe. The Hubble has had a major impact in many areas, including the study of the ways planets of our own solar system can be changed by the impact of cometary debris; how stars are born, live their lives, and often die in spectacular paroxysms of light and mass dispersal; how fast the universe is expanding and how old it is; and the formation and evolution of galaxies.

OUR NEAREST NEIGHBORS

In the early planning for what became the HST, the primary goal of the telescope was extragalactic astronomy. But astronomers knew that the HST was also a valuable tool for examining planets in our solar system as well as other astronomical targets much closer to home. And so it has proved, with observing time devoted to solar system research in each research cycle. The WF/PC and WF/PC2 were designed in part to take high-resolution images of planets' atmospheres, surfaces, and their attending moons. Some of the other Hubble instruments have examined the compositions of planetary atmospheres and properties of comets. Although even the Hubble's ability to resolve details cannot match what has been possible from a spacecraft sent into orbit around, or one that landed on, a planet, it does allow scientists to monitor ever changing planetary weather and surface patterns. Perhaps the most remarkable planetary images taken by the HST came when, over several days in 1994, comet Shoemaker-Levy smashed into Jupiter.

As this fragmented comet rushed toward Jupiter, astronomers worldwide joined to observe it with the HST and ground-based telescopes. The collisions actually occurred on the side of Jupiter turned away from Earth, but within a few hours the huge atmospheric shock waves from these crashes were readily detected. As the cometary chunks hurtled into Jupiter's atmosphere, they created enormous fireballs. Some of the shock waves persisted for more than a month and were tracked by the HST to provide astronomers with data on the movement of winds in the atmosphere of Jupiter. Astronomers had never before been spectators to this sort of cosmic cataclysm, and learned much about the structure of Jupiter's atmosphere by closely monitoring these gigantic natural probes.

THE BIRTH AND DEATH OF STARS

As well as shedding new light on our planetary neighbors, HST has expanded our knowledge of the lives of stellar objects, from birth to death. The idea that stars actually

Preceding pages: **STARS IN NEBULA NGC 6357 (2006)** High-resolution images from the HST reveal the secrets of one of the most massive stars known, Pismis 24-1. The brightest in a young star cluster, it is actually a double-star system consisting of two 100-solar-mass stars. They and other stars in the cluster illuminate the surrounding nebula, NGC 6357 in Scorpius. *Opposite:* **GALAXY CLUSTER ABELL S0740 (2007)** This spectacular composite, created with the ACS, highlights the giant elliptical galaxy ESO 325-G004 at the center of a cluster of galaxies 450 million light-years away.

450,000,000 LIGHT-YEARS

have lives—that they are born, live, and die as finite energy-generating and energy-consuming bodies—did not take a recognizably modern form until the mid-19th century. By the mid-20th century, scientists knew that stars were great spheres of glowing gas sustained by a delicate balance of forces. The inward pull of gravity, caused by a star's enormous mass, was balanced by the outward push of radiation from thermal and nuclear sources. Any imbalance caused the star to change.

Astronomers believe stars like the sun generally form individually or in clusters out of vast clouds of gas and dust. The Orion Nebula and its environs is a fine local example of a stellar nursery, as is the Eagle Nebula. The beautiful high-resolution, full-color Hubble images of these regions actually reveal newborn stars just emerging from their rapidly subliming sacks of ice, gas, and dispersing dust. Typically these clouds evaporate when the most massive, and therefore most energetic, stars start shining, flooding their neighborhoods with high-energy radiation. Spikes and columns of dense material can be seen standing in the shadows of stars illuminated by these superhot neighbors.

In observing a number of very young stars in some star-forming regions, as well as mature isolated stars, the Hubble has detected disks of matter around them that will in time form into planetary systems. These finds, together with similar ones by other telescopes, have led astronomers to suggest that such disks are common to stars, thus vastly increasing the likelihood of other solar systems. The Hubble has also taken high-resolution images of regions of star formation where, as a result of turbulence in these accretion disks, matter is violently ejected in shock waves back out into space. One of the most interesting examples is the Herbig-Haro object HH-47, imaged by the WF/PC2. At a distance of about 1,500 light-years, this jet is trillions of miles in length. It is believed to be the result of rapid inflow from an accretion disk surrounding a binary star system in formation.

Our own sun is far older than these systems. Stars similar in age to the sun are very long-lived, typically stable for billions of years. But once the hydrogen fuel available for fusion in such a star's central regions is exhausted, a series of developments propels the star into becoming a type known as a red giant. When our sun reaches this point in its life it will inexorably expand, becoming red and engulfing the orbits of the inner planets. The red giant stars that we see today are necessarily very old stars, so we find them typically in older regions of the galaxy, such as in globular clusters.

Red giant stars of the mass of the sun do not last terribly long by cosmic standards, probably a few hundred million years. Typically, for stars from one solar mass—that is, a star containing as much mass as our sun—and up to eight solar masses, the outer atmosphere dissipates in time. Perhaps it forms what is known as a planetary nebula. (These objects have nothing to do with planets, but William Herschel gave them this name because they had a disklike appearance in his 18th-century telescopes.) The HST has shown that these dissipating stars are extraordinarily beautiful and complex objects. With the formation of a planetary nebula, the mass-losing star eventually becomes a hot, extremely dense white dwarf star.

Stars yet more dense than white dwarfs can result from cataclysmic stellar explosions known as supernovae, which are among the most violent events in the universe. Astronomers believe that stars explode for a number of reasons, but true supernovae occur only in stars of at least eight solar masses. These stars exhaust their stores of hydrogen fuel quickly and rapidly expand to become giants, burning helium and later other elements, such as carbon. But after all the available fuel is exhausted, the core of the star collapses rapidly, making the entire star violently unstable. A prodigious amount of energy is released in an incredibly short time, causing a shock wave to travel through the star, literally blowing it apart. As the shock wave penetrates into space, it encounters and heats up gas and dust, creating a fantastic series of arcs, shells, and explosive remains. The Hubble has taken a close look at such a remnant, Supernova 1987A, which exploded in the Large Magellanic Cloud in 1987.

Supernovae typically result in incredibly compressed cores, denser by far than white dwarf stars, called neutron stars. The stellar material has collapsed in on itself at the atomic level, rendering protons and electrons no longer distinguishable and causing the entire star to behave like a single gigantic neutron. Neutron stars spin increasingly swiftly as they are reduced in size, just as an ice skater spins faster as she draws in her arms. If these rapidly rotating neutron stars are massive enough, they will continue to collapse to become black holes. These objects are so dense that not even light can escape their gravitational fields. Astronomers have also detected evidence for the existence of a supermassive class of black holes lurking in the centers of many galaxies, including our own Milky Way galaxy. The largest of these

objects can power incredibly energetic processes that produce quasars. Black holes cannot be seen directly, but reveal themselves by their gravitational presence as they perturb the material in their vicinity.

THE EXPANDING UNIVERSE

When Edwin Hubble first correlated the redshifts of galaxies with their distances in the late 1920s, he reckoned that for every megaparsec (3,260,000 light-years) one moved out into space, the redshift increased by approximately 500 kilometers a second. Calculations of this term—later known as the Hubble constant—changed as Hubble refined his observations and other astronomers recalibrated them. As a result of new measurements of the distances to galaxies in the decades that followed Hubble's death in 1953, other astronomers argued that the value was considerably lower than Hubble's initial estimate. By the early 1970s, when planning for the HST was seriously under way, quoted values of the Hubble constant had dropped to 100 kilometers a second per megaparsec and even lower.

Astronomers today use redshift to estimate distances in the deep universe, required for projects such as the Hubble Deep Field, and also, most significantly, to estimate the age of the universe, since the rate of expansion is an indication of the time since the big bang. The larger the Hubble Constant, the shorter the time since the big bang. Each reduction in the value of the Hubble Constant has therefore meant a lengthening of the estimated age of the universe.

Early estimates of this age, based on the original Hubble Constant, were around two billion years. Something was amiss, since this implied the universe was younger than many objects within it! Even a Hubble Constant of 100 gave an uncomfortably short age for the universe. As a result, scientists wanted to pin down this measurement, to see if the estimated age of the universe and the estimated ages of stars could be reconciled. Astronomers often joked about not knowing this fundamental constant to better than 50 percent of its value, calling it the "Hubble variable constant." When the HST was being built, NASA listed the measurement of the Hubble Constant as its top priority.

To meet this priority, astronomers argued that the HST had to be able to detect Cepheid variable stars at least as far away as the Virgo cluster of galaxies, 20 megaparsecs (about 65 million light-years) distant. Cepheid variable stars are reliable indicators of distance. A team of astronomers formed to pursue the project, choosing galaxies to observe that were likely to contain large numbers of Cepheid stars. Their collective goal was to narrow the constant to within 10 percent of its actual value.

In their final report in 2001, the 16-member Hubble Constant team, led by Carnegie Institution of Washington astronomer Wendy Freedman, reported that they had reached a value of 72 ± 8 km/sec/mpc, making the universe's expansion age around 13.7 billion years. However, another team of astronomers, this one led by Allan Sandage, a one-time student of Hubble's, had found a different value of the constant, using a type of supernova to measure distances to far-off galaxies. Sandage's group estimated that the Hubble Constant was closer to 58 ± 5 km/sec/mpc.

More recently, an entirely new and powerful method of estimating the age of the universe became available. The novel technique used microwave studies of the primordial background radiation, which astronomers interpret as the relic of the big bang. The Hubble Constant value determined by this independent method was 72 ± 0.05 km/sec/mpc, again yielding an age for the universe of about 13.7 billion years. Although these studies have not settled the question of the value for the Hubble Constant completely, the evidence at present points strongly to this value.

The HST has also been closely involved in establishing that the universe is accelerating. Until very recently, astronomers expected that as the universe aged, the expansion would slow down due to the mutual gravitational pull between its various constituents. In fact, observational studies of distant supernovae by the HST in combination with the largest ground-based facilities show that the rate of expansion is accelerating, and all the matter in the universe is being driven apart at speeds that increase in time. This acceleration is fueled by what astronomers and physicists call dark energy: a little-understood force that acts as a repulsive sort of gravity. The properties of dark energy need to be studied in detail by its effect on visible matter. At present, astronomers believe this is the most likely way that they will determine the fate of the universe.

TO THE FURTHEST REACHES OF SPACE AND TIME

When Robert Williams became the second director of the Space Telescope Science Institute, one of his many tasks was to administer the director's discretionary time, a fraction of the

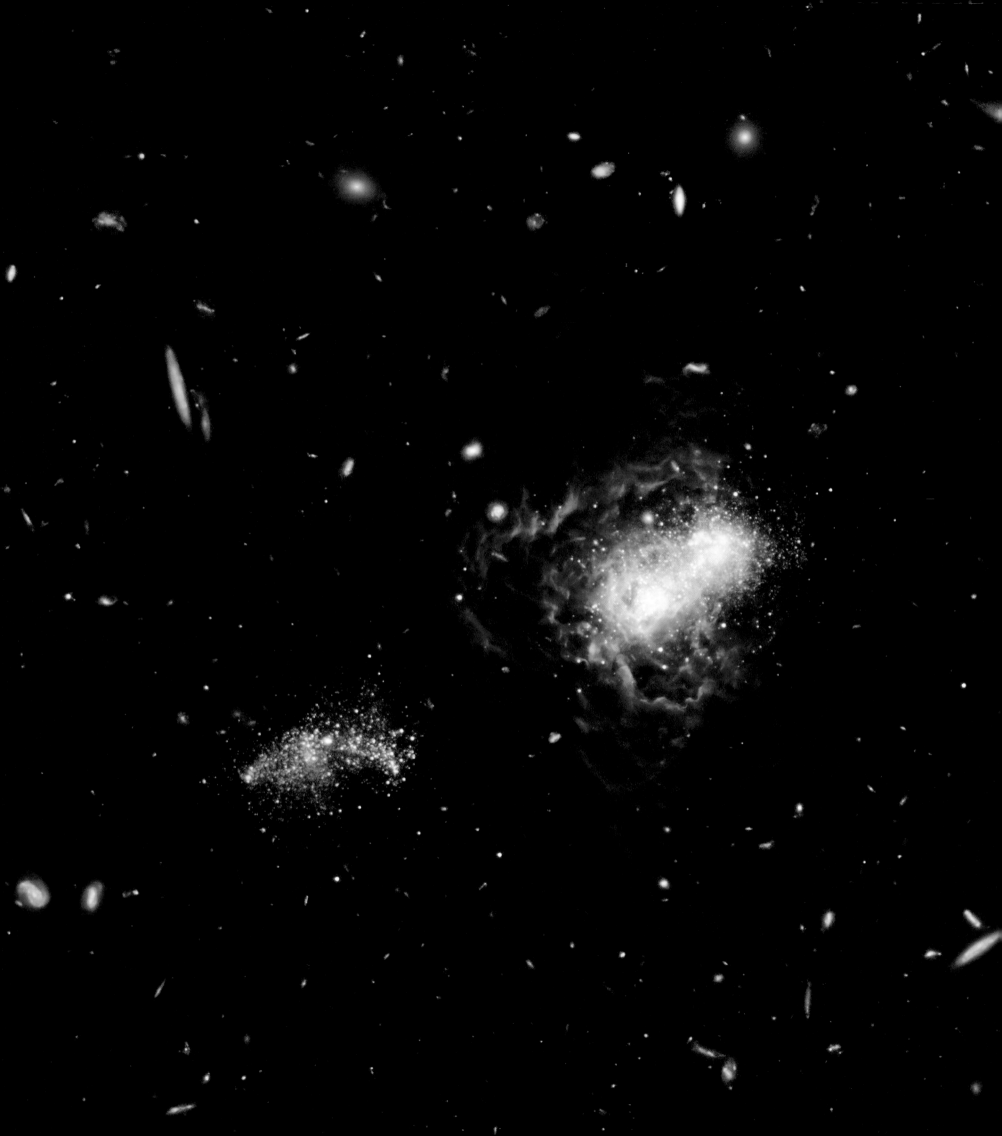

observing time available to the HST. The success of the first shuttle servicing mission in late 1993 induced Williams to convene an international advisory committee of specialists in extragalactic studies to explore how best to use the HST during this time. Eventually the members agreed to a deep survey of a selected part of the sky.

Whenever a new and more powerful telescope goes into operation, or a telescope capable of detecting wavelengths of light in unexplored regions of the electromagnetic spectrum, astronomers typically conduct new surveys of the whole sky. In the case of the Hubble, however, a deep, open-ended survey of the entire sky was not feasible. Hubble's small field of view meant such a project would take an impossibly long time. Instead, one of Hubble's great strengths is in imaging tiny, distant features, allowing astronomers, for example, to examine the structure of galaxies a small fraction of the age of our own. Williams's committee therefore settled on one or two long examinations of one area of the sky, both as a scientific mission and a public legacy for the HST. Since everyone wanted the HST to penetrate into space as deeply as possible, exposures had to be as long as possible so that the light of extremely faint galaxies would be recorded. Further, the exposures had to be of regions of space that were not blocked or partly blocked by foreground stars, galaxies, or clouds of dust and gas. In addition, the field had to be always visible as Hubble sped around its orbit, not blocked by a planet, Earth, moon, or sun.

The four-meter Mayall telescope at the National Optical Astronomy Observatories main campus at Kitt Peak outside Tucson was asked to scout for areas of the sky that met the astronomers' requirements. After its search, the astronomers decided on a field that lies just above the handle of the Big Dipper, in the far northern sky. Its angular extent is no larger than that of a dime seen from 75 feet, yet it covers an immense expanse of space, wholly beyond human comprehension. The Deep Field, as the resulting image became known, thus became a core sample of the universe, a composition generated from 342 separate exposures using the WF/PC2 for ten consecutive days in late December 1995.

At the end, traces of 1,500 galaxies in an unimaginable volume of space were captured in a two-dimensional image. The Deep Field was presented to the public in January 1996, sparking a worldwide effort by astronomers to examine this small patch of sky. Within a short time the Deep Field and the objects within it had been probed in the infrared, x-ray, and radio range, by telescopes on the ground and instruments in space. Eighteen months later, astronomers had determined enough distances of objects in the Deep Field to begin to add a third dimension to the initial two-dimensional image. Some galaxies in the field were so far away—10.5 billion light-years—that their light had been traveling since the incredibly remote past—75 percent back to the beginning of the universe for the most distant objects. After examining the irregular and highly varied shapes of these galaxies at the edge of time, astronomers came to realize that galaxies do not form in huge assemblies that then break into individual galaxies. According to the new view, galaxies actually start out life as small irregular clumps that gather into massive bodies by collision and accretion. They are cannibals that grow larger by gobbling up other galaxies.

The high-powered ACS, added on the fourth servicing mission in 2002, has penetrated even deeper into space than the Deep Field through another series of very long exposures called the Ultra Deep Field. These have consumed 412 orbits and are devoted to reaching an epoch when the first galaxies and quasars began reheating the intergalactic medium. The Ultra Deep Field, imaging a tiny portion of the southern sky in the constellation Fornax, was created through ACS observations combined with NICMOS observations in the far red regions of the spectrum, since these distant objects are highly redshifted. The combined images, taken between September 2003 and January 2004, disclosed that less than a billion years after the big bang the universe was filled with dwarf galaxies, but no fully formed galaxies. Even the HST's observing power, however, has been unable to reveal the formation of the very first stars and clusters of galaxies, perhaps some 200 million years after the big bang. Searching for these fantastically distant objects is a task for the James Webb Space Telescope, slated to be launched in 2018.

I ZWICKY 18 (2007) The 18th entry in Fritz Zwicky's first catalog of galaxies, I Zwicky 18, was originally considered to be a very young galaxy because of the colors of its stars. Its dwarf irregular character also suggested it was typical of the earliest formed galaxies, those that eventually merged to form the large galaxies common in our local universe. Although I Zwicky 18 has prominent starburst regions where stars are just being formed, the Hubble has recently found that there are also very faint, old stars within this galaxy, which means that it has been around for quite some time and may be as old as the Milky Way.

HUBBLE SPACE TELESCOPE OBSERVATIONS

OUR VIEW OF THE UNIVERSE

This all-sky map shows the distribution of fields observed with the HST, as well as the objects within them, over the life of the observatory through 2007. The sinusoidal curve is the plane of the solar system, where the planets are found. The map is oriented to the plane of the Milky Way, so observations of extragalactic space predominate at high north and south galactic latitudes, where views are least obscured by matter within our galaxy. Stars and nebulae are the objects being examined across the galactic equator, where extragalactic views are highly obscured. Prominent in the lower right are two satellite galaxies to the Milky Way: the Large and Small Magellanic Clouds. The dominant grouping of red dots (galaxies) at the top is the Virgo cluster. Thou-

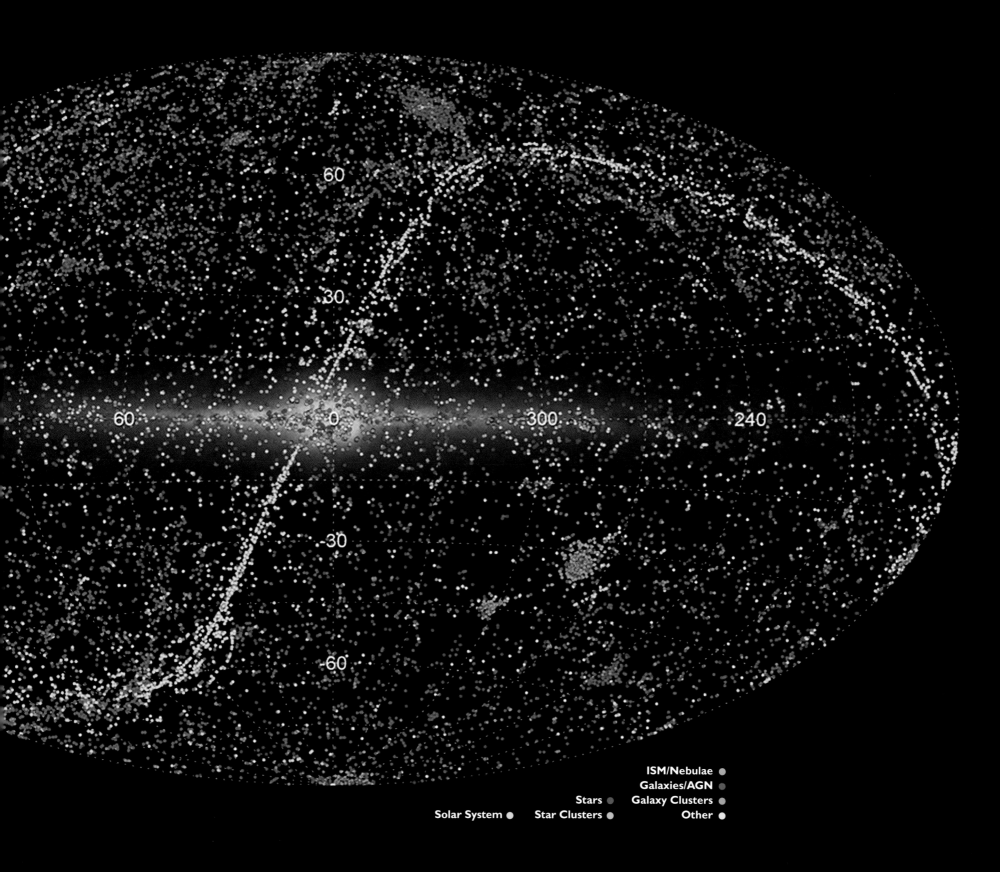

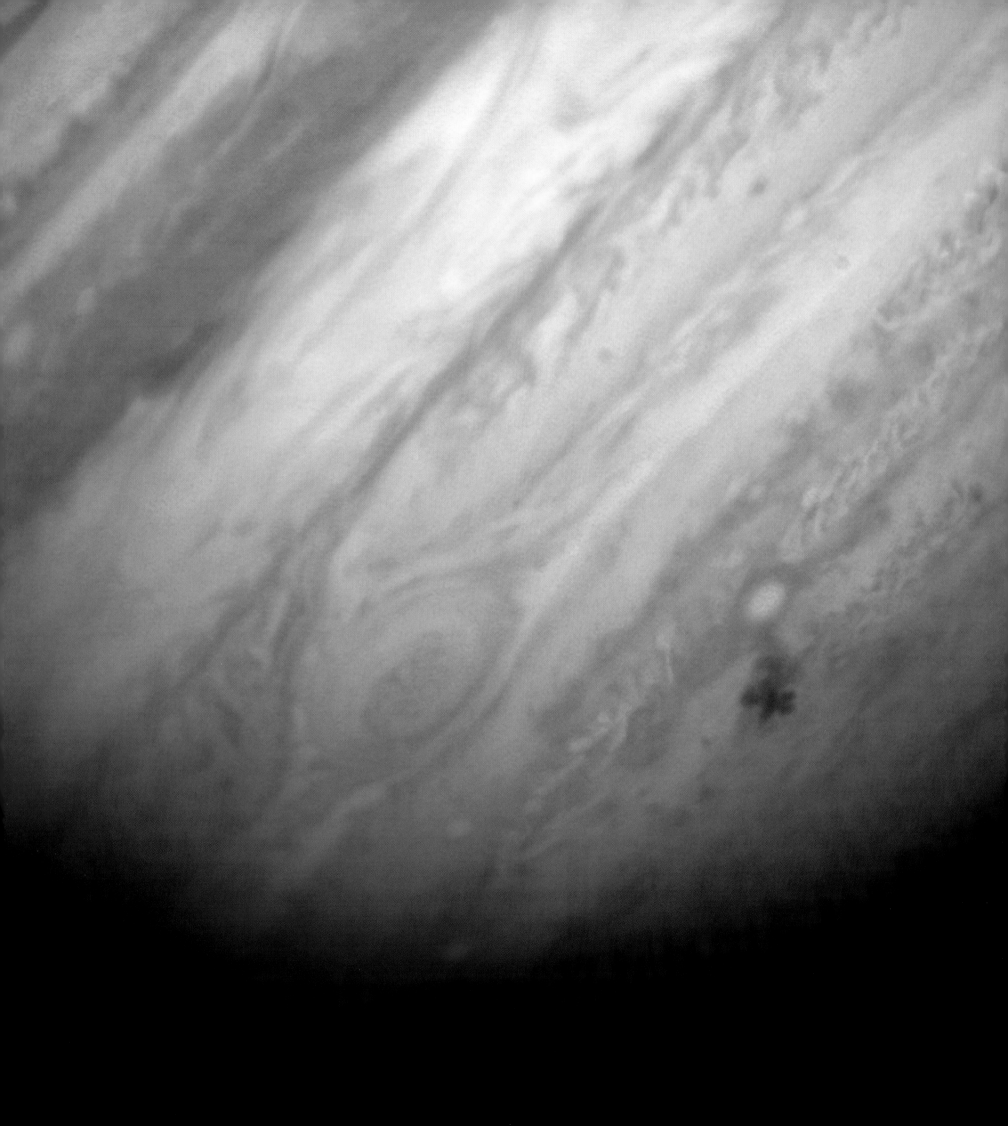

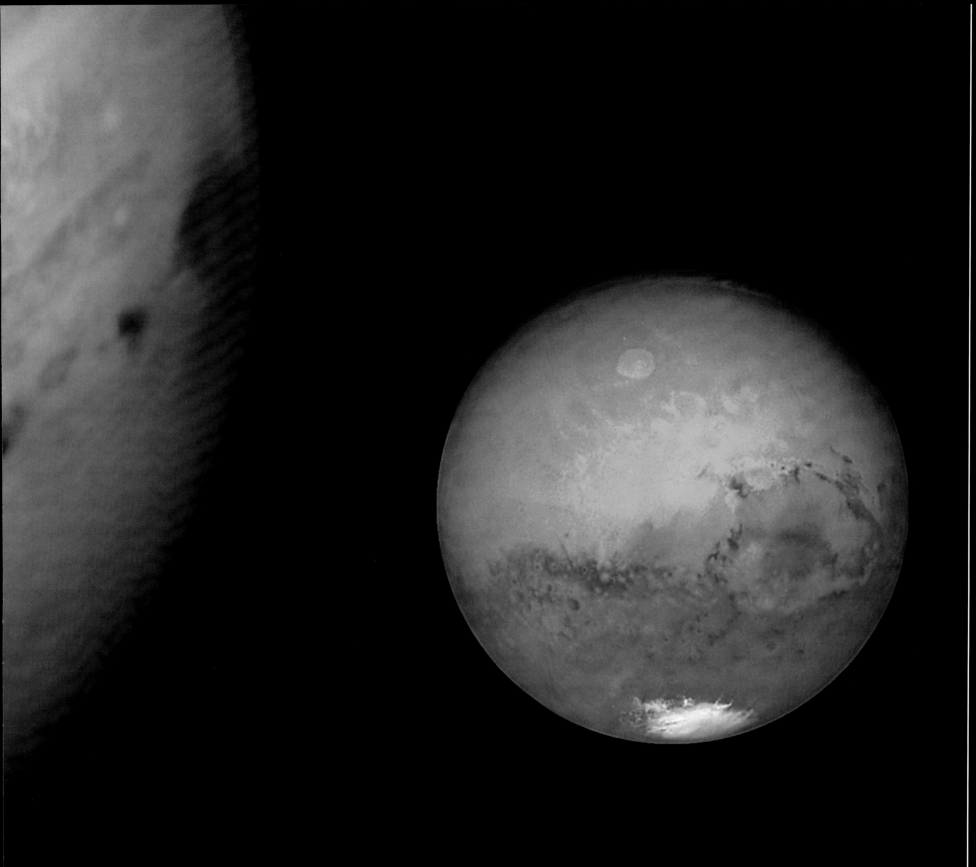

Left: **COMET IMPACTS ON JUPITER (1994)** For almost a week in July 1994, pieces of comet Shoemaker-Levy 9 smashed into Jupiter's atmosphere and left a series of dark smudges across its face that were larger than Earth. Torn up by tidal interaction with Jupiter in 1992, the debris train included at least 21 fragments up to a kilometer or more in size. Data from the Hubble were combined with views from the Galileo probe and from ground-based observatories to portray the first recorded collision of two solar system bodies. *Above:* **MARS (2003)** The Hubble also joined ground-based telescopes on August 27, 2003, to scrutinize Mars at its closest approach.

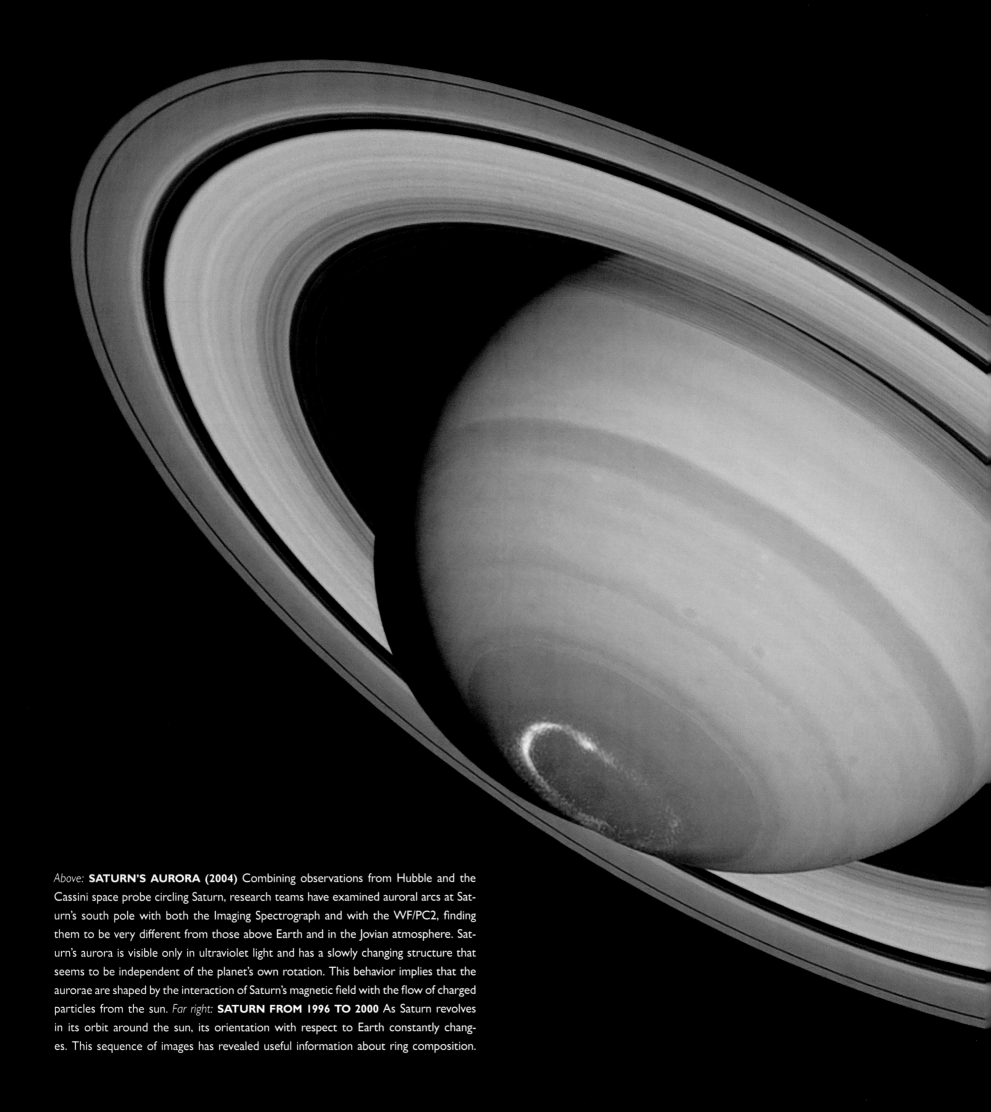

Above: **SATURN'S AURORA (2004)** Combining observations from Hubble and the Cassini space probe circling Saturn, research teams have examined auroral arcs at Saturn's south pole with both the Imaging Spectrograph and with the WF/PC2, finding them to be very different from those above Earth and in the Jovian atmosphere. Saturn's aurora is visible only in ultraviolet light and has a slowly changing structure that seems to be independent of the planet's own rotation. This behavior implies that the aurorae are shaped by the interaction of Saturn's magnetic field with the flow of charged particles from the sun. *Far right:* **SATURN FROM 1996 TO 2000** As Saturn revolves in its orbit around the sun, its orientation with respect to Earth constantly changes. This sequence of images has revealed useful information about ring composition.

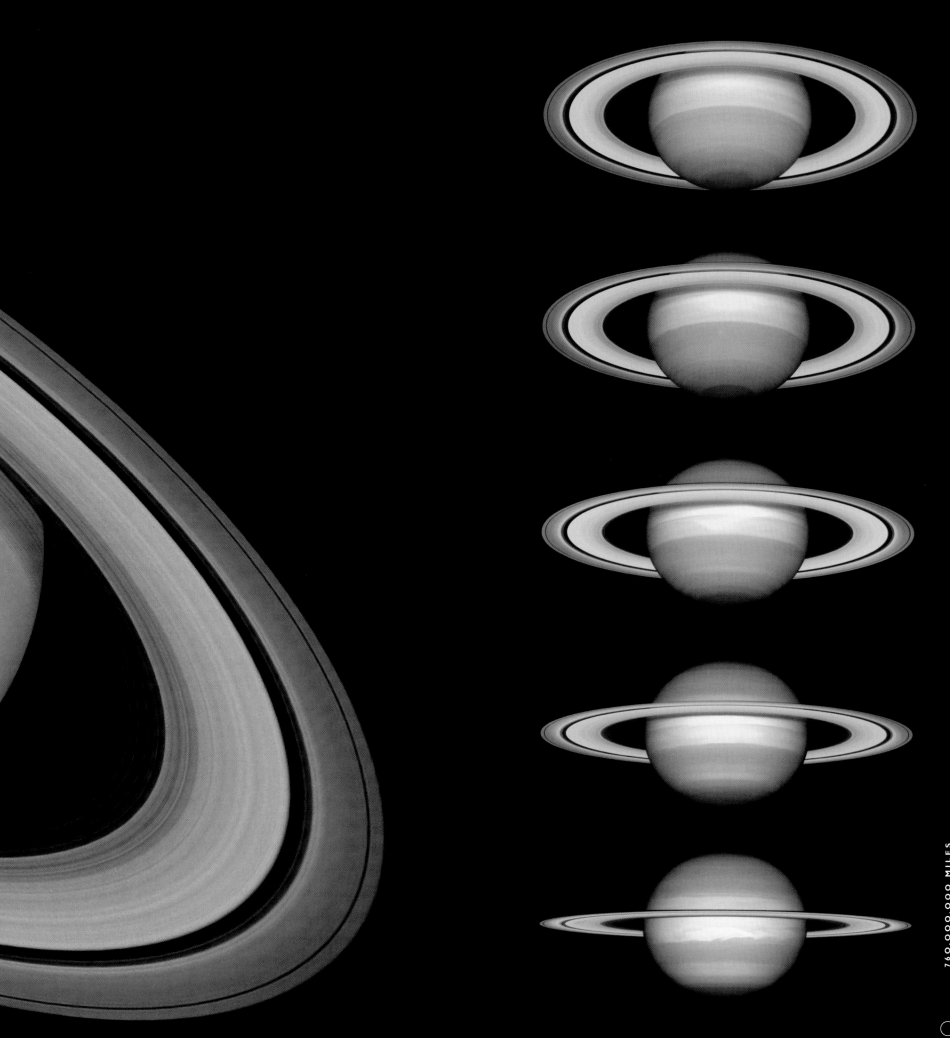

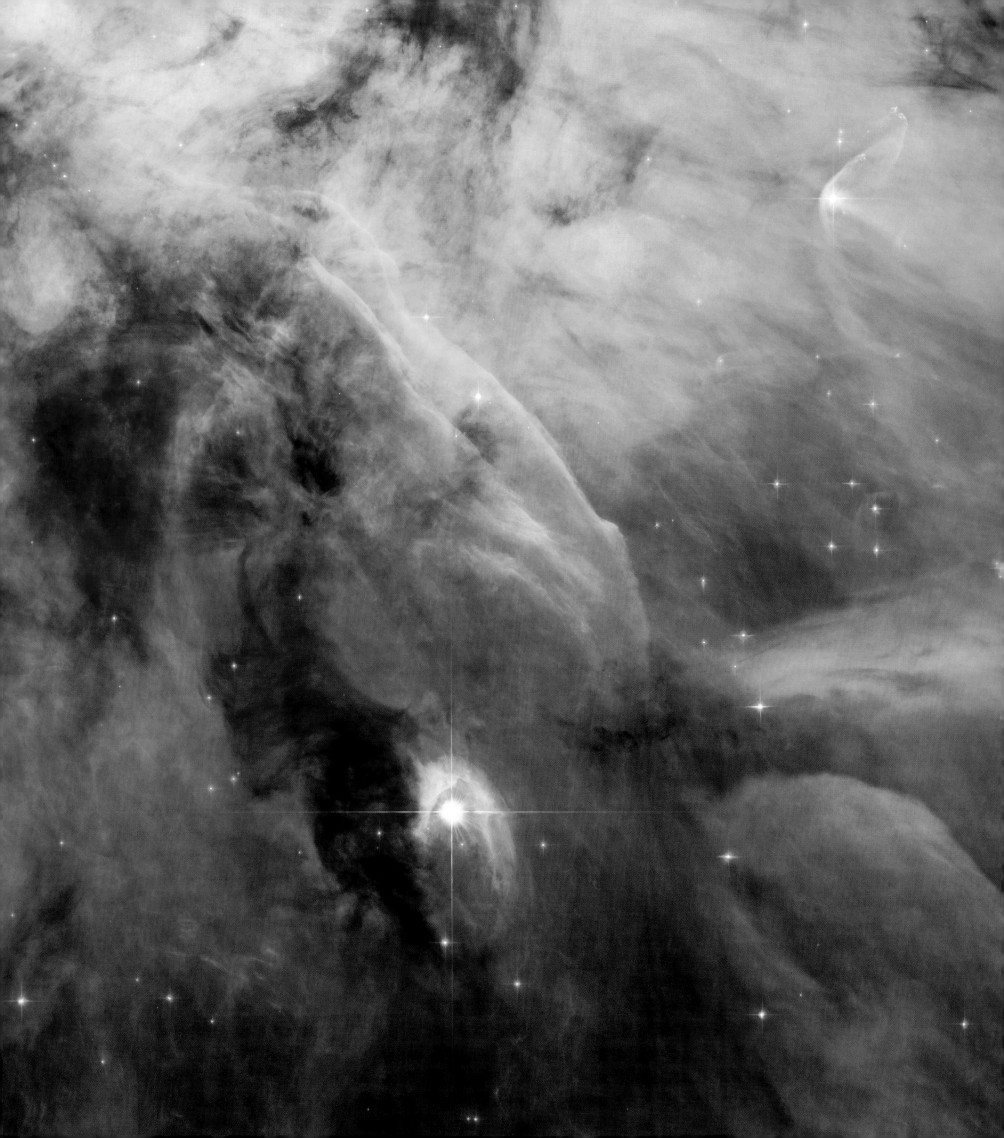

1,500 LIGHT-YEARS

ORION NEBULA (2006) To the astronomer, detail within the Orion Nebula is valuable for what it can reveal about how stars are formed and what happens to the embryonic gases and dust left over once they do form. To the rest of us, images such as these are wonderfully complex and appealing reminders of the magnificent structures betraying the turbulence of star formation, frozen in time. The Hubble Heritage Team carefully processed Hubble data to maximize the impact of the swirling and fluid forms.

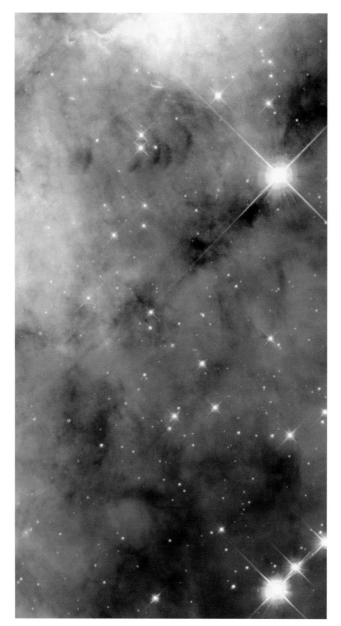

Opposite: **ETA CARINAE (1996)** When John Herschel hauled his father's 20-foot telescope to South Africa in the 1830s to continue the family project of recording nebulae, one of the most fascinating objects he cataloged was the Keyhole Nebula in the constellation Carina, buried deep in the southern Milky Way. Part of this nebula seemed to be highly variable in brightness and structure, which made the embedded star, Eta Carinae, the subject of continued investigation in the 20th century. Some spectroscopists believed it was a slowly erupting nova, a gigantic variable star; for astrophysicists it became known as the "gem of the southern skies." Hubble data confirmed that Eta Carinae is indeed in torment, as these images reveal, expelling vast clouds of gas and dust in bipolar plumes.

Above left: **STAR TURNING INTO NEBULA (2003)** The huge nebular region itself near the erupting star shows the effects of its vast stellar winds of charged particles. Spectroscopic examination of the expansion of the plumes, together with the directly observed expansion, confirmed that the eruption began some 150 years ago, around the time Herschel first observed the object. *Above top:* **EARLY HUBBLE VIEW OF STAR (1991)** The HST's WF/PC pulled in this image of the fragmented shell of Eta Carinae. *Above bottom:* **SHOCK WAVES (1996)** Contrasting images were also superimposed then subtracted to reveal changes in the size and structure of the plumes. The black ripples mark the position of the gaseous shock waves in April 1994 and the white ripples the positions of those waves 17 months later, in September 1995.

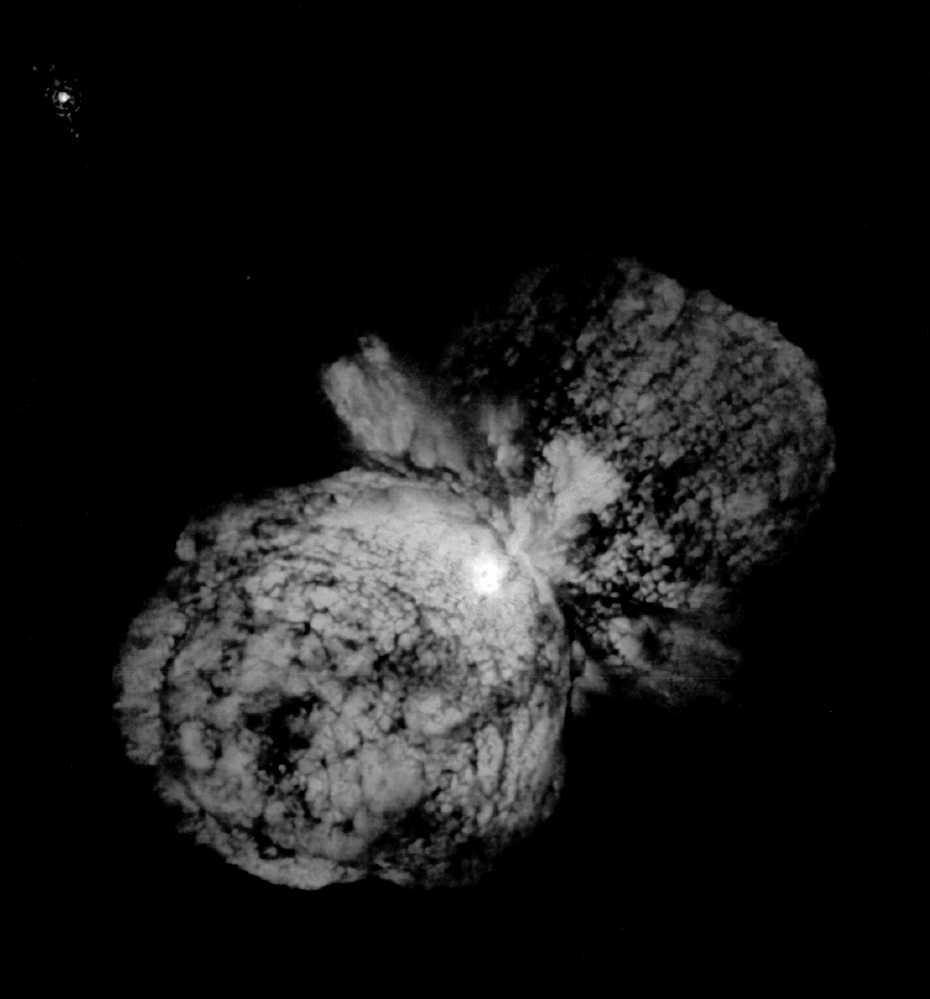

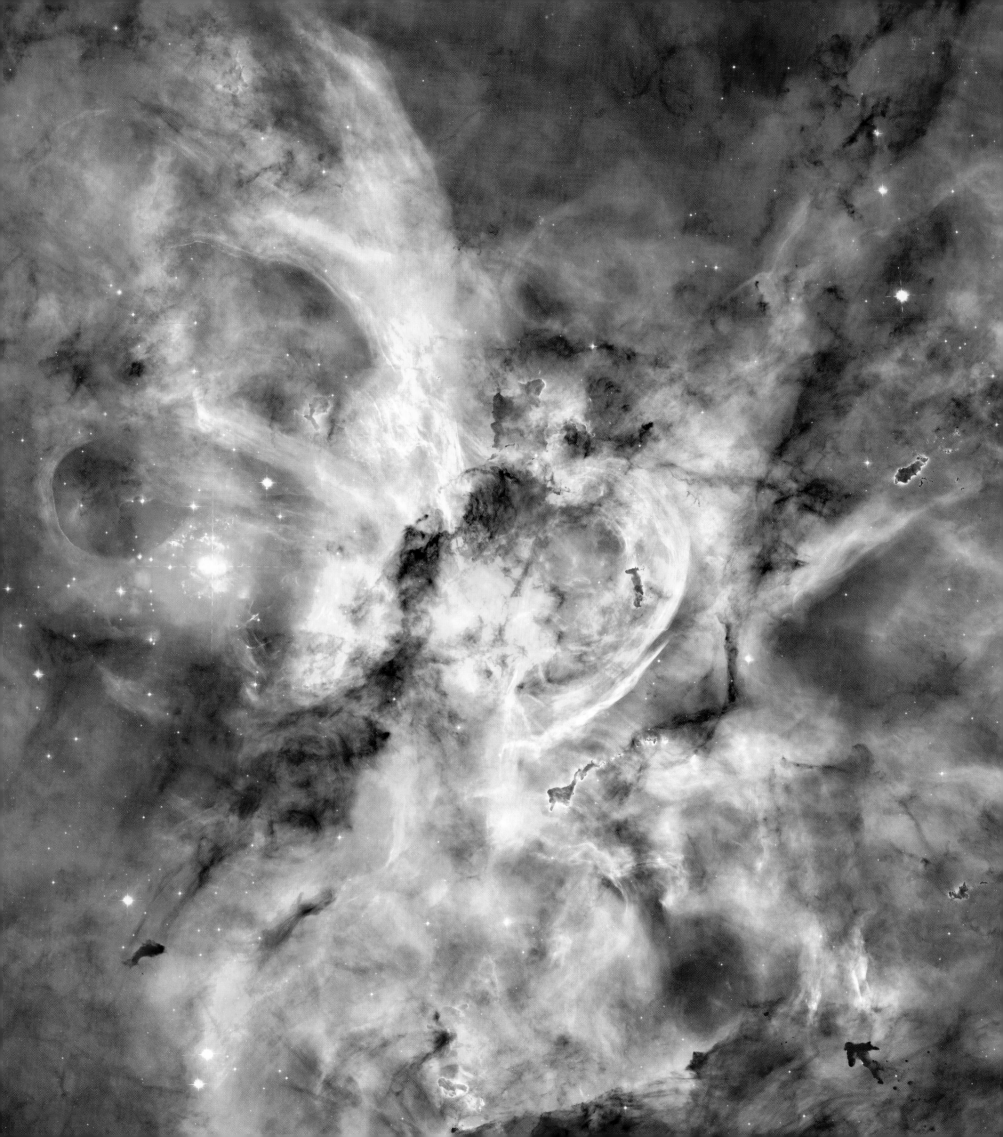

CARINA NEBULA (2007) This wide-field panorama of the Carina Nebula was imaged in 2007 to celebrate the 17th year of operation of the Hubble Space Telescope. Covering an area 50 light-years wide, about one quarter of the entire nebula, this mosaic includes the slow nova Eta Carinae at far left (pictured on the previous pages). This huge star-forming region contains at least a dozen stars between 50 and 100 times the mass of the sun. In addition to intense ultraviolet radiation, such stars give off very active stellar winds consisting of highly charged particles. These forces push the gas and dust in the cloud complex into contorted bubbles, streamers, walls, and knots and lead to the accelerated production of new highly massive stars. Massive stars such as Eta Carinae burn themselves out quickly and then explode. We may be witnessing the final stages before the star blows itself up as a supernova. When that happens, the nebula will be resculpted by the blast front. This image is a composite of 48 frames of data from the ACS with color information added from ground-based data from Cerro Tololo.

7,500 TO 10,000 LIGHT-YEARS

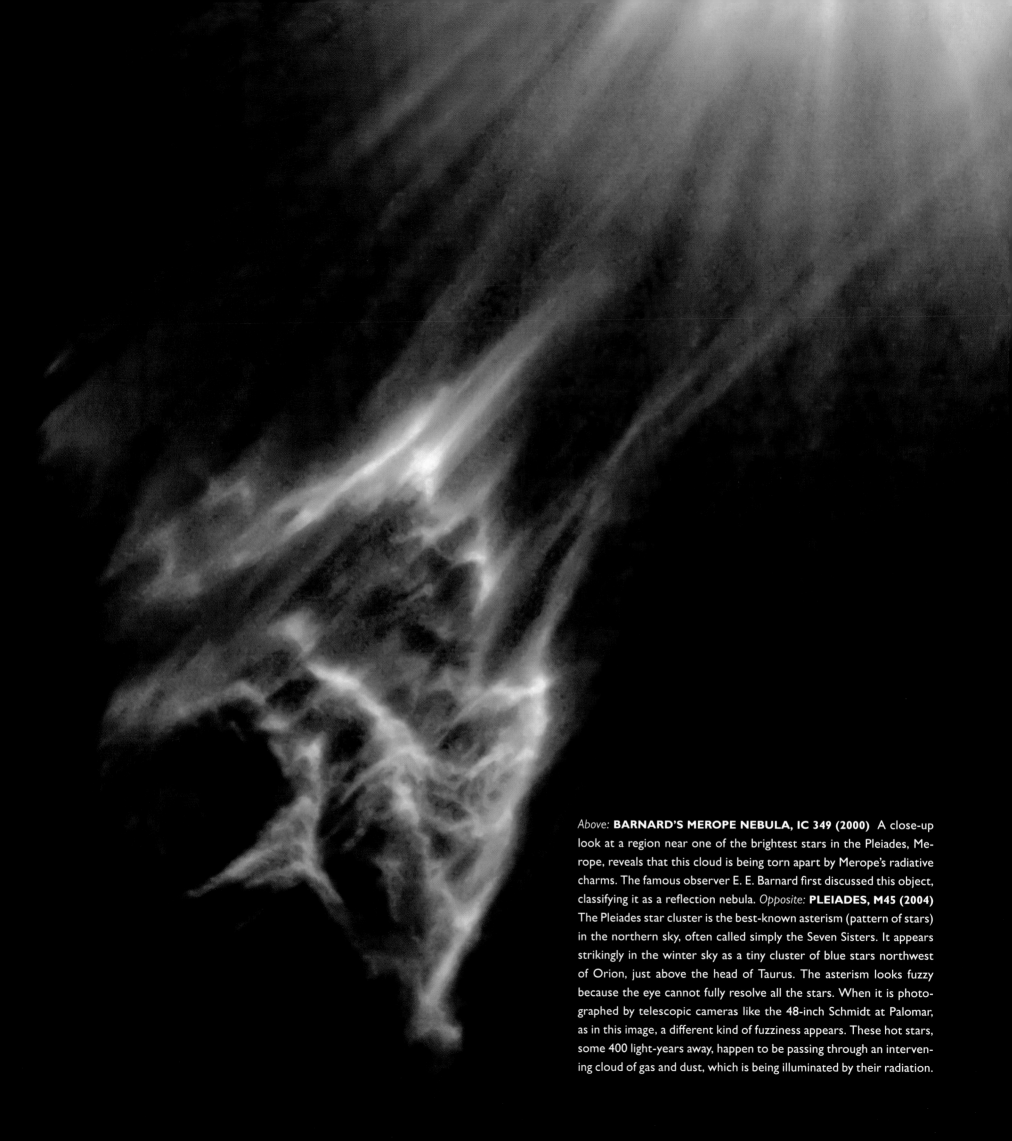

Above: **BARNARD'S MEROPE NEBULA, IC 349 (2000)** A close-up look at a region near one of the brightest stars in the Pleiades, Merope, reveals that this cloud is being torn apart by Merope's radiative charms. The famous observer E. E. Barnard first discussed this object, classifying it as a reflection nebula. *Opposite:* **PLEIADES, M45 (2004)** The Pleiades star cluster is the best-known asterism (pattern of stars) in the northern sky, often called simply the Seven Sisters. It appears strikingly in the winter sky as a tiny cluster of blue stars northwest of Orion, just above the head of Taurus. The asterism looks fuzzy because the eye cannot fully resolve all the stars. When it is photographed by telescopic cameras like the 48-inch Schmidt at Palomar, as in this image, a different kind of fuzziness appears. These hot stars, some 400 light-years away, happen to be passing through an intervening cloud of gas and dust, which is being illuminated by their radiation.

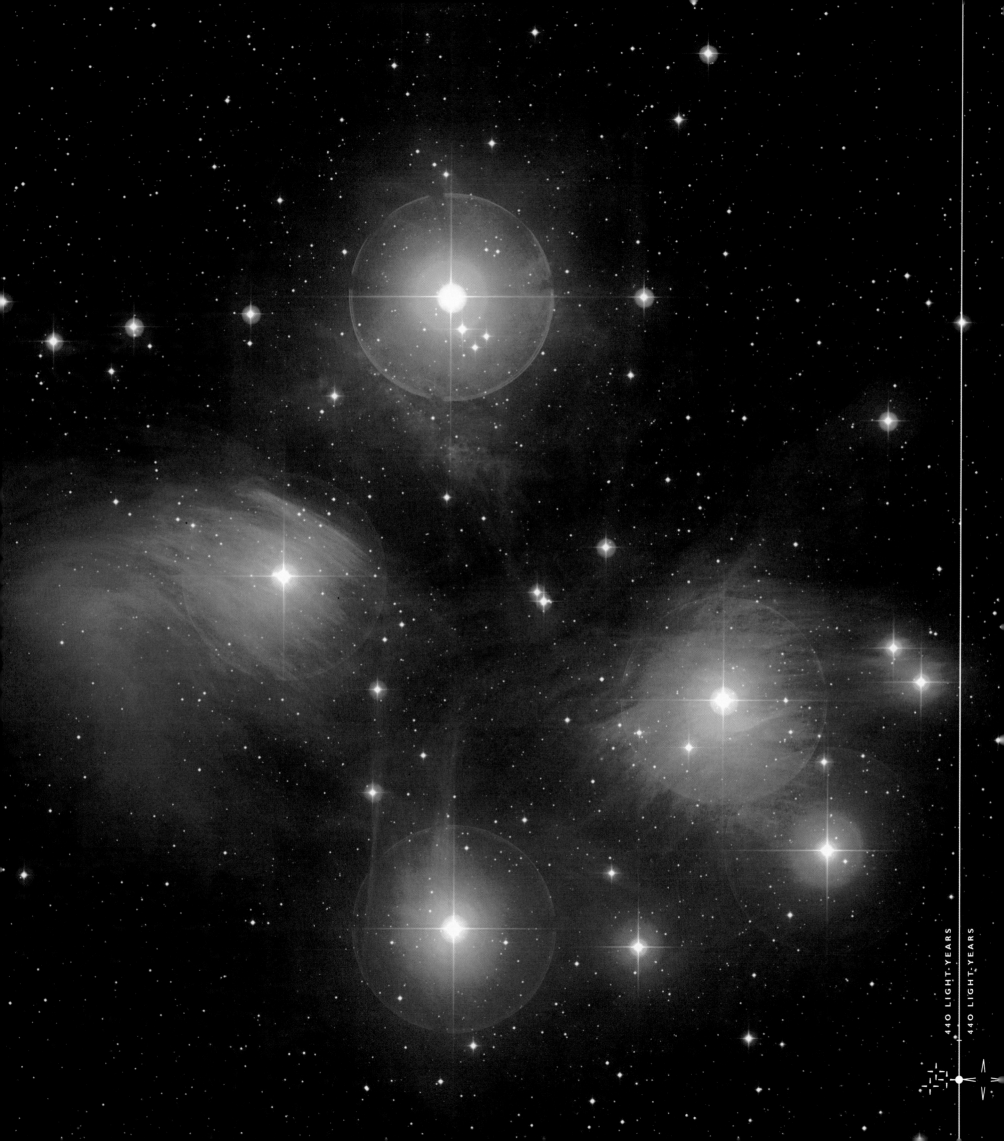

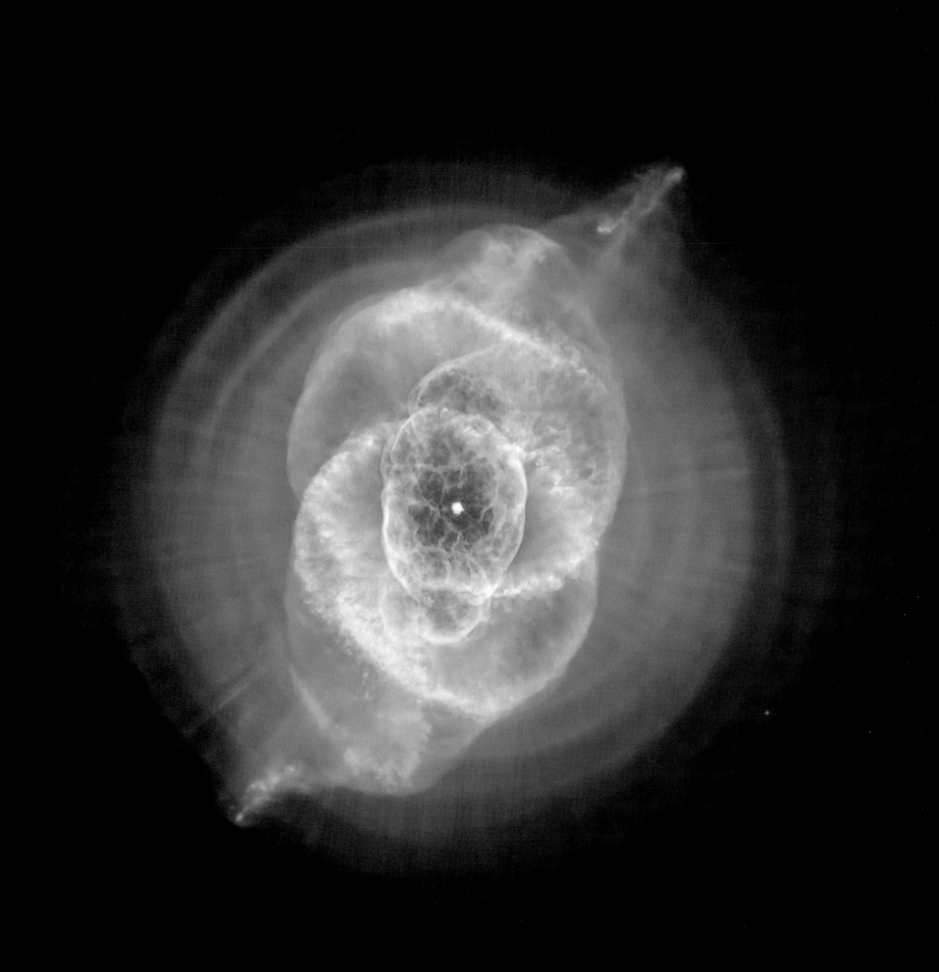

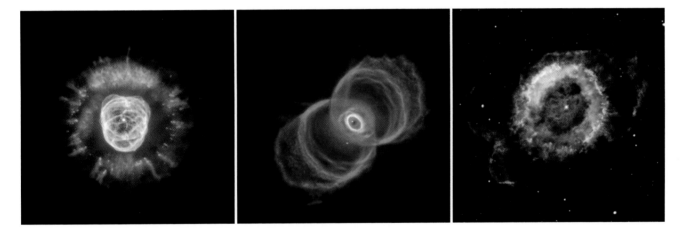

Opposite: **CAT'S EYE (2004)** In his search for new nebulae and comets, 18th-century astronomer William Herschel found tiny fuzzy objects that looked like planetary discs. His description of them as "planetary" became their classification, and since then many of these objects have been detected. They are now understood to be old stars in the process of shedding their outer atmospheres, in preparation for a very slow death as white dwarfs. The first stage comes when a star ceases fusing hydrogen in its core. This causes the center of the star to collapse and heat up, driving the outer layers of the star outward. The star thus expands as a red giant, eventually expelling a large part of that outer atmosphere. The "planetary" stage of this process is relatively brief, a few tens to hundreds of thousands of years, and so these objects are comparatively rare in space. Even so, many hundreds have been imaged, and their variations in form continue to amuse and astound astronomers. Thus we find that astronomers, amateur and professional alike, have pinned colorful names to these objects. *Above left:* **ESKIMO (2000)**; *above middle:* **HOURGLASS (1996)**; *above right:* **LITTLE GHOST (2002)** Hubble has greatly aided the study of the internal structure of these objects and has helped viewers better visualize their three-dimensional nature. Despite their ringlike structures, all of these nebulae are spheres of gas and dust, seen in profile.

3,000 TO 3,300 LIGHT-YEARS

3,000 LIGHT-YEARS

8,000 LIGHT-YEARS

2,000 TO 5,000 LIGHT-YEARS

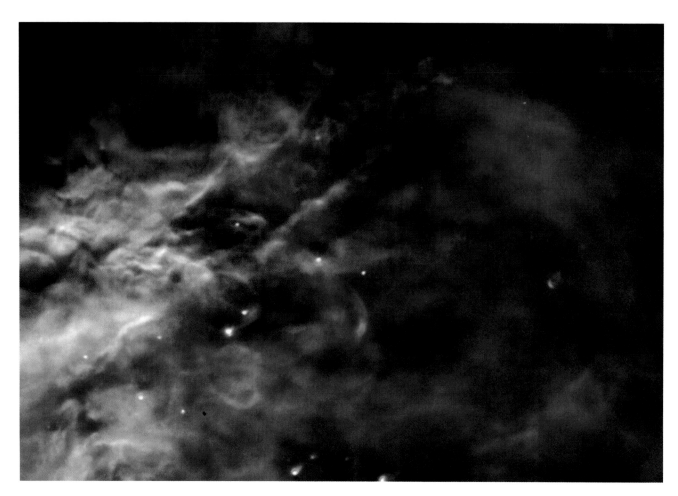

Above: **PROTOPLANETARY DISKS IN THE ORION NEBULA (1992)** Hubble has proven as valuable for imaging the earliest stages of star life as it has been for the latest stages. In a coordinated campaign involving many astronomers, the Hubble examined the closest stellar nursery to Earth, the Orion Nebula, and succeeded in resolving tiny features embedded inside on the scale of newly forming protoplanetary systems. Even before the Hubble was serviced in 1993, correcting its vision, C. R. O'Dell was able to image a small portion of the nebula precisely enough to detect these objects directly. In 1992 he found over a dozen such objects; some can be seen here in the lower center portion of the field, looking like tiny comets. O'Dell called them proplyds, and he and others continued observing them after the servicing mission with the improved vision of the WF/PC2. *Opposite:* **PROTOPLANETARY DISK SILHOUETTED AGAINST ORION NEBULA (2001)** A particularly clear example of a protoplanetary disk shows it set off in sharp contrast against the bright background of the Orion Nebula.

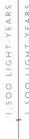

ORION NEBULA (2006) Tapestries of light and shadow in the Orion Nebula are part of a montage of fields nestled in the scabbard of Orion. High-energy ultraviolet radiation and an intense stream of charged particles from Orion's hot Trapezium stars interact with intervening walls and bubbles of gas in the nebula. These interactions might someday result in the production of new stars. Completed in May 2005, the Hubble Treasury Program of the Orion Nebula cluster was an ambitious project involving some two dozen astronomers, who combined their talents to monitor the nebula for 104 orbits, providing a useful dataset for problems in star formation.

1,500 LIGHT-YEARS

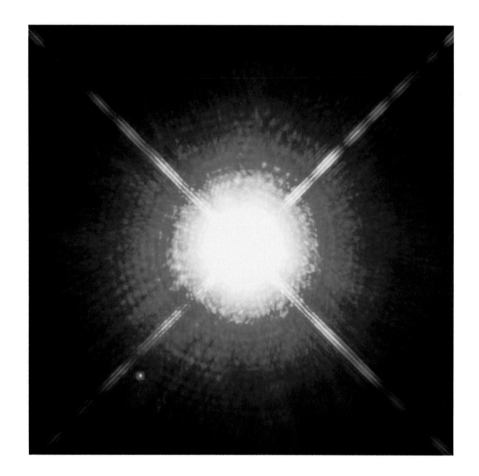

Above: **SIRIUS AND TINY COMPANION (2005)** The brilliant nearby star Sirius has a white dwarf companion, discovered in the 19th century. In this image, it can be seen as a tiny spot of light just below the lower left diffraction spike of the star. It was imaged with the Hubble by overexposing Sirius itself and making sure that the orientation of the diffraction spikes, artifacts of the telescope's optical system, did not obscure the companion. The Hubble's STIS recorded redshifts to confirm that the white dwarf companion packs almost a solar mass of material compressed into a sphere smaller than Earth. *Opposite:* **ORION'S TRAPEZIUM CLUSTER (2000)** From Earth, Sirius far outshines the combined light of the Trapezium stars, seen in this image from the montage Treasury series. But Sirius is bright because it is so close to Earth, a mere 8.6 light-years away. The Trapezium stars, in contrast, are some 1,500 light-years distant, and actually far more luminous.

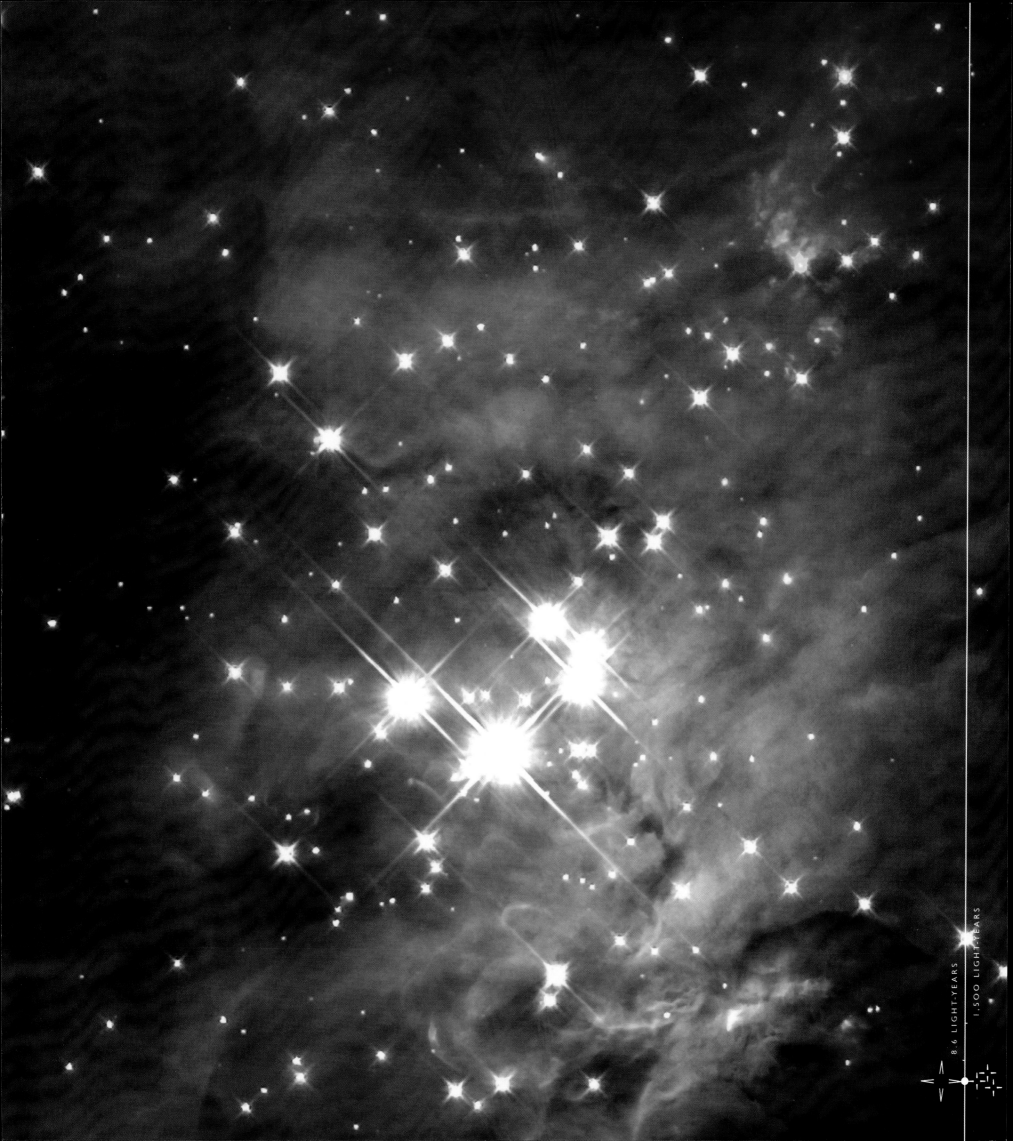

8.6 LIGHT-YEARS

1,500 LIGHT-YEARS

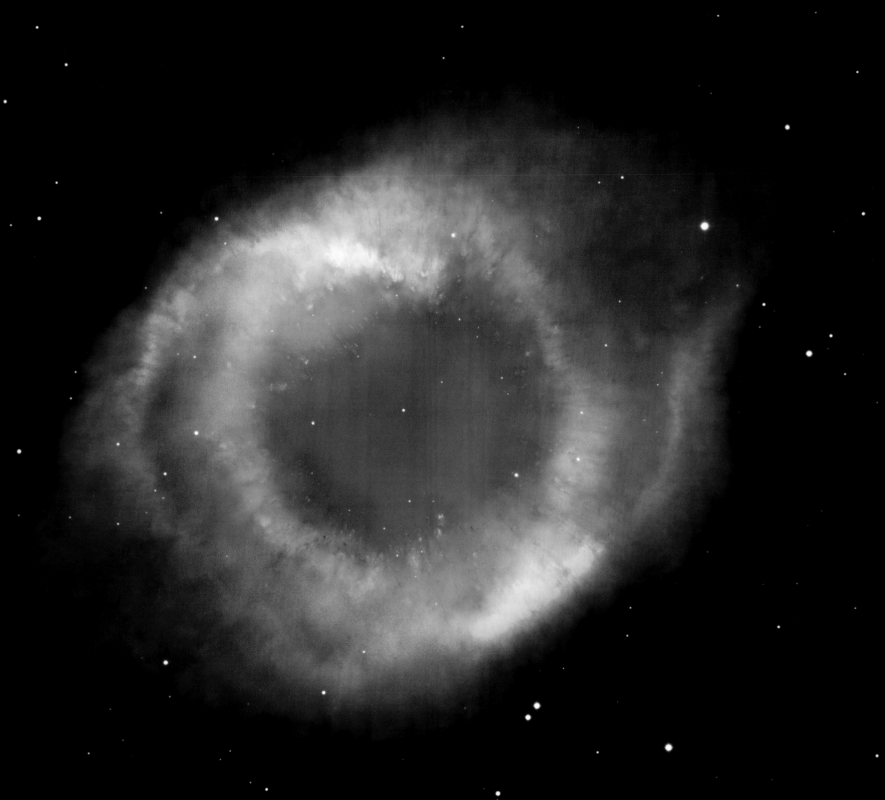

Above: **HELIX NEBULA, NGC 7293 (2003)** The Helix Nebula in Aquarius is one of the closest planetary nebula systems to Earth, and therefore was an excellent candidate for revealing its internal structure. But it also presented a challenge, because the angular size of the object is large, about one-half that of the full moon. Several ACS fields had to be superimposed to produce the image above. Once they were fitted together, the image was enhanced by wide-field data from the 0.9-meter telescope at Kitt Peak National Observatory. *Opposite:* **HELIX NEBULA, CLOSE-UP VIEW (2003)** A myriad of tiny comet-like streamers point to the center of the nebula, where the exposed core of the original star remains as a white dwarf.

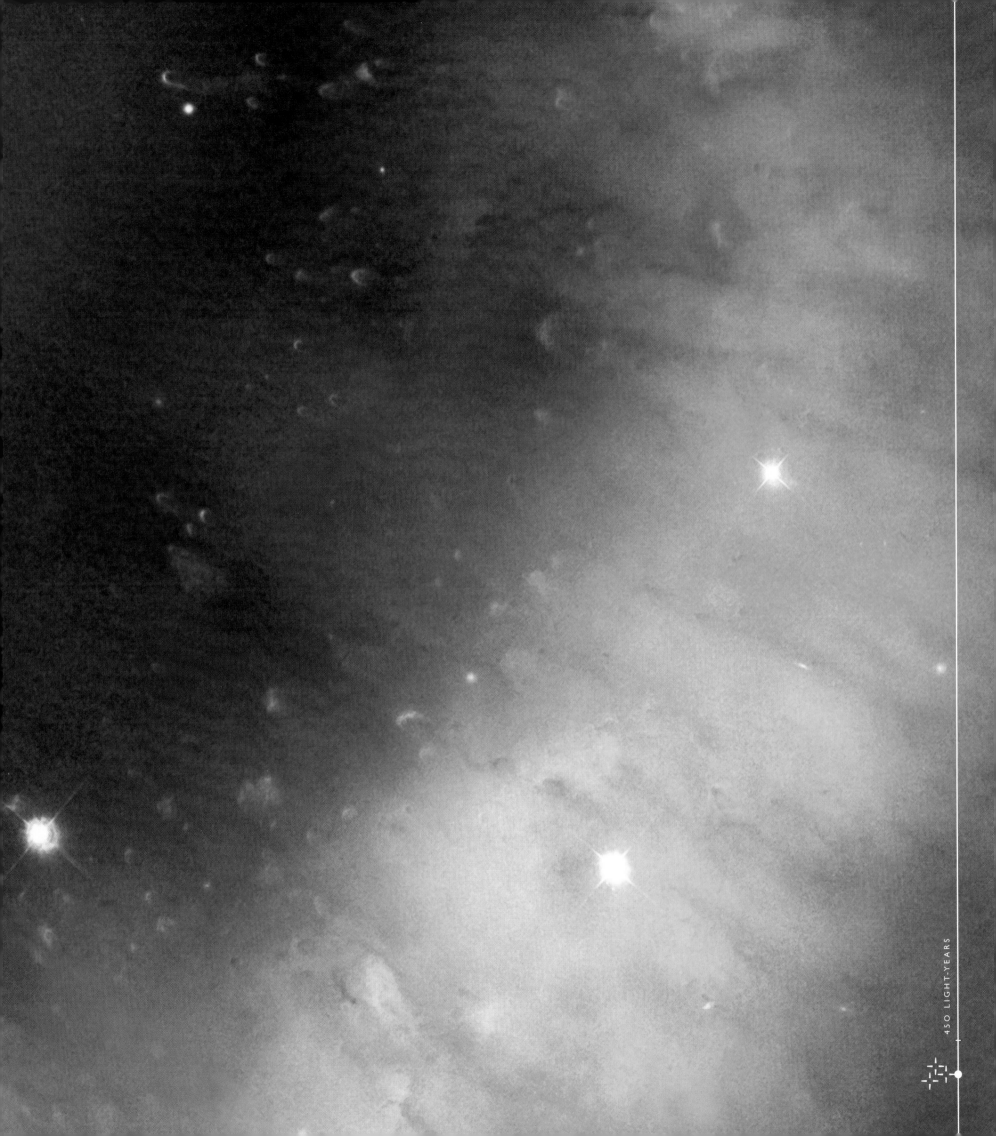

450 LIGHT-YEARS

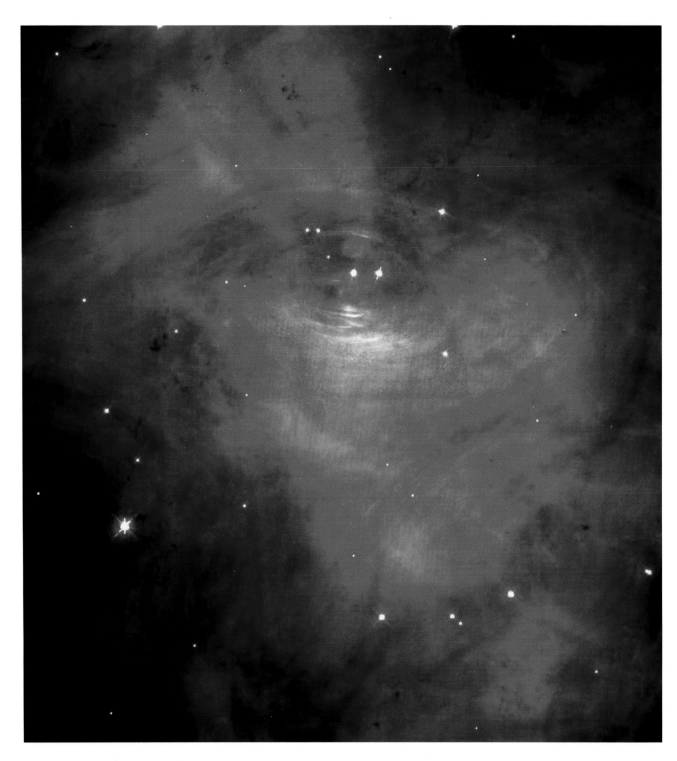

Above: **CRAB NEBULA, M1 (1996)** This nebula, in the horns of Taurus, was the first object cataloged by Messier. It is known today to be an exploding star in progress. X-ray observations confirm that the nebula is powered by the remnant of its progenitor star: a rapidly rotating pulsar, visible as the left of the pair of stars in the center of the image. *Opposite:* **CRAB NEBULA, COMBINED IMAGE (2005)** The Crab has been studied by at least three of the major space observatories, including the Hubble (green and dark blue), the Chandra (light blue), and the Spitzer infrared observatory (red), their data combined in this image.

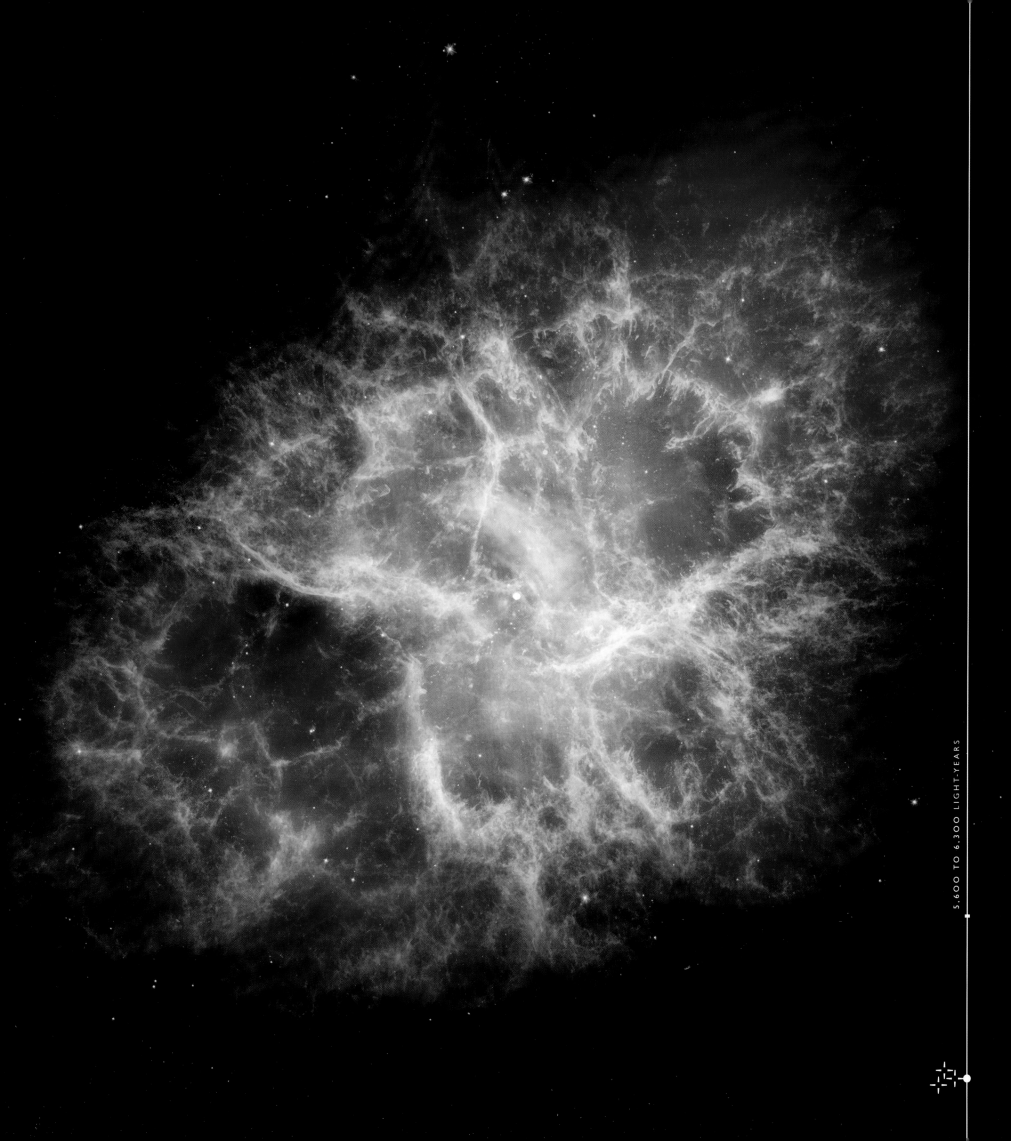

5,600 TO 6,300 LIGHT-YEARS

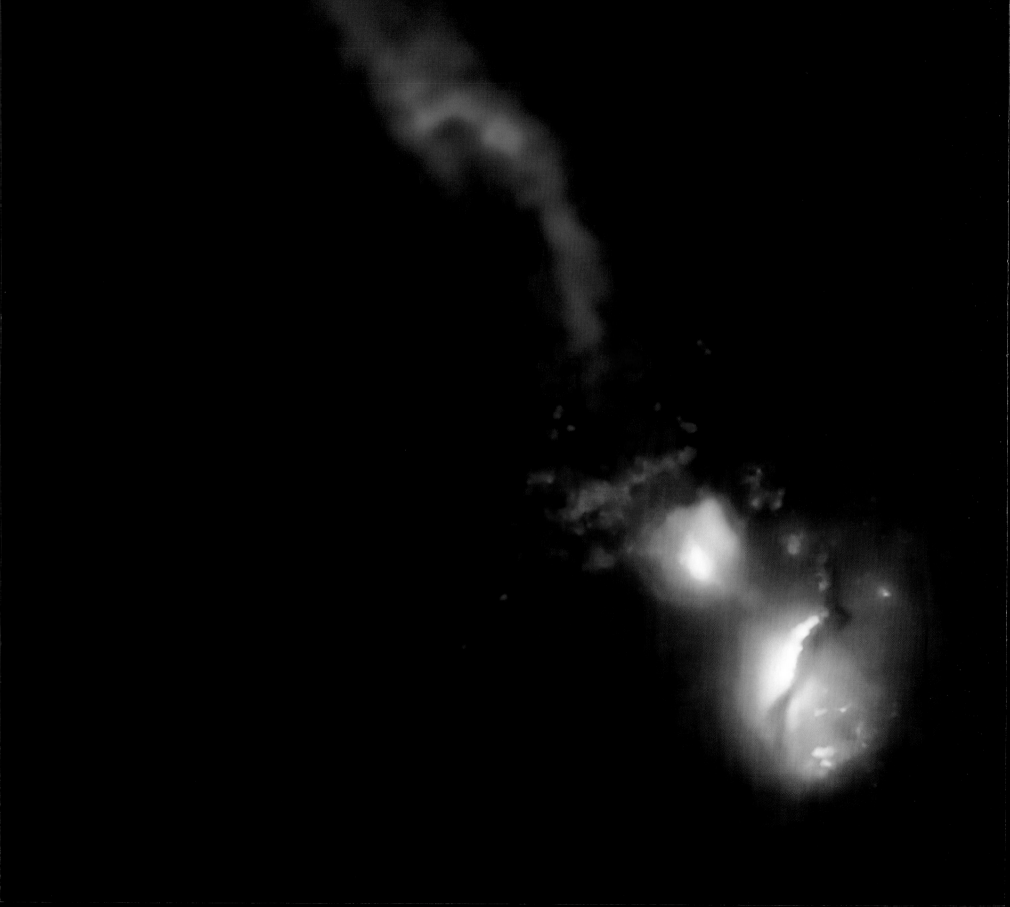

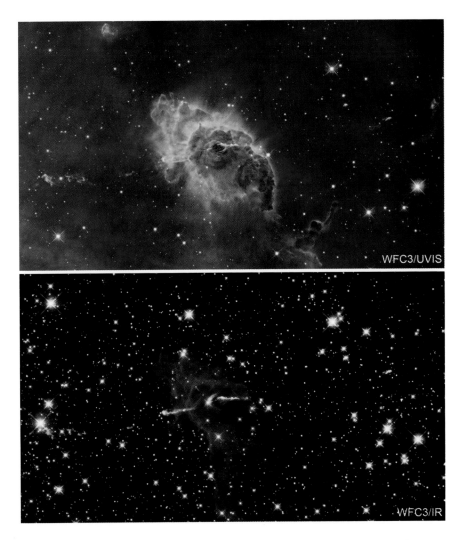

Opposite: **BLACK HOLE FIRES AT NEIGHBORING GALAXY (2007)** This extraordinary image shows a supermassive black hole in the center of one galaxy shooting a relativistic jet of intergalactic dimensions toward a companion galaxy (above it), an interaction that stimulates both star formation and disruption on a huge scale. The image is a composite of optical and ultraviolet data from the Hubble (red and orange), radio data from the Very Large Array radio telescopes (blue), and X-ray data from the Chandra (purple). *Above:* **JET IN CARINA** (July 2009) WFC3 operates in two modes: in the visible/ultraviolet range and in the infrared range of the spectrum. This cloud in the Carina Nebula, imaged in the visible mode (top), shows the gas and dust surrounding some very young stars in the process of formation some 7,500 light-years distant; the infrared mode (bottom) penetrates the gas and dust to reveal the young stars forming at its center. One is clearly visible, churning the cloud by expelling high-speed jets of material.

THE HUBBLE CONSTANT

CALCULATING THE EXPANDING UNIVERSE

I n the mid-1920s, few if any astronomers believed the universe was expanding. By the mid-1930s, almost all did. This rapid change was brought by two developments: the observations of distant galaxies by Edwin Hubble and Milton Humason at the Mount Wilson Observatory and the application of Einstein's theory of general relativity to the universe. Astronomers decided that the rate at which the expansion velocity changes with distance was a crucial measurement for understanding the universe. By the 1950s, this measure had become generally known as Hubble's Constant, H.

It is measured in terms of kilometers per second per megaparsec (a megaparsec is one million parsecs, about 3,260,000 light-years): If H has a value of 60 kilometers per second per megaparsec, a galaxy at a distance of 1 megaparsec will be moving away at 60 kilometers per second. The inverse of the Hubble Constant gives scientists a measure of what is often referred to as the age of the universe but is more accurately described as the expansion age. This is not necessarily the same figure as the time since the universe started expanding.

If, for example, the expansion now observed in telescopes was faster in the past and has decreased to the current rate because of the mutual gravitational attraction of galaxies, the expansion age will be the maximum

time passed since the beginning of expansion. If the universe is evolving, as astronomers generally believe it is, then the Hubble Constant will continue to change, and H is better referred to as H0—the value of the Hubble Constant at present.

If we take our current view of the universe and run time backward, in the distant past all of the space in the universe and all of the energy and matter it contains must have filled a tiny volume. For some astronomers in the 1930s this was absurd. Surely something was wrong in the reasoning. For Georges Édouard Lemaître, the implication was that the universe must have started expanding from such a fantastically dense and hot state and that the expansion was the product of what we call the big bang.

Not until the mid-1960s did the idea of the big bang become dominant. Unexpected evidence was secured by two radio astronomers in New Jersey. Arno Allan Penzias and Robert Woodrow Wilson had been monitoring radio emissions from a gas ring encircling the Milky Way. They detected a faint hiss of radio noise—traces of the big bang event in the form of very faint microwave radiation. They won the Nobel Prize in 1978 for their research; they had detected the predicted radiation, clinching evidence for the big bang.

When the Hubble Space Telescope was launched in 1990, estimates of the Hubble Constant, and so the time since the big bang, varied widely, and an accurate determination was judged to be one of the Hubble Space Telescope's crucial tasks. The Hubble's observations have helped to settle the debate, constraining the limits of the Hubble Constant to 73.8 +/− 2.4 kilometers per second per million parsecs. This sets an age for the universe of 13.7 to 14 billion years.

VARIABLE STARS IN SPIRAL GALAXY M81 (1993) One of the most ambitious collective studies ever executed by the Hubble's astronomers was also one of the original reasons for building the Hubble: refining the age of the universe. The Hubble Key Project selected a number of galaxies for study, searching for the same class of variable stars Edwin Hubble used to determine the distances to nearby galaxies. With the telescopes available to Edwin Hubble, one could reliably observe these variables only in nearby galaxies. But the HST's greater imaging power allowed astronomers to extend their range. This series of images of a star field in the spiral galaxy M81 shows how a variable star of the Cepheid class changes in brightness over time. The sequence provided a measurement accurate to within 10 percent at a distance of 11 million light-years, considered a great advance in capability at the time, since earlier estimates varied by a factor of four. This accuracy has since been superseded, and thus the distance scale and the expansion rate of the universe have been refined to a value of 13.7 billion years, a value that agrees with determinations from several independent techniques.

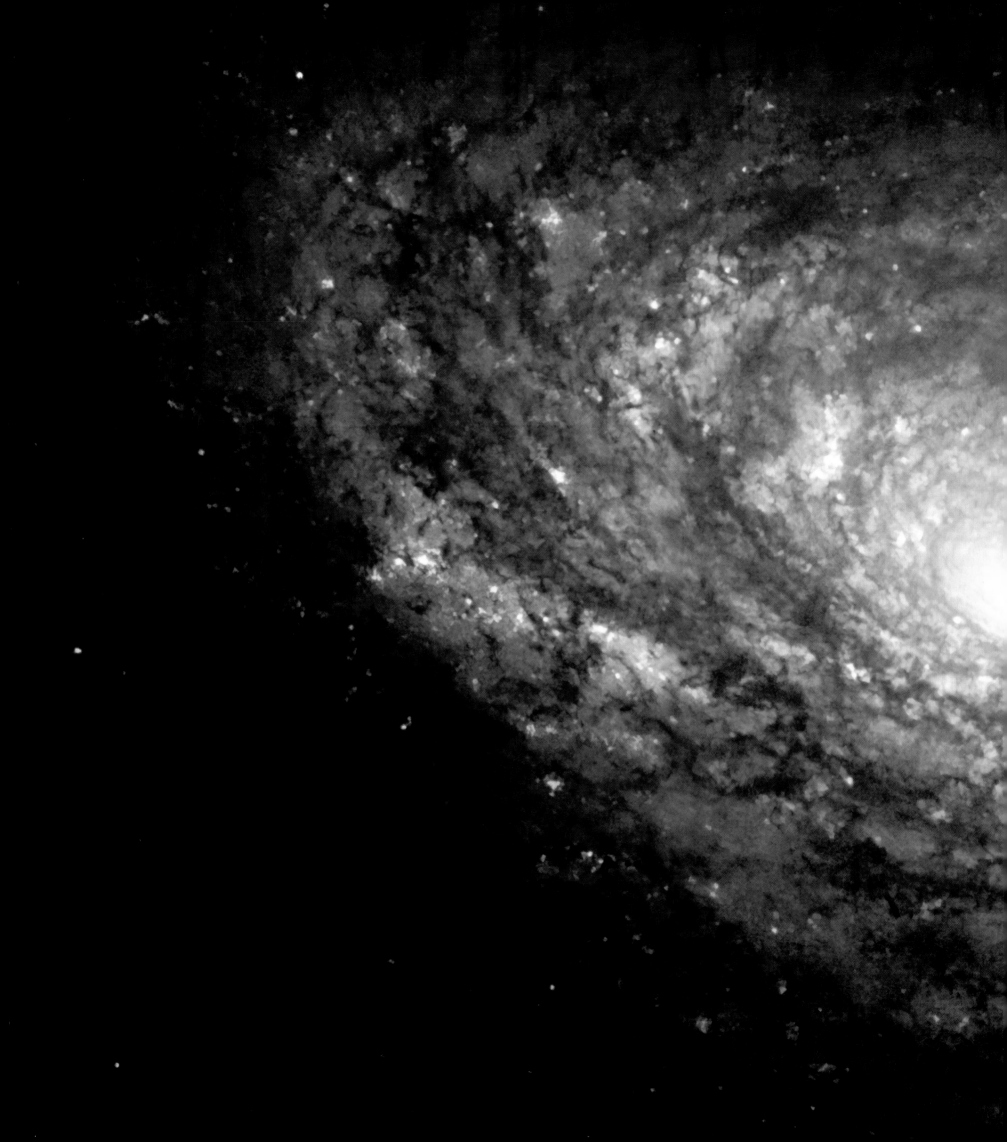

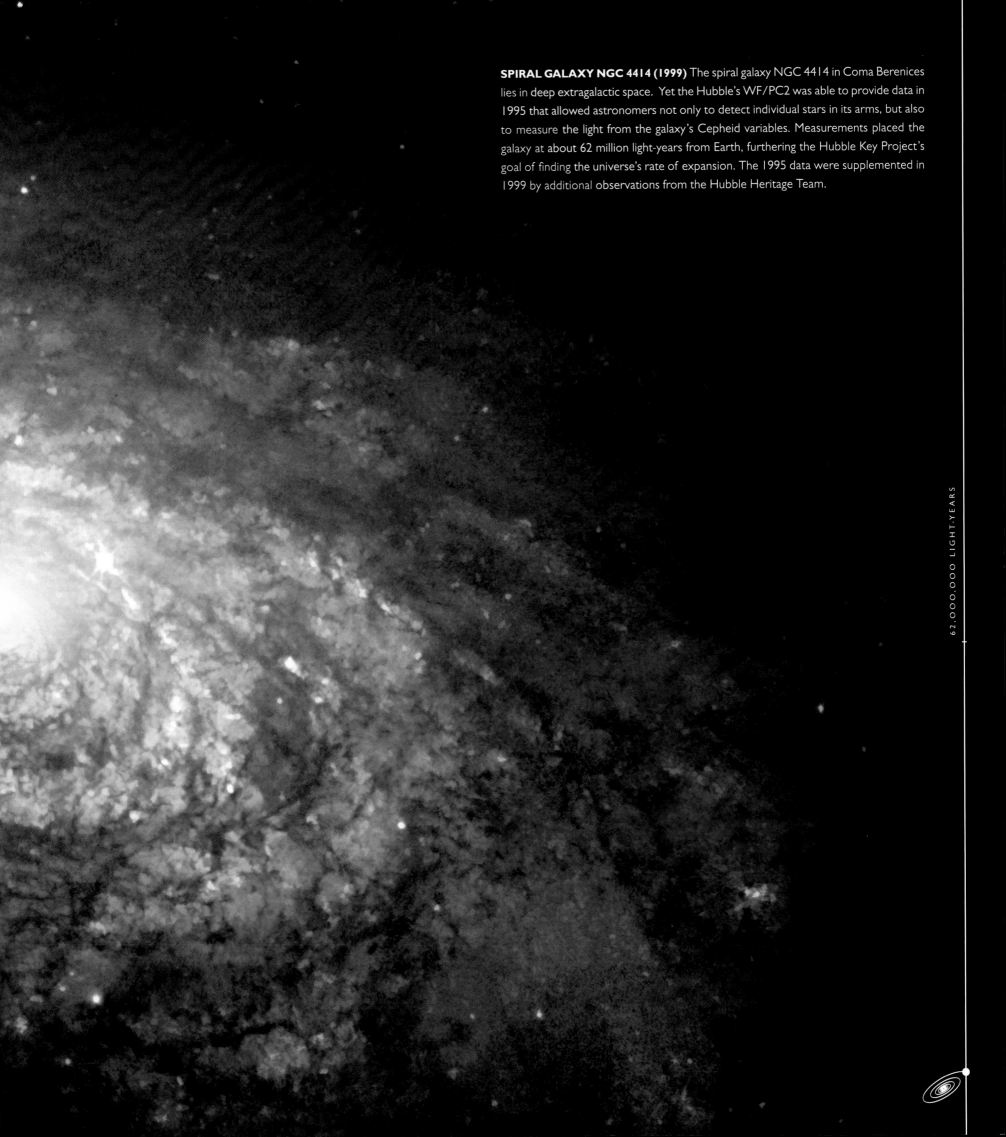

SPIRAL GALAXY NGC 4414 (1999) The spiral galaxy NGC 4414 in Coma Berenices lies in deep extragalactic space. Yet the Hubble's WF/PC2 was able to provide data in 1995 that allowed astronomers not only to detect individual stars in its arms, but also to measure the light from the galaxy's Cepheid variables. Measurements placed the galaxy at about 62 million light-years from Earth, furthering the Hubble Key Project's goal of finding the universe's rate of expansion. The 1995 data were supplemented in 1999 by additional observations from the Hubble Heritage Team.

62,000,000 LIGHT-YEARS

GALAXY CENTAURUS A (1998) The central portion of the giant elliptical galaxy Centaurus A may show the results of a titanic collision between an elliptical and a spiral galaxy. Visible here are dust lanes from the remnant spiral arms superimposed on the body of the elliptical. Blue clusters of young stars are also easily resolved in this Hubble image. Centaurus A is one of the brightest radio objects in our skies and also one of the closest, a mere 10 to 13 million light-years away. It is is believed to be powered by a supermassive black hole in its center.

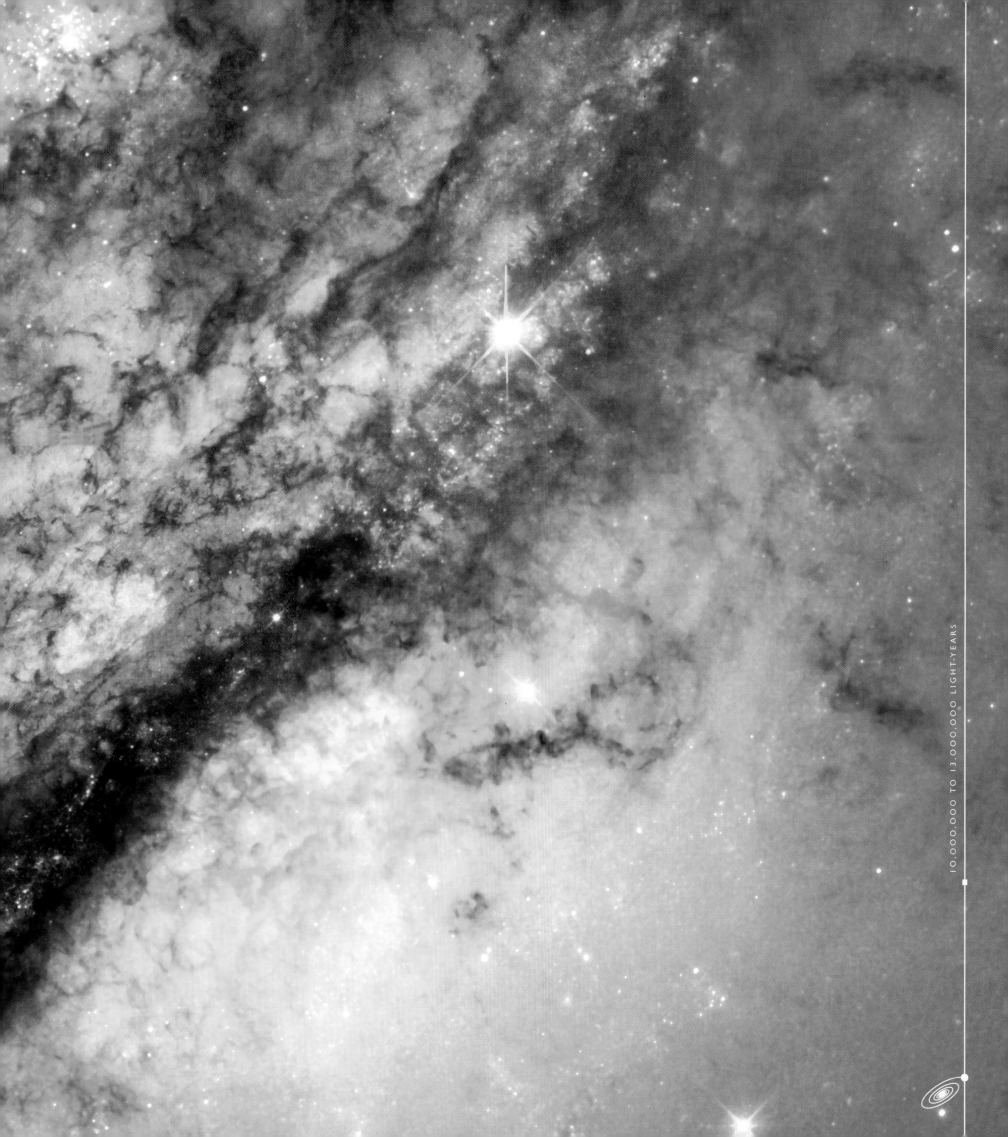

NGC 5584 (2010) A composite of several visible light exposures secured by WFC3, this image shows a spiral galaxy 72 million light-years away in the constellation Virgo. The observations of pulsating stars called Cepheid variables in the galaxy enabled astronomers to measure NGC 5584's distance to a new level of accuracy. This and similar distance determinations to some other relatively nearby galaxies gave new information on how rapidly the universe is expanding and hence enabled astronomers to more precisely estimate its age.

Opposite: **GALAXY M82 (2006)** The starburst galaxy M82 appears to be a collision in progress. Its bright blue disk is embedded in a shredded envelope of glowing reddish clouds.

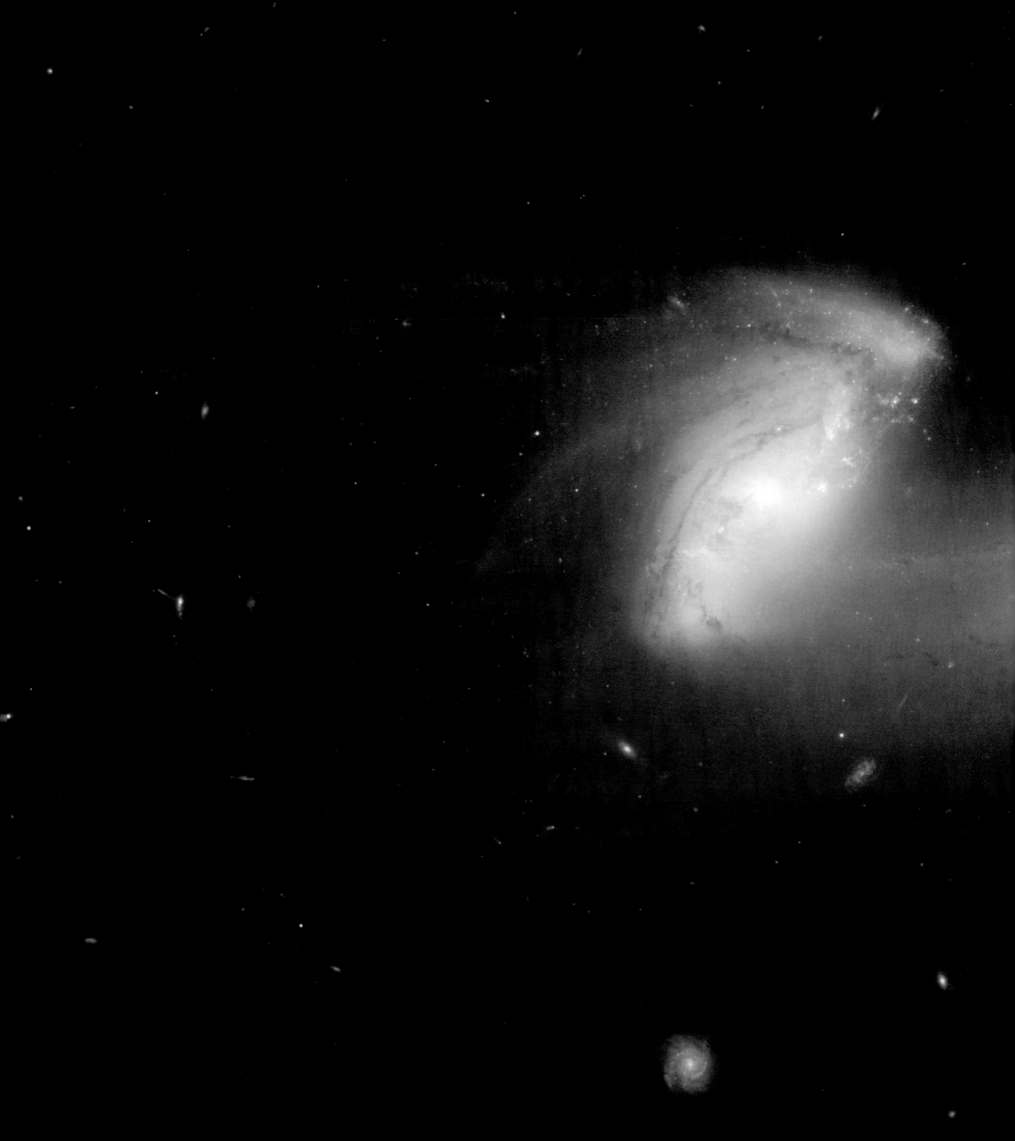

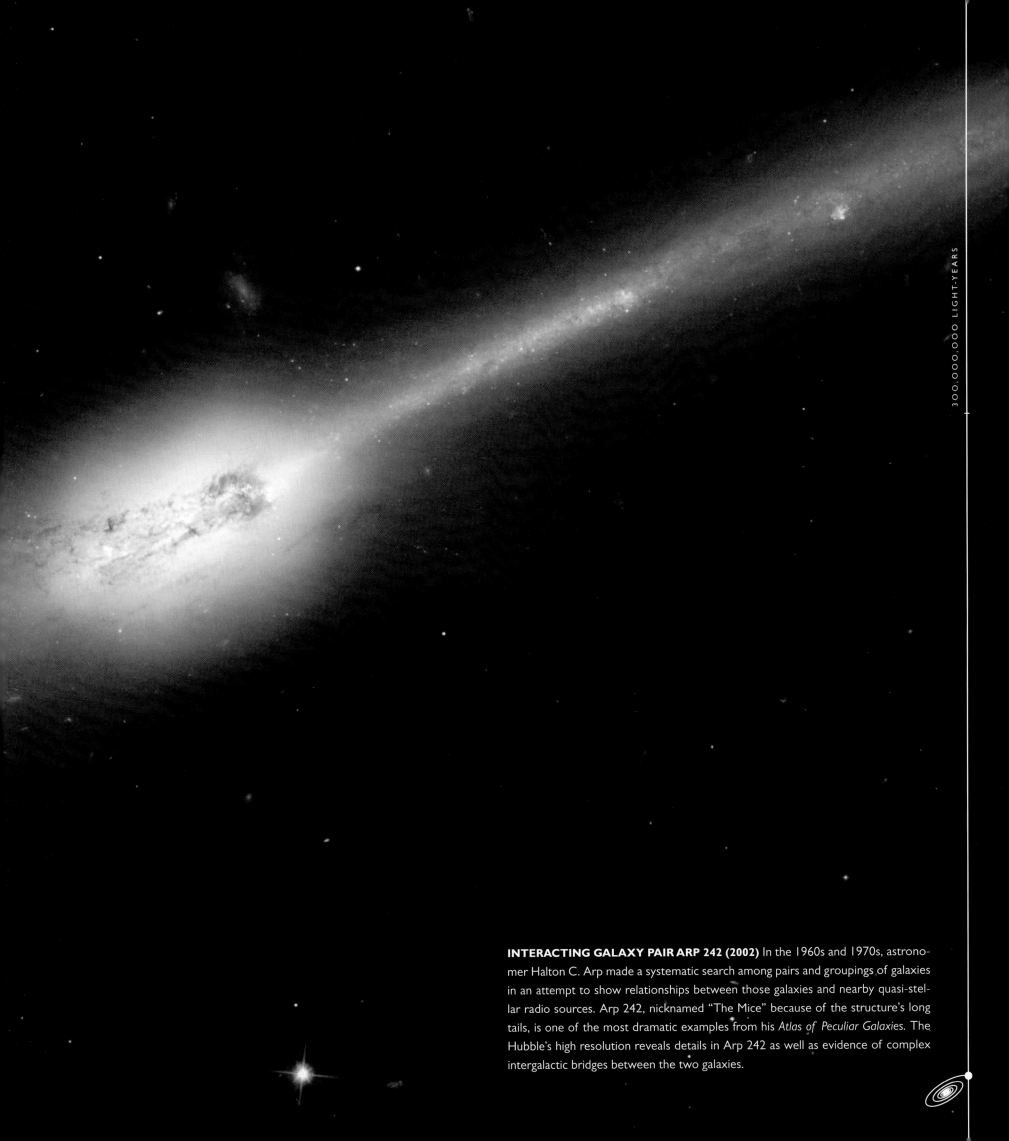

INTERACTING GALAXY PAIR ARP 242 (2002) In the 1960s and 1970s, astronomer Halton C. Arp made a systematic search among pairs and groupings of galaxies in an attempt to show relationships between those galaxies and nearby quasi-stellar radio sources. Arp 242, nicknamed "The Mice" because of the structure's long tails, is one of the most dramatic examples from his *Atlas of Peculiar Galaxies*. The Hubble's high resolution reveals details in Arp 242 as well as evidence of complex intergalactic bridges between the two galaxies.

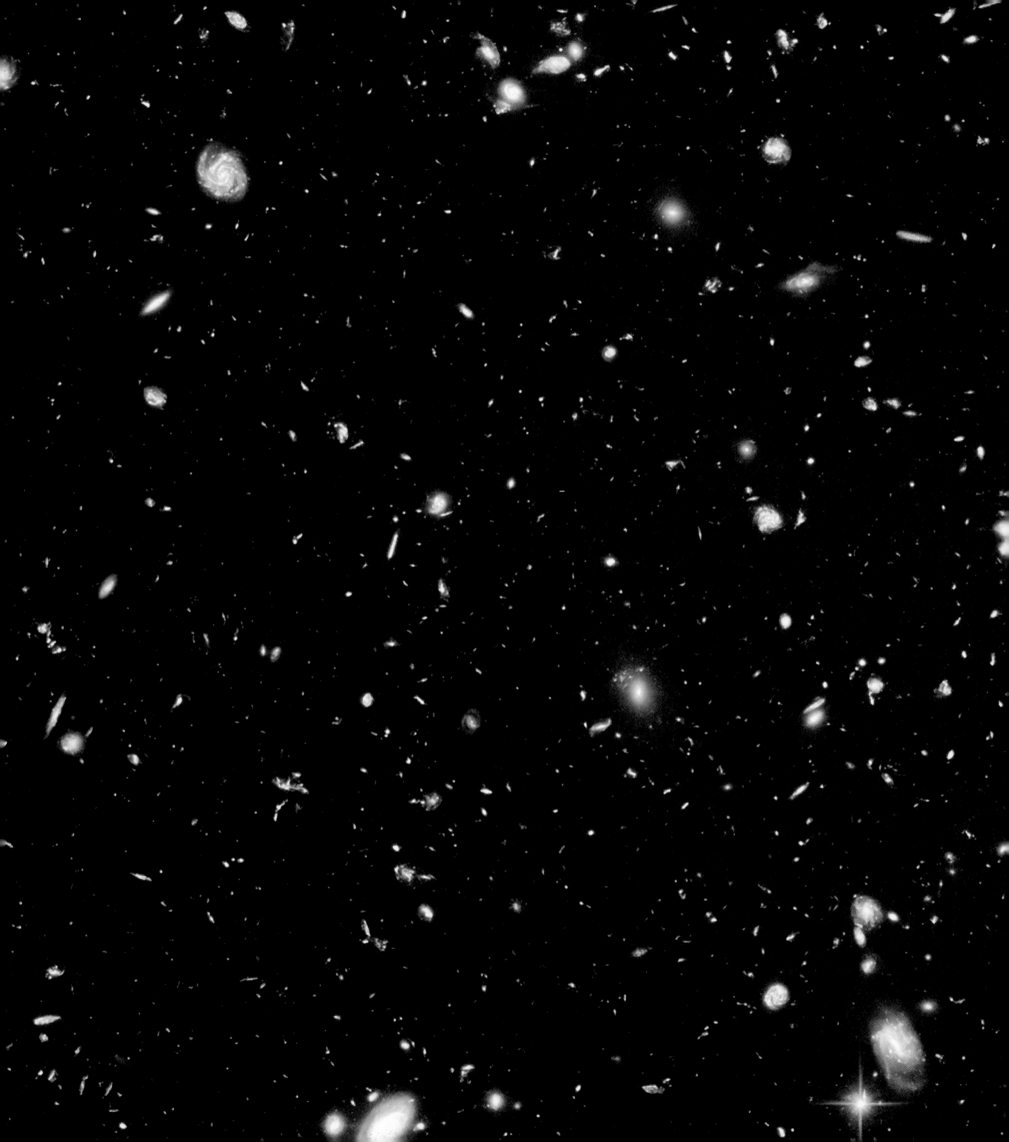

REMOTE GALAXIES IN ULTRA DEEP FIELD (2004) With an accumulated exposure time of just over 11 days devoted to a single portion of the sky in the southern constellation Fornax, the Hubble imaged the deepest visual and infrared field yet, using both the ACS and WF/PC2. Called the Hubble Ultra Deep Field, this composite image contains over 10,000 galaxies. Many of the smallest reddish objects are irregular in shape and may be among the farthest objects from Earth, hence caught in the earliest stages of their lives some 13 billion years ago. Objects with diffraction spikes are stars; all the rest are galaxies.

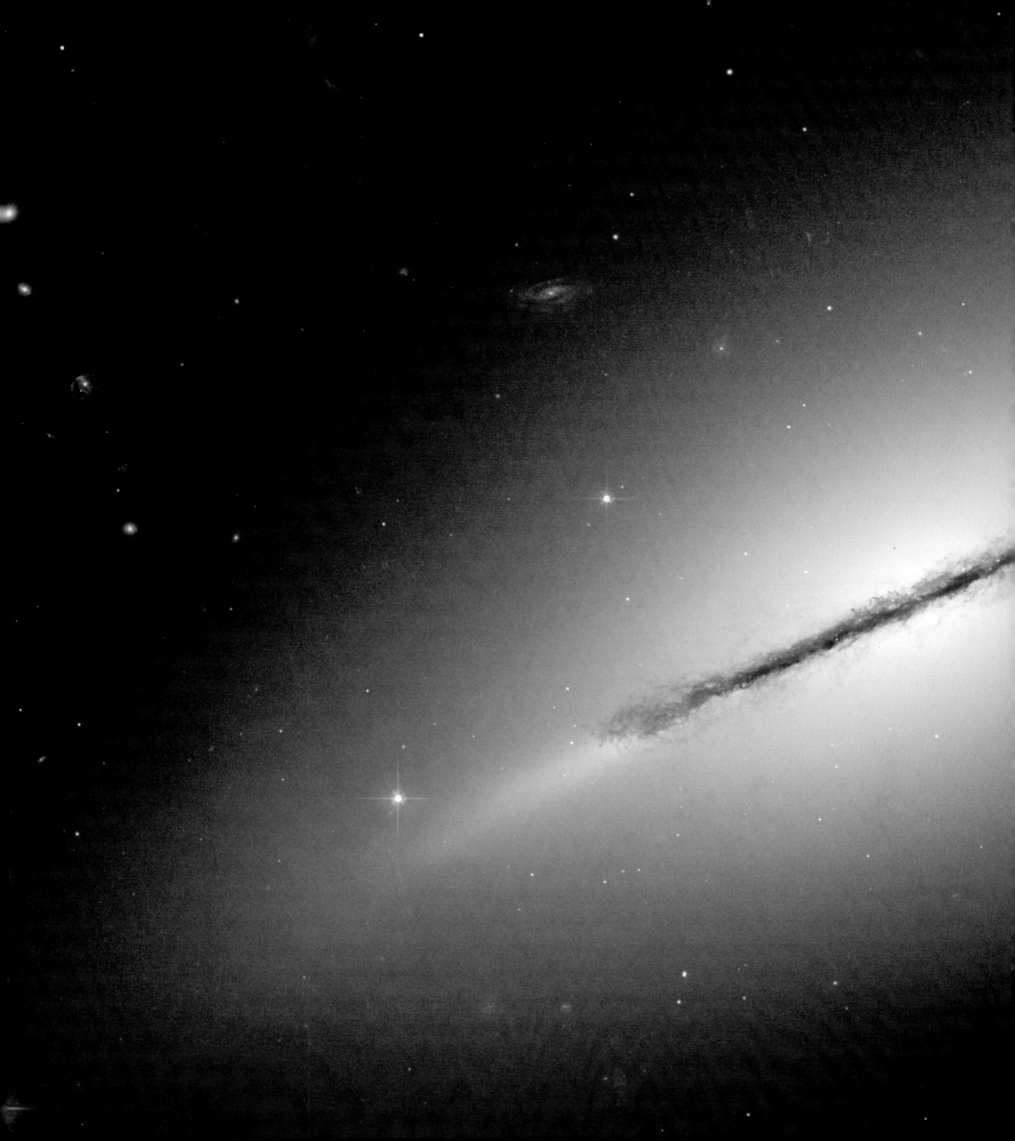

GALAXY NGC 5866 (2006) Our journey through Hubble's universe has taken us from some of the smaller bodies in Earth's neighborhood, such as the eruptive Jovian moon Io, to the distant vistas of the Hubble Ultra Deep Field. The trip has uncovered a bewildering menagerie of creatures exhibiting forms ranging from pure chaos to rigid order. It is the authors' choice to end this visual tour with order, and so we present an edge-on spiral galaxy in the constellation Draco, the Dragon, more than 40 million light-years away.

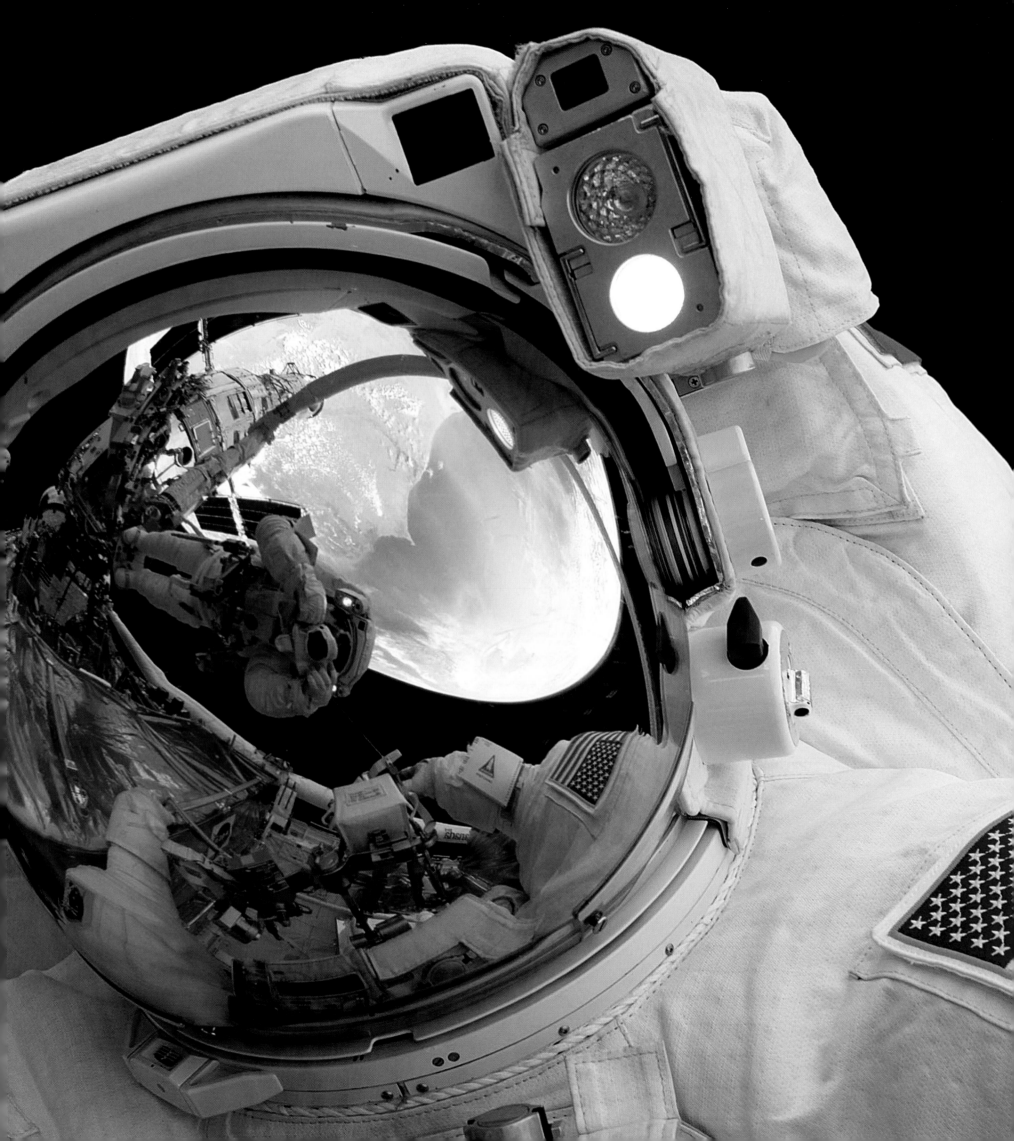

The Hubble Space Telescope has been

exploited by astronomers to address a remarkable range of scientific questions. It has also reshaped how both astronomers and the general public view the universe.

Scientists expected dazzling images after the Hubble was launched, but even they were surprised by the beauty and power of the Hubble's vision. The most familiar astronomical objects, when viewed at the Hubble's very high resolution, have often shown new and unexpected aspects.

Just as unexpected was the startling extent to which the telescope's images would grab the attention of newspapers, magazines, and television, as well as being widely disseminated via the Internet and books. Some have become cultural icons. They have graced the cover of *Time* magazine. They have been featured on prime-time news. They have even appeared in advertisements for electronics hardware and adorned T-shirts, wristwatch faces, coffee mugs, calendars, and CD covers. A collection of 14 images is accessible to blind and visually impaired people using a special printer that embosses the images so readers can run their

fingers along the contours. The HST and the vistas it has opened have clearly struck a resonant chord.

The Hubble has already assumed a prominent place in the history of telescopes. Novel telescopes like the HST spring in part from a desire to address specific scientific problems. They also arise from an abiding faith that a more powerful telescope will make possible major new discoveries and so refine and reshape our views of the universe. As Lyman Spitzer put it in his 1946 report on the "Astronomical Advantages of an Extraterrestrial Observatory," the most significant discoveries to be made with a large telescope in space would be those astronomers never expected. Spitzer also reckoned that "the chief contribution of such a radically new and more powerful instrument would be, not to supplement our present ideas of the universe we live in, but rather to uncover new

phenomena not yet imagined, and perhaps modify profoundly our basic concepts of space and time."

What we might call the "Hubble era" in astronomy has brought about more than one profound transformation. The electronic and computer-based image processing technologies have not remained the Hubble's exclusive domain. The images from the Hubble have shown all of us what is possible, and, as they have done before, amateurs and professionals alike have rushed to adapt these new techniques to their own backyard telescopes. Leaving behind photographic recording and the home darkroom, they have embraced the powerful new format of digital imaging. In so doing, they have sparked a new fascination for the deep sky and the many wonderful and dazzling things found in it. They have connected simple Webcams to small commercial telescopes and homemade contraptions. They have downloaded freeware capable of stacking thousands of electronic images automatically, discriminating in favor of the best ones and rejecting the fuzzy ones. In so doing, astronomers have produced enhanced images of the

Opposite: **AT WORK (2009)** Astronaut John Grunsfeld at work during one of the three space walks he and Andrew Feustel made during Servicing Mission 4. A veteran of four earlier journeys into space, two of them missions to Hubble, Grunsfeld and his crewmates installed two new science instruments, Wide Field Camera 3, and the Cosmic Origins Spectrograph, as well as batteries, gyroscopes, and a fine guidance sensor.

sun, moon, planets, stars, nebulae, and galaxies that compete with and even surpass those taken by the great mountain observatories of the 20th century.

The fifth and final servicing mission to Hubble began with launch of the space shuttle *Atlantis* on May 11, 2009. Getting to launch, however, was anything but smooth. Citing safety concerns, NASA Administrator Sean O'Keefe postponed and then canceled the mission in the wake of the disintegration of the shuttle *Columbia*'s reentry into the atmosphere on February 1, 2003, near the end of its 28th mission in space. But after O'Keefe left the space agency and in the wake of a public and congressional outcry over the cancellation, a new NASA Administrator, Michael Griffin, ordered a reanalysis of the risks involved in repairing Hubble one more time. He then decided to reinstate the mission. During five space walks that followed in May 2009, the astronauts installed two new instruments: a powerful third-generation CCD camera called the Wide Field Camera 3 and an advanced ultraviolet spectrograph. WFC3 has both sharpened and widened Hubble's vision, from the ultraviolet through the visible ranges as before, and now deep into the near infrared, where star birth can be studied in detail. The astronauts also performed some critical housekeeping in the hope of extending the HST's life expectancy. They replaced batteries, gyroscopes, and parts of Hubble's fine guidance system. They also added a new backup Science Instrumentation Command and Data Handling Unit to be sure that Hubble's vision would not be interrupted for many years.

On his fifth space mission, and third visit to Hubble, astronomer-astronaut John Grunsfeld worked flawlessly in space with his colleagues—including veteran astronaut Mike Massimino, who was on his second visit to Hubble—for almost two weeks to yet again dramatically upgrade Hubble's scientific capabilities. After the mission, Grunsfeld reflected, "This is a really tremendous adventure that we've been on, a very challenging mission. Hubble isn't just a satellite—it's about humanity's quest for knowledge."

But no telescope represents the final word in telescope building, not even the Hubble Space Telescope, which after its five servicing missions now has capabilities far more powerful than it had upon launch. And no single telescope today, in space or on the ground, can be as effective at exploring the universe working only in isolation. Each depends synergistically on collaboration with the growing array of instruments constantly being improved by today's astronomical institutions and the nations that support them.

Astronomy was one of the first scientific disciplines to think globally in terms of cooperation instead of competition. Then it was the need for uninterrupted synoptic monitoring of the sun, planets, and stars. Today, in the first years of the 21st century, global cooperation has taken on a whole new meaning. The biggest of the instruments of discovery have become so complex, so large, and so expensive, that they call for different nations to cooperate in their construction. A case in point is, What will succeed the Hubble?

Even before the HST was launched, astronomers were pondering a more ambitious successor. These plans eventually jelled into what is now known as the James Webb Space Telescope (JWST). Due to be launched toward the end of this decade, possibly in 2018, the JWST will be an infrared-optimized observatory stationed more than a million miles away from Earth in a direction constantly opposite the sun in space, far beyond the moon's orbit. The James Webb Space Telescope's primary mirror will be some 6.5 meters in diameter and so will offer almost six times the light-collecting area of the Hubble's 2.4-meter mirror. One of its chief scientific goals is to explore the details in the farthest reaches of space that have been sensed by the Hubble, in effect to travel once again to a time when the first galaxies and stars were being born. The JWST will see in them detail that astronomers hope will yield answers to new questions as well as to the questions raised by the Hubble's observations.

But it will not be an exclusively American venture. In June 2007 the European Space Agency and the Canadian Space Agency both formalized an agreement with NASA to launch JWST on an Ariane 5 European rocket as well as to provide a significant portion of the scientific instrumentation. Such international cooperative agreements have existed before, including with Hubble, but as the scale of space astronomy's very biggest efforts has grown, so has the need for nations to cooperate to make them a reality. JWST will be a truly international venture.

The human drive to understand how the universe works, even at the greatest distances from Earth, has produced some of the most creative and aesthetically wonderful machines in existence and is one of the great adventures of the human spirit. The Hubble Space Telescope exemplifies this drive, and it will surely be remembered as one of the most successful.

Opposite: **STAR-FORMING REGION IN NEARBY GALAXY (2004)** The Small Magellanic Cloud is an irregular galaxy that orbits around our own. Hot, young, and blue stars are pictured in one of the cloud's star-forming regions.

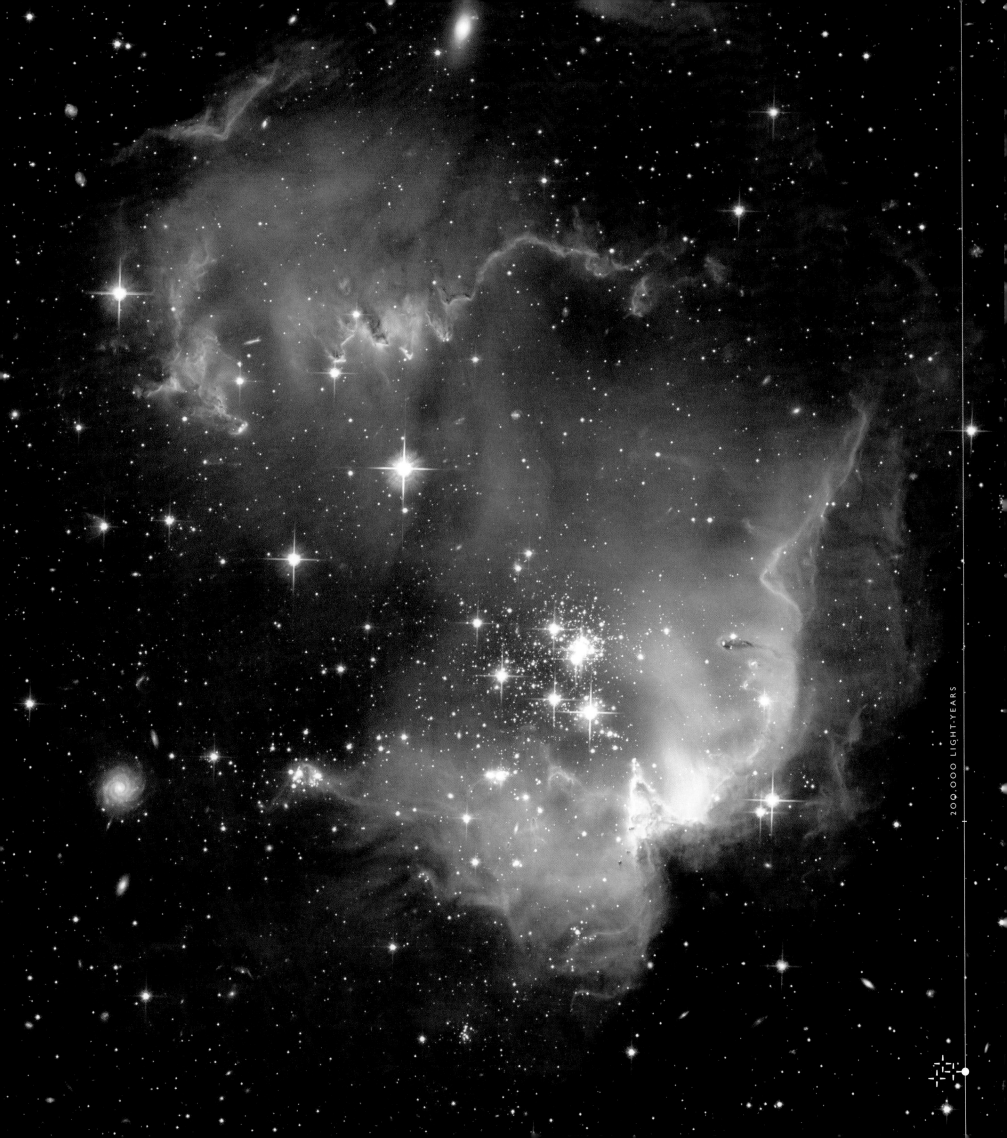

END NOTES

INTRODUCTION

9 "extend a human presence across our solar system." Mike Allen and Eric Planin, "Bush outlines space agenda; President Calls for Moon Trip by 2030," *The Washington Post,* 15 January 2004.
10 "The best is yet to come from Hubble." Bruce Margon, quoted in Timothy Dwyer, "Closing a Window on the Universe: Hubble Workers Lament Decision," The Washington Post, 18 January 2004
10 a pennywise and pound-foolish decision. Rep. Mark Udall, quoted in Guy Gugliotta, "Doomed Hubble's Fans Flood NASA with Ideas," The Washington Post, 21 March 2004.
11 "the height of irresponsibility." Guy Gugliotta, "Shuttle Aid to Hubble is Unlikely, NASA Says," The Washington Post, 12 March 2004

CHAPTER 1

34 when astronomers died H.N. Russell, "Where Astronomers Go When They Die," *Scientific American,* 149 (1933), pp.112-3.
38 not yet major research areas in astronomy A number of the historical issues discussed in this and the next chapter are examined at greater length in Robert W. Smith (with contributions by P. Hanle, R. Kargon, and J. Tatarewicz), *The Space Telescope: A Study of NASA, Science, Technology and Politics,* Expanded Paperback Edition, New York: Cambridge University Press, 1993.
42 "swallow hard" Oral History Interview, J. Rosendahl with J. Tatarewicz, September 12, 1984, National Air and Space Museum Collection.

CHAPTER 2

46 "possibly the most exciting single manuscript page" Owen Gingerich and Albert van Helden, "From Occhiale to Printed Page: The Making of Galileo's Sidereus—Nuncius." *Journal for the History of Astronomy* 34, 2003, pp. 251-267, on p. 251.
48 30 times closer Albert Van Helden, "The Invention of the Telescope." *Transactions of the American Philosophical Society* 67 pt. 4, 1977.
48 "the art of picturing and drawing." Mary G. Winkler and Albert Van Helden, "Representing the Heavens: Galileo and Visual Astronomy," *Isis* 83, 1992, pp. 195-217, on p. 195.
49 helping him map their distribution. Michael Hoskin, *The Cambridge Illustrated History of Astronomy.* New York: Cambridge University Press, 1997.
50 a distinct and peculiar plan of structure." William Huggins, *The Scientific Papers of Sir William Huggins.* London: William Wesley, 1909. p. 114.
50 "stars should henceforth register themselves" Alex Pang, "Technology, Aesthetics, and the Development of Astrophotography at the Lick Observatory," in Tim Lenoir, ed., Inscribing Science: Scientific Texts and the Materiality of Communication. Palo Alto: Stanford University Press, 1998, pp. 223-248, on 224.
50 the 200-inch Hale telescope at Palomar. Helen

Wright, *Explorer of the Universe: A Biography of George Ellery Hale.* 1966. Repr American Institute of Physics, 1994.
51 not made of stars, but of galaxies. Robert W. Smith, *The Expanding Universe: Astronomy's "Great Debate" 1900-1931.* Cambridge: Cambridge University Press, 1982.

CHAPTER 3

72 [Hubble Space Telescope] might actually work." E-mail, Joe Dolan to High Speed Photometer Team, May 21, 1990.
72 we are doomed to failure." Oral History Interview, S. Faber with R. Smith, June 3, 1992, National Air and Space Museum Collection, and S. Faber Notebook Entry for June 19, 1990.
74 of a galaxy's center. John Noble Willford, "First Hubble Findings Bring Delight," *New York Times,* August 30, 1990, p. B 10.
74 "even a nearsighted Hubble is pretty powerful." *Time,* January 4, 1993, p. 60.
74 2 billion for the capabilities it has." Steve Maran, quoted in Jim Detjen, "Scientists Come Close to Age of Universe," *Philadelphia Enquirer,* January 17, 1991, p. 18.

CHAPTER 4

106 "the future generations of stars will arise." Scoville et al 2001, p. 3018.
109 seven ten-thousandths of a second of arc. Ray Villard, "From Idea to Observation: The Space Telescope at Work," *Astronomy,* June 1989, pp. 38-44, on p. 43.
111 The Astronomical Journal. Scoville, et al, 2001.
126 would be lost to the distant past." Scoville, et al 2001, p. 3018

CHAPTER 5

This chapter is written by Elizabeth A. Kessler and based on her dissertation, "Spacescapes: Romantic Aesthetics and the Hubble Space Telescope Images," Unpubl. University of Chicago, March 2006.
140 "massive stars and their surroundings." Paul Scowen, et. al., "Hubble Space Telescope WFPC2 Imaging of M16: Photoevaporation and Emerging Young Stellar Objects," *The Astronomical Journal* 111 (1996), pp. 2349-2360, on p. 2360.
140 typical of scientific articles. Jon A. Morse et al. "Hubble Space Telescope Wide Field Planetary Camera 2 Observations of Eta Carinae," *The Astronomical Journal* 116 (1998) pp. 2443-2461, on p. 2444. And C.R. O'Dell and Shui Kwan Wong, "Hubble Space Telescope Mapping of the Orion Nebula I. A Survey of Stars and Compact Objects," *The Astronomical Journal* 111 (1996) 846-855, on p. 848.
140 "only with their thoughts." "The Hubble Achievement," editorial, *New York Times,* 3 May, 2002, late ed., sec. A: 22.
140 visual appeal is a secondary concern. Michael Lynch, and Samuel Y. Edgerton, Jr., "Aesthetics and Digital Image Processing: Representational Craft in Contemporary Astronomy," *In Picture Power: Visual Depiction and Social Relations* [Sociological Review

Monography 35]. London: Routledge, 1988.
140 graphics programs such as Photoshop Ray Villard and Zoltan Levay, "Creating Hubble's Technicolor Universe," *Sky and Telescope,* Sept. 2002: 28-34.
141 moving from the tangible to the abstract. Bruno Latour, *Pandora's Hope: Essays on the Reality of Science Studies,* Cambridge: Harvard University Press, 1999.
142 to repay the public that supports us." "Astronomers Unveil Colorful Hubble Photo Gallery," Space Telescope Science Institute press release, October 21, 1998. Hubble Site http://hubblesite. org/newscenter/archive/1998/28/text.
144 awe, wonder, and transcendence. Edmund Burke, *A Philosophical Enquiry into the Origin of Our Ideas of the Sublime and the Beautiful,* ed. Adam Phillips. Oxford: Oxford University Press, 1998.
150 "the American Southwest." "Hubble's New Camera Delivers Breathtaking Views of the Universe." *Hubble Space Telescope News,* April 30, 2002. Space Telescope Science Institute. < http:// sites.stsci.edu/pubinfo/PR/2002/11/pr.html

CHAPTER 6

171 a public legacy for HST. M. Livio, S. M. Fall and P. Madeu, eds. *The Hubble Deep Field.* New York: Cambridge University Press, 1998, on p. 27.

EPILOGUE

215 concepts of space and time." Lyman Spitzer, Jr., "Astronomical Advantages of an Extra-Terrestrial Observatory," Douglas Aircraft Company, Sept. 1, 1946.

JBO/MERLIN]; 199, NASA, ESA, and the Hubble SM4 ERO Team; 200-201, The team, led by Jeremy Mould (Caltech), consisted of Sandra Faber and Garth Illingworth (Univ. of California, Santa Cruz), Wendy Freedman, John Graham, and Robert Hill (Carnegie Institution of Washington), John Hoessel (Univ. of Wisconsin, Madison), John Huchra (Center for Astrophysics, Cambridge, MA), Shaun Hughes (Caltech), Robert Kennicutt (Univ. of Arizona), Myung Gyoon Lee (Carnegie), Barry Madore (Caltech), Peter Stetson (Dominion Astrophysical Observatory, Victoria, British Columbia), and Anne Turner (U. Arizona), Laura Ferrarese and Holland Ford (Space Telescope Science Institute); 202-203, The Hubble Heritage Team (AURA/STScI/NASA); 204-205, E.J. Schreier (STScI), and NASA; 206, NASA, ESA, A. Riess (STScI/JHU), L. Macro (Texas A&M University), and the Hubble Heritage Team (STScI/AURA); 207, NASA, ESA, and The Hubble Heritage Team (STScI/AURA); 208-209, NASA, H. Ford (JHU), G. Illingworth (UCSC/LO), M.Clampin (STScI), G. Hartig (STScI), the ACS Science Team, and ESA; 210-211, NASA, ESA, and S. Beckwith (STScI) and the HUDF Team; 212-213, NASA, ESA, and The Hubble Heritage Team (STScI/AURA); 214, NASA, 2009; 217, NASA, ESA, and the Hubble Heritage Team (STScI/AURA) - ESA/ Hubble Collaboration; 218, 221, 222, NASA.

SUGGESTED READING

Berendzen, Richard, Richard Hart, and Daniel See-ley. *Man Discovers the Galaxies*. New York: Science History Publications, 1976.

Christianson, Gale E. *Edwin Hubble: Mariner of the Nebulae*. New York: Farrar, Straus, Giroux, 1995.

Clair, Jean, ed. *Cosmos: From Romanticism to the Avant-Garde*. New York: Prestel Publishing, 1999.

Coles, Peter, ed. *The Icon Dictionary of the New Cosmology*. Cambridge, Mass.: Icon Books, 1999.

Crowe, Michael J., *Modern Theories of the Universe. From Herschel to Hubble*. New York: Dover, 1994.

DeVorkin, David H., ed. *Beyond Earth: Mapping the Universe*. Washington, D.C.: National Geographic, 2002.

Galileo, *Siderius Nuncius or The Sidereal Messenger*, translated with introduction, conclusion, and notes by Albert Van Helden. Chicago: University of Chicago Press, 1989.

Gingerich, Owen. *The Book Nobody Read: Chasing the Revolutions of Nicolaus Copernicus*. New York: Walker & Company, 2004.

Goodwin, Simon. *Hubble's Universe: A Portrait of Our Cosmos*. New York: Viking Penguin, 1997.

Gribbin, John, *The Birth of Time: How Astronomers Measured the Age of the Universe*. New Haven, Conn.: Yale University Press, 1999.

Hetherington, Norriss S., ed. *Encyclopedia of Cosmology: Historical, Philosophical, and Scientific Foundations of Modern Cosmology*. New York: Garland Publishers, 1993.

Hoskin, Michael A. *William Herschel and the Construction of the Heavens, with astrophysical notes by D.W. Dewhirst* (1st American ed.). New York: W.W. Norton and Company, 1964.

Hoskin, Michael A., ed. *The Cambridge Illustrated History of Astronomy*. New York: Cambridge University Press, 1997.

Hubble, Edwin. *The Realm of the Nebulae, with a foreword by James E. Gunn*. New Haven, Conn.: Yale University Press, 1982.

King, Henry C. *The History of the Telescope, with a foreword by Sir Harold Spencer Jones*. Cambridge, Mass.: Sky Publishing Corporation. 1955.

Learner, Richard. *Astronomy Through the Telescope*. New York: Van Nostrand Reinhold, 1981.

Livio, Mario, Keith Noll, Massimo Stiavelli, and Michael Fall, eds. *A Decade of Hubble Space Telescope Science* (proceedings of a conference at the Space Telescope Science Institute, held in Baltimore, Md., April 2000). New York: Cambridge University Press, 2003.

Overbye, Dennis. *Lonely Hearts of the Cosmos: The Story of the Scientific Quest for the Secret of the Universe*. Boston: Back Bay Books, 1999.

Panek, Richard, *Seeing and Believing: How the Telescope Opened Our Eyes and Minds to the Heavens*. New York: Viking, 1998.

Petersen, Carolyn Collins, and John C. Brandt. *Hubble Vision: Further Adventures with the Hubble Space Telescope*. New York: Cambridge University Press, 1998.

Petersen, Carolyn Collins, and John C. Brandt, *Visions of the Cosmos*. New York: Cambridge University Press, 2003.

Preston, Richard. *First Light: The Search for the Edge of the Universe* (1st rev. ed.). New York: Random House, 1996.

Rector, Travis, et al. "Digital Image Processing Techniques to Create Attractive Astronomical Images from Research Data." *Astronomical Journal* (forthcoming).

Smith, Robert W. *The Expanding Universe: Astronomy's "Great Debate,"* 1900-1931. New York: Cambridge University Press, 1982.

Smith, Robert W. *The Space Telescope: A Study of NASA, Science, Technology, and Politics, with contributions by Paul A. Hanle, Robert H. Kargon, and Joseph N. Tatarewicz*. New York: Cambridge University Press, 1993, expanded and revised version.

Tucker, Wallace, and Karen Tucker. *The Cosmic Inquirers: Modern Telescopes and Their Makers*. Cambridge, Mass.: Harvard University Press, 1986.

van Helden, Albert. *Measuring the Universe: Cosmic Dimensions from Aristarchus to Halley*. Chicago: University of Chicago Press, 1985.

Wright, Helen. *Explorer of the Universe: A Biography of George Ellery Hale*. Woodbury, N.Y.: American Institute of Physics, 1994.

Wright, Helen, *The Great Palomar Telescope*. London: Faber and Faber, 1953.

ACKNOWLEDGMENTS

National Geographic gives special thanks to Zoltan G. Levay, senior image processing specialist at the Space Telescope Science Institute, for sharing his expertise and depth of knowledge in the reproduction of Hubble imagery, and to Greg Bacon and the Space Telescope Science Institute for their generous contribution of the HST orbit diagram used on page 43 of this book.

We have depended upon, and benefited from, many talented and dedicated people. Elizabeth Kessler wrote the entirety of Chapter 5 and lent her insight and expertise to the whole of the work. Kevin Eans deftly succeeded in securing the best images, Paul Massoud provided thorough and critical fact-checking, Nick Scoville, Ken Janes, John Huchra, and Karl Hufbauer kindly read portions of the manuscript. Zoltan Levay and the Hubble Heritage Team were most generous with their time and images. Trish Graboske, Joan Mathys, Tracy McGowan, and Lawana Bryant provided advice and encouragement; Sam Serebin made the book visually appealing; Pat Daniels deftly edited the manuscript; and Barbara Brownell Grogan kept us all on track. We also wish to acknowledge the support provided by the National Aeronautics and Space Administration, the National Science Foundation, and the National Air and Space Museum's Guggenheim fellowship program that led to historical research and exhibitry that informed the present work.

—The Authors

ABOUT THE AUTHORS

David DeVorkin is curator of the history of astronomy and the space sciences at the National Air and Space Museum, Smithsonian Institution, where he was curator for the "Explore the Universe" exhibition, opened in September 2001. His most recent books include *Beyond Earth: Mapping the Universe*, a companion volume to the exhibition; *Henry Norris Russell: Dean of American Astronomers*; and *The Hubble Space Telescope: Imaging the Universe*.

Robert W. Smith is a professor of history and Director of the Science, Technology and Society Program at the University of Alberta, and formerly a member of staff at the National Air and Space Museum. His books include the award-winning *The Space Telescope: A Study of NASA, Science, Technology and Politics*; *The Hubble Space Telescope: Imaging the Universe*; and *The Expanding Universe*. He has closely followed Hubble's history for more than 25 years.

Elizabeth Kessler is a visiting assistant professor at Ursinus College in Collegeville, Pennsylvania. She completed her Ph.D at the University of Chicago in 2006, where she wrote her dissertation on the images from the Hubble Space Telescope. Much of her research on the topic was conducted in 2003 while she was a Guggenheim predoctoral fellow at the National Air and Space Museum.

HUBBLE: IMAGING SPACE AND TIME
by David DeVorkin and Robert W. Smith

Published by the National Geographic Society
John M. Fahey, Jr., Chairman of the Board and Chief Executive Officer
Timothy T. Kelly, President
Declan Moore, Executive Vice President; President, Publishing
Melina Gerosa Bellows, Executive Vice President, Chief Creative Officer, Books, Kids, and Family

Prepared by the Book Division
Barbara Brownell Grogan, Vice President and Editor in Chief
Jonathan Halling, Design Director, Books and Children's Publishing
Marianne R. Koszorus, Design Director, Books
Susan Tyler Hitchcock, Senior Editor
Carl Mehler, Director of Maps
R. Gary Colbert, Production Director
Jennifer A. Thornton, Managing Editor
Meredith C. Wilcox, Administrative Director, Illustrations

Since 1888, the National Geographic Society has funded more than 13,000 research, exploration, and preservation projects around the world. National Geographic Partners distributes a portion of the funds it receives from your purchase to National Geographic Society to support programs including the conservation of animals and their habitats.

National Geographic Partners
1145 17th Street NW
Washington, DC 20036-4688 USA

Get closer to National Geographic explorers and photographers, and connect with our global community. Join us today at nationalgeographic.com/join

IMAGING SPACE AND TIME

Staff for This Book
Patricia Daniels, Editor
Sam Serebin, Art Director
Kevin Eans, Susan Blair, Illustrations Editors
Tiffin Thompson, Researcher
Michael Horenstein, Production Project Manager
Marshall Kiker, Illustrations Specialist
Jodie Morris, Design Assistant

Manufacturing and Quality Management
Christopher A. Liedel, Chief Financial Officer
Phillip L. Schlosser, Senior Vice President
Chris Brown, Technical Director
Nicole Elliott, Manager
Rachel Faulise, Manager
Robert L. Barr, Manager

For information about special discounts for bulk purchases, please contact National Geographic Books Special Sales: specialsales@natgeo.com

For rights or permissions inquiries, please contact National Geographic Books Subsidiary Rights: bookrights@natgeo.com

First paperback printing 2011

ISBN: 978-1-4351-4809-3 (B&N ed.)
ISBN: 978-1-4262-0322-0 (hardcover)
ISBN: 978-1-4262-0411-1 (deluxe edition)
Printed in China
19/RRDH/4